Researching Visual Arts Education in Museums and Galleries

Landscapes: The Arts, Aesthetics, and Education

VOLUME 2

SCOPE

This series aims to provide conceptual and empirical research in arts education, (including music, visual arts, drama, dance, media, and poetry), in a variety of areas related to the post-modern paradigm shift. The changing cultural, historical, and political contexts of arts education are recognized to be central to learning, experience, and knowledge. The books in this series present theories and methodological approaches used in arts education research as well as related disciplines - including philosophy, sociology, anthropology and psychology of arts education.

RESEARCHING VISUAL ARTS EDUCATION IN MUSEUMS AND GALLERIES

An International Reader

Edited by

Maria Xanthoudaki
Politecnico di Milano, Italy

Les Tickle
University of East Anglia, U.K.

and

Veronica Sekules
Sainsbury Centre for Visual Arts, U.K.

KLUWER ACADEMIC PUBLISHERS
DORDRECHT / BOSTON / LONDON

A C.I.P. Catalogue record for this book is available from the Library of Congress.

ISBN 1-4020-1636-0

Published by Kluwer Academic Publishers,
P.O. Box 17, 3300 AA Dordrecht, The Netherlands.

Sold and distributed in North, Central and South America
by Kluwer Academic Publishers,
101 Philip Drive, Norwell, MA 02061, U.S.A.

In all other countries, sold and distributed
by Kluwer Academic Publishers,
P.O. Box 322, 3300 AH Dordrecht, The Netherlands.

Printed on acid-free paper

Printed in the Netherlands.

TABLE OF CONTENTS

LIST OF CONTRIBUTORS

Marianna Adams is senior researcher at the Institute for Learning Innovation in Annapolis, Maryland, USA. She has headed education departments at the John and Mable Ringling Museum of Art in Sarasota, and the Museum of Art in Ft. Lauderdale, Florida. She got her Ed.D.at the George Washington University in Washington, DC.

Susan Hazelroth Barrett works as an independent art educator in Columbus, Ohio helping learners develop strategies for looking thoughtfully and enjoyably at art. She has worked as a Montessori teacher, and for ten years in the education team of the John and Mable Ringling Museum of Art in Sarasota, Florida.

Meg Black earned a PhD at the Lesley College Graduate School of Education in Cambridge Massachusetts in 2000. She is a practising visual artist who exhibits her work internationally and has taught at several Boston colleges.

Lynn D. Dierking is Associate Director of the Institute for Learning Innovation, USA. She has a Ph.D. in Education from the University of Florida, and has worked as an educator in a variety of settings, including several museums. She has published extensively and before coming to the Institute, directed the Science in American Life curriculum project at the National Museum of American History, Smithsonian Institution, and was Assistant Professor of Education at the University of Maryland, USA.

John H. Falk is the director of the Institute for Learning Innovation. He has doctorates in Biology and in Education from the University of California, Berkeley. He worked at the Smithsonian Institute for 14 years and has published extensively, including co-authoring with Lynn Dierking *The Museum Experience* (Whalesback 1992), *Learning From Museums* (AltaMira Press 2000), and *Free Choice Learning: Stories of Lifelong Learning in America* (Roman and Littlefield, in press).

Folkert Haanstra is professor of Cultural Education and Cultural Participation at the Utrecht University and senior researcher at the SCO-Kohnstamm Institute for Educational Research of the University of Amsterdam, The Netherlands. He studied psychology and Fine Art and he has carried out extensive research into arts education and museum education.

George E. Hein is Professor Emeritus at Lesley College Graduate School of Arts and Social Sciences in Cambridge, Massachusetts, USA. He has developed comprehensive, qualitative evaluation systems for museum programmes and is the author of *Learning in the Museum* (Routledge 1998).

Jane Leong is Assistant Professor of the National Institute of Education at Nanyang Technological University in Singapore. She received her M.A in art history from the Arizona State University in 1991, and is currently conducting doctoral research on art museum education and national identity at the University of Durham in the UK.

Maaria Linko has a Ph.D. in Sociology from the University of Helsinki, where she has worked as Senior Lecturer. She has specialised in the reception of art using qualitative methods. Currently she is Lecturer at the Open University, University of Helsinki, Finland. Her publications include *The Spectators' Theatre* (Katsojien teatteri 1986), *Strange Art or Real Art* (Outo ja aito taide 1992), and *The Longing for Authentic Experiences* (Aitojen elämysten kaipuu 1998).

Silvia Mascheroni is an art historian specialising in museum and gallery education. She has carried out several research projects in the fields of cultural heritage education and art education and taught in training courses for teachers and museum educators in collaboration with museums, universities and training institutions. She was member of the National Commission for Museum Education of the Italian Ministry of Cultural Heritage and Activities (1995-1999).

Juliet Moore Tapia is Assistant Professor of Art Education at the University of Houston, Texas. She earned both her Ph.D. in Art Education and her MA degree in anthropology from Penn State University, Pennsylvania. She previously worked for the J.Paul Getty Trust and the Los Angeles Cultural Affairs Department.

Helen O'Donoghue is Senior Curator and Head of Education & Community Programmes at the Irish Museum of Modern Art (IMMA), Dublin, Eire. Post qualifying in Fine Art at the National College of Art, Dublin, she carried out research projects resulting in a series of videos exploring children's visual development. At IMMA, she has initiated a number of new models of engagement with contemporary art for artists, community groups and schools.

Marjo Räsänen is Senior Researcher at the Department of Art Education, University of Art and Design, Helsinki, Finland. She worked as an art teacher in a secondary school for five years and as a senior lecturer in the Department of Art Education at UIAH where she also got her PhD in 1997.

Veronica Sekules established and runs the education department at the Sainsbury Centre for Visual Arts, University of East Anglia, Norwich, UK. Her degree and doctorate are in Art History, specialising in medieval art. In the field of education she has a particular interest in developing methodologies which explore means of understanding that can, in turn, lead to creativity.

Irene Stylianides is a graduate of the University of Crete, where she qualified as a pre-school teacher. She has experience as a pre-school, special school and primary school teacher in Nicosia and in Paphos, Cyprus.

Les Tickle is Professor of Education at the University of East Anglia, Norwich, UK. He has been an art educator for more than thirty years in schools and higher education and has published extensively on curriculum, teacher education, and art education. His books include *The Arts in Education: some research studies* (Croom Helm 1987) and *Understanding Art in Primary Schools: cases from teachers' research* (Routledge 1996).

Douglas Worts is a museum educator and audience researcher at the Art Gallery of Ontario in Toronto Canada. He has also taught museum education at the University of Toronto. He has published many articles in museum journals, and spoken at conferences in Canada, the USA, Australia, New Zealand, France and England.

Maria Xanthoudaki is a research associate in the Faculty of Architecture, Politecnico di Milano, Italy. She graduated as a teacher from the University of Crete and gained her MA (art education) and PhD (museum education) at the University of Sussex, UK. She currently works in training museum educators and teachers through collaboration with universities and museums.

MARIA XANTHOUDAKI, LES TICKLE AND VERONICA SEKULES

INTRODUCTION

Museum Education and Research-based Practice

During the final decades of the twentieth century, the emphasis which museums and galleries placed on their education programmes shifted from a quantitative exercise to a qualitative one. While in the 1980s there was an urgency about using educational visits to increase visitor numbers, the following decade saw an increasing interest in questions of intellectual and physical access. Governments and museum institutions alike, especially local authorities responsible for museum policies, began to recognise their potential as stimuli in the fields of formal and informal education. Research, under the aegis initially of powerful foundations such as the Getty Institute for art education in America, was demonstrating increasingly that museum education could change people. Case studies were mounting which showed that new issues were being raised through museum education, that it could be empowering for the learner, leading to revelatory moments of understanding. The 1990s saw an increasing professionalisation of the practices of education. After a shaky start, during which time new museum education posts looked vulnerable, there are now scarcely any museums, throughout the world, which do not provide educational programmes and 'interactive' resources associated with displays and events as a regular feature of their work.

While there is little problem now about posts being funded and the importance of museum education work being officially recognised, there is still tension about its broader cultural agendas and contexts. The politically driven debates about access, widening participation and social inclusion have impacted heavily on education departments and are hardly ever accompanied by training or research programmes on the educational efficacy of these policies. The 19th-century notion of the museum as educationally civilising, has only slightly shifted to it perceiving itself as socially and culturally cohesive and ideally also, inclusive. But what is happening now, is not so much a distinction between elite and commonplace, or disorder and enlightenment in the social fabric, as one between humdrum and transformative experience. What Bennett termed the 'culturally differentiating practices' of the museum (Bennett 1996, 99-105), policing the norms of public conduct, have shifted in their emphasis to the museum as provider of the extraordinary, of spectacle and sensation. This was also one of Tony Bennett's points, but this has had both an interesting and a worrying implication for education. In an age which recognises the power of the consumer, education is being used as part of the instrument, for 'audience development'. So, as well as helping to improve knowledge and deepen

1

M. Xanthoudaki, L. Tickle, V. Sekules (eds)
Researching Visual Arts Education in Museums and Galleries, 1-12.
©*2003 Kluwer Academic Publishers. Printed in the Netherlands.*

understanding (both complex notions which will be unpacked extensively in the course of this book) there is an expectation that education will deliver popular entertainment. This has had the spiralling effect of increasing the pace of activity, and in the interests of widening audience participation, especially from families, it has imposed a pressure to deliver extensive play-centred diversions at the expense of sustained and perhaps more difficult work with longer-term goals.

The desire for spectacle in the museum is part of the tension, heightened in the field of education, which exists between popular expectations, institutional aims and the professional agenda of the practitioners working within it. At best this tension is symbiotic, in the sense that there is a shared sense of mission towards general cultural benefit. As Stephen Weil quoted recently in 'Making Museums Matter', what is important is that the museum perceives itself as making a difference in society, 'reaching a consensus on merit'. The intentions of a good museum are to be a force for good 'to make a positive difference'. The demands for accessibility are normative, the museum's benevolent improving influence is a citizen's inalienable right. (Weil 2002, 55-74). This feel-good aspiration is one with which most institutions would identify and can easily be seen as propitious for the development of worthwhile community-focussed education. Conversely, there is Bourdieu's much more jaundiced view that the charismatic ideology of the museum is entirely self-serving, offering a pretence at democratic access while all the time reinforcing notions of cultural exclusiveness. Museums and their publics operate in a system of mutually reinforcing values of cultural competence, concealed from the uninitiated but which: 'betray in the smallest details of their morphology and their organisation, their true function which is to strengthen the feeling of belonging in some and the feeling of exclusion in others'. In his terms education, such as it exists in the élite French museum, reinforces the system and any transformative experience is tainted by élite cultural values of obeisance to grandeur and recognition of some agreed, but invisible, standards of quality (Bourdieu 1993, 236). Both are in a sense very authoritarian points of view, and while Weil or Bourdieu might offer alternative theoretical positions, practical experience can lead to a very different perspectives. Among museum educators and researchers responsible for daily contact with objects and people in the museum, it is possible for views to be entirely differently nuanced and to be both more measured and more optimistic about the possibilities there for educational and social experiment and change.

The multiplication in museums and art galleries both of informal education opportunities and more structured education programmes bear out this mood of professional optimism and are characterised by diversity, innovation, and practical curiosity about the best way to develop learning. Normally, the ideas that emerge come not from broad institutional aspirations, but from individuals or small teams working to busy schedules, using their own imaginations.. Ideas tend to spread via formal or informal professional networks at regional meetings and conferences, such as those run regularly in the UK by Engage or the Group for Education in Museums, by the American Association of Museums in the United States, or internationally by ICOM. The emerging diversity is a matter for celebration and cuts across institutional, regional, national and cultural boundaries through a sense of shared interest and commitment. However, largely because of lack of time and resources, in

the rush for lively programming which is often imposed as a result of institutional pressure or expectations, a great deal of innovative practice goes unreported and many educational issues do not get adequately debated in the wider world. In any case, the informal sharing of experience is not enough for the systematic development of understanding about the educational processes that occur in museum and gallery settings. There is an international as well as local need for museum and gallery educators to investigate their work on a systematic research footing, to transmit their research across the art education community, and to build the whole community's practices on the most enlightened understanding possible.

The call for a more substantial and sustained approach to the development of 'research-based practice' is clear. For intrinsic professional reasons, practice that is well informed, carried out on the basis of evidence, is likely to be more satisfying and enduring, as well as effective in achieving its goals. For extrinsic reasons of accountability, marketing and such, it is also likely to be more plausible, justifiable and acceptable. But what does this concept imply for professionals who work in museums and galleries as educators? The educational community can gain from research done by researchers who are not necessarily themselves educational practitioners, or who are working in a contingent field characterised by a wide cultural perspective. Then, ideally, practice will be informed both by the substance and the methods of applied educational research. This concept usually implies a relationship in which educators need the skills of reading or listening to other people's research, judging its value and perhaps applying its lessons. But in addition to that, the practices of all educators working in the field of museums and galleries can be immediately, directly, and systematically researched using Action Research and other qualitative research methods to inform subsequent developments in practice, both at a personal and institutional level. In that case individual practice, and the experiences of those being educated, form a basis for personal and professional research the very purpose of which is to inform the practitioner, to bring about direct application of that research to that practice, in order to improve it. The urgency to develop the skills for conducting research is paramount, and those skills subsume the skills of reading others' substantive research and methodological reports. However, doing practice-based research is not enough in itself because as Stenhouse (1975) pointed out, research should be both systematic and public. Skills of recording, publishing, or otherwise communicating the understanding that derives from practice-based research are also important. Here, educators are not just the receivers of wisdom, they are its producers too, active in the wider community of art educators, contributing directly to society's professional and cultural knowledge base.

The idea that museum and gallery educators should be proficient in the use and conduct of applied educational research is at the heart of this book. It is becoming imperative that the experience of practice-based research methodologies developed in other educational arenas should be brought into the work of museum and gallery educators. There is a need and an opportunity to develop a research culture and to extend methodological expertise among gallery educators through the informed use of others' research and through their own research-based practice.

The growing debate about museum and gallery education shows that some key themes and issues stand out as being deemed worthy of close attention, both *in situ* as activities are devised by practitioners, and in a more generalised theoretical way among policy makers and researchers. Among the concerns, understanding of the needs and interests of different types of museum audiences is a theme of inquiry that has also blossomed since the last decades of the twentieth century. The reasons for this growth in interest are a close mix of intrinsic educational concerns (to do with engagement, motivation and sustaining involvement), extrinsic accountability (to do with increasing audience participation), and demographic trends (such as greater use of gallery visits by school groups). But there is also an underlying recognition that the idea of 'types' of audience collectivises individual visitors in a simplistic and unjustifiable manner. A growing awareness of the deeply personal and individual nature of aesthetic encounters has resulted in a search for understanding about their meaning, their value, and the processes involved in bringing them about. Not surprisingly perhaps, the 1990s saw that issue rise to prominence, as the characteristics of visitors' experiences and the nature of their learning in museum and gallery settings became a focus for authors such as Csikszentmihalyi and Robinson (1990), Falk and Dierking (1992), Hein (1998), Hooper-Greenhill (1991), Taylor (1986), Tickle (1996), and others. Authors in this volume, bringing together case studies from Britain, Canada, Eire, Finland, Greece, Italy, the Netherlands, Singapore, and the USA, have each participated in that growth period with their own contributions to the development of educational practice, and to our appreciation of the potentials of applied research methodology. Their new work published here as a collection brings the voices of researchers, practitioners and visitors together in a new way, that will hopefully lay a foundation for international co-operation in the future development and communication of research-based practice.

In the eternal quest for 'best practice', not only educationalists and researchers, but the professional organisations, trusts, research councils and funding bodies who have an interest in the field of museum education, have an increasing desire to reach an understanding of the nature of the affective and multi-sensory experiences of viewing material culture. This is coupled with a desire to know how best to promote positive and productive attitudes towards it, and how to effect learning from it. That has raised the stakes for practitioners in the field and encouraged them to develop curiosity about the most appropriate methods for intervention in relatively informal situations, and about the relationship between experience and learning. Many of the contributions to this book are concerned with planned interventions of various kinds, providing a richness from practice-based research that displays the 'thinking behind the teaching' as well as describing the activities and experiences of students, and providing evaluative evidence of events. The possibility for self-exploration and self-learning, illuminating the world of the visitor left in contemplation, without the intervention of another educator, provides an added dimension to the notion of researching practice, with the possibility of the 'teacher as researcher' (Stenhouse 1975) transformed into the *visitor as researcher*. The potential for a phenomenological view of research to become genuinely a source of our understanding has yet to be tapped. It is, as Crotty (1998, 84) put it, to recognise that "each of us must explore our own experience, not the experience of others, for no

one can take that step back to the things themselves on our behalf". Of course, practice-based research might well, and often does, reveal educators exploring their experience of educating. In a similar way, students inquiring into their experience of learning bring multiple first-hand perspectives to their search for understanding.

How to generate and sustain partnerships between galleries and museums on the one side, and colleges, school teachers, other organised groups, or individuals, on the other, is gaining increasing attention. The ways in which different artistic interests, institutional agendas, and personal beliefs about teaching or learning come together have highlighted the processes of negotiation and accommodation between stakeholders in education generally and gallery education in particular. Those issues expose some of the nuances and subtleties that underlie the provision of experiences through joint ventures, and those nuances are drawn out in some of the chapters presented here.

Overlaying these mostly micro-level concerns about the immediate and interactive engagement of visitors there are some broader issues about the social / cultural role that museums play in their communities that have come to bear more notably in recent times. The origins and history of museums and galleries as a general world wide phenomenon, as well as the backgrounds to individual institutions, seem no longer sufficient grounds to which appeals can be made for defining their purpose and their aims. Like most other circumstances, those in which museum and gallery educators and their visitors find themselves, have shifted to some degree or other from continuity, certainty, and clarity, towards instability, new thinking, and ambiguity. That new macro-level condition plays its part among the sponsors, patrons, and policy makers associated with museums and galleries, as well as among educators (and researchers), in the wider world. It is not simply a threatening condition; it is also facilitating, creating space and opportunities for initiative to flourish, ideas to be tested, arguments to be advanced. That spirit of initiative, inquiry, and investment also characterises the contributions to this book.

The contributions are grouped into four sections, reflecting on fundamental topics underlying the educational role of museums and galleries. The sections are a) *Museums and Lifelong Learning*, discussing the continuously-increasing tendency of many museums to respond to the needs and interests of different types of public, aiming at widening access and social inclusion, and building long-term audiences and lifelong learning opportunities; b) *Museums and Formal Education*, focusing on educational provision for schools, which for the majority of museums and galleries is seen in the context of a mission towards the education of the current young /future adult visitors and the support of the teachers and the curriculum; c) *Museums and Personal Discovery*, emphasising the personal, individualised character of the museum experience and the richness of visitors' meaning-making processes; and d) *Museums in Society*, tackling issues related to the ever-growing presence of contemporary museums in the community, in terms not only of services and activities, but also of contribution to socially-relevant issues and consideration of community groups and their needs.

Within those four sections, the authors represent a range of perspectives, used to create in-depth reports of art education in museums and galleries. All the research stems directly from educational practice and policy in very particular contexts,

indicating at once the variety and detail of these researchers' / practitioners' concerns, and their common interests. In bringing the collection together we have focused on education in museums and galleries that display the visual arts in order to concentrate attention in this instance to one, albeit broad, field of activity. Our aim has been to present accessible and readable accounts of educational projects and programmes that have been conducted in these diverse situations, with different groups of people, and in relation to a range of different art collections. Most of the projects have incorporated research as an intrinsic part of their provision and process, exemplifying the principles of research-based practice. Others have shown how research has been undertaken in order to inform the practices and policies of others. Some have been included to represent the institutional and policy contexts in which practice is carried out.

The first section, *Museums and Lifelong Learning*, throws up issues about the importance of sensitive recording of what is often substantial prior experience in the interests of acknowledging that for adult participants work within the museum can be a powerful force for self-discovery, or for the development of cultural interpretation, comment, and understanding (Burke 2002, 97-116). Some astute and sensitive observations are made in both the Dutch and the Finnish research about the nature of affective experiences in the museum in relation to learning. Much of the research follows on from the radical tradition of adult education as a means of critical engagement, individual empowerment and student-centred learning, and this lies both explicitly and implicitly in the background to the American paper. Social and Cultural politics was especially the focus in the work from Ireland where the museum became a real force for campaigning and change for women living in the surrounding areas. Completely overturning Bourdieu's notions of the cultural exclusivity of the museum, somewhat controversially, the Irish Museum of Modern Art, in true spirit of widening access, has consistently exhibited the products of its adult workshops.
........................

In chapter one, Marianna Adams, John Falk and Lynn Dierking argue that paradigm shifts are occurring throughout society and those changes influence museums in two areas: 1) how the visitor and the museum experience are perceived by researchers and practitioners and 2) how we understand and study learning. Researchers are challenged to create new approaches and methodologies that are sensitive to a Post-modern / Constructivist model of museums and of visitors. The Institute for Learning Innovation has developed a more responsive approach to understanding learning in museums through the Personal Meaning Mapping (PMM) methodology. It has been used in a variety of contexts and museums with excellent results. In addition, PMM has been used as a catalyst for organisational growth and as a vehicle for professional development. In the end, adjusting research methods to the Post-modern model is ultimately about changing how we think about visitors, researchers, and practitioners. It requires us to carefully consider how the museum experience contributes to visitors' understanding and it helps us envision how museums function as a part of a larger fabric of learning experiences.

In his chapter, Folkert Haanstra presents a study of visitors' experiences carried out in The Netherlands, in the context of the role those Dutch museums are

requested to play as centres of knowledge and advice for the educational system and for individual visitors. This chapter first describes recent developments in Dutch museum education, with focus on shifting and sometimes conflicting goals. He uses nation wide surveys and interviews with museum educators, giving attention to the special role of art museums, and draws on audience surveys about visitor characteristics. What is not known, he argues, is how visitors perceive and experience the museum and how this influences their learning experiences. This chapter presents the results of two empirical studies on personal learning experiences of museum visitors. Three dimensions of museum guidance are distinguished: a cognitive dimension (providing knowledge), a meta-cognitive dimension (information on the goals and the set-up of the exhibition) and an emotional, motivational dimension. Data were collected in museums with mixed collections of art objects, historical objects and ethnographic objects. The outcomes are presented in relation to recent theories on learning styles and are used for the development of suggestions for museums to facilitate learning experiences of visitors.

In the third chapter of this section, Jane Leong examines the practice of art education in the Singapore Art Museum, drawing attention to policy issue at levels more general that those concerning the specific work of museum educators. Her analysis of the museum policy and programme, and of the relationships between these and the public experience of art museums are the main concerns of the chapter. The exhibition and public educational programmes which serve as a focus of inquiry and basis for her discussion raise three main issues for museum educational policy, in Singapore as well as more widely: a) the creation of an awareness of national heritage among museum visitors; b) the notion of equity and inclusive museum education; and c) the concept of learning for life. According to Leong, a number of 'reality factors' that either enable or inhibit the implementation of the art museum educational policy need to be taken into account in order to bring about an effective education programme.

Maaria Linko's chapter examines experiences of both making visual art and encountering art in museums. It is set in a context of a sociological discourse on the character of modern culture, as an increasingly important manifestation of individualisation and personal longing for authentic experiences. She presents empirical data from autobiographical writings gathered in Finland in 1995 during a thematic writing competition which suggest that amateurs seek powerful experiences in different fields of art. Based on the data, she shows how desires for such experiences usually have a strong emotional component. The emotional experiences of cultural products often include intensive and nostalgic processing of a person's memories and experiences, so those emotional and cognitive elements are intertwined in an artistic experience. Observations about the importance of the emotional experience and the yearning for authenticity are mirrored against the discussion of modern culture, showing that claims of the modern individual's inability to have genuine experiences and emotions are exaggerated.

Helen O'Donoghue pursues the issue of learning experiences, but with a strong community orientation. She offers an analytical and critical account of the work of the Education and Community department at the Irish Museum of Modern Art.

Education initiatives at IMMA have developed since the museum opened in 1991, aiming to encourage access to and engagement with the museum's resources for people of all ages both in the formal and informal education sectors. The chapter concentrates on artist-based interactive projects involving adults from the local community. The museum's context in relation to national policies and developments are described and the main issues arising from this work both in the Irish context and in relation to international museum education are explored. The models studied in this context challenge the boundaries between educator and curator and between artist and participant and museums and broader society.

Section B, *Museums and Formal Education*, focuses on the use of museums as educational resources at different school levels: primary school, university, and continuing education level. The contribution of museums and galleries in art teaching and learning is being attributed increasing importance. The educational potential of original objects in developing skills, knowledge and understanding through processes of personal discovery and meaning-making sees museums and galleries as fundamental resources for supporting and complementing multi-disciplinary school teaching, for teachers' professional development in visual arts, but, even more, for developing a more positive relationship with art and with life.

As far as school education in concerned, museum visits are seen no longer as an end-of-term treat or as 'unfocused' outings, but as the ground for developing creative and lasting partnerships between museums and galleries and educational institutions (schools, universities, teacher training institutions, etc.), partnerships that provide the framework for integrating the work carried out in classroom and the needs of the 'receivers' (teachers and learners) with the museum experience and the new knowledge to acquire. The collaborative aspect of the work also emphasises the value of discussion and that of creation of a climate of understanding respectful of the differing roles of each participant involved in teaching and learning.

On the other hand, partnerships at the level of teacher training imply opportunities for developing teachers' experiences and expertise in using museums for visual arts education no longer as 'executors' of pre-fabricated packages of museum activities, or as simple attendants during the visit but as active participants, through the development of personal experiences with original objects, of educational strategies to be used in work with their pupils, and of research and evaluation skills focusing on the in-depth study of their own development as well as their pupils' learning and understanding (Sekules et al 1999).

In the first chapter of this section, Silvia Mascheroni brings the issue of museum-school collaboration into focus by analysing the evidence of evaluation of a long-term joint programme between the Brera Gallery and primary schools in Milan. The project began in 1994 and goes on to this day, including in-service training courses for the teachers involved, regular gallery visits and related classroom activities. Evaluation focused on pedagogical strategies, content of courses, and relationships between the project participants. The study emphasises the value of collaborative work between schools and museums for both teaching and learning, suggests an evaluation model for potential use in similar situations and presents recommendations for the improvement of practice.

Maria Xanthoudaki studies the contribution of museum and gallery visits to art education in primary schools by researching the ways in which different pedagogical approaches to museum visiting can help teachers develop their art teaching. The evidence for the analysis is drawn from comparative research in a number of institutions and schools in England and Greece. The research revealed two basic methodological 'models' of educational programmes that appear to determine the level and ways of incorporating a visit into the classroom practice. These are discussed in the context of the existing curricula and school practice in the two countries. The comparative approach aims to draw attention to more 'universal' realities rather than institutional, classroom, or country characteristics, and develop suggestions for the improvement of the relationship between museum educational services and art practice in schools.

Meg Black and George Hein study personal encounters in art museums and offer a number of reflections for structuring field trips in such a way as to maximise students' personal meaning making. The authors describe how fifteen undergraduate art education students at an urban women's college participated in a guided field trip to the Museum of Fine Arts, Boston. The goals of the trip were to familiarise the students with the setting and for them to experience in detail selected works of art. The study examined how these students, from different social and ethnic backgrounds and with varying previous engagement with art, experienced the trip. Students were asked to reflect on the visit orally, in writing and by creating a two-dimensional representation of the trip. The data yielded rich insights into the students' diverse experience of this common activity. Despite the tightly organised nature of the field trip, students' varying life experiences, different levels of perceptual skills and different expectations for the trip resulted in personal constructions of its meaning.

In the last chapter of this section, Veronica Sekules addresses once more the important issue of partnership between schools and museums. She explores the development of the role of the artist as teacher and workshop facilitator in the context of the art museum. Based on her experience of research projects over ten years, Sekules suggests that the character of such work needs to develop within a climate of understanding of the different cultures of museum and school, respecting the integrity and distinctiveness of each contribution. Artists' workshop methodology has derived mainly from current artistic movements and practices, changing from artisan-craft-worker to celebrity performer, issue-based activist, and conceptual thinker. It is the more modest role as creative facilitator working in partnership alongside school teacher and museum educator which is perhaps of most enduring value in museum education. Her arguments, although not directly tackling the issue of teacher-training, offer valuable reflections about the range of possibilities that can be created by museums as a way for supporting teacher professional development as much as pupils' learning.

What most of the papers in section C, *Museums and Personal Discovery*, have in common, is an emphasis on deep personal reflection, inquiry or research which leads to some development of the professional person as well as the private one. This is especially true of Tickle's paper in examining how artists use the museum as a source of inspiration for their own creativity. Rather in contrast to the prevailing

notion among some commentators that museum culture is primarily fulfilling a social agenda to do with pleasure and enjoyment (Weil 2002, 53-74), there is much evidence here of solitary encounters which are not necessarily pleasurable or comfortable at all. Again, echoing methodology from the radical end of adult education, autobiography is a strong theme. In both Rasanen and Stylianides papers, there are some surprising departures from conventional educational writing about the museum, and in Stylianides' case an unusual account of the viewing of art shifting from being a stressful experience to one that becomes cathartic and ultimately healing.

.....

The use of the gallery as a place of autobiographical encounter is the framework of the chapter of Irene Stylianides. She describes an introspective account of the experiences of an art educator who combined the phenomenological perspective of research as a 'first person experience' with the claim that the purpose of the arts is 'the education of feelings and the development of sensibility'. In seeking to understand how a genuine love of art could be reconciled with deeply felt negative and aversive responses to some objects, and to one extensive collection of art, data were gathered and analysed in ways which connected directly between past life experiences and new encounters in the gallery. The implications of these connections and their intrinsic emotional processes for working as an art educator with children are described.

In chapter twelve Les Tickle also examines the gallery as a site of research, reporting a study carried out in co-operation with professional artists in a project which investigated the ways they responded to work by other artists held in a major gallery, and how they used it as a stimulus in the creation of their own work. The research considered the complex relationships between past and new experiences in artists' professional learning. The processes of development and use of professional knowledge was investigated, with the intention of understanding the problematic nature of 'the artist as researcher'. That concept was, in fact, the starting point for the project, as the relationship between existing works of art, and the creation of new works, had become a focal point for policy and for debate in educational contexts in both mainstream schooling and in the arts education institutes. A theoretical basis is proposed as a means of extending both the conceptualisation and the practice of the notion of art as research.

Continuing the study of the personal experiences, Marjo Räsänen deals with the nature of the experiential art understanding of students in the context of art history, aesthetics, and criticism, connected to reflective observation, conceptualisation, and the production of their own art. She examines a model that aims at 'transfer', which means the ability to apply artistic inquiry in understanding artworks, in making one's own art, and in coping with real-life situations. Examples of how teachers can use museums for bridging students' life worlds and art worlds are provided in two case studies. The first is a part of an action research project with an emphasis on feminist art criticism. The pupils of the high school under study interpret a painting from the 1890s in the Museum of Finnish Art through storytelling and their own art making. In the second case, adolescents build connections between 'low' and 'high' art in an exhibition of Asian visual culture. The images are connected with students'

lifeworlds through their own art making utilising contemporary self-portraits. The cases illustrate how different discourses affect on the students' identity construction and how productive activities can be used in understanding art.

In the final chapter of this section, Juliet Moore Tapia and Susan Hazelroth-Barrett argue that distinctions exist between modernist and postmodernist forms of art museum education. They posit that postmodernist art museum educators are concerned with pedagogical approaches that both serve as cultural critique and encourage visitors and students to develop their sense of connectedness between themselves, the objects in the museum and the world at large. The authors argue that these approaches are appropriate for cultural institutions, such as museums, that address issues of cultural identity, representation and interpretation in a period of post-modern complexity and challenge. This chapter describes the educational theory of the John & Mable Ringling Museum of Art in Sarasota, Florida and relates that pedagogy to specific examples of programmes. It argues that although the museum as a socio-political construct which has been analysed in some depth during recent years, there remains a need for the exploration of the effects of postmodernism upon art museum education.

Section D, *Landscaping the Future*, addresses the socio-cultural role of the museum. Museums and galleries are faced with an increasigly strong role as bonds between cultural and social origins and history of society and different community groups, and their contemporary reality; as custodians of the testimonies of such a course; as transmitters of knowledge as well as of the need of the individual to re-address its identity. They are seen, that is, as important contributors to the progress and improvement of the social continuum, but their role is understood no longer as that of authoritative, 'sacred' possessors of knowledge, but, in the context of the postmodernist approach, as that of interpreters of individual experience that allows plurality of views, learning and understanding.

Douglas Worts discusses the more general issue of the socio-cultural role of the museum. Traditionally, art and visual culture have provided opportunities for individuals to connect to the deeper cultural reality of a group. By living with and reflecting deeply on the symbols of culture, individuals developed more or less of a personal consciousness of the world in which they lived. As our modern world of specialisation evolved over recent centuries, art was increasingly housed in museums - largely because of it's objectified value, both economic and intellectual, which had to be protected - thus removing the art from any integrated form of symbolic experience in the lives of individuals. Today, there is a profound public need and desire for symbolic experience that can re-connect individuals at a deep level to nature, to other people and to the past. Museums have the potential to play a part in responding to this public need, yet they have not assessed how to balance their custodial responsibilities for material objects with their cultural facilitation role in the realm of symbolic experience. Museums are hampered by a tradition that honours intellectual knowledge about objects over the more irrational and creative experiencing of cultural symbols. This chapter explores some of the many issues related to this topic, with a focus on research done in the pluralist city of Toronto, and within a framework of understanding the role of culture in the sustainability of human life on our planet.

This collection, then, provides an indication of the range and diversity of work that has developed in recent times, in terms of locations, topics, and research methodology. It would be impossible in a single volume to represent adequately the full geographical spread of contemporary developments in museum and gallery education in the visual arts. It would be difficult in the space we have even to describe the multitude of interesting projects we are aware of, or to do justice to all of the methodological innovations being used to research those practices. By careful selection and juxtaposition of these contributions, we have sought to open up the realm of possibilities across the boundaries of particular institutions, places, and research-based practices in a way that stimulates further development and international collaboration among gallery and museum educators.

The issue of training and professional development for museum and gallery educators has become important, with the establishment of a number of courses and in-service qualifications, each characterised by its own approach and philosophy. Professional Development is a topic worthy of its own volume. It has not been addressed directly in this book, but we hope indirectly to set a path for educators to follow, through the course we have taken in focusing on the potentials of research-informed practice and practice-based research approaches. The case studies included in the book are intended to be read by educators for their potential practical application of ideas in planning educational interventions, for their potential adoption of the disposition to research one's practice or one's learning experiences, and for their methodological value in bringing that disposition to bear. To that extent, it may serve as a useful course book to assist those studying to develop the range of their professional experience.

REFERENCES

Bennett, Tony, *The Birth of the Museum*. London and New York: Routledge. 1995

Bourdieu, Pierre. Outline of a Sociological Theory of Art Perception, *The Field of Cultural Production*. Cambridge: Polity Press. 1993, 215-237.

Burke, Penny J. *Accessing Education, effectively widening participation*. Stoke on Trent, Sterling VA: Trentham Books. 2002.

Crotty, Michael. *The Foundations of Social Research*. London: Sage. 1998.

Csikszentmihalyi, Mihalyi, and Rick E. Robinson. *The Art of Seeing: An Interpretation of the Aesthetic Encounter*. Malibu,CA: The J.Paul Getty Museum and the Getty Center for Education in the Arts. 1990.

Falk, Johnb H. and Lynn D. Dierking. *The Museum Experience*. Washington DC: Whalesback Books. 1992.

Hein, George. *Learning in the Museum*. London: Routledge. 1998.

Hooper-Greenhill, Eileen. *Museum and Gallery Education*. Leicester: Leicester university Press. 1991.

Sekules, V., L. Tickle & M. Xanthoudaki. Seeking Art Expertise: Experiences of Primary School Teachers, *Journal of In-Service Education*, 25/3 (1999): 571-58.

Stenhouse, Lawrence. *An Introduction to Curriculum Research and Development*. London: Heinemann. 1975.

Taylor, Rod. *Educating for Art*. London: Longman. 1986.

Tickle, Les. *Understanding Art in Primary Schools*. London: Routledge. 1996.

Weil, Stephen E. *Making Museums Matter*. Washington DC and London: Smithsonian Institution Press. 2002.

Section A

MUSEUMS AND LIFELONG LEARNING

MARIANNA ADAMS, JOHN H. FALK & LYNN D. DIERKING

THINGS CHANGE

Museums, Learning, and Research

Abstract: This chapter will address how changes in our perception of museums and learning are resulting in a paradigm shift in how we approach research of learning in and from museums. Traditional notions of the museum as ultimate authority and arbiter of taste are being challenged as we recognise that visitors make their own meaning in museums. An evolved understanding of the nature of learning suggests that learning is a relative and constructive process that is dependent on personal, socio-cultural, and physical contextual factors. To be meaningful, research on learning in and from museums, therefore, must be designed to be responsive to these realities. Personal Meaning Mapping, one such approach that was specifically developed with these criteria in mind, is explained and illustrated through three case studies.

INTRODUCTION

When we think of the monumental changes that have occurred in our lifetime, the ones that most often come to mind are those that directly affect our daily lives, such as the growing significance of the Internet or radical discoveries in science. These changes are easy to identify and fairly easy to accommodate. Fundamental changes in how we perceive a situation or describe the dimensions of a problem, on the other hand, are much trickier to recognise and often our adjustment to them is much more difficult. Thomas Kuhn (1970) described this phenomenon as a paradigm shift. Depending on where one is in the wave of change and how astute or open to change an individual might be, paradigm shifts can be seen as either an exciting possibility for transformation or as a frustrating and disorienting period of displacement. This chapter will address how changes in our perception of museums and learning are resulting in a paradigm shift in how we approach research on learning in and from museums.

CHANGES IN PERCEPTIONS OF ART MUSEUM

Think about what art museums do. Essentially, they have changed very little in the last century. Museum staff continue to collect objects that they preserve and conserve. These objects are displayed and some form of interpretation is provided for the objects. Although changes have occurred in the areas of interpretation of objects and museum education (Roberts, 1997), the core functions of an art museum today are very similar to what they were 50 or even 100 years ago. So what is the big paradigm shift in the museum world? It is in the way we think about the role of museums in society and the nature of the visitors' museum experience.

M. Xanthoudaki, L. Tickle, V. Sekules (eds)
Researching Visual Arts Education in Museums and Galleries, 15-32.
©2003 Kluwer Academic Publishers. Printed in the Netherlands.

Traditional notions, "such as the authority of the curator, the sanctity of objects, and even the prestige of the institution itself as a source and distributor of knowledge," are being challenged (Roberts, 1997, 132). Developments in critical theory about knowledge and social movements that seek to include and empower previously marginalised or excluded voices have resulted in shifts in the relationship of the museum to its visitors as well as to the broader community (Roberts, 1997; Crimp, 1993; Harris, 1991; Hooper-Greenhill, 1992):

> The museum is being re-conceptualized as a set of transactions between exhibitor and visitor in which meaning and value are constantly renegotiated. The museum as final authority on itself is disappearing (Harris, 1991, 7).

Museum professionals have an opportunity to embrace these changes, but whether or not they do recognise and accept this paradigm shift, visitors will continue to make what meaning they can from museum experiences regardless of, and often counter to, what museum staff intended or expected them to make.

CHANGES IN PERCEPTIONS OF LEARNING

We all learn – continuously. Learning is as critical to our survival in a modern, technologically-sophisticated society as it was in ancient, more traditional societies. That humans learn has not changed, neither has the way people learn. What has changed dramatically is our understanding of how, why, and what people learn.

Much of what we understand about learning is based in a Behaviourist-Positivist conceptual framework. Underlying this framework are a number of assumptions, most significantly that learners come to the learning situation knowing nothing, or virtually nothing and, after a suitable educational intervention, exit "knowing" something. That something is the "thing" that the instructor/designer chose for them to learn. Because, according to this framework, learners are assumed to be virtual blank slates, their prior experiences, interests, and motivations are assumed to be, if not irrelevant, then not aggressively factored into the analysis of the learning process. This model of learning focuses primarily on the acquisition and retention of new information (Sylwester, 1993). Behaviourist teaching strategies tend, therefore, to be more lecture-based where the teacher provides the *What*, *When*, and *How Fast* of the learning experience. Although the Behaviourist-Positivist learning model has been helpful in advancing our understanding of learning, like most theoretical models, it has limitations.

Through advancements in neuroscience research we are able to literally see the brain learn. Rather than the straightforward process suggested by the Behaviourist model, learning has been revealed to be a relative and constructive process (Falk & Dierking, 2000; Pope & Gilbert, 1983; Roschelle, 1995; Rosenfield, 1994; Solomon, 1987; Sylwester, 1993). This framework is usually referred to as the Constructivist-Relativist model of learning. From this perspective, learning is seen as a continuous, highly personal process. Learners start from different cognitive frameworks and build on learning experiences to create unique, highly individualised schemas. Operating from a Constructivist perspective requires accommodating to the diverse and individualised nature of learning. Certainly the Constructivist theory of learning

is not a new development; the ideas have been circulating in academic circles for quite some time. But we do not have to visit very many exhibitions to realise that the Behaviourist-Positivist learning model is thriving in art museums. Many museum practitioners, consciously or unconsciously, operate as if by properly adjusting the lighting, composing the right label, and positioning an object "just so," all visitors to the museum will emerge having had the same experience and having learned exactly the same thing. For art museums, that "thing" to be learned is often a set of facts about the period or style of the art or artist.

In the Constructivist model, learning is seen as a highly contextual process. The learners' prior knowledge, experience, interests and motivations all comprise a personal context, which is imbedded within a complex socio-cultural and physical context. Learning can be described as the interaction and negotiation of these three shifting contexts in time and space (Falk & Dierking, 1992, 2000):

> In a world that allows for multiple perspectives, the conditions for meaning have
> become as important as the meanings themselves (Roberts 1997, 132).

This model also factors in the importance of time in the learning process. In every learning event "there are delays between an experience and genuine understanding and these delays are uncomfortable for educators" (Oakes & Lipton, 1990, 39). Rather than understanding these delays as a natural part of the learning process, they are frequently regarded as unsuccessful learning. For example, if a museum visitor is not able to articulate information acquired or meanings made immediately upon exiting an art exhibition, the assumption is often made that learning did not occur, when, in reality, a conversation with that visitor a few days or even months after the visit is likely to reveal that the museum experience was a very rich learning experience (Adams, et.al, 1997).

From a Constructivist perspective, learning in and from museums is not just about what the museum wishes to teach the visitor. It is as much about what meaning the visitor chooses to make of the museum experience.

> At their most basic, museums communicate. In communicating, they ignite
> memories, activate emotions, and spark interchange. What visitors do with these
> possible responses is part of the narrative they craft. What they craft may or may
> not have anything to do with the messages institutions intend. (Roberts 1997, 137)

It is not that one learning model must take precedence over the other for both have contributions to make to our understanding of learning. Rather, a meaningful and respectful dialogue between the two positions must be constantly negotiated in the museum learning environment.

CHANGES IN MUSEUM LEARNING RESEARCH

Along with a paradigm shift in our understanding of how visitors learn in museums, it follows that our approach to learning research must also shift. Clearly the research techniques and strategies that evolved to study learning from a Behaviourist perspective have many strengths but there is a need to refine those techniques and to create new ones that are more aligned with the assumptions underlying the Constructivist learning model. Researchers of past studies of museum learning have

found it difficult, if not impossible clearly to document evidence of learning in museums (Falk, 1999; Falk & Dierking, 2000). Is the implication to be drawn, therefore, that learning does not occur in these settings? Not at all! This dilemma is best explained through the use of an analogy. Imagine that you hear a bird singing. You look up into the trees but you do not see a bird. You even get binoculars but still do not see the bird. Does that mean the bird does not exist? Of course not! Perhaps the bird is on the ground and you directed your focus up into the trees. Perhaps the binoculars were not powerful enough or they were directed at a different tree than the one the bird was singing in. The reality is that the bird is still singing. You just do not have the appropriate tool or search image to find the bird and actually see it singing. In the same way, the methods we have used to collect data on museum learning are not sufficient. A major impediment to the successful understanding of the role that museums play in facilitating public learning is the paucity of valid and reliable instruments specifically suited to the unique contextual realities of free-choice learning. Free-choice learning describes learning that occurs across the life span, is self-directed and guided by individual learners' decisions about what, when, where, why, and with whom to learn. (Falk & Dierking, 1995).

The Institute for Learning Innovation, an Annapolis, MD-based non-profit learning research and development organisation, has committed its resources to understanding learning from a Constructivist-Relativist perspective across a wide range of free-choice environments, particularly museums. For the Institute, research is used to generate theory about learning and the museum experience. That theory has two uses. First, it is used to inform practice for museum practitioners and other free-choice educators, and establishes the cycle of theory informing practice that, in turn, informs theory again. Second, theories built on research findings are also used to inform and generate new research methods. In their search for more productive and sensitive methodologies, Institute researchers developed a set of five characteristics that any responsive research methodology needed to incorporate in order to yield more meaningful and faithful evidence of the depth and complexity of a free-choice learning experiences: 1) Emphasise validity over reliability; 2) Allow for the visitors' agendas to emerge; 3) Address the effect of time on learning; 4) Respect that learning is situated and contextualised; and, 5) Be open to a broad range of outcomes.

Emphasise Validity Over Reliability

In research design and methodology, a series of trade-offs must constantly be negotiated. One important trade-off is how to negotiate the balance between reliability and validity. Both are important components. Ideally there is an exact balance between the two but there is always a tension within a research design as to which is given greatest weight. Invariably, researchers must choose to lean towards one side or the other. Reliability essentially means that if a sample of visitors were surveyed today and given the identical survey tomorrow, the results would be statistically the same. This means that the items on the survey consistently measure the same thing. Most standardised tests emphasise reliability to the extreme

detriment, many critics would argue even demise, of validity. Validity is the degree to which measures actually measure something of meaning to measure. For example, measuring how much time visitors spend in front of a painting may be "reliable" but may not actually meaningfully measure art appreciation. Research has shown that lengthy "dwell" times in front of paintings may actually be non-art-related conversations related to lunch arrangements or social gossip (Menninger, 1996).

Both reliability and validity are important components. Ideally there is a balance, but there is always a tension between the two within a research design. Invariably, though researchers must choose to focus on one side or the other. Often, Behaviourist-Positivist research methodologies have emphasised reliability at the expense of validity. A Constuctivist-Relativist perspective would suggest that the emphasis should be more focused on establishing meaning and consequently, would place a greater weight on validity. We would argue that methods should put "the emphasis on measuring meaningful, challenging things, measured in ways that seamlessly mirror reality" (Falk & Dierking, 2002).

Allow for the Visitors' Agendas to Emerge

A responsive research methodology, then, would capture evidence of how the multiple perspectives that visitors bring to and construct in the museum emerge, rather than impose the museum's point of view. Many research methodologies try to structure visitor responses in rather narrow terms. Questions are developed and visitors are asked to respond to those questions, usually in an order predetermined by the researcher. It is the museum's (and/or researcher's) agenda that gets addressed with this approach. The visitors' agendas, while they may occasionally sneak in around the edges of these methodologies, are rarely allowed to flourish and come to the front in the data collection or analysis stages.

More responsive methodologies give the visitors' agendas room to emerge as fully as possible. Visitors' prior experiences, knowledge, and interests are essential variables in collecting and making sense of the data. Consequently, a variety of perspectives on exhibitions, programmes, and the totality of the museum experience are factored into the mix. When visitors are encouraged to raise what is at the forefront of their thinking we come closer to understanding the various ways in which people approach and connect with the museum experience. Given the potential disparity between museum professionals' and visitors' views of what is happening in the museum, methods that capture these different perspectives have great value.

Address the Effect of Time on Learning

Many research methodologies tend to limit investigation to the physical and temporal boundaries of the museum. Historically, data on museum learning tended to be collected from visitors inside the museum. Given that learning is an on-going and complex process that occurs over time, it should be expected that museum experiences require time to be accommodated and integrated into the fabric of

visitors' lives. For example, if a museum experience is very intense or powerful, visitors often cannot synthesise, reflect upon, and then articulate their experience in just a matter of minutes. Certainly collecting immediate exit responses is valuable but, when possible, attention needs to be given to how visitors integrate the experience with the rest of their life and that requires an interval of weeks, months, and sometimes, years. New understandings of the nature of learning are forcing new methods for documenting learning. As a result, there is growing appreciation within learning research communities for the need to extend the time line for assessing learning (Falk & Dierking, 1992; 2000; Falk, 1998). Much of what an individual learns in a museum, zoo, or science centre only becomes apparent after the experience, and then only in relation to the individual's or family's construction of knowledge and experience.

Respect that Learning is Situated and Contextualised

Learning research models were first developed for use in laboratories where animals and humans were tested in clinically controlled conditions rather than in their natural environments. It was assumed this was not problematic because this theoretical model posited that learning was a generalised, a-contextual phenomenon – as long as the stimulus was the same, and laboratory conditions facilitated sameness, the response would be the same! These laboratory studies, however, only reliably measured how animals and people learned and behaved in laboratories, and could not be generalised to learning and behaviour elsewhere in the real world.

A more sensitive research approach requires that data be collected in as close to a natural, unobtrusive manner as possible. Efforts should be made to embed data collection within the visitor experience, involving visitors in experiences that feel comfortable and appropriate, rather than feeling like they are being tested, probed, or prodded. Both the setting for data collection and the data must be authentic and closely tied to the experience being assessed.

Be Open to a Broad Range of Outcomes

Typically, the theoretical model of learning we have used in the past has divided learning artificially into cognitive, affective, and psychomotor domains with the greater value placed on cognitive learning. Museum exhibition developers and programmers often limit their thinking about learning to knowledge-based outcomes such as, "Visitors will learn three characteristics of Baroque art." Instead, affective outcomes would resemble the following statement: "Visitors will leave an exhibition about Baroque art with a heightened interest for the topic and a desire to learn more. A psychomotor outcome might be "Visitors will be able to create a Baroque-style composition with art materials." Methodologies then look for evidence related to such outcomes. Since other dimensions of learning are not looked for in this model, the research methods would not readily discern them.

Research shows that learning can not be so easily divided into cognitive, affective, and psychomotor domains, but rather emerges as a complex array of

diverse, interconnected effects (Damasio, 1994). More sensitive research methodologies need not only to recognise a variety of outcomes or dimensions of learning but also actively to seek evidence of a broad array of learning outcomes.

The Institute for Learning Innovation has sought to describe the potential types of outcomes that might result from visits to museums. Clearly there is the traditional notion of subject-based outcomes, where visitors build or refresh their knowledge, attitudes, and perceptions about a particular topic or phenomenon. However one can also imagine socio-cultural outcomes, such as a visitor learning about or increasing his/her appreciation for one another, on both an individual and cultural level. There are also aesthetic/re-creative outcomes such as renewing, refreshing, and restoring, often manifested by wonder, awe, joy, and enjoyment. Michael Kimmelman articulately expressed this dimension when he said,

> Museums exist to offer us something that we can't find anywhere else: an encounter, whether with an object or idea...an encounter we deem true and authentic in a place respectful of this private transaction (Kimmelman 2001).

In addition, another important outcome that is rarely discussed relates to visitors' actual understanding of how one can use a museum as a resource for free-choice learning and leisure, an outcome we refer to as museum literacy. Visitors are constantly constructing the meaning of these institutions as places for renewal, restoration, and learning. Hopefully after each visit people better understand how they might actually use museums to accomplish these goals. Depending upon the entering knowledge, understanding, and attitude of the visitor, museum experiences can, on occasion, result in transformation, significant changes in thinking, attitudes, beliefs, behaviours, or habits-of-mind.

The Process of Developing a Responsive Methodology

The need for the development of new, more responsive research methodologies emerged during the Institute's investigations of numerous museum exhibitions and programmes. For example, in a comprehensive evaluation of the Virginia Museum of Arts' Lila Wallace Reader's Digest Collections Access project *Spirit of the Motherland*, evidence strongly suggested that most visitors were interested in creating their own narrative within the exhibition of African art and artefacts, and that they had learned *something* in the exhibition (Dierking, Adams, & Spencer-Etienne. 1997). However, our research methodologies at the time limited our understanding of the complexity, depth, or degree of change in visitor learning as a result of their museum experience. It also appeared that other researchers were struggling with a similar inability to "find the singing bird." In a search for more responsive methodologies, we drew on developments in other related fields. For example, the work in authentic or performance-based assessment provided information about ways to develop reliable scoring rubrics and analysis approaches for a variety of qualitative responses (Persky, et.al., 1998).

These and other projects/readings were moving us actively to explore other ways of thinking about measuring changes in learning. One particularly interesting approach was concept mapping (e.g., Barenholz & Tamir, 1992; Gaffney, 1992;

Novak, Gowin, & Johansen, 1983; Novak & Musonada, 1991; Ross & Mundy, 1991), an approach that seemed more respectful of the complexity of learning processes. However, concept mapping appeared to have two major deficiencies. First, most concept mapping approaches required the learner to undergo considerable training so that they would know how to "correctly" construct a concept map. Not only did such training seem totally impractical in the free-choice setting where people have neither the time nor the inclination to invest in such a process, but it also seemed that the training would over-influence visitors' understanding of the topic. Second, the "scoring" rubrics used by concept map researchers were still very positivistic and reductionist. Although learners were permitted to "map" all of the idiosyncrasies of their personal cognitive reality, scoring was based upon the degree to which maps matched some pre-determined cognitive reality. In other words, it was assumed that there was, basically, a single "right" answer. The real breakthrough came in finding a way to use the strengths of concept mapping – the ability to more accurately overcome the personal construction of ideas – while understanding what we perceived to be its deficiencies – an unnecessarily lengthy training period and an overly positivistic scoring protocol. The result was Personal Meaning Mapping.

ONE APPROACH TO A CONSTRUCTIVIST RESEARCH METHODOLOGY

In its search for more responsive methodologies that address the five criteria listed above, John Falk and researchers at the Institute for Learning Innovation developed an approach called Personal Meaning Mapping (PMM) (Falk, in press; Falk, Moussouri & Coulson, 1998; Luke, Adams & Falk, 1998).

What is Personal Meaning Mapping?

Personal Meaning Mapping is designed to measure how a specified learning experience uniquely affects each individual's understanding or meaning-making process. It does not assume that all learners enter with comparable knowledge and experience nor does it require that an individual produce a specific "right" answer in order to demonstrate learning.

The PMM assessment assumes that it is the norm, rather than the exception, that free-choice learning experiences have an effect on the underlying structure of an individual's understanding. However, exactly what an individual might learn as a consequence of a specific learning experience will vary considerably depending upon the individuals themselves and the social/cultural and physical context of the experience (Falk & Dierking, 1992, 2000).

The focus of PMM is not exclusively on the nature of change but equally on the degree of change in learning. The major insight of PMM is that quality learning experiences change people; the better the experience, the greater the change. Thus, what is most profitably quantified is not just what visitors learn but also how much and to what depth and breadth learning occurs. PMM is still interested in what a person learns but the focus is on that person's unique "what," not some prescribed

outcome. The method accepts and accommodates the multi-dimensionality of learning, uses this fact to generate different, equally valid measures of learning, and allows measurement of both individual and group learning. A brief overview of how the method works follows.

Data Collection in Personal Meaning Mapping

The use of PMM in data collection involves asking individuals to write down on a blank piece of paper as many words, ideas, images, phrases or thoughts as come to mind related to a specific concept, word, phrase, or even an image – prior to viewing an exhibition or participating in a programme. The 'prompting' word or phrase is placed at the centre of the page, and the words, ideas, images, or phrases written down by individuals in response to the initial prompt form the basis for an open-ended interview. Developing the prompt is part of the art of using the PMM methodology. Prompts have to be tested to determine the degree to which they elicit valid and meaningful responses. Individuals are typically given as much time as they need or want to write down all of their words, thoughts, phrases, and ideas. When they indicate that they are finished, data collectors then encourage individuals to explain why they wrote down what they did and to expand on their thoughts or ideas. This discussion allows individuals to articulate and negotiate their perceptions and understandings, and to provide more specific understandings from their own cognitive frame of reference. Their expanded responses are recorded by the data collector on the same piece of paper, using the visitors' own words and thought process. To permit discrimination between unprompted and prompted responses, the data solicited by the data collector are recorded in a different colour ink than were the initial words, images, and phrases recorded by the individuals themselves.

When individuals emerge from the exhibition, or the programme is completed, they are asked to revisit their initial PMM. Specifically, they are asked to look over their earlier thoughts, ideas, images, and phrases, and decide if there is anything they would change, delete, or add to what is on their paper. To distinguish between their pre-experience responses and their post-experience responses, visitors are given yet another colour of ink with which to write. When they are finished, data collectors again conduct an open-ended interview, probing any changes or enhancements in their understanding indicated by their responses. At this time, data collectors are also free to ask visitors a set of additional, more structured questions if they have not already been addressed during the PMM interview. These responses are written in yet another colour of ink.

To capture longitudinal data about the change in learning, follow-up PMM interviews can be conducted at intervals of weeks, months, or even years after the museum experience. The Institute has conducted the follow-up interviews over the phone, using the written maps from the museum visit as a discussion guide. Visitors are reminded of what they wrote and said on the pre- and post-visit maps and asked to expand upon these based upon what, if anything has arisen since their visit. Another way to gather longitudinal data with this methodology, particularly with student groups, is to identify two groups of individuals, one that has and one that has

not participated in the learning experience. These individuals are asked to complete a PMM months or years after the experience and the two groups are compared. This process of comparing two groups is an adaptation of the Behaviourist-Positivist control/treatment group methodology; however, the assumptions that drive the collection and the analysis of the data are Constructivist.

The PMM studies conducted by the Institute to date have used as few as 30 subjects and as many as 200. Statistically significant findings have been possible even with small sample sizes. At this point, no effort has been made to establish the optimum sample size for the PMM methodology.

Analysing Personal Meaning Map Data

PMM data is first reviewed and clusters or patterns in the responses are identified. A set of dimensions or scales is established based on the particular needs and focus of each research study. These dimensions can look at a variety of indicators. For example, one dimension might measure the extent of visitors' knowledge and attitude by counting the change in the quantity of relevant vocabulary used. Another dimension assesses the breadth and range of visitors' conceptual understanding by documenting the universe of conceptual categories generated and the change in that universe affected by the educational experience. Other dimensions have included measures of the depth of visitors' understanding, how deeply and richly someone understands the concepts they use, changes in the mastery of a topic, a more holistic or gestalt measure of the change in overall facility with which someone uses their understanding, and changes in emotional expression, which measures the degree of change in the depth of affective expression used before and after an educational experience.

The resulting data are a series of change scores based on rubrics developed for each study. Clear and concise scoring rubrics are developed for each dimension and are similar to rubrics used in performance-based assessment. Typically, teams of authorities, such as museum educators, curators, and scholars, confer on both the development and scoring of the rubrics permitting measurements of both validity and reliability. These scores can be used as dependent measures and compared to a wide range of independent variables (e.g., the learning intervention, age, gender, time involved in the experience). Analyses can include both parametric statistics such as Analysis of Variance and t-tests, or non-parametric statistics such as Chi square and correlations.

What is Learned from Personal Meaning Mapping?

Personal Meaning Mapping was designed specifically for use in free-choice learning environments such as museums and community-based programs. To date, it has been used and tested in a variety of museums and performing arts organisations in the US and internationally. In addition to refining the instrument and analysis procedures, the use of the methodology has revealed much about visitor learning in and from museum exhibitions and programs. Use of the methodology has permitted

a depth and breadth of understanding of museum visitor experiences far beyond that provided by more traditional methodologies. The following case studies provide a glimpse of the ways that this methodology can help practitioners and researchers better understand learning in museums. Although other data collection methodologies in addition to PMM were used in these studies, such as tracking, focused observations, and written surveys, the use of PMM is the focus of the case studies.

Understanding the Impact of an Exhibition of Contemporary African Art
The National Museum of African Art (NMAfA) in Washington, DC, wanted to study visitor learning in the temporary exhibition of contemporary African art, *Nsukka: The Poetics of Line*, to inform the future installation of the museum's permanent collection of contemporary African art. The NMAfA also wanted to use this study as an opportunity to build organisational capacity by designing this research as a participatory evaluation process, which meant that a team of NMAfA staff and volunteers worked closely with Institute researchers to collect, analyse, and interpret the data. Entry and exit Personal Meaning Maps were used to ascertain visitors' preconceptions and perceptions about contemporary African art, as well as the degree to which experience in the *Nsukka* exhibition enhanced visitors' understanding of contemporary African art in general. The NMAfA did not elect to conduct a longitudinal follow-up component.

A total of 69 randomly selected visitors participated in this study during spring 1998. They provided responses to the prompt, "Contemporary African Art," before viewing and upon leaving the exhibition. Each individual's pre-visit knowledge and feelings about contemporary African art was compared with their post-visit knowledge and feelings across three semi-independent dimensions. The first dimension measured change in the concept categories or dimensions of the ways visitors thought about contemporary African art. Before viewing the exhibition visitors most commonly used two concept categories to discuss contemporary African art. First, they talked about it in reference to traditional African art forms and content, such as expecting the work to be about family or ancestors. The second most common pre-visit dimension related to elements and principles of art. Visitors for whom the word "African" registered most strongly in their minds were likely to expect that contemporary African art would have such elements of art as earthy colours and intricate patterns. Visitors for whom the word "Contemporary" was the word they focused on would talk about contemporary African art in terms most often used for American contemporary art, such as bright colours or geometric shapes.

After viewing the *Nsukka* exhibition, visitors' responses to the PMM repeatedly suggested that they increased and broadened the ways in which they thought about contemporary African art. For example, visitors were less likely to refer to traditional African art forms and content after having seen the exhibition. They were more likely to refer to specific contemporary African artists that they learned about in the exhibition and they were more likely to refer to the social, cultural and political content of contemporary African art. In addition, after having seen the exhibition, visitors were more likely to refer to the emotional power of

contemporary African art and seemed to feel more confident in making personal judgements and evaluations of contemporary African art, building upon their previous knowledge or conceptual interest when talking about it. For example, if a visitor was interested in the social, political, or cultural aspects of art in the pre-visit PMM, he/she tended to talk more in-depth about those issues after having seen the exhibition.

The second dimension assessed how the experience in the exhibition changed the visitors' awareness of and attitudes toward contemporary African art. The PMM data suggested that visitors left the exhibition with an increased awareness of the relationship of contemporary African art to the broader world of contemporary art. In addition, the visitor increased his/her awareness of the relationship of contemporary African art to contemporary African society. This finding was particularly important to NMAfA as they believed their biggest challenge with the future installation of their contemporary African art collection would be in expanding most visitors' rather narrow view of African art from one that was traditional and static to include one that was dynamic and evolving.

The third dimension sought to measure the degree to which the exhibition affected enthusiasm or level of interest in the subject. Data strongly suggested that not only did visitors respond very positively to the exhibition but many visitors expressed an interest in seeing or learning more about contemporary African art.

The findings provided the NMAfA staff with a richer and more complex way of thinking about the conceptual frameworks visitors bring with them to the museum and how those might be used to connect and expand visitors' understanding. The study also suggested that a successful exhibition, one visitors find to be powerful, meaningful, and memorable, has a strong story line or thematic narrative. Accompanying concepts, such as the social, political, or cultural connections, or emotional content embedded in the art, seemed most meaningful when they supported the story line.

Implementing this study as a participatory evaluation by involving staff at all levels of the process did appear to be successful in building organisational capacity. Staff and volunteers reported an increase in their overall understanding of, and respect for, the general visitor, including the variation in visitors' background, tastes, and perceptions. Staff and volunteers very much enjoyed the opportunity for direct contact with visitors and felt the experience was mutually beneficial to visitors. Many visitors said they were very grateful for the opportunity to participate in the study because it greatly enriched their experience. The staff and volunteers noted that they enjoyed witnessing visitors' discoveries and changes in perception. Visitors who participated in the evaluation paid more attention to the exhibition and, consequently, seemed to get more out of it. Therefore, participation in the evaluation served an educational, interpretative function. This finding stimulated the staff to think about how the benefits of the evaluation process might be incorporated into other educational programming. (Adams & Luke, 1998).

Understanding the Longitudinal Impact of a School/Museum Programme
In the spring of 1993, the National Gallery of Art in Washington D.C. began a multiple-visit programme for fifth and sixth graders in inner-city schools in the District. The programme, called "Art Around the Corner", reflected the Gallery's desire to increase involvement with the D.C. schools and to include the Gallery's collections in the public school curriculum, while at the same time enhancing students' enjoyment and learning. For two years students visited the NGA six times during each school year. Students also received a sequence of lessons from a museum docent. The lessons introduced students to the sensory, technical and expressive properties of art. The docents also visited the students' classrooms two times per year. The programme culminated in "Docent for a Day" when each student chose a work of art on display at the Gallery to present to his or her family and friends.

The Institute for Learning Innovation conducted evaluations for this programme from its inception (Abrams & Falk, 1995, 1996; Abrams, Falk & Adams, 1997). The first few studies, although highly qualitative and conducted with a very small sample of children, strongly suggested that the programme was having a positive effect on student learning in art. After the programme had moved from its early pilot phase and had matured into a well-organised experience for children, the Gallery staff were ready to embark on a more rigorous longitudinal impact study (Luke, Adams & Falk, 1998). The evaluation was focused primarily on how participation in "Art Around the Corner" influenced students' ability to interpret and discuss works of art over a period of one to three years after their participation in the programme.

This study presented a particularly complex methodological challenge. Researchers were investigating evidence of a causal relationship between the "Art Around the Corner" programme and students' ability to discuss and interpret a work of art. More specifically, researchers were exploring whether or not participation in 'Art Around the Corner' influenced students' ability to discuss and interpret works of art more effectively. Causal relationships such as this one are particularly difficult to investigate among human beings, given the myriad of variables which have an effect on people's lives in general, and interpretation of art in particular. In fact, we have begun to suggest that investigating causality is probably not the most appropriate approach to take. Rather, we try to understand the contribution an experience has made to the quality of someone's life.

The research question under investigation suggested a quantitative approach in order systematically to document evidence of the ways in which the "Art Around the Corner" experience contributed to student understanding of art. Adding to the methodological dilemma was the reality that art itself is difficult, if not impossible, to define and the experience of viewing and appreciating art is highly personal and subjective, necessitating qualitative inquiry when assessing learning in the arts. Some have even argued that the subjective nature of the arts raises a question as to whether or not learning in the arts can or should be assessed at all (Eisner, 1998).

With this philosophical quandary in mind, Institute for Learning Innovation researchers were hopeful that PMM would be a methodology that could successfully

combine qualitative and quantitative strategies within a single methodology. The research design employed in this study was flexible enough to allow for a diversity of aesthetic responses about art, while at the same time rigorous enough to allow for the systematic collection of quantitative data. A modified version of the PMM methodology was developed to accommodate the age and writing abilities of the students in the sample.

Fortunately, the participating elementary schools were feeder schools into one of the District's junior high schools. By working with entire classes of seventh, eighth, and ninth grade students, the researchers could collect Personal Meaning Maps from students who had been 5th and 6th graders in the ''Art Around the Corner'' programme from 1-3 years ago. In addition, the same data could be collected from students who had not had the museum programme so that their interpretations could be compared to students in the programme. The PMM prompt in this case was a reproduction of a work of art to which students were asked to respond.

Evidence strongly suggested that ''Art Around the Corner'' had a significant and long-lasting impact on students. First, the program made a difference in students' ability to describe a work of art. Students who participated in the program used rich and detailed vocabulary to describe the painting, while non-participating students were much less descriptive.

Second and more importantly, the programme had a substantial effect on students' ability to support their interpretations of a work of art. While both programme graduates and non-programme students were capable of providing interpretations of the painting, ''Art Around the Corner'' graduates connected with the painting on a much more sophisticated level than did non-programme students. Programme graduates supported their interpretations with clear, thoughtful evidence from the painting. Students who had not participated in 'Art Around the Corner' tended to give vague or general support for their interpretations that often did not relate to the painting at all. Blind scoring of student responses revealed that Programme graduates' descriptions were significantly richer than non-programme students. These long-lasting effects were evident in all graduates, including students who had participated in the programme one, two or even three years before (Luke, Adams, and Falk, 1998; Witmer, Luke, & Adams, 2000).

Understanding Learning in an Interactive Art Space
The PMM methodology was also used to investigate another art museum exhibition at the Speed Art Museum in Louisville, KY (Adams, 1999). In this study the exhibition was the Art Sparks Interactive Gallery in the Laramie L. Leatherman Art Learning Center. An evaluation team was made up of education department staff members and Institute researchers and pre- and post-visit PMMs were collected from 39 families visiting the gallery. As a way of keeping young children occupied while the adults worked with interviewers, children were asked to make a drawing of their expectations for the interactive gallery before visiting and another drawing of their impressions after visiting 'Art Sparks'. Researchers asked children to talk about their drawings. What started primarily as a way to give adults some time to complete their written PMMs resulted in a very rich data source about how young

children related to the interactive art experience. In the school study, students completed pre-visit maps and, several weeks after the museum visit, completed drawings and written explanations about their visit. A longitudinal PMM was not conducted with family visitors.

This study went beyond seeking to measure the degree of visitor satisfaction. Through the PMM methodology, a framework evolved that described the ways that visitors used the interactive gallery to construct their own personal meaning. For example, the data suggested that visitors made shifts in knowledge about art and about how to engage with it. In addition, the role of social learning was highlighted as visitors noted that the experience was "memory-making." Families responded to the physical and emotional safety that the gallery provided for them to explore. And finally, the gallery stimulated families to make personal connections between the art and their own lives. This framework was extremely helpful for the museum staff to understand better exactly how visitors approached and made sense of the experience.

In the school study, the adapted PMM, which included drawing and writing, provided strong evidence that repeated experience in the 'Art Sparks' gallery resulted in students remembering more about the permanent collection. This issue was a particular concern for the museum since some staff feared that the appealing participatory nature of the interactive gallery would overshadow the permanent collection. The playful, self-paced character of the Art Learning Center seemed to stimulate students to look more closely at the art in the main galleries and to think more conceptually about the work.

CONCLUSION

The Personal Meaning Map methodology has yielded rich insights into understanding how visitors find and make meaning in and from museums that could not have been gleaned from methods that use only written surveys, structured or semi-structured interviews, and tracking. To be sure, these other methods are valuable sources of information, but the PMM methodology manages to highlight findings that those other methods do not reveal. When looking over PMM data, museum staff and researchers remark that they could not imagine gathering such rich data using any other methodology. For example, when staff at the Speed Art Museum reflected upon the framework that arose from the PMM data, it was the authentic ring of the categories, based upon an analysis of visitors' actual words that struck them most powerfully. They were much more confident in the PMM-derived framework than they would have been in one that they might have put together without the visitors' voices.

These case studies are but a few examples of ways that the PMM methodology has enabled researchers to probe more deeply into the nature of visitor learning in art museums. Because the PMM methodology is a very flexible instrument, it has proven to be easily adapted to address the specific research needs of a variety of institutions and programs. Fortunately, researchers around the world are using it as well, adding to the Institute's understanding about the method's usefulness, rigor,

and validity. It has provided useful information at all stages of a project, from the beginning stages through to summative investigation.

Despite the very encouraging results from the use of PMM in studies conducted thus far, it is important to note that this methodology is not a one-size-fits-all instrument. True to its Constructivist nature, there are no recipes for when to use or not to use the PMM methodology. Certainly the availability of adequate resources is an important factor when deciding if PMM is appropriate. Like all good performance-based assessment approaches, PMM demands considerable time and resources to implement. Much more time is spent in the open-ended PMM interview process with visitors than in other types of interviews. It also requires a significant commitment of time and energy from visitors. We have found that visitors thoroughly enjoy participating in PMM studies and often remain talking with researchers at length, if the situation is amenable. However, there are circumstances when PMM does not work to its full potential, for example, it is difficult to conduct good Personal Meaning Maps with families at a special programme. The level of distraction at such an event, such as performances or art-making activity centres, works counter to the level of reflection needed by visitors to respond to a PMM.

Selecting the appropriate word, phrase, or image for the prompt used in the PMM is also a complicated task. It is possible to be both too broad and too narrow. Careful pre-testing of the prompt is required. At this point, the effectiveness of longitudinal PMM's conducted over the telephone has been uneven and needs more refinement. Analysis of PMM data is also time-consuming. It requires the assistance of skilled researchers to conduct and/or guide staff in the development of useful scoring techniques. The method also requires familiarity with both qualitative and quantitative analysis procedures.

Clearly, however, when the PMM methodology is used judiciously at critical junctures in the design and implementation of an exhibition or programme, the methodology can supply significant insights into how visitors learn in and from museums. The most obvious advantage of Personal Meaning Mapping is that it can look at change within as well as across individuals and register the degree and intensity of that change over time. Moreover, it enables a quantitative analysis that is extremely sensitive to the qualitative nature of learning in free-choice environments.

In addition to the obvious advantages of PMM, there are several unanticipated advantages that have also emerged. When PMM is incorporated into studies, it tends to engage the interest of museum staff in ways that less flexible methodologies do not. This then opens up new possibilities for unique professional development experiences to occur. For example, museum practitioners often get insights into the ways that their own assumptions about visitors prevent them from really seeing and understanding visitors. After reviewing results from a PMM study, one staff member remarked, "Wow! I finally understand the kind of impacts we should be having on our visitors!" Also, the process of constructing scoring rubrics for analysing PMM data requires a deeper level of staff communication and involvement than usually occurs in most assessments. Consequently, engaging in a PMM study can encourage the development of a community of learners among museum practitioners.

Conducting PMM studies also provides a vehicle through which researchers and museum staff can negotiate more meaningful relationships with visitors. Since the

methodology requires more active participation from visitors, they quickly realise that the process is highly personal, for it centres on their own experience and ways of articulating it. Consequently, researchers can, in effect, crawl inside the heads and hearts of visitors to a greater degree than they can with more traditional approaches.

Finally, the use of PMM data also serves as a valuable diagnostic tool for better understanding the dimensions of a particular museum experience. Museum professionals have used the results to inform the design of exhibitions and programmes. The results have enabled museum staff to better articulate the dynamics of the museum experience for the rest of the museum staff, for potential funders, and for the museum field at large. The frameworks can serve as a starting point for in-depth dialogue about optimum effects of a museum learning experience.

As a methodology that responds to paradigm shifts in how we understand and think about the way people use and learn from museums, PMM has shown great promise in furthering our understanding of the rich and complex learning experiences that result from museum experiences. As PMM continues to be employed in future studies, it will no doubt continue to evolve and spawn other related approaches as yet unconsidered.

Marianna Adams, Ed.D., is a Senior Associate, John H. Falk, Ph.D., Director, and Lynn D. Dierking, Ph.D., Associate Director at the Institute for Learning Innovation, an Annapolis, Maryland-based non-profit learning research and development organisation dedicated to understanding, facilitating and communicating about free-choice learning.

REFERENCES

Abrams, Courtney and John H Falk,. 'Art Around the Corner': Evaluation Pilot Testing. Annapolis, MD: Institute for Learning Innovation, 1995.

Abrams, Courtney and John H. Falk. *'Art Around the Corner': Year Two Evaluation Report*. Annapolis, MD: Institute for Learning Innovation, 1996.

Abrams, Courtney, John H. Falk, and Marianna M Adams. *'Art Around the Corner': Year Three Evaluation Report*. Annapolis, MD: Institute for Learning Innovation, 1995.

Adams, Marianna M. *Summative Evaluation Report: Art Learning Center Art Sparks Interactive Gallery for the Speed Art Museum, Louisville, KY*. Annapolis, MD: Institute for Learning Innovation, 1999.

Adams, Marianna M., Falk, John H., Cobley, Joanna, and Pruitt, Robert. *Phase I Evaluation: Report Motivations and Expectations of the General Museum Visitor for the National Museum of African Art*. Annapolis, MD: Institute for Learning Innovation, 1997.

Adams, Marianna M. and Luke, Jessica J. *Personal Meaning Map Study of Nsukka: The Poetics of Line Exhibition for the National Museum of African Art*. Annapolis, MD: Institute for Learning Innovation, 1998.

Barenholz, H. & Tamir, P. A Comprehensive Use of Concept Mapping in Designing Instruction and Assessment." *Research in Science and Technological Education*. 10(1): 37-52 (1992).

Crane, V., Hicholoson, H., Chen, M. & Bitgood, S. *Informal Science Learning*. Dedham, MA: Research Communications Ltd., 1994.

Crimp, Douglas. *On the Museum's Ruins*. Cambridge, MA: Massachusetts Institute of Technology, 1993.

Damasio, A. R. *Descartes' Error: Emotion, Reasons, and the Human Brain*. New York: Avon Books, 1994.

Dierking, Lynn D., Adams, Marianna M., & Spencer-Etienne, Maria. *Final Evaluation Report for Spirit of the Motherland for the Virginia Museum of Fine Arts*. Annapolis, MD: Institute for Learning Innovation, 1997.

Eisner, Elliot. "Does Experience in the Arts Boost Academic Achievement?" *Art Education* 54.3 (April 1998).

Falk, John H. "Museums as Institutions for Personal Learning." *Daedalus*. 128(3): 259-275 (1999).

Falk, John H. "Pushing the Boundaries: Assessing the Long-Term Impact of Museum Experiences. *Current Trends*, 11, pp. 1-6 (1998).

Falk, John H. "Personal Meaning Mapping." In C. Scott (ed.). *Museums & Creativity*. Sydney, Australia: Powerhouse Museum, in press.

Falk, John H. & Dierking, Lynn D. *Learning From Museums: Visitor Experiences and the Making of Meaning*. Walnut Creek, CA: AltaMira 2000.

Falk, John H. & Dierking, Lynn D. *Public Institutions for Personal Learning: Developing a Research Agenda*. Washington, DC: American Association for Museums. 1995.

Falk, John H. & Dierking, Lynn D. *The Museum Experience*. Washington, DC: Whalesback, 1992.

Falk, John H. & Dierking, Lynn D. *Lessons Without Limit: How Free-Choice Learning is Transforming Education*. Walnut Creek, CA: AltaMira. 2002.

Falk, John H., T. Moussouri, and D. Coulson. "The effect of visitors' agendas on museum learning". *Curator* 41.2: 107-120.

Gaffney, K.E. "Multiple Assessment for Multiple Learning Styles". *Science Scope*, 15(6): 54-55 (1992).

Harris, Neil. "The Focus Group Experiment in a Historical Context." *Insights: Museums, Visitors, Attitudes, Expectations*. Malibu, CA: The J. Paul Getty Trust, 1991.

Hooper-Greenhill, Eileen. *Museums and the Shaping of Knowledge*. London: Routledge, 1992.

Kimmelman, Michael. "Museums in a Quandary: Where Are the Ideals?" New York: *New York Times* website <www.nytimes.org>, August 26, 2001.

Kuhn, Thomas S. *The Structure of Scientific Revolutions*. Chicago: The University of Chicago, 1970.

Luke, Jessica J., Adams Marianna M., & Falk, John H. *'Art Around the Corner' Longitudinal Impact Study National Gallery of Art*. Annapolis, MD: Institute for Learning Innovation, 1998.

Menninger, Margaret. Presentation at the Visitor Studies Association Annual Meeting, 1996.

Novak, J.D. , Gowin, D.B. & Johansen, G.T. "The Use of Concept Mapping and Knowledge Vee Mapping with Junior High School Science Students." *Science Education*, 67(5): 625-645, (1983).

Novak, J.D. & Musonada, D. "A Twelve-Year Longitudinal Study of Science Concept Learning." *American Educational Research Journal*. 28: (1991) 117-154.

Oakes, Jeannie & Lipton, Martin. *Making the Best of Schools: A Handbook for Parents, Teachers, and Policymakers*. New Haven, CT: Yale University, 1990.

Persky, Hilary R., Sandene, Brent A., Askew, Janice M. *The NAEP 1997 Arts Report Card: Eighth-Grade Findings from the National Assessment of Educational Progress*. Washington, DC: U.S. Department of Education: Office of Educational Research and Improvement, 1998.

Pope, Mauren & Gilbert, John. "Personal Experience and the Construction of Knowledge in Science." *Science Education* 67.2 (1983): 193-203.

Roberts, Lisa C. *From Knowledge to Narrative: Educators and the Changing Museums*. Washington, DC: Smithsonian Institute, 1997.

Roschelle, Jeremy. "Learning in Interactive Environments: Prior Knowledge and New Experience." In J. Falk & L. Dierking (eds.). *Public Institutions for Personal Learning*. Washington, DC: American Association of Museums, 1995.

Rosenfield, Israel. *The Invention of Memory: A New View of the Brain*. New York: Basic Books, 1994.

Solomon, J. "Social Influences on the Construction of Pupil's Understanding of Science." *Studies in Science Education* 14 (1987).

Ross, B. & Mundy, H. (1991). "Concept Mapping and Misconceptions: A Study of High-School Students' Understandings of Acids and Bases." *International Journal of Science Education*, 13(1): 11-23.

Sylwester, Robert. *A Celebration of Neurons: An Educators Guide to the Human Brain*. Alexandria, VA: Association for Supervision and Curriculum Development, 1993.

Witmer, Susan R., Luke, Jessica J., and Adams, Marianna M. "Exploring the Potential of Museum Multiple-Visit Programs," Art Education: *The Journal of the National Art Education Association*, September 2000, Vol. 53, No.5, pp. 46-52.

FOLKERT HAANSTRA

VISITORS' LEARNING EXPERIENCES IN DUTCH MUSEUMS

Abstract. Through audience surveys much is known about visitors' characteristics, but still little is known about how visitors perceive and experience the museum and how this influences their learning. This chapter presents the results of two empirical studies on personal learning experiences of museum visitors. Quantitative and qualitative instruments are used to get more systematic information about the learning experiences. Data were collected in Dutch museums with mixed collections of art objects, historical objects and ethnographic objects. Three dimensions of museum guidance are distinguished: a cognitive dimension (clarification of subject matter), a meta-cognitive dimension (information on the goals and the set-up of the exhibition, the routing etc.) and an affective, emotional dimension.

INTRODUCTION

From the many museums to which my parents took me, one is still vividly on my mind. When I was ten years old we visited an ethnographic museum in Leiden and while exploring the building I ended up in a dimly lit room with five large Buddha statues. I sat down on a bench in front of the statues and was absorbed by these mysterious images. During the rest of the visit I returned several times in order to confirm my first experience in that room and on the way out we bought a post card of the statues which I hung on the wall of my room.

I would now describe my experience as a mixture of aesthetic involvement and indefinite religious feelings and as Hein (1998) writes, it is not unusual for visitors to describe epiphanies in recounting their own history with museums. The memory of the visit to the Leiden museum was revived, when as a researcher I asked people to write about profound experiences in museums (Haanstra 1992). A woman wrote about the same Buddha statues in the dusky room in Leiden museum which she experienced as a place for silent contemplation. However the last time she saw them the museum was under reconstruction. The statues were placed in a small room and there was a high pitched noise of some electric machinery. To her sadness the magic was gone.

Somewhat later I was asked to evaluate an exhibition in the Leiden National Museum of Ethnology on Japanese way of life around the 1850's. The Buddha statues were exhibited there as well, but now in a totally different context. I had not known the statues were Japanese and finally learned some background information. In this evaluation study again visitors told about how they experienced the statues and some did so in comparison to the original presentation.

The different methods of display of the Buddha statues and the diverse ways in which visitors experience them illustrate the questions addressed in this chapter:

33

M. Xanthoudaki, L. Tickle, V. Sekules (eds)
Researching Visual Arts Education in Museums and Galleries, 33-48.
©2003 Kluwer Academic Publishers. Printed in the Netherlands.

What are the learning experiences of museum visitors? And: How can we 'measure' these experiences? This chapter presents the results of two empirical studies on this topic in Dutch museums. First we present some contextual information on museum visits in the Netherlands and a theoretical background to the studies.

MUSEUM VISITORS IN THE NETHERLANDS

The studies reported here took place in the 1990s and were carried out in four different museums. During and after the studies all four museums have been expanded and redesigned. This is characteristic of the frantic renovations in many museums in the Netherlands in trying to keep up with what they consider to be the desires of the public. As in many other countries Dutch museums battle with all kinds of recreational sites, amusement parks, shopping malls etc. Museums try to attract visitors with renovated buildings, more spectacular presentations and a more visitor-oriented approach in general. Not only the quality and quantity of museum exhibitions have risen but also the supplies in the museum shops and the menus in the museum restaurants. Museums have been organising more and more events and activities such as workshops, lectures, demonstrations, living history, museum theatre, master classes etc.

Since World War II the number of museum visits had constantly been rising, but since the middle of the 1990s the numbers have been showing a stagnation. The Netherlands is a small country and with about 730 museums, the museum density is high. About half of these museums have historical collections and about 10% are exclusively art museums. Compared to other western European countries the Dutch population shows an average interest in museums: about 31% yearly visits one or more museums (SCP, 2000). People who have enjoyed higher education are strongly represented and measured against civil status and family situation, the museum visiting public (in particular museums for the visual arts) includes a relatively high proportion of single people (de Haan, 1997). The museum public contains a growing number of people aged 40 and over, whereas visits to museums by young people have actually declined since the 1970s.

Through audience surveys much is known about visitors' characteristics in the Netherlands, but still little is known about how visitors perceive and experience the museum. That was the reason the educational section of the Association of Dutch Museums commissioned a research project on this topic. The study had to look into ways of getting more systematic information about these learning experiences. The undertaking of this research gave a broader scope on learning and evaluation than did the more usual museum studies.

NEW VIEWS ON LEARNING AS A FRAME OF REFERENCE

Current visitor research primarily serves marketing goals. Besides questions on background variables of the visitors they frequently contain a number of evaluative questions. Sometimes a general opinion about the museum or an exhibition is asked but most of these questions deal with the kind and quantity of information given, for

instance whether the visitors attended the audio-visuals and how they liked them. Evaluation studies on learning effects are scarce. And, as in Great Britain and the US, traditional museum research on learning effects in the Netherlands followed a strict goal-attainment approach, in which goals refer to measurable learning or performance outcomes shown by visitors as the result of exhibit exposure. This approach was criticised for its behaviourist premises and its restricted means-end model (Haanstra, Heijden & Sas, 1996). The passive nature most goal referenced studies attribute to the visitor as well as the environmentally deterministic manner in which the effectiveness of exhibitions is explained were in disagreement with new theories of human information processing.

Constructivist learning theories stress that individuals are actively engaged in attempting to understand and interpret phenomena for themselves. Theories on learning styles indicate that people have different ways for perceiving and processing information. New theories also take into account that affective variables play an important role in learning (e.g. Simons, Van der Linden & Duffy, 2000). Quality of learning outcomes is largely dependent on the quality of the learning activities. The internal regulation of learning activities (by the student, the visitor) and external regulation of learning activities (by the instruction, the exhibition) act upon each other.

Vermunt (1989, 1992) presents a theory, which attempts to connect theories of learning and theories of instruction. He describes three kinds of internal learning activities. Cognitive processing activities refer to the functions that pertain to information processing and task execution as such (e.g. relating, structuring, analysing, and memorising). Affective processing activities relate to the motivational and emotional aspects of learning (e.g. expecting, generating emotions, appraising, motivating). Meta-cognitive regulation refers to the functions that control and steer the cognitive and affective functions (e.g. orienting, planning, monitoring, evaluating, and reflecting).

Instructional activities parallel the three different kinds of learning activities. Cognitive instructional activities (presenting and clarifying the subject matter) can be distinguished from affective instructional activities (creating a promoting affective climate) and meta-cognitive instructional activities (regulating the learning processes). The way in which museum curators and educators design displays, presentations and instruction often have consistent, stylistic aspects, that just as in the case with the diverse learning styles of visitors, are connected to their mental models of learning and instruction and to their instructional character and orientations.

These theoretical approaches to learning and instruction are influencing new directions in visitor studies (e.g. Falk & Dierking, 1992; Hein, 1998) and demand a more open-ended approach to evaluation, in order to gain insight into the attitudes, values, preferences and experiences of museum visitors. Hein recognises a pragmatic approach using multiple methodologies (both quantitative and experimental design and qualitative naturalistic) as well as multiple instruments, ranging from pre-structured questionnaires to open-ended interviews. The studies reported here follow this eclectic approach.

A COMPARISON OF LEARNING EXPERIENCES IN THREE MUSEUMS

The goal of the first study was to capture the learning experiences of individual visitors in relation to different displays and educational guidance in museums.

The study compares the learning experiences of visitors in three Dutch museums (Amsterdam, Assen and Leeuwarden). It focusses on adult visitors to the permanent collections, not for temporary exhibitions.

All three museums are located in historical buildings and have mixed collections of historical objects, archaeology, fine art and applied art (costumes, porcelain, silver etc.). Even though the museums have similar collections reflecting the local history, their approaches to the presentation of display and education are quite different. Interviews with museum curators and educators confirmed these differences. At the time of the study the Leeuwarden museum had the most traditional display of the museum collection. The museum staff was not satisfied with it and thought that it was outdated. The museum contained a large number of rooms but lacked a clear route. Guidance was limited to textual information. Leaflets with more general information were available in addition to information labels on some of the individual objects of the vast collection of porcelain, paintings, utensils and interior decoration.

The Assen and the Amsterdam museum both had a more thematic approach. Objects were placed in context and often fulfilled an intermediary function to tell a story about the local history. The display in the Assen museum was directed to entertain and educate the visitor through a mix of real life reconstructions (e.g. a labourer's cottage from the 1920's), hands on experiences, audio-visual media, the use of colours, noise, smell, etc. In addition to maps and a museum-visiting route, the museum employs hosts and hostesses to help visitors with their orientation in the museum.

The display in Amsterdam originated from the late seventies, but had been updated and renovated several times. It was more modernist and distant in style and contained no real-life reconstructions. Information was provided on text panels with three different levels: headings, thematic narrative information and detailed information on the artefacts. The permanent exhibition made moderate use of other media, such as video. Some information about the collection and the suggested museum route were indicated on leaflets for visitors.

METHODS FOR EVALUATION

Questionnaire

In order to find out how visitors experienced the three museums, different instruments were used. First of all a closed-option questionnaire was designed to measure the cognitive, meta-cognitive and the affective aspects of presentation and display in the museums. The visitors in this study had to rate a total of twenty-two statements on a five-point scale ranging from 'completely agree' to 'completely disagree'.

Evaluation of the cognitive aspects was concerned with the presentation and clarification of the subject matter. Examples of statements used to cover this aspect are: "The explanation of objects is understandable'; 'The museum shows different points of view'; 'You have to know a lot in advance otherwise much escapes you'; 'They use difficult language to explain things'.

Parts of the questionnaire dealing with the meta-cognitive aspects were concerned with the method and degree of control of the learning experiences. Examples of statements are: 'You easily get lost in this museum'; 'If you want to know more about a subject it is indicated where to find it'; 'The museum collection is subdivided in clear parts'; 'You get help from the museum staff if you want to know something'.

Finally, evaluation of the affective aspects was concerned with the creation and promotion of an affective and comfortable climate. Examples of statements are: 'The museum has an inviting atmosphere'; 'The museum has an attractive interior', 'The presentation holds your attention from beginning till the end'; You can rest when you feel like it'.

Semantic Differential

The second evaluation instrument was a semantic differential. The semantic differential enables direct ratings of concepts, persons, objects, etc. according to scales anchored at the extremes by bipolar adjectives such as beautiful-ugly, or simple-complicated. Responses consist of a pattern of ratings.

The semantic differential was originally developed to measure the 'connotative' meaning of concepts: that is the sentiments they represent for a person (Osgood, Suci & Tannenbaum, 1971). The use of the semantic differential was broadened to apply to the assessment of persons, art objects, buildings etc. Several authors advocate the use of the semantic differential to measure what implications a museum has for a person and to judge museum displays (e.g. Klein & Wüsthoff Schäfer, 1990).

Examples of scales used to rate museums in this study are: 'dull-varied', 'passive-active', 'cold-warm'; 'untidy-tidy' and 'clear-confusing'.

Learner Report

In addition to the pre structured instruments a more open-ended evaluation method was used. Visitors were asked some questions about what they got out of the visit. The questions asked were based on the so-called 'learner report' (de Groot, 1986). The ideas behind the learner report are consistent with the new learning theories mentioned before. Within the theoretical framework of human information processing De Groot argues that complex knowledge and skills are not 'behaviour' but rather mental programs or dispositions stored in the memory to be used freely and consciously by the learner. Consequently, if we want to detect the effects of learning, we must go to the learner and interrogate him or her with the right questions about what he or she has learned. In that way we can get a more complete

list of possible learning effects than we usually do by relying on our traditional measurements, observations and inferences.

Further he proposes a heuristic classification of sentences referring to learning effects according to different dichotomies. In models of learning and memory (Boekaerts & Simons, 1995) a distinction is made between conceptual knowledge, action knowledge and episodic knowledge. Conceptual knowledge refers to general concepts and principles, whereas action knowledge (or procedural knowledge) refers to knowing how to use knowledge and to solve problems. According to this latter distinction de Groot introduces learner reports of the type: "I have learned that..."and 'I have learned how to..." The third type of knowledge is episodic knowledge, which is based on personal, situated and affective experiences. In de Groot's proposal these are statements about the self in the form of: "I have learned that I...".

Learner reports have been used in different educational settings, for example, to evaluate the effects of arts education (Van der Kamp, 1980) and literature (Janssen, 1998). Different forms of learner reports are possible. Learners can rate pre-structured learning-effect statements, but preferably learners write their own learning-effect sentences corresponding to de Groot's classification. It is important to instruct the respondents that learning should not be used in a strict sense. Especially in an informal learning situation such as a museum, the visitors who write learner reports are encouraged to use sentences like: 'I have discovered that I'...; 'I have experienced that I'

Motives

The total questionnaire in this study consisted of questions on the instruction and presentation in the museum, a semantic differential, a pre-structured learner report and some questions concerning demographic variables and motives for visiting the museum. Different kinds of motives can be distinguished. A motive is called intrinsic if an activity is pursued for its own sake. In the case of a museum visit, this means out of interest for the collection itself, for a certain exhibition or even for a particular object. A motive can be called extrinsic if the visit is a means to achieve other goals or external rewards, such as being in the company of others or to use the museum visit to achieve a certain status. Finally there are motives that could be called conditional. For instance if weather conditions make someone visit a museum, rather than stroll in the city.

A random sample of 334 casual visitors filled in this questionnaire after they visited one of the three museums. The visitors were evenly divided over the three museums. A total of 92 visitors wrote an extensive learner report about their museum visit in the format explained above. They were also asked to write about a museum visit that they still remembered well and that made a special impression on them.

BACKGROUNDS AND MOTIVES OF VISITORS

The demographic variables of the visitors match the general profile of the audience for museums. Among other things this means there is a proportionally larger representation of higher educated compared to the average member of the Dutch population. No crucial differences exist between the respondents from the three museums. Half of them had visited the museum before.

Visitors to all three museums indicated that intrinsic motives for the visit were most important. By far the most important motive indicated was 'to see beautiful things'. It was followed by intrinsic motives such as 'to experience the atmosphere of the past' and 'to learn something'.

Second came extrinsic motives such as 'to find diversion' and social reasons, such as 'to share a meaningful experience with other people (family, friends)'. Last came motives that can be described as conditional. It concerns motives such as 'as I was in town anyway' and 'because of the weather'.

No doubt social desirability plays a role when people are asked to answer these questions directly. It is more acceptable to say that you came to learn something than to say you came just for fun or because you sheltered for the rain. So in general intrinsic motives prevail, but it is remarkable that although the three museums studied are not art museums in particular, the aesthetic motive is rated highest in all three of them. As we shall see later on this corresponds to the important learning experiences reported by the visitors.

VISITORS' PERCEPTIONS OF THE THREE MUSEUMS

First of all we had to find out whether the theoretical dimensions (cognitive, meta-cognitive and affective) could be empirically confirmed in the answers by the visitors. For this purpose we used factor analysis as a statistical method. This method enables one to see whether some underlying patterns of relationships between the answers exist such that the data may be 'reduced' to a smaller set of factors or components .

Factor analysis confirmed the three dimensions in the questions on the presentation of the museum. Consequently scores on the items of the three dimensions were summed and for every museum a mean score on the three scales 'cognitive aspects', 'meta-cognitive aspects' and affective aspects' could be calculated. The reliability of the latter two scales was satisfactory, but the reliability of the scale measuring cognitive aspects was rather low. The estimate of reliability is based on the average correlation among the items.

A factor analysis was also performed on the ratings on the semantic differential and now four factors were defined. The strongest factor found was interpreted as 'activity'. It is defined by the scales: 'dull-varied', 'passive-active', 'calm-exciting' and 'uneventful-eventful'. The second factor found was interpreted as atmosphere. It is defined by the scales 'artificial-lifelike'; 'matter-of-fact- full of atmosphere'; 'cold-warm'; 'unemotional'- emotional'; 'uninviting- inviting'. The third factor was defined by scales such as: 'confusing-neatly arranged'; 'untidy-tidy'; 'orderly-

disorderly'. The fourth factor was interpreted as 'comprehensibility'. The three scales 'simple-complex', 'clear-confusing' and 'comprehensible-incomprehensible' defined it.

The first two factors 'activity' and 'atmosphere' correspond to the affective dimension of the museum display, the third factor corresponds to the meta-cognitive dimension and the fourth factor corresponds to the cognitive dimension.

Scores on the four scales were totalled and the mean scores for the museums were calculated. The measures of reliability of the totalled scales were satisfactory.

The mean results on the totalled scores indicated that visitors were on the positive side in their judgements of the museums. That is, in general they indicated the museums as being understandable, that they were well guided through the displays and that they found the atmosphere rather stimulating. As the three museums were thought to represent different approaches to museum pedagogy, such as text panels, videos, leaflets and so forth, the question was to what extent the audience experienced these differences.

Indeed the outcomes showed some clear differences. The Assen museum with its multi-sensory approach obtained the highest scores on the different affective dimensions. The largest difference was for the 'activity' dimension. This dimension was based on scores on the semantic differential. The Amsterdam museum with its more distant and modernist approach obtained the lowest scores for the affective dimension.

The Leeuwarden museum scored lowest on the meta-cognitive dimensions, while there were no significant differences between the other two museums in this respect. As indicated, the staff themselves were of the opinion that both the display presentation and the layout of the museum in Leeuwarden were unsatisfactory.

No clear differences between the museums existed on the scores relating to the cognitive dimensions. This was unexpected, as both the Amsterdam and the Assen museum had put in much more effort to explain and to communicate the collection. The failure to detect differences in this respect may be due to the scales used. This point will be discussed later on.

VISITORS' EXPERIENCES

Close on one hundred visitors wrote about their museum visit. They were asked to write about their learning experiences using the formats 'I have experienced/learned/discovered that..', 'I have experienced/learned how...', 'I have experienced/learned that I..' etc. Furthermore they were asked to write about how they undertook the visit itself. Lastly they were asked to write something about a museum they remembered well and to indicate what made it so special. This resulted in about 100 pages of text. Content analyses of the statements were carried out with a qualitative data analysis software system (Peters, Wester & Richardson, 1991). A sample of responses was used to develop taxonomies of response categories.

The starting point of the analysis was taxonomy based on Falk and Dierking (1992). They conceptualise the museum visit as an interaction of three contexts: the personal context, the physical context and the social context. Within each of these main categories, subcategories were directly derived from the data set. The learning

experiences were considered part of the personal context. The categories are not mutually exclusive as the learning experiences often are related to remarks on the physical and the social context of the museum.

Table 1. Taxonomy of experiences of visitors of three Dutch museums

Personal context
- Episodic or anecdotal learning experiences (visual aesthetic experience, personal memories and nostalgia, contact with the past, awareness of regional culture; awareness of own interests, preferences and dislikes
- Conceptual and procedural or contextual learning (facts and figures, brushing up one's knowledge from school subjects, new insights)

Physical context
- The collection; objects and artefacts
- Educational guidance (texts, audio-visual media, hands on displays, etc.)
- The museum building; museum lay- out

Social context
- Company (family, friends)
- Other museum visitors
- Attendants; museum staff

Personal Context

Many of the learning experiences consist of accounts of how visitors personally experienced objects of the past and how they tried to make sense of them. Some examples are:

> I learned about the function of certain objects and I was touched by seeing an object that people used thousands of years ago;

> I am trying to imagine the people behind those objects and paintings

Also many experiences are about aesthetic feelings and preferences ranging from admiration for technical details and craftsmanship:

> I discovered I preferred the still-lives Those rummers with sparkling wine. How is it possible to paint such transparency!

to a more general feeling of satisfaction because of the visual impact of the presentation:

> I noticed that the beauty of the things I saw made me feel happy. You look differently at the city when you leave the museum.

Often this aesthetic experience is strengthened by personal memories:

> I have experienced that the old paintings and photos of Amsterdam are a joy to look at. And recognising the places I know from my youth makes it more fun.

> It was a re-experience of this beautiful region, the buildings, the landscapes, the costumes etc. Perhaps some nostalgia, in summer holidays I used to stay here a week with my aunt and uncle

So a great majority of the written learning experiences from the three museums involved this kind of episodic or anecdotal learning. To a lesser degree visitors reported conceptual and procedural-contextual learning. Some visitors report that they learned new things about the city or the region of which the presentation was about. For instance:

> I learned about the different architectural styles and I did not know the building regulations in this city were already that strict in previous centuries;

> I discovered that the many of the woods in this province were planted in the 1930's as relief work for the unemployed;

> I found out that this province is more than cows and meadows. It has a rich cultural history and it played an important political role as well..

> I have learned how they built those megalithic tombs and now I will look at them differently when I see them again.

There were no large differences in the number of learning experiences in the different categories. Of course the content of the learning differed among the three museums. For instance visitors to the museum in Amsterdam reported most learning about Dutch national history and Golden Age. Several visitors connected what they saw and experienced with prior knowledge, especially knowledge from their school days:

> I recognised some of those portraits from history books in schools and learned some new things about them;

> Since primary school I have seen countless images of the Golden Age of The Netherlands. I experienced that the museum was a confirmation of my views and knowledge, it did not change it.

The historical presentations also give rise to comparisons with our present existence:

> You feel spoilt by luxury and comfort when you compare your life with how people lived not even long ago. But perhaps there was more solidarity and a feeling of a community then;

> I discovered when looking around in this museum that much of our time, such as the noise, the rush and the mass production are no improvement when I compare it to the lives of our ancestors.

Physical Context

In addition to these kinds of learning experiences (which we range under the personal context of the museum visit) the visitors wrote about other aspects of their museum visit as well. We will not go into these remarks in detail. The visitors named

different objects on display that they found characteristic for the museum they visited and several mentioned the impact of the museum building. In all three cases the fact that the museums were historical buildings added value to the experience. In the Amsterdam museum for several visitors the contrast of the old building and the modern design of the display was unfortunate.

Relatively few comments were made about the educational guidance (texts, audio-visual media, and hands on displays). As museum educators know, visitors are ambivalent about texts. Often they find it too much:

> I am not in a museum to read, but to look and to experience.

But when information is lacking or sparse the visitors complain as well:

> There was too little information so I felt a bit stupid walking round like that;

> When there is no explanation these things mean little to me.

As far as the meta cognitive aspects are concerned, several visitors wrote that they appreciated that the museum gave clear indications as to how to orientate oneself in the building and what to expect at which place. But there were a few respondents who did not care about these kind of orientations and wrote that they liked to wander through the building and preferred to discover things on their own.

As the questionnaire indicated, visitors were generally positive about the way the collections were presented. In only a few cases, the display as a whole was critically judged. A visitor of the Leeuwarden museum writes:

> I experienced the whole museum as very static. In a show-case museum such as this one I do not get involved in what they show me. Those many silver objects only come to life when it is shown how they were made and how they were used. Furthermore the museum made a chaotic impression. There were too many objects and topics on a small surface. I realise they have beautiful things in their collection, but I felt too irritated to enjoy them.

Visitors also wrote about the social context of the museum visit. Some indicated the joy of sharing their interest or enthusiasm with others:

> I felt proud that so many beautiful things of our region have been preserved. I like to show these to my children and grand children.

Others indicated that they learned things about the collection from friends or a relative. But some stressed that company would only irritate them and that they strongly preferred to visit a museum on their own. Other remarks on the social context referred to the role of the museum staff, which was mostly helpful, but sometimes the presence of the staff was considered too obvious or even threatening.

Memories Of A Special Visit.

The same categories of analysis apply to the question about a visit to a museum that made a special impression. Reported examples of conceptual learning were scarce. However there was an even stronger emphasis on personal emotional experiences. First of all they concerned aesthetic feelings and secondly, feelings of identification

with the past or with other cultures. The affective aspects of the museum display played an important role (the atmosphere of the building, lighting of objects) in furthering these feelings.

Sometimes the curiosity and excitement the museums had evoked was described in physical terms. Visitors wrote in terms of 'swallowing...', 'absorbing...', 'breathless looking at'; 'the urge to see more'; 'a hunger for objects'; etc. But memories were not always that exalted. For instance some respondents wrote about the pleasure of repeated visits to a museum or to a special art-work in a museum:

> I often go to that museum for relaxation, not for the need to be stimulated or surprised by new things. For me it is like leafing through a familiar photo album.

As far as the social context is concerned, some respondents again described the importance of sharing their experiences with their company. However much more often they described the pleasure of a quiet museum and the feeling that the place had belonged to themselves. On several occasions the respondents wrote about visiting impressive exhibitions, but that the pleasure of the visit was reduced or disturbed by crowds attracted by the same exhibition, or by attendants who had been too watchful.

EVALUATION OF AN EXHIBITION IN AN ETHNOGRAPHIC MUSEUM

The second study into learning experiences is an evaluation of an exhibition on Japanese art and history in the 19th century in the ethnographic museum in Leiden. The exhibition showed the daily life of Japanese merchants. It contained a large-scale model of a house with different rooms, for instance a room for the tea ceremony and a room for women with a make up table and all kinds of objects and clothes. The exhibition also showed art objects and religious objects. The religious aspects of life were represented by the five bronze Buddha statues, which were now situated in a Japanese garden.

Design And Methods

As the total museum was due to be renovated, the exhibition was used as one of a series of pilots for the future displays. The museum staff wanted to find out to what extent learning about Japanese life in the nineteenth century occurred and how visitors experienced the different parts of the exhibition. Therefore, the study combined a traditional quasi-experiment to test pre-determined learning goals, with a more qualitative evaluation through measuring the personal learning experiences. A total of 350 visitors participated in the study and filled in questionnaires.

The experiment showed significant gains in short term learning about the subject of the exhibition. But what matters here is that some of the instruments used were comparable to the those used in the study to find out about how visitors experienced the museum. These instruments were the closed-option questionnaire on cognitive, meta-cognitive and affective aspects of museum presentations, a semantic differential, and learner reports.

Again respondents were asked what had been their motives for visiting the exhibition and as in the first study, the motive 'to see beautiful things' scored highest. As far as the questionnaire is concerned, a factor analysis confirmed the three elements of museum presentation. Again the affective and the meta-cognitive scales were reliable indicators and again the cognitive scale was least consistent. Visitors were satisfied about the clarification of the subjects and the about the layout and structure of the exhibition. The affective climate of the exhibition did not score very high. The exhibition was considered aesthetically pleasing but somewhat aloof.

Different Use Of Semantic Differential

In this evaluation the semantic differential was used in a different manner. Instead of asking about the connotative meaning of the exhibition as a whole, visitors were asked to rate their attitude towards the interior of a Japanese house. The scales used differed partly from the scales in the first study and were adapted to the subject. A random sample of visitors was asked to rate the scales before their visit and another random sample was asked to do the same after they completed their visit. A factor analysis was performed on the ratings and two factors were defined. The strongest factor found was interpreted as 'evaluation'. It is defined by scales such as: 'beautiful-ugly'; 'pleasant –unpleasant'; 'tidy-sloppy' and 'delicate-coarse'. The second factor was interpreted as 'calmness' and consists of scales such as: 'calm-vivid'; 'empty-full'; 'subdued-bright' and 'orderly-chaotic'.

Outcomes showed significant differences between pre and post ratings on the two scales. Visitors rated the interior as more positive after visiting the exhibition and they considered the interior higher on calmness. So visitors considered the interior as more calm, empty and orderly after the visit to the exhibition.

Visitors also wrote learner reports about personal experiences. An extra question was asked about the way the Buddha statues were exhibited. A majority of visitors who saw these for the first time appreciated the presentation of the statues in the Japanese garden as a part of the exhibition about Japanese life. But visitors who remembered the old arrangement (the one I had seen when first visited the museum) had mixed opinions. Quite a lot preferred the past display with the statues standing all by themselves, without the context of Japanese life from the past, but with a more dramatic impact and aesthetic power.

The Leiden National Museum of Ethnology reopened in the spring of 2001. The five Buddhist statues found their place in the permanent exhibition about Japan. The way they are presented is a compromise between the old arrangement and the more casual display in the exhibition about Japanese life in the nineteenth century. A computer with touch screen provides the visitor with all kinds of information about the statues, including their history of display in the museum itself. The old display is characterised as evoking a mystic atmosphere. Even though most visitors were impressed, according to the computer text this atmosphere had nothing in common with the way in which Buddhism is part of everyday life in Japan. The text concludes that the present exhibition does more justice to the specific artistic qualities of the statues.

DISCUSSION

Even though the two studies were also undertaken to give direct feed-back to the museums involved about the impact of their displays, a main goal was to see whether some theoretical notions about learning and experiencing in the museum could be applied to inform practical outcomes. Therefore we will first discuss the different instruments used and after that we will go into the results and make some more general remarks about museum experiences.

Methods of Evaluation

In both studies a questionnaire was used based on Vermunt's (1992) notion of cognitive, meta-cognitive and affective aspects of teaching and learning. The outcomes indicate that application of this distinction in the museum context is plausible. The three dimensions were confirmed by factor analysis and museums could be rated on the resulting scales. However the cognitive dimension was measured least satisfactory. The internal consistency was moderate to low, which means the items had too little in common.

A reason for this might be that the items represented different conceptions about the cognitive aspect of a museum presentation. Hein (1998) distinguishes different educational theories, and these different views will lead to different kinds of display presentations and textual guidance. For instance a didactic expository approach will lead to a sequential display with descriptions of what is to be learned and guidance as to what is the 'correct' interpretation of the exhibits. On the other hand a display could present a range of points of view and provide experiences that allow the visitor to draw his or her own conclusions. The statements in our questionnaire represented these different approaches. For example 'The explanation of objects is understandable'; 'They use difficult language to explain things' refer to what Hein calls a 'didactic, expository approach' (Hein 1998, 25-29), whereas items such as 'The museum shows you different points of view' and 'you can make your own judgements' fit in the constructivist approach. In future research, these different approaches should be more explicitly included in the questionnaire and it is recommended that there should also be a differentiation between approaches to different cognitive aspects.

Already in 1967 Nunnally concluded that the semantic differential had become an important 'workhorse' in psychology for the investigation of attitudes and other types of sentiments. The two studies show that the method can still be useful to measure opinions of visitors in museum settings. First of all it can be used to evaluate the connotative meaning of museum display as a whole. The second study showed it can also be used in a more targeted fashion, for instance to find out whether the evaluative connotation of certain objects or concepts changes through visiting an exhibition.

The learner report is based on ideas of de Groot: that learning effects are mental possessions of the learner, of which the learner is aware, and on which he or she can take a position. The learner report as an instrument has far from reached the status of the semantic differential. Questions about reliability and validity of learner reports

have been raised (Kesteren, 1989) and analysing the answers is labour-intensive. It is obvious that the learner report is not particularly suited for testing 'facts and figures' knowledge. Rather it is an instrument that stimulates the articulation of a wide range of personal learning experiences. For this reason it is well suited for exploratory studies into learning in the museum environment.

Learning Experiences Of Visitors

Although there were some critical comments and some mild frustrations, in general the respondents in both studies behaved as satisfied customers. Even the Leeuwarden museum was not severely criticised, although the staff was highly critical itself. Only few visitors gave a more general and reflective view on this display as a whole. The kind of 'museum literacy' possessed by a professional staff can hardly be expected from the average visitor. It seems the museum visitor is not easily disappointed as long as he or she finds some specific objects that satisfy the aesthetic needs or the intellectual curiosity.

But as indicated before, this is not what most museums today aim for. In the competition for the pleasure-seeking audience many Dutch museums have introduced active multi-sensory exhibits, hands on experiences, living history and the like. At the time of the study the Assen museum could be said to meet the wishes of the public for stimulating experiences more than the other two museums. This was mirrored in the reactions of the audience, as the museum was rated most highly on the affective dimension of the display. But differences between museums were small and it would be erroneous to conclude that the public always prefers an active way of empathising with what is shown rather than contemplation and distance.

As de Haan (1997) states, the continued promotion of the museum as a cultural attraction can carry a risk. The current profile of the average museum visitor (higher education, older than 40, no children living at home) does not indicate that this group is in search of spectacle and low-threshold entertainment. On the contrary museums appeal precisely because they are "places for reflection and distance from the everyday world" (ibid. p.171)

The studies in this chapter support this view of the museum as well. Equally in the three museums with mixed collections as in the ethnographic museum, the most often- cited motive for visiting, was to see beautiful things. And from their memories of extraordinary museum visits many visitors emphasised enjoyment of the perceptual experience itself in quiet undisturbed surroundings. This description corresponds to the well-known descriptions of the detached character of aesthetic perception in terms of disinterestedness (Kant, 1978) or 'psychical distance' (Bullough, 1977).

The museum that positions itself towards this kind of intrinsic perception is in many respects the opposite of the entertainment-oriented museum. In this museum the objects are standing outside life in their rooms or display cases and their sole purpose is to be subject to the aesthetic perception of the visitors. Such an a-historical and de-contextualised approach of the exhibits has both advantages and disadvantages. If the first time I had seen the Buddha statues they had been exhibited

in the Japanese garden (or even in their present display), I doubt that they would have made such a deep impression on me. But that first experience remained a personal aesthetic feeling and only after I saw them again in context I started to understand some more about their function in Japanese culture.

To put this in more general learning-specific terms: after my first confrontation the episodic representations of the statues were not connected to conceptual and contextual representations. Learning experiences will be deepened when such connections do take place. Therefore it is the challenge for the museums to stimulate visitors to relate these important personal (episodic) experiences with more general concepts and strategies.

This is a difficult task as museum education, unlike traditional education in the classroom, is characterised by a loose external control of learning activities. Museums must capitalise on the supposed skill of their visitors in independent learning. On the other hand, unlike in traditional education, many museum visitors come with an intrinsic motivation and openness to new experiences. A good balance between the cognitive, meta-cognitive and affective aspects of the museum offers the best conditions to enhance these learning experiences.

REFERENCES

Boekaerts, M. & Simons. P. R. *Leren en instructie*. 2nd ed. Assen: Van Gorcum, (1995).

Bullough, E. 'Psychical distance'as a factor in art and an aesthetic principle. In: G. Dickie & R.J. Sclafani (Eds.) *Aesthetics: a critical anthology*. New York: St. Martin's Press (1977).

Falk, J. H. & Dierking. L.D. *The museum experience*. Washington: Whalesback Books, (1992).

Groot, A.D. de *Begrip van evalueren*. 's-Gravenhage, VUGA, 1986.

Haan, J. de *Het gedeelde erfgoed* Het culturele draagvlak 3 Rijswijk: Sociaal en Cultuur Planbureau, 1997.

Haanstra, F *Beieving en waardering van museumbezoek*. Amsterdam: SCO-Kohnstamm Instituut (1992).

Haanstra, F., Van der Heijden, P & Sas, J. Evaluation Studies in Dutch Art Museums In: *Evaluating and Assessing the Visual Arts in education. International perspectives*. New York: Teachers College Press (p. 207 – 221) (1996).

Hein, G. E. *Learning in the Museum*. New York, London: Routledge, 1998.

Kamp, M. van der *Wat neemt de leerling mee van kunstzinnige vorming?* SVO reeks 29. Den Haag: SVO, 1980.

Kant, I. *Over schoonheid* Meppel/Amsterdam: Boom, 1978.

Kesteren, B.J. van Gebruiksmogelijkheden van het learner report. *Tijdschrift voor Onderwijsresearch*, 14, nr. 1, p13-29, 1989.

Klein, H.J. en B. Wüsthoff-Schäfer. *Inszenierung in Museen und ihre Wirkung auf Besucher*. Materialien aus dem Institut für Museumskunde Heft 32, 1990.

Nunnally, J, C. *Psychometric theory*. New York: McGraw-Hill Book Company. 1967.

Osgood, Ch.E., G.J. Suci en P.H. Tannenbaum. *The measurement of meaning* (8th printing). Urbana: University of Illinois Press, 1971.

Sociaal en Cultureel Planbureau *Sociaal en Cultureel Rapport 2000*. Den Haag: Sociaal en Cultureel Planbureau, 2000.

Simons, R.-J., Linden, J. van der & Duffy, T. *New learning*. Dordrecht/Boston/London: Kluwer Academic Publishers, 2000.

Vermunt, J.D.H.M. (1989) *The interplay between internal and external regulation of learning, and the design of process-oriented instruction*. Paper presented at the third Conference of the European Association of Research on Learning and Instruction. Madrid.

Vermunt, J.D.H.M. (1992) Leerstijlen en sturen van leerprocessen in het hoger onderwijs: naar procesgerichte instructie in zelfstandig denken. Amsterdam/Lisse: Swets & Zeitlinger.

JANE LEONG

ART MUSEUM EDUCATION IN SINGAPORE

Abstract. This study examines the practice of art education in one art museum (the Singapore Art Museum) through an analysis of its policy and curriculum, and the relationships between these and the public dimension of art museum education. The exhibition and public educational programmes serves as a basis for the discussion of three main issues in relation to museum educational policy in Singapore: (i) the creation of an awareness of national heritage among museum visitors, (ii) the notion of equity and inclusive museum education, and (iii) the concept of learning for life. The 'reality factors' that enable and inhibit the implementation of the art museum educational policy are presented and their implications for other contexts are considered: the tension between governmental aims of nation-building and post-modern concepts of art and art experience; policies of inclusion and the effects of self-exclusion for those without cultural capital; and the pressure to relate art education to economic development.

INTRODUCTION

Throughout the developed world, structural trends and changes in society have exerted a profound influence on the role of museums and galleries for the 21^{st} century. Among the principal trends are the emergence and implications of post-industrial society, developments in technology, changing government attitudes, and the concept of education for life (Middleton 1998, 27-34). On an international level, the context of art museum and gallery practices are readily related to an aesthetics revolution, which over the last decade, has brought about a complex artistic transformation, renewing people's history and bringing artistic and creative interests into people's lives (Dalin and Rust 1996, 55-56).

No exception to these general trends, the Singapore National Heritage Board (NHB) has made considerable efforts to explore and present local culture and heritage through a network of three national museums. In the case of the art museum this has resulted in a search for new perspectives and possibilities of integrating the educational role of the museum into its core identity. This is spelled out in the mission statement of the Singapore Art Museum (SAM):

> To preserve and present the art histories and contemporary art practices of Singapore and the Southeast Asia region so as to facilitate visual arts education, exchange, research and development. (NHB 2000).

This chapter centres on an analysis of the existing art museum educational policy in Singapore as a case study of international trends. The chapter shows that 'reality factors' - the tensions between governmental policies and the aesthetic and educational mission of art museums - have to be taken into account in this case, and suggests that such factors are also likely to be found in other contexts too. Three interrelated areas are examined:

49

M. Xanthoudaki, L. Tickle, V. Sekules (eds)
Researching Visual Arts Education in Museums and Galleries, 49-63.
©2003 Kluwer Academic Publishers. Printed in the Netherlands.

1) The context of the Singapore Art Museum's mission and educational policy.
2) The role and function of education within the museum's overall aims and strategies.
3) Implications of art museum educational practices in Singapore: the 'reality factors' that enable and inhibit the implementation of the policy.

In general, art museums do not just collect art but also contribute to the production of cultural knowledge and influence the ways in which we imagine our community and ourselves. Hence, it is necessary to first evaluate SAM's role in the local cultural context. Second, an analysis of the art educational practices in the SAM will throw light on its purposes in relation to the overall mission of the Museum. Finally, the factors that enable and inhibit the implementation of the art museum educational policy will be addressed to place SAM's aims and strategies in a broader context of educational policy in Singapore before we consider the more general implications for art museum education in other contexts.

THE CONTEXT OF SINGAPORE ART MUSEUM'S MISSION AND EDUCATIONAL POLICY

Infrastructure For The Arts

The role of SAM is closely related to the national cultural developments of Singapore, where an infrastructure for the arts has been set in place for the new millennium. This includes the establishment of arts institutions such as NHB; National Arts Council; an arts centre – the Esplanade, to be completed by 2002; the development of an arts market, and the upgrading of art colleges. The establishment of SAM in 1996, being reincarnated from the former National Art Gallery, marks an important development in the arts infrastructure of the nation.

The Singapore Committee on National Arts Education in 1996 affirmed the significance of arts education to the nation's development. In *The Next Wave of Creative Energy: report of the Committee on National Arts Education* (1996, 20-22), the provision for arts education in the context of Singapore's economic, social and cultural development was recommended. A three-pronged approach was proposed as an effective way of implementing national arts education at the levels of the school system, the community at large, and tertiary arts institutions. Museums and libraries will provide a core resource for the intellectual capital of the nation, and can further their potential by seeking partnerships with industry and formal education establishments to form a network of centres of learning for life.

Against this backdrop of a response to the changing needs of the cultural development of the nation, SAM has become part of a network of art centres and community centres to provide arts education for schools and the general adult population. It can therefore play an important role in helping to raise the standards of artistic knowledge and produce a critical mass of creative citizens.

The Arts and Knowledge-based Economy

From the mid-1990s, phrases such as "a global city for the arts" and "cultural renaissance" have entered into the official discourse of government leaders in their pronouncement of policies. *Singapore: Global City for the Arts*, a glossy brochure jointly produced by the Tourist Promotion Board and the Ministry of Information and the Arts in 1995, makes a very clear declaration of the government's intention of forging close links between the arts and the economy (TPB 1995, 5).

> In the new millennium, a cultural renaissance of historic importance will accompany the dramatic economic transformation of East Asia. By being of continuing service to the region and the world, Singapore hopes to do for the arts what it has done for banking, finance, manufacturing and commerce, and help create new ideas, opportunities and wealth.

It is not surprising that the government's justification for turning the nation into a regional hub for the arts often carries economic overtones. As a young nation, the Singaporean education system has been developed over the past four decades to fulfil the dual needs of nation-building and of sustaining economic development (Ashton and Sung 1997). The Government's current policy towards the development of arts and culture is consistent with this. The state's view of the culture industry as a new and desirable area for economic growth was evident when Prime Minister Goh Chok Tong – on the occasion of announcing the vision for Singapore to be a "Renaissance City" – stated that "artistic creativity is an important element of a knowledge-based economy" (*The Straits Times*, Sept. 26, 1999).

A more recent state initiative in the arts further testifies the state's pragmatic and rational approach to cultural development. In March 2000, the government announced that SGD50 million would be devoted to the development of art activities in the next five years, which doubled the previous funding to the arts. Armed with a checklist of six strategies, including developing flagship arts companies and an arts economy, the intention is to turn Singapore into "a world-class city with a vibrant cultural scene". The two aims of the "Renaissance city" report were reiterated by the Minister for Information and the Arts: (i) to make Singapore a global city of the arts, and (ii) to strengthen the sense of national identity by nurturing an appreciation of local arts and culture (*The Straits Times*, 10 March 2000).

Arts in Nation-building

The government's interest in the culture business (or arts industry) is seen as a way to promote economic growth and a way to preserve traditional values admired by the government (Tamney 1996, 154-7). The national museums are therefore accorded the role of engendering a sense of nationhood through the understanding of the history and heritage of Singapore. In the case of the Art Museum, the educational programmes have been designed to promote an understanding of the nation's visual arts history as well as nurture an appreciation of the arts of Southeast Asia and the world.

From the perspective of the government leaders, the arts and cultural policy are clearly linked to wealth creation and employment potential. In these terms, creativity

is treated as instrumental in improving technology and industrial development in the country (Spring 1998, 88). From the standpoint of the individual, however, this raises a concern about the economic worth of the arts overshadowing their intrinsic values. Arts education is not just about acquiring skills in preparation for a career in the area. While not all students will become artists, all will be spectators of art and consumers of enormous amount of TV, film and photo images. Hence the society could certainly benefit from increased visual literacy. The visual arts are multi-faceted and are connected to most aspects of our lives, including social issues, aesthetic issues, trends of our time and personal commitment, etc. The arts cannot be easily pinned down to be solely instrumental to the economy. What about art forms like installations that cannot be commodified? Will they be considered of lesser value in the government's sponsorship scheme for the arts?

A fundamental question about policy making at the national level arises from these concerns. Can the educational role of the art museum mediate between the macro-policies of the state (which emphasised national identity, social cohesion and the arts serving the economy) and the purposes of education from the perspectives of the personal development of individuals (i.e. the concern about empowerment, emancipation, equality and self-development)?

On the evidence of the state's funding towards arts education and cultural developments, the overall climate augurs well for the development of educational programmes in the museums. However, the mission of SAM echoes the policy on arts and arts education on a national level, whereas it also has great potential to develop as a site for artistic research and a location for empowering learners to feel valued as individuals, through an understanding and appreciation of the intrinsic values of the arts. Should SAM therefore make provisions for the needs of both national and personal goals?

CURRENT THEORIES AND PRACTICES

Among the many roles that an art museum assumes, education has increasingly become an integral component of museum programmes. The unique qualities of learning in a museum setting where the objects become the centre of the educational experience have been argued for, celebrated, promoted, and researched during the past three decades (e.g. Luca 1973; Berry and Mayer 1989; Hooper-Greenhill 1991, 1999; Karp 1992; Kaplan 1996). Theories and practices in museum and gallery education relating to the learning requirements for school children and the public show that over the years, the educational role of the museum has become more reflexive, self-aware and integrated with the core identity of conservation, scholarship and display, though this varies from institution to institution and from country to country. Generally speaking, within the educational role more audience-driven programmes are developed to cater to perceived visitors' needs. For instance, the broad shifts in learning theory and practice have made a significant impact on museum displays. The museum is increasingly expected to discover and respond to the public's demands rather than simply tell the public what curators think they need to know. A paradigm shift is particularly evident in the move from didactic delivery,

based on the monolithic meta-narratives of modernist knowledge, to a more audience engaging, actively constructivist and diverse approach to knowing (Hooper-Greenhill 1999: xi).

Kelly (1986, cited in MacDonald 1987, 213) argues that in an information society, people draw their status from the experiences they have and the information they control, rather than the wealth objects they possess. Hence, museum visitors attend quality shows for their information, and blockbusters for the experience, which they can share with others. Visitors now want 'experiential' exhibits where the object will not be so separated from the viewer. As such, proliferations of open-air museums and children's museums have been established, in which direct contact with the exhibited objects is encouraged among the visitors. To follow this line of argument, successful educational programmes are the ones that are underpinned by an understanding of the needs of learners of different ages, which utilise different perceptions and ways of representing the world (Hooper-Greenhill 1999, 21). The provision for a diversity of programmes and the needs for regular review and assessment are seen as crucial to ensure that the museum curriculum stays abreast of these global developments in the 21st century. Furthermore, the implications of learning theory and visitor studies will be essential to museum professionals in their planning and management of educational programmes. For example, although the examination of communication theories is beyond the scope of this paper, it is important to consider research findings on various meaning-making processes that groups and individuals use in relation to art objects in a museum context (e.g. Hein 1998; Hooper-Greenhill 1999).

In discussing the educational role of museums, it is pertinent to consider concepts such as Giroux's critical pedagogy which has arisen "from a need to name the contradiction between what schools claim they do and what they actually do" (Giroux 1992, 153). Schools claim to offer equality of education and opportunity to all, but children from different social and cultural backgrounds have manifestly different school experiences. Museums, too, claim to be for everyone, but research studies indicated that museums are not experienced equally by all (e.g. Bourdieu and Darbel 1990; Hooper-Greenhill 1994; Merriman 1997). In the case of an art museum, not every visitor is equally motivated, equipped and enabled to experience art directly (Wright 1997). As SAM also aspires to be accessible to the general public and is part of a national strategy for cultural education, it raises important issues of equity and inclusive education in the Singaporean context, and of the relationship between museum policy and practice, which will be addressed in the last section.

THE PRACTICE OF ART EDUCATION IN SAM:
MECHANISMS AND ENABLING FACTORS

To achieve the educational purposes of SAM, museum professionals have developed both exhibitions and specific educational programmes to highlight the artistic context of Singapore. This two-fold focus is specified as follows (NHB 1998):

Promote awareness and appreciation of 20th century art practices in Singapore and
Southeast Asia through exhibitions, publications and public education programmes
for local and overseas audiences;
Encourage an active and stimulating cultural environment in Singapore through
public educational programmes and exhibitions on a diversity of art trends and
practices.

Although over the years, the role of museum education has moved beyond
providing access to collection or simply creating a teaching and learning
environment for individuals, SAM faces the challenge to maintain a balance
between the role of a 'public art museum' and an 'aesthetic museum'. The former,
the newly formulated educational mission, emphasises the museum's responsibility
as a public institution, answerable to the community, whereas the latter stresses that
the sole purpose of the museum is the presentation of art works as objects of
'aesthetic contemplation' and not as illustrative of historical or archaeological
information (Duncan 1995,16). The following will address the various strategies
adopted by curators and educators at SAM as mechanisms for achieving its
educational mission.

Exhibition Programmes

Since the inauguration of SAM in 1996, sixty-five exhibitions have been presented
to the public (Figure 1). The different categories of exhibitions over a five-year
period are presented in Figure 2. The broad categories, namely 'Singapore',
'Southeast Asia' and 'International' are established to highlight the focus of SAM's
exhibition programme. It is evident that the number of exhibitions revolving around
local arts (38%) and Southeast Asian arts (25%) far exceeds exhibitions with an
international orientation.

The assertion of a sense of local identity through exhibitions is a deliberate move
on the part of the museum. The vision of the Art Museum as a cultural site for
fostering a sense of local and regional identity can also be seen in the curatorial
approaches of the exhibition programmes. For example, in the exhibitions, entitled
"Imaging Selves" (1998-99) and "Landscapes in Southeast Asian Art" (2000-2001),
the curatorial strategies had avoided forging a 'grand narrative' (with art works
shown in a linear and chronological manner). Instead, the curators interpreted the
themes in a variety of ways, illuminating and interpreting the diversity and hybridity
of approaches and techniques employed by Southeast Asian artists. In post-modern
terms, diversity is seen to be valued as artists often work in a range of subjects,
styles and techniques, rendering the dichotomy of labels like 'Asian art' or 'Western
art' invalid. Moreover, the presentation of contemporary Southeast Asian art in the
Singapore context highlights the dissolution of the notion of the stereotyped
"others".

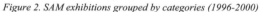

Figure 1. Distribution of exhibitions grouped by categories at SAM (1996-2000)

Figure 2. SAM exhibitions grouped by categories (1996-2000)

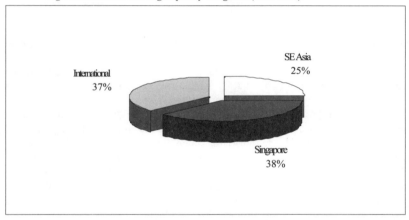

However, the role of art exhibitions in defining national and cultural identity is problematised as the question about whose voice is being represented in the museum could be posed. It foregrounds a larger issue of the power of the state in constructing a 'local heritage' in its visual arts development. The Singaporean tension lies in its attempt to assert a sense of local identity (uniqueness and individuality) and the desire for gaining parity with the West and to be part of the international art scene. The self-congratulatory tone in the local art scene is partly attributed to the immature development of art criticism in the country (Da Cuhna 1998, 117). In the visual arts scene, there is a tendency for SAM to 'honour' selected pioneer local artists as a means to construct a sense of 'cultural identity'. The question of why some local

artists were chosen to present their works in the art museum over the others has yet to be addressed. In other words, "what we see and do not see in art museums – and on what terms and by whose authority we do or do not see it – is closely linked to larger questions about who constitutes the community and who defines its identity" (Duncan 1995, 8-9).

It can be argued that to attain a balance between the voice of the state and the rest of the community, the curatorial power should be mediated through more frequent dialogues with artists and the public about the exhibition programme. If this were done on the basis of 'critical policy' (adapting Giroux's notion of critical pedagogy) there is considerable potential for the museum's role in developing a critical mass for visual arts appreciation, and in empowering the public and schools in defining their cultural experiences. Furthermore, where Giroux (1989, 149) advocates that the school curriculum policies and modes of pedagogy have to "draw upon student experience as both a narrative for agency and a referent for critique", so the strategies in SAM's education provisions might also be developed to critically engage students'/visitors' knowledge and experience. In fact, the museum could develop partnerships with private galleries and non-commercialised art spaces to give a 'voice' to more artists in the community, and to engage larger audiences.

Educational Programmes

The educational programmes offered by SAM include some programmes that cater to schools, ranging from kindergarten to tertiary levels and public programmes for the general audience. Between 1999 to 2000, a total of 120 public and educational programmes were organised by SAM, including symposiums, forums, talks, workshops, film screening, music and dance programmes, as well as a visual arts festival for children (NHB 2001). School programmes are developed to enable teachers to use the art museum as a resource centre for developing their art curriculum. The National Heritage Board stated that more than 150,000 school children visit the museums as part of their national programme annually (NHB, online). Over the years, art museum educators have adopted an interdisciplinary approach by encouraging children to study art exhibits in their cultural context through making links with history, literature, drama and religion. Some of the recent workshops for school children involve art production techniques as well as developing critical and analytical skills through art writing. Furthermore, teacher-training workshops, art camps and art competitions are among the proactive ways of involving schools in the museum educational programmes.

The objective of the public education programmes is to nurture a wider range of audiences by raising their awareness of the artistic heritage of Singapore and Southeast Asia. The notion of 'the general public' as an abstract body, however, impoverishes our view of the characteristics, agendas and desires of museum visitors. As the visitors of museums are not a uniform group, the museum curriculum should address differentiated audiences through research into their needs (Hooper-Greenhill 2000: 29). The aim of museum educational programmes in

helping the public to realise the concept of life-long learning, often implicitly suggested by museum policy makers, remains a key issue for further exploration.

IMPLICATIONS OF ART MUSEUM EDUCATIONAL PRACTICES IN SINGAPORE

Having addressed the context of the formation of SAM's educational policy and placed it in relation to the overall mission of the museum, the following sections will examine the 'reality factors' that enable and inhibit the implementation of the policy. The local perspectives on policy-making will be discussed in relation to the discourses at an international level, namely the notions of nation-building, inclusive education and lifelong learning.

Nation-building: Heritage and Identity

What does it mean when the art museum asserts that it aims at reflecting a cultural identity through its exhibitions and educational programmes? Karp (1992) discusses the relationship between personal identities and community identities, as manifested in forums of public culture, ranging from museums and fairs. He maintains that the multiple identities that people experience in various communities often overlap and even contradict one another. There are four aspects of the process of identity formation as these emerge in museum-community relations (Karp 1992, 20):

 (i) identities are defined by the content and form of public-culture events such as exhibitions and performance;
 (ii) identities are subjectively experienced by people participating in public culture, often in ways conditioned by their other identities and experiences;
 (iii) expressions of identities can contain multiple and contradictory assertions – that is, there can be more than one message in a single expression or performance of identity – and the same is true for the experience of identities;
 (iv) identities are rarely, if ever, pure and uncontaminated by other identities, because they are usually fabricated from a mix of elements.

The above description is pertinent to this discussion and helps to elucidate the notion of 'identity' as constructed through a dynamic interaction of personal, social and cultural factors. It is also significant to highlight that one can neither sustain a 'pure' tradition/heritage nor a 'whole' identity in the contemporary environment. The concrete expressions of a tradition, and traditions more generally, do not develop 'automatically'. For a tradition to continue, it cannot remain the same because human history unfolds with new circumstances and new challenges (Kwok 1994).

In the Singaporean context, the complexity of forging a sense of 'national identity' through an understanding of the local artistic heritage is deepened by elements of 'postmodernism'. The post-modern condition can be attributed partly to the revolution in information technology and mass communications, leading to a

profusion of signs, symbols, images, and fashions in everyday life, which are often transmitted instantaneously by electronic media. The conventional distinctions between 'high' and 'low' culture tend to dissolve with the popularisation of tastes and lifestyles (Connor 1989; Harvey 1989). The pervasive sense of fragmentation and pluralism, which characterise post-modern culture, promotes the 'politics of differences'. Identity is no longer unitary or essential, but fluid and shifting, fed by multiple sources and taking multiple forms (Kumar 1997).

Post-modernity, however, is inconsistent with the Singapore government's attempt to divide culture into distinct categories, such as Western art, Asian art and so on. Furthermore, public policies about cultural identity assume that there are naturally defined ethnic groups, and each person belongs to only one of them (Tamney 1996, 189). The local/official interpretation of 'multiculturalism' is based on a four-culture framework (Chinese, Malay, Indian and Eurasian) and becomes more of an exercise to keep the different communities peacefully apart than to draw them dynamically together. Some local art professionals and academics have proposed an 'open-ended' and global approach to cultural and artistic development rather than a single authoritative approach (e.g. Kwok 1994; Kuo 1998). This is because "a lively culture cannot be created by decree. It must depend upon the participation of individuals, free to express themselves in their search for the meaning of life" (Jeyaretnam 1994, 94). Although the art museum is well placed as a location for the community to engage in a cultural dialogue, a tension still exists as such an aspiration contrasts sharply with the current political, cultural and educational reality of Singapore.

Accessibility: Inclusive Educational Programmes

The notion of promoting a sense of 'inclusive community' through its exhibitions and educational programmes was stated by the director of SAM in many instances. For example, "we place great emphasis on art education targeted at general and specific levels...to serve the varied needs of our museum visitors" (NHB 1999). As mentioned earlier, it is clear that a discussion of equality and inclusive education in the museum immediately raises a fundamental problem: why do some people visit the art museum and others simply 'exclude' themselves from the opportunities provided?

In their now classic study, *The Love of Art*, Bourdieu and Darbel (1990) argue that works of art in art museums transmitted specialised messages, the decoding of which is learned at school or in the family. Hence, aesthetic appreciation is socially determined, with those who possess the competence to experience art, feeling at home in the gallery or museum and knowing how to behave there. For those less well equipped, misunderstanding and confusion are inevitable. As such, the claims by art museums to be accessible to all is but "false generosity, since free entry is also optional entry, reserved for those who, equipped with the ability to appropriate works of art, have the privilege of making use of this freedom, and who thence find themselves legitimated in their privilege, that is, in their ownership of the means of

appropriation of cultural goods ... and the institutional signs of cultural salvation" (Bourdieu and Darbel 1990, 113).

The contribution of Bourdieu and Darbel to the present analysis is that they provide a useful starting point by placing museum visiting in its broader socio-political context. Emphasis is laid on the importance of individual socialisation, principally through family and school, as an explanatory factor. They are chiefly concerned with the theory of social reproduction, in which school and family are among the mechanisms whereby inequalities are reproduced and maintained.

Bourdieu's arguments are important in illuminating the gap between what the museums claim to do and what they actually do. The notion of 'habitus' and 'cultural dispositions' of people who enjoy art help to explain why for certain groups in the society, museums are 'not for us'. Nonetheless, the theory remains insufficient to be fully applied to the Singaporean context. One has to note that Bourdieu's work tends to over-emphasise class distinctions to the exclusion of other explanatory factors. Moreover, his arguments are directed towards the situation as it existed in Europe in the mid-1960s and not all aspects are applicable to the contemporary Asian context. Another weakness of his analysis lies in his concern with oppressive aspects of museums and their role in social reproduction and is not easily able to explain the current popularity of museums. Furthermore, his work only focuses on visitors with no information regarding deterrents to non-visitors (Merriman 1997).

Merriman (ibid) notes that the cultural context of museum visiting can be examined through the study of visitor experience as well as the study of non-visitors. This is certainly one of the research areas for SAM as it could survey the main characteristics of its museum visitors. For instance, a study of the difference in attendance patterns by age, social and educational background of its visitors will benefit curators and educators in the planning of programmes.

Another issue that deserves attention is the usage of SAM by schools. It is crucial for museum educators to develop an understanding of the factors that inhibited teachers and students from using the art museum as a resource for educational purposes. The common constraints Singaporean teachers face in utilising museum resources include the teaching of large classes, timetable constraints, the difficulty of organising school visits and lack of staff resources (Leong 1997). Although the Art Museum has made considerable efforts to develop its educational services for schools, there are still barriers that hinder the success of such programmes.

Learning for Life: Building a Museum-going Culture

Prior to addressing the concept of lifelong learning in the art museum, it is worth noting its triadic nature on a macro level (Chapman and Aspin 1997, 270). Lifelong learning is for:

- economic progress and development;
- democratic understanding and activity;
- personal development and fulfilment.

Lifelong learning has become a global message and can be readily related to the report by UNESCO of an International Commission on Education for the Twenty-first century (Delors 1996). Of particular relevance to this discussion is that the responsibility for 'education throughout life' is placed on the individual. Hence it is not surprising to read the following statement published by SAM in its annual report:

> The museum experience is part of a lifelong learning experience. SAM offers opportunities for individuals to find their level of intellectual and emotional engagement with the works of art and the ideas presented through exhibition (NHB 1998, 30).

In assessing the strategies for realising the vision of 'learning for life', the importance of building a core of repeat visitors to museums becomes a primary focus. It is quite clear that the emphasis is placed on 'individuals' who should make use of the 'opportunities' provided by the museum for their development. The premise that individuals can benefit from continuous learning is based on the notion of equal opportunities. This problem has been addressed earlier as there is still a high possibility that those with 'cultural capital' will benefit more from museum-visiting when compared with those who do not possess the 'cultural dispositions' to make use of services provided by the art museum.

Coffield (1997, 87-88) states that the responsibility for the creation of a learning society should not be placed solely on the individual but is the responsibility of all social partners. Learning is both participatory and individualistic and in the case of art education, neither schools nor museums can do it alone. In the process of developing a collaborative learning environment for the arts, a balance needs to be achieved by moving away from the paternalistic role of government and the intrusive and exploitative approaches adopted by some private interests (Chapman and Aspin 1997, 259). A collaborative partnership involving schools, museums and community centres in furthering the cause of arts education would be a good starting point for promoting 'heritage' awareness among young children and the public.

CONCLUSION

This chapter has examined the practices of art museum educational policy in Singapore through a close analysis of both enabling and inhibiting factors that affect the implementation process. It began by outlining the context of the Art Museum's mission in the current arts infrastructure in Singapore, setting out the recent developments and main issues for debate. The second part deals specifically with current theories as applied to art museum educational practices and discussed the significance of such theories in relation to SAM's approaches and strategies. Finally the third section highlights the 'reality factors' that affect the implementation of policies at the national level. The discourses on nation-building, social inclusion and the provision for lifelong learning opportunities in social, economic and individual terms are presented.

In relation to the challenges that influence the role of museums and galleries in the contemporary society of Singapore, SAM is regarded as a significant

contribution to the cultural development of the nation. The government's authoritarian approach towards the development of the arts, however, remains a major concern. To a large extent, the analysis of the existing art educational practices in Singapore helps to put into perspective the major issues relating to policy-making at both national and international levels. The following implications are drawn from this study and are key messages for the SAM educational policy makers as well as other museum educators at wider level.

A greater degree of artistic freedom and flexibility need to be built in at all levels of the implementation of museum educational policy.

To promote 'inclusive education', the Art Museum has to develop methods to evaluate visitors' experience in both the short and long term.

Museum educators and school teachers could work together in developing a framework for integrating art museum programmes more fully into the school curricula. It is necessary for both parties to consider the needs within the school curriculum while maintaining a flexible and open environment for teaching and learning in a museum context.

A collaborative culture needs to be established among the Art Museum, schools, community centres and non-commercialised art spaces to foster active participation in the arts. It must be emphasised that the ability to appreciate art can be acquired and that 'experiencing art' is not a mystical or solely individual process but can be facilitated through collaborative learning. In this way, the potential exclusion of individuals without the necessary cultural capital may be turned into an inclusive policy and practice.

The multidimensional development of the individual should be a central concern in the development of museum educational programmes. The arts are multifaceted and can give students a far more realistic experience of making judgements in a complex world than other subjects that concentrate more on showing them how to 'arrive at the right answer'. This is of particular importance in the knowledge-based economy as individuals are constantly interpreting and translating 'information' into 'knowledge'.

The Singapore Art Museum as a seat for learning and as a space for cultural dialogue is crucial to the development of the nation. As such, it embodies the tensions which exist in new and long existing nations between the educational and the aesthetic functions of museums. Whereas older nations and their museums may have had opportunity, in a period of grand narratives and modernism, to create an unproblematic vision of national identity, SAM is a particular illustration of how much more difficult this can be in a post-modern world. Furthermore, as a consequence of the post-industrial emphasis on investment in human capital and knowledge industry, SAM is required by government policy to ensure a link between art education and economic development. In this respect, too, it offers an indicative illustration of the tensions which have invaded education more generally,

and which all museums meet as they become more conscious of their educational mission.

Jane Leong is Assistant Professor of the National Institute of Education at Nanyang Technological University in Singapore.

REFERENCES

Ashton, D.N. and Sung, J. "Education, Skill Formation and Economic Development: The Singaporean Approach", in A. H. Halsey, H. Lauder, P. Brown, A. S. Wells (Eds.) *Education, Culture, Economy, Society*. Oxford: Oxford University Press, 1997.

Berry, N. and S. Mayer (Eds.) *Museum Education: History, Theory and Practice*. Reston, Virginia: National Art Education Association, 1989.

Bourdieu, P. and A. Darbel (1990*) The Love of Art: European Museums and their Public*, trans. Caroline Beattie and Nick Merriman, Stanford University Press, 1990; originally published as *L'Armour de l'art: Les Musées d' art européens et leur public*, 1969.

Chapman, J. D. and D. N. Aspin *The School, the Community and Lifelong Learning*. London and Washington: Cassell, 1997.

Coffield, F. "A Tale of Three Little Pigs: Building the Learning Society with Straw", in F. Coffield (Ed.) *A National Strategy for Lifelong Learning*. University of Newcastle upon Tyne: Department of Education, 1997, 77-93.

Connor, J. *Postmodernist Culture: an introduction to theories of the contemporary*. Oxford: Blackwell, 1989.

Da Cunha, D. (Ed.) *Debating Singapore: Reflective Essays*. Singapore: Institute of Southeast Asian Studies, 1998.

Dalin, P. and V. Rust *Towards Schooling for the Twenty-first Century*. London: Cassell, 1996.

Delors, J. *Learning: The Treasure Within*. Report to UNESCO of the International Commission on Education for the Twenty-first Century. Paris: UNESCO, 1996.

Duncan, C. *Civilizing Rituals: Inside Public Art Museums*. London and New York: Routledge, 1995.

Giroux, H. "Schooling as a Form of Cultural Politics: Toward a Pedagogy of and for Difference", in H. Giroux and P. McLaren (Eds.) *Critical Pedagogy, The State, and Cultural Struggle*. New York: State University of NY, 1989.

Giroux, H. *Border Crossings: Cultural Workers and the Politics of Education*. New York and London: Routledge, 1992.

Harvey, D. *The Condition of Postmodernity*. Oxford: Blackwell, 1989.

Hein, G. E. *Learning in the Museum*. New York and London: Routledge, 1998.

Hooper-Greenhill, E. *Museum and Gallery Education*. Leicester: Leicester University Press, 1991.

Hooper-Greenhill, E. (Ed.)*The Educational Role of the Museum*. London and New York: Routledge, 1999.

Hooper-Greenhill, E. "Changing Values in the Art Museum: rethinking communication and learning". *International Journal of Heritage Studies*, 6.1 (2000) 9-31.

Jeyaretnam, P. "What sort of culture should Singapore have?" in D. Da Cunha (Ed.) *Debating Singapore: Reflective Essays*. Singapore: Institute of Southeast Asian Studies, 1994.

Kaplan, F.E.S (Ed.) *Museums and the Making of "Ourselves": The Role of Objects in National Identity*. London and New York: Leicester University Press, 1996.

Karp, I. "On Civil Society and Social Identity", in I. Karp, C. M. Kreamer, and S. D. Lavine (Eds.) *Museums and Communities: The Politics of Public Culture*. Washington: Smithsonian Institution Press, 1992, 19-33.

Kumar, K. "The Post-Modern Condition", in A. H. Halsey, H. Lauder, P. Brown, A.S. Wells (Eds.) *Education, Culture, Economy, Society*. Oxford: Oxford University Press, 1997.

Kuo Pao Kun "Contemplating an Open Culture: Transcending Multiracialism" in A. Mahizhnan and Lee Tsao Yuan (Eds.) *Singapore: Re-Engineering Success*. Singapore: Oxford University Press, 1998.

Kwok Kian-Woon "The Problem of 'Tradition' in Contemporary Singapore", in A. Mahizhnan (Ed.) *Heritage and Contemporary Values*. Singapore: Times Academic Press, 1994.

Leong, J. "Towards a New Partnership: Art Museum-School Relationships in Singapore", paper presented at the Asian Pacific Confederation for Art Education Conference, Melbourne, Australia, 1997.

Luca, M. The Museum as Educator, in: *Museums, Imagination and Education*. Paris: UNESCO, 1973.

MacDonald, G. "The Future of Museums in the Global Village", *Museum*, 39.3 (1987) 209-216.

Merriman, N. "Museum Visiting as a Cultural Phenomenon", in P. Vergo (Ed.) *The New Museology*. London: Reaktion Books, 1997.

Middleton, V. T. C. *New Visions for Museums in the 21st Century*. London: Association of Independent Museums, 1998.

National Heritage Board (NHB) *Annual Report 1996-97*. Singapore: NHB, 1998.

National Heritage Board (NHB) *Annual Report 1997-98*. Singapore: NHB, 1999.

National Heritage Board (NHB) *Annual Report 1998-99*. Singapore: NHB, 2000.

National Heritage Board (NHB) *Annual Report 1999-2000*. Singapore: NHB, 2001.

National Heritage Board (NHB) [online] Available: http://www.nhb.gov.sg/About_NHB/support/support.shtml [2 March 2001]

Singapore Committee on National Arts Education. *The Next Wave of Creative Energy: report of the Committee on National Arts Education*. Singapore: National Institute of Education, 1996.

Spring, J. *Education and the Rise of the Global Economy*. New Jersey: Lawrence Erlbaum Associates, 1998.

Tamney, J.B. *The Struggle Over Singapore's Soul: Western Modernization and Asian Culture*. Berlin and New York: Walter de Gruyter, 1996.

Tourist Promotion Board (TPB) *Singapore: Global City for the Arts*. Singapore: TPB and Ministry of Information and the Arts, 1995.

Wright, P. "The Quality of Visitor's Experiences in Art Museums" in P. Vergo (Ed.) *The New Museology*. London: Reaktion Books, 1997.

MAARIA LINKO

THE LONGING FOR AUTHENTIC EXPERIENCES

The Subjective Meaning of Visual Art for Museum Audience and Amateur
Artists

Abstract. In the light of the sociological discourse on the character of modern culture, artistic experiences
are examined as a manifestation of individualization and as individuals' longing for authentic experiences.
The empirical data from autobiographical writings suggests that amateurs seek powerful experiences as
visitors to an art museum as well as when producing art works themselves. Such experiences usually have
a strong emotional component which includes intensive and nostalgic processing of one's memories and
experiences. Emotional and cognitive elements are thus intertwined. Observations about the importance
of the emotional experience and the yearning for authenticity are mirrored against the sociological claims
that modern individuals are unable to have genuine experiences.

THE DISCOURSE OF AUTHENTICITY

What kind of meanings are given to art when visiting museums or in our everyday
lives? How are self-realization, individualism and the quest for authenticity
intertwined? Have we lost our capacity for authentic experiences completely? These
questions are discussed in this chapter, which is based on analysis of
autobiographies that have been written from the point of view of the meaning of art
during each writer's life.

The findings reported in this study are based on empirical data which consist of
autobiographical writings written from the point of view of individual's experiences
as part of the art audience or their experiences of making art themselves. A writing
competition titled "Tracing art experiences" was organized by the Research Unit for
Contemporary Culture, University of Jyvaskyla together with the Finnish Literature
Society in 1995 to gather the data for the research. Altogether 684 writings were sent
to the organizers and accepted as fulfilling the purpose. Of these writings 113 that
dealt mainly with visual art were used for this study. The length of these writings
varied between less than two pages to 36 pages. Longer stories were usually more
traditional autobiographies dealing with incidents, aspirations and motivations
during the life course. Some stories were descriptions of only one memorable
moment, memories of perceiving artworks or stories of producing them.

In recent sociological thinking the motivations for leisure activities in
contemporary western societies have been interpreted from the point of view of
modern consumerism which is connected to new hedonism (Campbell 1987), new
nomadism (Maffesoli 1994) and experience orientation (E*rlebnisgesellschaft*)
(Schulze 1993). Instead of committing ourselves to one activity we have become

M. Xanthoudaki, L. Tickle, V. Sekules (eds)
Researching Visual Arts Education in Museums and Galleries, 65-76.
©*2003 Kluwer Academic Publishers. Printed in the Netherlands.*

used to demanding constantly new experiences. The role of art museums has become that of an ingredient of pre-packaged experiences, or at least there has been a fear of that development. Specifically there has been a worry that standardisation and pseudo-individualisation typical of popular media products will enter all fields of life (Adorno 1991). George Ritzer (1992) calls this the Macdonaldization of society.

Along with this postmodern development with constantly changing forms of hedonism there is another modern pursuit which has not disappeared. That is the desire for authenticity. Reaching *authentic experiences* and aspiring the sense self-realization has become almost a moral duty for a modern individual (Berman 1971; Giddens 1991). These and many other analysts of contemporary society share the view that modern individuals search for experiences which are subjective, exciting and forceful in nature. The longing for authentic experiences seem to be a shared feeling for men and women and for people in different age groups (Linko 1998). However, what is authentic to one viewer is not necessarily the same to another viewer.

CONCEPTUAL FRAMEWORK

Postemotionalism Or The Authenticity Of Experience

Following the tradition of critical theory of the Frankfurt school, Stjepan Mestrovic (1997) has questioned (post)modern individuals' capacity to encounter authentic feelings and experiences. Mestrovic argues that a *postemotional type,* a personal type which is described by capacity of showing only rationally organized, inauthentic feelings has become more and more common in western industrialized societies. Mestrovic's claims are grounded in the notion that human action is not only based on rational thinking and knowledge but in a combination of emotions and cognition and in postemotionalism, interaction between these two is severely threatened. Mestrovic goes as far as claiming that contemporary Western societies are entering a new phase of development in which synthetic, quasi-emotions become the basis for widespread manipulation of self, other, and the culture-industry as a whole. Mestrovic (1997, p. xi) writes:

> What seem to be postmodern circulating fictions are not really rootless or chaotic, and that postmodernism implies neither human freedom from traditional constraints nor nihilism. Rather, postemotional society introduces a new form of bondage, this time to carefully crafted emotions.

Mestrovic claims that culture industry has manipulated emotions and therefore they have turned into mechanized post-emotions. Taken seriously, we should then be able to show that we have also lost the capability to enjoy *authentic experiences*. For that purpose it is necessary to define what we mean by authenticity. First of all, authentic experience is a subjective sensation which necessarily has an emotional component. Marshall Berman (1971, p. 304) connects it to brief "clear moments" in an individual's life. According to Berman, experiencing authenticity means meeting and knowing our true selves. This is something that individuals crave for but the sense of authenticity is realized only in brief moments. Only in moments when we

deep down can sincerely tell ourselves that we hope that this moment would last forever, can we really know our true selves, Berman argues. In Berman's (1971, p. 304) definition these brief moments of knowing oneself are the only authentic moments a modern individual can reach. Charles Taylor (1991, p. 86-98) sees the idea of authenticity not only as an expression of individualism but even as the main characteristic of modern life. He argues that by expressing verbally and in actions what is original and authentic in us we will find our inner capacities.

In the culture of authenticity individual freedom is based on self-determination and makes individuals' lives meaningful. Simultaneously it brings us responsibilities and obligations to make choices. It has been argued that authenticity includes also a moral dimension which means that a modern individual is responsible for finding one's true self, because:

> To be true to oneself means finding oneself, but since this is an active process of self-construction it has to be informed by overall goals - those of becoming free from dependencies and achieving fulfillment. Fulfillment is in some part a moral phenomenon, because it means fostering a sense that one is 'good' a 'worthy person': 'I know that as I raise my own self-worth, I will feel more integrity, honesty, compassion, energy and love'. (Giddens 1979, p. 91)

Anthony Giddens (1991, p. 79) argues also that, if we ignore our inner experience, we are condemned to repeat it, prisoners of traits which are inauthentic because they emanate from feelings and past situations imposed on us by others.

This chapter focuses on subjective, authentic experiences of art. This means that whenever *art* and meanings given to art are discussed, art is defined as cultural product that the public or the subjects of research talk about as art. In practice in this case art is a category which consists of paintings, statues, graphic art, drawings, collages and ceramics. These products however, are not necessarily accepted as art by insiders of the art world. Here subjects of this research are seen as members of active audience. This means that meanings are formed in constant negotiation or communication with the product and the surrounding culture (See Stacey 1994) but it does not indicate that the audience would have power over the producers of the cultural products (Morley 1996, p. 191; 1997, p. 125)

Art experience is an expression used instead of 'reception' to emphasise the active role of the audience. Art experience may be only mildly emotional and soon forgotten, or purely cognitive observation of an art object. On the other hand, it may be an intense, highly emotional, experience; an experience to remember which could also be called an aesthetic encounter. All contacts with art are not strong aesthetic experiences, but my main focus is on intense and emotional experience of art. This relative side of experience is emphasized. However, it should be noted that emotional art experience is a relative concept in which content is subjective and contextual.

It has been claimed that effects behind emotional experience are more or less physiologically constructed and relatively autonomous of cognition. "The notion of the 'discursive construction' of affect is at best a half-truth and by itself it is radically inadequate to theorize emotion as an individual or a cultural force". He continues: "Cultural-constructionist accounts of affect cannot or will not give serious explanatory consideration to the relatively independent agencies of physiology of

non-mental processes." This is a relevant point and should be kept in mind as a restriction for the scope of research, but within the field of sociology it is possible to study verbal, contextualised expressions, although writing or talking about experience is not similar to immediate, "raw" experience (Denzin 1991, 69; Jensen and Pauly 1997; Ellis and Flaherty 1992, 4).

Self-Actualisation Or Making Distinctions?

When we enter an art exhibit we enter a social scene with a mentality which orients our attention to experiences. As with producing art, being exposed to it also opens up the possibility of entering into a self-actualisation process. Experiencing art by seeing or doing often gives space to self-reflection, reproducing our past, our memories and current values, aspirations and dreams.

However, at the entrance we cannot avoid meeting also the values of the art world, the nonverbal code of behaviour expected from the visitors and our whole knowledge of the legitimate culture, its hierarchical mode of giving value to some art forms and individual artists (Becker 1982; Bourdieu 1980). In Pierre Bourdieu's theory of the reproduction of social classes, knowledge and especially a certain attitude towards art has been an efficient way of gaining cultural capital, distinguishing oneself from those who are less educated, less experienced and therefore less capable of making distinctions. Although the general idea of the importance of making distinctions is still true it should be added that in the 1990's we were merely more and more confused by the constantly changing definitions of "art" and of "high" and "low" culture, and of "good" and "bad taste". We might consciously have put our own immediate experience first and neglected the taste-makers' opinions and code of expression. We as individuals are yet to define the contents of the experience, but it is still questionable whether it is possible to enjoy our subjective reception without letting the "legitimate taste" and the way it is expressed disturb our subjective experience.

LIFE HISTORY RESEARCH

Visitors' subjective, often emotional reactions to paintings in museums and other exhibits are analyzed here. These experiences are compared to amateur artists' descriptions of subjective experiences when they are making art. In which contexts do unforgettable experiences occur? How do the visitors describe these experiences? The question of how and to what extent it is possible to express art experiences verbally, especially strongly felt emotional experiences, was also a matter for inquiry in the study. So, some main expressions and contexts of emotional art reception are extracted and their cultural significance is discussed. Finally, drawing from empirical evidence based on individuals art experiences Mestrovic's claims of postemotionalism are discussed.

Life-Historical Material As Research Data

The advantage of using life-historical material is that it gives room for a more contextualized notion about the circumstances in which one's interest in art might grow, and how it is inhibited and perhaps changed during the course of life. In short: this material makes it possible to see the meanings given to art as part of individuals' everyday life. The problematic side of using this kind of material is to estimate to what extent the meanings expressed in the writings are due to the 'autobiographical pact' (Lejeune 1989), the inherent rules of producing a coherent life-story. The minimum requirement for this symbolic pact between the author and the reader of an autobiography is that the narrator of the life story and the narrated self in the story is the same person. The reader must be convinced that the writer has an honest pursuit for truthfulness.

The data for this research consist of verbal expressions on art experiences even though non-verbal, perhaps partly subconscious emotions and other reactions would be part of one's art experience. However, verbal, contextualized expressions make data accessible for analysis.

In this case, the autobiographies were analyzed by careful reading of the data to produce a set of themes. Thematic analysis constructed from the data was then undertaken for further reading of the primary data. Expressions and paragraphs under each theme were systematically searched. Among those chosen, the most important were: 1) the meaning of art as self-realization and as an expression of individuality; 2) the therapeutic meaning of art and 3) the social environment (pressure, inhibitions, positive feedback etc.) and its meaning to the amateur artist or museum visitor. Expressions under these themes were analyzed within the context in which they came out, sometimes within the context of the entire story. The findings of the study are reported and discussed by using some individual stories as examples of typical ways of giving meanings to art experiences.

Approximately 20 of these 113 stories that comprise the data for my study were subjected to more detailed thematic analysis but my interpetations are based on close reading the whole data. Of the 113 writers only 15 were men. The cases reported in this chapter are therefore more often women than men.

THEMATIC READINGS OF ART EXPERIENCE

Art As Self-Realization

A retired English teacher writes in her autobiography entitled *Tracing art experiences* of her perhaps most memorable contact with a painting. She saw the painting in London at the Tate Gallery (now Tate Britain):

> I visited London in the 1970's. When I saw Marc Chagall's painting *The poet reclining* at Tate Gallery I returned to look at it time after time. In that painting there is a pig and a horse in a large courtyard, and behind them are buildings and dark green trees. Warm, purple sky. The poet having rest in the lower part of the painting. This picture is made for me, and now I can understand better than before why it is so. I have sometimes had a dream in which I am hanging it as my only painting on the wall of a spacious white room, where light is reflected from the

opposite window. There is the warmth of the hearth, a table, a chair and a bed. I am
at home.

Before relating this episode the writer had told about her childhood on a farm
and about her nostalgic emotions about the farm. The emotional impact inspired by
the painting is not possible to understand without this autobiographical context. The
interpretation of her taste as socially contructed is less complicated. The social
variables included in the description are in homology with each other: an English
teacher visiting London and choosing modern art for contemplation. An English
teacher possesses an academic status. For a holiday trip teachers tend to prefer
places that offer cultural value and even enforce their professional skills. Also,
according to Bourdieu (1969), only the highly educated people enjoy modern art.
However, the forceful emotional reaction is not evident without studying the "lived
experience" of this writer. This strong emotional experience is an authentic one and
at the same time, it is that of self-realization in the sense that Taylor defines it.

The opening of each story often sets the tone or crystallizes what is essential
about the childhood environment and its relation to art experiences or cultural
activities in general. Often the first sentence made clear if the parents had demanded
a fulfilment of the puritan work ethic or there had been encouragement to try artistic
hobbies and interests. Whether the childhood years were in the 1920's, as is the case
with the oldest writers, or in the 1970's, the basic questions they consider remain the
same: how art entered in the writer's life and how family members reacted to it.

Early memories of successes, of getting positive feedback, appear vital for
experiencing art in later periods of life. For instance a graphic artist now in his
sixties remembers having been extremely shy as a young schoolboy and that caused
him a lot of suffering. However, both the teacher and other pupils noticed his special
talent in drawing. During recess the pupils gathered around his desk to see him
draw. That experience encouraged him to draw and paint also at his home farm even
if only hard work at the farm was appreciated and he had to hide from his angry
elder brother. Incidents of this sort are often remembered as *turning points* and they
have been used as material for self-construction. These memories may become
cherished symbols for finding something that is extremely important for them and
positive feedback can be something to remember for the rest of one's life.

Art As Self Therapy And Construction Of Identity

Producing art had therapeutic meaning to the subjects. Also seeing an artwork
sometimes had a similar meaning. At times of dissonance, conflict or sorrow losing
oneself in the art making process was often described in expressions such as of
achieving peace of mind, in a situation filled with anxiety or insecurity.

The most common type of story was that of many female writers, who had
shown artistic interest and talent in childhood but did not end up being a
professional artist, perhaps never even pursuing a career in arts. Instead, in
adulthood, they had used all their energy to fill family and work responsibilities. At
some point when they had passed the most intense phase of caring or alternatively
were faced with a crisis, they had started either to paint, draw, take photographs or

do various arts and crafts. Typical turning points were those such as the empty nest, sudden unemployment, mental or physical health problems or divorce. Men did not report similar therapeutic meanings as a basis for art experience, there were only 15 male writers. However, all of those who evaluated the meaning art in their lives emphasised its capacity to make life more meaningful.

Womens' persistence as non-professional artists and as museum visitors can be interpreted as an expression of an atmosphere in contemporary culture where modern society demands a personally constructed identity from its citizens. In this culture of individualism women especially are often faced with situations in which their personal identity is threatened as is often the case with women whose energy is used in fulfilling other family members needs. For instance, Camilla, a middle aged writer admits that she has experienced the demands of being a good mother and a wife in irreconcilable conflict with her inner desire to create, to be an artist. In a poem she has written she crystallizes this problem:

> Do I love you
> when images
> are bristling before my eyes
> words and tones
> in my ears -
> and I am peeling
> potatoes.

In a culture which emphasizes individualism, therapy - seeking seems to be a common motivation, as Christopher Lasch (1978, p. 7-13) pointed out in his book *The Culture of Narcissism*. Robert Bellah et al. (1986, p.124) also interpreted the importance of all kinds of therapies as a characteristic of individualism in modern culture. Therapy, seeking can also be seen as a symptom of people's inner need for experiencing something *real* at least momentarily, to feel their existence as individuals. In a culture in which frames for proper experience are more and more given by professionals in each possible field of action, spontaneous experience has become more and more difficult to achieve.

In the experience of the authors' self-therapy described in the present study, art was often successful. One of the biographers, a woman in her thirties who was an amateur photographer, felt she had lost the spontaneous, authentic experiences she had enjoyed while practising her leisure activity. She could not enjoy similar satisfaction with her child. Instead she felt trapped with demanding expectations of motherhood. Having spent a difficult time she started to take pictures at night while she was awake with the child anyway. After "a crisis" she realized that the child had threatened her individual identity and that was why she could not enjoy motherhood. She learned to accept her need for self-realization as an individual - taking photographs acted as the key symbol and realization of her identity - and since then she was also capable of enjoying motherhood. She realized that she had been depressed and selfish. In this process an art photograph proved useful. A key moment was when she saw a picture of an infant in a photographic journal. In that picture the baby appeared to the writer as an adventurous individual, an "individual in the universe open to all possible opportunities, ready to explore new things". This

was a brief moment which made her see her own baby as an interesting individual. This meaning for the picture could not be given before the woman had gone through the mental process described above. This was one of the many stories in which art was used as a means for construction of identity or even as a 'means of survival' in some really difficult situations. However, my data showed clearly that emotions and strength derived from art making or perception are not only a way of enforcing one's capacity of social action. More than that it is a question of a subject's inner process of empowerment, self perception and personal experiences. Finding "one's true self", processing one's problems and achieving new skills are individual and internal processes that usually cannot be shared with anyone else.

The social impact in these self-reflections is, however, often unavoidable. Women writers especially often take other people's and particularly their spouses' views seriously. In several stories women felt that their spouses have objected, belittled or shown jealousy over their art-making, whereas men barely mention their wives in their writings. On the other hand, there were a couple of stories in which the husband had encouraged his wife's art-making. To put it briefly: a wife is never a problem in men's self-realization through art, but a husband can be a problem to a female artist. My interpretation is that some spouses seem to feel that when their wives make art they disappear into a world that cannot be shared. In addition to this the division of household work may cause conflicts because making art demands time and energy.

Many writers use an expression that they experience a *necessity to make art*. This was an deeply experienced inner feeling and not authored by agents from the outside. The necessity of making art was reasoned by the fear of 'losing one's true self in the dullness of everyday life'. This and other expressions they use mediate a serious attitude to the chosen activity, even if it was non-professional in most cases. This seems to be the reason why the non-professional artist is often vulnerable to critique from the outside. She (or he) has devoted much of her energy to this self-realization and if its meaning is questioned she feels that not only her art but her whole identity, often painfully constructed, is questioned. This was the experience of many amateur artists and art lovers.

The Impact Of Art In Museums

The autobiographical writings showed clearly that the visitors to a museum or other exhibitions search for emotional experiences. In the light of the autobiographical data those whose interest in art found its expression only in *art perception* in museums are in a way in a less vulnerable situation than those who are committed to producing it themselves because a disappointing contact with an art work may be forgotten and visiting a museum rarely causes trouble in a family. On the other hand a "successful" contact with an art object may produce a strong experience, which can be described as a momentary feeling of authenticity. This may leave a valuable memory. This was true for a 35 year old secretary Sara, who went to an exhibition of national realist Pekka Halonen's paintings. As with many others, Sara begins her story by describing her childhood. She grew up on a small farm and there were no

paintings in her childhood home. Later in her youth some pictures clipped from chocolate boxes were hung on their walls. The writer remembers however, that her father had an eye for esthetics and urged the children to pay attention to the beauty of nature.

Sara describes in detail how a year before writing the story she wanted to visit an exhibition of Pekka Halonen's paintings in a museum in Northern Finland. She had trouble getting company because no one she knew was interested in art. In fact, finally when she got a ride, her friends preferred staying in the car instead of paying for a museum visit. The bottom line in Sara's story is the ambivalence she experiences between a sincere interest in Halonen's art and the authenticity of her reception and the feeling that art and museums are meant for experienced museum visitors, 'insiders' who master a proper behaviour and conventional responses to art works. At first she is painfully aware of her lack of cultural capital:

> I was walking with a shriveled leaflet from one object to another. It was silent, only vague whispers here and there. Shoes make a noise when moving from one painting to another. Guards in every hall. They are silent, they must be professionals or pretending to be ones. I decide to make an expression on my face: screw up your eyes, take an inward oriented look, no staring at anybody. Become lost in your thoughts, give an impression that your recent visit to Italy makes you compare something that you saw there to paintings in this museum. Glimpse at the leaflet quickly just to check the name of the painting which you in fact knew beforehand. Do not notice other museum visitors, they simply do not exist. There is only you and your experience, in these halls and in this way of breathing. [...]

But what happened when an individual painting absorbed the inexperienced visitor into its world? The public space momentarily became intimate and the visitor experienced a private and deeply emotional art experience. It was caused by Halonen's painting *The Grove of the Dead*.

> I forgot all this when I came to 'The Grove of the Dead'. I forgot the noises from the shoes of other visitors, I forgot the expression on my face. I forgot about the proper way of breathing and screwing up my eyes. Neither did I remember to hold the leaflet right. As when death comes, there is no one to inform you about it beforehand, and in this case too, I wasn't informed, that's why I forgot. Are they all dead? Or only the children? Why is the mother also in the grove of the dead? Who are they? Who knows about this? My throat was tight and I couldn't control my breathing. The Grove of the Dead was the sadness of dark colours but more beautiful than joy in its colourfulness. True, the verdure of life is missing even though trees curve over a pond as in a grove in summertime. The colourless verdure of the grove of eternity (--) Have they drowned? asked my inner child. I saw the eyes of the mother and the tightness of my throat moved into my nose, as when crying. (--) I recognised the look of something that resembles lived life without the look of showing presence. Why are they looking away, who are they waiting for? Who is dead? Mother's skirt. Is similar fabric still sold somewhere? Did they come here at the same time - silent sadness moves from the woman's eyes to me. I forgot the unwritten rules. Breathing superficially, mouth open, I was fluttering my eyes trying to prevent tears. Had I misbehaved. You are not supposed to show emotions. The guard is staring at me - is that woman going to damage or steal. I am overwhelmed by the demand of civilized behaviour. [...]

Sara's experience cannot be shared with anybody and other museum visitors only make her worry about the appropriateness of her behaviour. It is only when the

intensity of experience makes her temporarily forget the environment, that she can give way to a thought that perhaps somebody else might experience the same way as she does. The experience is emotional and she cannot prevent herself from crying. Still it is a cathartic experience and leaves a vivid memory.

The writer herself gives the interpreter tools for contextualization. In a country with a long tradition of active cultural politics aiming at the democratization of culture Sara grew up in an environment where a contact with art was rare. A certain interest had arisen in her and she went to see paintings by one of the very few painters she happened to know and which she believed would prove meaningful to her. Despite anxiety caused by a museum context that she wasn't familiar with she in fact was open-minded for this kind of experience. Her whole story gives the impression that she felt that the insiders' attitude towards art was inauthentic. As opposed to this, her intense and subjective experience when confronting an art work is a moment when she momentarily experiences her authentic self. In Berman's (1971, p. 301) interpretation any authentic experience can only last for a limited time because the outside world which is experienced as inauthentic cannot be distanced for a long period of time.

As in Sara's case important experiences of art were usually linked to individual art objects (instead of the whole exhibition), usually paintings that affected the perceiver emotionally. These paintings were often figurative and most typically they represented well known "legitimate high art" from the end of the nineteenth century or beginning of the twentieth century (such as paintings by van Gogh or Monet; or Finnish national realism such as Akseli Gallen-Kallela, and Pekka Halonen; or by a more modern but still figurative painter Hélène Schjerfbeck). Purely abstract paintings were never mentioned as sources of memorable experiences. When people told about their memorable experiences they never described them by using specialist terms and expressions conventional in newspapers' art critique such as style, technique, composition or other dimensions. The tone of description was emotional and utterly subjective.

The expressions that amateur artists and recipients used resembled one another, sometimes they were almost identical. Intense moments when people were 'lost in art' were similar to 'flow' experience as described by Mihaly Csikszentmihalyi (1993, p.178-179). Flow is a sense of intense concentration, realization and pleasure. It gives a feeling of life that usually seems to be somewhere else, not being here at this particular moment. The feeling of flow is also a combination of extreme concentration and voluntary suspension of self-control, though simultaneously one knows that control could be regained if needed. In fact, flow experience is a type of experiencing authenticity. Both are temporary feelings of harmony and wholeness of the self.

CRAFTED VS. AUTHENTIC EMOTIONS

The theoretical framework for this study was based on the discussion of the nature of authentic experience in individuals' lives. Let me add a citation from Mestrovic

(1997) which does not include much optimism about whether or when authenticity is valued:

> The missing ingredient in most sociological theorizing is the role of the emotions. I argue that contemporary Western societies are entering a new phase of development in which synthetic, quasi-emotions become the basis for widespread manipulation by self, other, and the culture industry as a whole. (--) I argue that what seem to be postmodern circulating fictions are not really rootless or chaotic, and that postmodernism implies neither human freedom from traditional constraints nor nihilism. Rather, postemotional society introduces a new form of bondage, this time to carefully crafted emotions.

Mestrovic's main argument, to put it briefly, is that postemotional (or post outward oriented) individuals are only capable of showing rationally organized feelings. The contemporary postemotional type has lost the connection between emotion and action. Emotion has been mechanized in the way that postemotional types can 'feel' a vast range of quasi-emotions from indignation to compassion, yet are unable to put these feelings into appropriate action.

Is this the case with individual relationships with art? If mirrored against the data analyzed above, the crucial point is that is it only possible to experience pre-packaged quasi-experiences, such as we would experience in Louvre when we see *Mona Lisa* and notify that "we have done it". Nowadays, we are offered more and more experience packages with more and more detailed components. My argument is though, that experencies cannot be predicted from the marketed products. Instead, people have a strong need to go through their memories from different periods of life and their felt emotions, their lived experience. Art, both making and perceiving it, is one suitable medium for this rearranging of our own memories. Amateur artists and art lovers expect to get emotional experiences through art. In these experiences emotion and cognition are intertwined.

From the package it is not possible to predict its meaning. Buying a T-shirt at a museum does not necessarily mean that the the visitor would not be interested in making personal contact with some works of art. The authenticity of experience is a subjective matter, and what is authentic to one viewer is perhaps not authentic to another viewer. For instance, an authentic image could be a printed picture of an angel bought at a stationery shop or Chagall's painting at the Tate Gallery. My interpretation is that people tend to be more and more interested in works of art that they judge as authentic and meaningful to themselves and give less value to potential cultural capital they carry. In this sense the power of "good taste" seems to be diminishing.

In conclusion, the autobiographical and interview data analyzed showed clearly that there are plenty of people who are willing to make commitments in their relationship to art. The longing for new experiences does not always mean that people rush from one emotionally effective pre-organized event to another although pre-packaged experience tourism has become more and more popular. In my interpretation the subjective authenticity and the commitment people showed are empirical findings which do not support Mestrovic's (1997) claim of people's incapacity for authentic experiences and true emotions. Many forms of cultural

products have changed but not perhaps the basic questions people want to deal with when they search for experiences through art and other cultural products.

Maaria Linko, Dr.Soc.Sci., is a sociologist and a lecturer at the Open University at University of Helsinki, Finland.

REFERENCES

Adorno, Theodor. The Culture industry: selected essays on mass culture. London: Routledge, 1991.

Becker, Howard S. Art worlds. Berkeley: University of California Press, 1982.

Bellah, Robert, Richard Madsen, William Sullivan, Ann Swidler, and Steven Tipton,. Habits of the heart. Individualism and commitment in American life. New York, NY: Harper and Row, 1986.

Berman, Marshall. The Politics of authenticity. Radical individualism and the emergence of modern society. London: George Allen and Unwin, 1971.

Bourdieu, Pierre. "The Aristocracy of culture". Media, Culture and Society 3.2 (1980): 225-254.

Bourdieu, Pierre and Darbel, Alain. L'amour de l'art. Les musées européens et leur public. Paris: Editions de Minuit, 1969.

Campbell, Colin. The Romantic ethic and the spirit of modern consumerism. Oxford: Blackwell, 1987.

Csikszentmihalyi, Mihaly. The evolving self: a psychology for the third millennium. New York: Harper Collins, 1993.

Denzin, Norman K. 'Representing lived experiences in ethnographic texts'. Studies in Symbolic Interaction 12 (1991): 59-70, 1991.

Ellis, Carolyn and Flaherty, Michael G.. 'An agenda for the interpretation of lived experience'. In: Carolyn Ellis and Michael G. Flaherty (eds.) Investigating subjectivity. Research on lived experience, p. 1-16. Thousand Oaks, CA and London: Sage, 1992.

Eskola, Katarina. Elämysten jäljillä. Introduction. Helsinki: Suomalaisen Kirjallisuuden Seura, 1998. (Tracing art experiences. Introduction. Finnish Literature Society).

Giddens, Anthony. Modernity and self-identity. Cambridge, Mass. Polity Press, 1991.

Jensen, Joli and Pauly. "Imagining the audience: losses and gains in cultural studies". In Marjorie Ferguson and Peter Golding (eds.), Cultural studies in question, s. 155-169. London: Sage, 1997.

Lasch, Christopher. The Culture of narcissism. New York: W.W. Norton and Company, 1978.

Lejeune, Philippe. On Autobiography. Theory and history of literature 52. Minneapolis: University of Minnesota Press, 1989.

Linko, Maaria. Outo ja aito taide (Strange art or real art. The reception of art among technical school students and high school students). University of Jyväskylä, Finland: Research unit for contemporary culture, publication nro 30, 1992. In Finnish with English summary.

Linko, Maaria. Aitojen elämysten kaipuu (The Longing for authentic experiences). University of Jyväskylä, Finland: Research Unit for Contemporary Culture, publication no. 57, 1998. In Finnish with English summary. Dissertation.

Maffesoli, Michel. The Time of the tribes: The decline of idividualism in mass society. Theory, culture and society. London: Sage, 1994 [1988].

Mestrovic, Stjepan. Postemotional society. London: Sage, 1997.

Morley, David. "Populism, revisionism and the "new" audience research". In: Curran, James, David Morley and Valerie Walkerdine (eds.) Cultural studies and communications 279-293. London: Arnold, 1996.

Morley, David. 'Theoretical orthodoxies'. In: Curran, James and al. (Eds.) Cultural studies in question. London: Sage, 1997.

Noro, Arto. Gerhard Schulzen elämysyhteiskunta. In: Keijo Rahkonen (ed.), Sosiologisen teorian uusimmat virtaukset. Helsinki: Gaudeamus 1995, p. 120-140. (The Experience society by Gerhard Schulze).

Polly, Greg. "'Since feeling is first': The problem of affect in cultural studies". Paper presented at the Crossroads in Cultural Studies Conference, Tampere July 1996.

Ritzer, George. The MacDonaldization of society. London: Sage, 1992.

Schulze, Gerhard. Die Erlebnisgesellschaft. Kultursoziologie der Gegenwart. Frankfurt: Campus, 1993.

Taylor, Charles. The Ethics of authenticity. Toronto: The Canadian Broadcasting company, 1991.

HELEN O'DONOGHUE

COME TO THE EDGE

Artists, Art and Learning at The Irish Museum of Modern Art (IMMA)
A Philosophy of Access and Engagement

Abstract. This chapter focuses on two interactive projects involving artists and adults from the local community in research projects which have informed general access and education programmes at the Irish Museum of Modern Art. The first project, entitled *Unspoken Truths*, concentrates on an experimental process which introduced working class inner city Dublin women to contemporary art and artists in the context of the Museum and engaged with the community development sector in Ireland. It represented a defining moment in the development of the Museum. It also had a big impact on how marginalised working class communities reconsidered their relationships to museums, suggesting a model for access and informed thinking in this context both within the museum and in the wider world. The participants in the second project, all local older people were strongly empowered on seeing that exhibition and having it mediated by the women who created it. They began to consider seriously for the first time the validity of their own lives as source for their art work. Older people's contact and involvement with contemporary art and artists is keenly felt to be essential to the exploration of new forms of expression and personal creativity. It contributes to the ongoing process of dealing with change in society.

INTRODUCTION

The Irish Museum of Modern Art (IMMA) is housed in the Royal Hospital Kilmainham, in a magnificent 17th century building, which lies west of the city centre of Dublin, legislative and cultural capital of Ireland. The Royal Hospital was restored by the Government in 1984 and opened as the IMMA 1991. Through its permanent collection and temporary programmes, the museum presents International and Irish art of the modern period with associated access programmes. This was the first time that Ireland had a national institution to collect and exhibit contemporary art. Since opening to the public the museum has exhibited and represented a broad range of Irish and international art through its exhibitions, off site projects, National Programme and Artists Work Programme. The latter is a studio-based Museum initiative, where artists can live and work for periods of time in studios on site.

Built into the new Museum's policy was an inclusive policy which aimed to create access to the visual arts as well as engagement both in meaning and practice for all sectors of society. The post of curator for Education and Community programmes was the first curatorial post created. From early 1991 the Education & Community department set in train a series of project models which would reflect the policy of the Museum and act as models of good practice. These are realised through realistic and practical projects that relate to people and have meaning for

M. Xanthoudaki, L. Tickle, V. Sekules (eds)
Researching Visual Arts Education in Museums and Galleries, 77-89.
©2003 *Kluwer Academic Publishers. Printed in the Netherlands.*

them. The Education and Community department works closely with both the Exhibitions and Collection departments to create access programmes.

The temporary exhibition programme has represented a broad diversity of artists working in a broad range of art forms. The Permanent Collection has grown as a result of a major founding donation from the businessman and Senator Gordan Lambert. It has developed annually with a government provided acquisitions budget, further donations from artists and collectors and long term loans of collections such as the British collections created by the Weltkunst and the Musgrave Kinley Outsider Trusts. The latter is significant as this collection was offered to IMMA as the trust identified IMMA and its policies of inclusion as an appropriate home. The exhibition programme represents both large-scale historical retrospectives and work made by contemporary artists, these are drawn both from the Collection and created by a temporary exhibitions programme. All education or community exhibitions are treated in the same manner as any other exhibition. An example of this was the winter period of 1997/98 when the community based project 'Once is Too Much', was exhibited alongside a retrospective of Andy Warhol's, work from a five year period of the New York based artist Kiki Smith and a display from IMMA's collection. On average the Education and Community department is responsible for two Museum shows annually.

MAKING CONNECTIONS

> No institution seriously concerned with providing access to the emancipating power of culture could live with the definition of artist as producer and non- artist as consumer which has governed museum practice since the early 19th century. We are all participants in a cultural process. This is a basic principle for the work of IMMA as a whole and for the Education and Community department in particular. IMMA is not based on the 19th century model of value which emphasises exclusivity and separation where meaning and value are mysteriously locked into a privileged art object only to be accessed by the initiated and then disseminated to the public. IMMA operates on the principal that meaning and value reside in the individual, that the artwork is a catalyst that can unlock that meaning and that people are capable of dealing with even the most challenging aspects of contemporary practice. Declan McGonagle 1996 (Director IMMA 1990-2001)

When the Irish Museum of Modern Art opened in 1991 it was in a social climate of great change. Ireland in the 1980's, as in previous decades, still suffered from mass emigration and unemployment, inner city and suburban housing schemes developed by the local authorities were the victims of bad planning in the 1960's and 70's and crime and drug abuse was destroying the social fabric of many areas. Throughout the country locally based support groups worked to raise awareness of local needs and mobilised communities to take collective action. Community development programmes grew in cities and in rural areas to address these conditions and to articulate the needs of local communities. This movement has been recognised by government and funding is currently provided on an annual basis throughout Ireland. From the late 1970's the arts were part of this developing awareness and community arts practice developed throughout the country but often its profile suffered in the

wider arts field due to lack of adequate funding or long term commitment from support agencies.

> Community work is about analysis of social and economic situations and collective action to bring about change. It is about justice, participation and the right of people, particularly the most marginalised to make collective decisions regarding their lives. (Crickley 1993)

Early in 1991, the museum's Curator for Education and Community programmes created links with the local community and introduced a range of groups to IMMA.

From the outset the Family Resource Centre in St. Michael's Estate in Inchicore, one of the parishes adjacent to the IMMA, expressed an interest in working closely with the Museum to explore ways of introducing local people to its programmes. The underlying principle that both organisations shared is that the development of this new audience would not be as passive recipients but as active voices in the unfolding policy of the Museum.

"Unspoken Truths" was an artist-initiated project, which engaged thirty-two women in an exploration of the meaning that Dublin as a city, which is rapidly changing, had in their lives. It involved two community development projects, one from the North Inner City and one from the South Inner City. The project developed into a deeply moving archival record of the thirty-two women's lives as individuals growing up in Ireland and explored themes that were both personal and collective. The process engaged a number of artists, poets and writers who were co-ordinated one artist Ailbhe Murphy, to create opportunities for the women to reflect upon and to analyse the patterns in their own lives. The project used the principles of art education and applied them in a community development context and the result was manifested in a series of major events; a touring exhibition of 14 artworks; a major national conference, a video documentary and a publication.

> The experience of creating Unspoken Truths sharpened our analysis in relation to mainstream culture and arts. The Museum became a challenge in the positive sense, because it challenged our organisation to ask questions and develop its thinking around the arts and who gets to participate and who gets to benefit from such institutions. (Fagan 1991)

The project created a natural cross city link between the Family Resource Centre in Inchicore on the south side and the Lourdes Youth and Community Services Centre in Sean McDermott Street on the north side. What was new and unique to the process of making links at community level, was the inclusion of a new national cultural institution and an artist.

THE ARTIST

The role of the artist is crucial in all contexts and in the "Unspoken Truths" project, the artist Ailbhe Murphy, was interested in engaging, seemingly, two disparities (a community of women and an arts institution) as equal partners and to create a forum which could broaden the vision of each party and contribute to a larger vision of 'community'.

> It became clear to me at a meeting held in the Irish Museum of Modern Art, soon
> after it opened, that not only was there a strong commitment to develop policies of
> access and engagement in relation to the wider community, but that there was an
> opportunity for artists and community groups to shape and inform those policies.
> My practice to date had raised so many questions about the definitions used in
> Ireland for artists who choose to work collaboratively. (Murphy 1991)

Ailbhe Murphy's desire to develop her work to engage with not just the ideas
inherent in a place but with those living in that place has created a model which was
very new in Ireland. Her confidence in her role as an artist and her motivation to
work collaboratively broadened her agenda to include a new museum as part of the
process, questioning its then as yet untested policy of access and engagement with
its public.

The first phase of the project commenced in August 1991 and continued to May
1992 when the decision to create an exhibition was made. The aims and objectives
of the project were:

- To reach a broader understanding of art, through a constructive exploration of
 the nature of contemporary art practice and to raise the question: who, or what,
 normally qualifies to be included in the process?
- To develop a model of practice which would address a wide audience within the
 fields of Community Development and Arts practice.
- To explore the potential that can be realised through collaboration between Arts
 Institutions and Community groups.

During the first phase the group worked on a weekly basis both in their own
community centres and in the IMMA meeting a cross section of writers, visual
artists and poets, they visited exhibitions and embarked upon making work. At the
core of this work was the building up of an atmosphere of trust and support, so that
the women would feel safe to reveal and share their life stories. This support was
provided by the community development projects. An evaluation was carried out at
this stage and the following key points were identified:

- Each of the women felt that they wanted to make public the empowering
 experience that they had had as a group.
- It was felt by all involved that a public manifestation of the process would
 establish a case for more provision of access programmes to the arts for
 community groups.

As a result, two major decisions were made: to stage an exhibition at the Irish
Museum of Modern Art to bring the experience of the project to a wider audience
and to produce a publication about the project which would represent it in the
absence of the work and its makers.

FROM THE PRIVATE TO THE PUBLIC

The exhibition was opened at a very important juncture in Irish life, by the recently
elected and first ever woman president of the country, Mary Robinson, on the eve of
a national election that resulted in a change of government. (Subsequently, an
initiative of this newly formed government was the creation of a new government
ministry for Arts, Culture and the Gaeltacht under the direction of the poet and

human rights activist, Michael D. Higgins.) On the occasion of this public opening the women each stayed with their work on exhibition and mediated it for the President, family, friends and general visitors. The shift from the private space to the public arena was a daunting and frightening prospect for many. Each of the women was supported to consider how best to represent her story in the public domain and to consider the most appropriate way of describing her part of the process. One woman chose to place her name in the space as the only way to represent her involvement in the process.

The experience of mediating their own work was hugely significant for the women on that night. A meeting was called after the event and a decision was made to form a roster for the duration of the exhibition to extend the mediation to general visitors and groups for the next three months. This was the first time in Ireland, that a national cultural institution hosted a project of this nature and the first time that the participants of such a programme mediated their own work in the galleries. This was an important feature of the exhibition whenever it travelled over the next four years.

This process of engaging the wider public in this direct manner revealed the strength of the exhibition and its ability to communicate to a wide cross section of the public. It also demonstrated the value of the stories behind the work and proved that the fourteen artworks could be catalysts for a range of discussions and sharing of experience. Above all, the project and the work made for it raised many social and political issues.

The women, the artist and the Education and Community Curator took part in a series of evaluative processes throughout the project period and these steered the project's development and contributed to the development of material for a video documentary and the final publication. Some of the women used the video document as part of a presentation at two International conferences on global poverty, in Copenhagen and in Brussels in 1995. The evaluation also formed the basis for a major conference in January 1993 which acted as an opportunity to disseminate the evaluation findings and to debate and promote a new model of art in /from the community.

The findings of an evaluation carried out by the arts consultant Martin Drury, revealed the following as key to the success to the project:

> It is clear that in the workshops with the other artists and in the more regular rhythm of the project work led by Ailbhe Murphy, some very good principles of good art education were adhered to. While other sections of this evaluation are concerned with personal and community development values and practices, it is appropriate here to record that the project exemplified and enacted the truth that art education has a distinctive contribution to make to personal development in intellectual and social terms....

> What the 'Unspoken Truths' project is principally about is the discovery by the women of their artistic selves complementary to their other selves, their working selves, their domestic selves, their family selves, their private selves. The seriousness with which the women took the project is an antidote to the notion that community arts practice is recreational or in the usual pejorative fashion that this term is used, therapeutic....

> Perhaps in 'Unspoken Truths' time has been the critical resource. There has been time crucially for the unlearning before the learning could begin. The unlearning of muteness and reticence as regards the kinds of intimacy you could have with a group and the kind of ways of working, kinds of materials that could be employed. Above all though, the time seemed to allow for some reclamation of the lost or abandoned artistic self and its grafting onto the mother self, the daughter self, the private self, the wife self, the working self, and the domestic self.... (Drury 1993)

The experience of working on this project defined the ground rules associated with the engagement of communities that traditionally are not included in cultural processes. The main learning was that:

1. Collaboration with community development organisations has to be on an equal footing, advancing the aims and objectives of both the Museum and the Community Development organisations.
2. It is very important to have a clear structure for a project and to build in a realistic timeframe. Flexible time to work on a developmental process is essential.
3. Realistic budgeting measures have to be carefully considered at the planning stages of a project.

MUSEUMS AND COMMUNITIES

Unspoken Truths was an unusual collaboration for its time, and one that charted new territories. It required a long-term commitment from IMMA, which had to pace itself to keep time with the communities' schedules and rhythms. IMMA was fluid in its approach to programming sections of its exhibitions and curatorially explored a variety of ways of working. For example, this fluidity allowed for the women's desires, which were originally voiced in May 1992 to have a public outlet in an exhibition in November of that year.

Unspoken Truths has contributed significantly to the development of IMMA's policy and practice. The public conference raised many important issues for museums and those in community work which were articulated by many and in particular in a presentation by the community activist and lecturer at the National University of Ireland, Maynooth, Anastatia Crickley, who raised the question of how the access and inclusion policies would translate into practice and how equality of participation and outcomes would be assured: 'Merely opening doors does not mean equality of access and can do little for equality of participation and outcomes.' She continued by illustrating the challenges that the project posed for community work,

> It demonstrated very clearly a different way of getting people involved and a different way for people to learn about themselves and others. It also poses an ongoing challenge in linking community art and community work in ways that do not reduce community work to personal development in a group, but acknowledge personal development as important for collective efforts. In effect 'Unspoken Truths' is a blow against what Paulo Friere calls the "Culture of Silence" a step in promoting his "Cultural Action for Freedom (Friere, 1977)

Four main themes were highlighted by Crickley's analysis of Unspoken Truths, they are:

1. Museums and Communities

...there are many complexities in the relationship between museums and communities. It is arguable that for many communities, alienation and exclusion make such a relationship extremely difficult to develop in the first place. While for others museums offer enrichment, fulfillment and opportunities to reinforce their views of their own role, status and position. Duncan Cameron writing in 1971 distinguishes between two different perspectives on the museum, as temple or as forum.

2. Messages from Unspoken Truths for Art, Community Art and Community work.

One of the clear messages that Unspoken Truths speaks for me is that the process and product is about excellence and the struggle for excellence. Excellence requires more than just a passing nod.

3. Questions and Challenges involved in linking Community Arts and Community Work

Unspoken Truths, has demonstrated that individual personal development and expression can be linked through community arts and to community action and development.

4. Policy Control and development in Community Work/Community Art Relations.

Women from St Michael's Estate and the north inner city have demonstrated to us the possibilities for excellence in art when appropriate resources and support are made available.

To summarise, the work that emerged expressed both deeply personal individual stories and collective histories. This work was multi-faceted including paintings, sculptures, and installations. It was a collaborative project that spanned the period 1991 to 1996. It inspired many more community groups to approach IMMA and request access. It contributed to an ongoing model of working with community groups for the Irish Museum of Modern Art. Many of the original participants have developed and maintained links to ongoing programmes and subsequent projects such as, 'Once is Too Much'. The model has influenced the Older People's programme and informed ongoing professional development programmes such as those for teachers and youth workers and has suggested a framework for a bi-annual community access programme 'Focus On....'

THE MUSEUM AS A FORUM FOR INTERACTION AND DEMOCRATIC LEARNING

Two concepts which have been very important to my life and education, and which the Irish Museum of Modern Art espouses as founding principles, are collaborative work and lifelong learning. Alongside its work with schools, the Museum has led the way in Ireland in working with local community groups, retirement associations, women's and men's groups. Artists have come out of creative isolation and learned new forms of collective activity as teachers, art workers and community artists. The Irish Museum of Modern Art was practising lifelong learning years before politicians and commentators discovered it. Five years ago a group of older people from Inchicore, who had come to the Museum 'to learn to draw', produced one of the most moving exhibitions I have ever seen in an art gallery, the magical 'Ribbons of Life' show. (Pollak 1999)

Since before the Museum opened in May 1991, a close working relationship was developing with the St. Michael's Parish Active Retirement Association, a group of older residents in the nearby area of Inchicore, geographically close to, but not included in St. Michael's Estate programmes. The group was involved in developing a significant exhibition as part of the Museum's inaugural programme 'Inheritance and Transformation'. This exhibition was a document of the group's involvement with the visual arts. Each member of the group was photographed and interviewed about their personal history of art education and their motives for becoming interested in painting on retirement.

Their exhibition acted as a catalyst in developing a partnership between IMMAand the agency Age and Opportunity (a government funded national agency that promotes positive attitudes to ageing), and through this partnership national policy work and international programmes have grown. At local level the programme commenced on a weekly basis throughout 1991 when they were preparing to participate in the inaugural exhibition.

During the first ten years curator Ann Davoren, of the Education and Community department developed a multi-faced programme integrating all aspects of the Museum's activities at the Museum. Workshops included practical sessions with artists in order to develop a deeper understanding about personal impulses to make and to express through visual means.

The objectives of the programme were:
- To ensure that the Museum caters for as wide an audience as possible and to encourage involvement in the Museum by identifying and responding to people's needs.
- To work with a small number of older people in order to inform the wider policy of engagement with the community in general and with older people in particular.
- To break down existing barriers to the involvement of older people in contemporary visual arts, by involving them in as many ways as possible including the influencing of museum policy.

This programme was structured to involve three elements of art education: making art, meeting artists and discussing with them the conceptual basis of their work (this involves contact with visiting international artists exhibiting at the museum, artists on the Museum's studio programme and longer term contact programmes with both Irish and International artists living and working in Dublin) and looking at art in the museum's temporary exhibitions and Permanent Collection. Ongoing engagement with the museum acknowledges the role that older people have to play in contemporary visual culture.

> The Museum introduced us to new interests at our time of life - the Golden Age,
> really . If we look at it properly and have a positive outlook, age is a number only
> and all in the mind (Phyllis McGuirk, member of the group)

Initially the weekly programme introduced basic art making skills, using a broad range of art processes and also introduced the older people to a cross section of younger artists. After experiencing the Unspoken Truths exhibition and meeting the women involved in it, the work of the older people changed significantly. The first

autobiographical works emerged a year later in 1993, in 'Ribbons of Life', each ribbon depicting the story of its maker's life. This was developed into a longer-term process over the following three years exploring the meaning of place and of how it changes over time; 'A Sense of Place' became a series of oil paintings on canvas. Since 1991, the work has been exhibited annually at IMMA and in other venues as part of a national arts festival, Bealtaine, developed to highlight the involvement of older people in contemporary arts. Members of the group act as hosts for their peers and for younger visitors to these exhibitions.

The older peoples programme was almost eight years old when the Museum was invited to take part in a transnational EU Socrates funded project on Museums, Keyworkers and Lifelong Learning in association with the Victoria and Albert Museum, London; Swedish Museum of Architecture, Stockholm; Buro fur Kulturvermittlung, Vienna; Museu Municipal de Vila Franca de Xira, Portugal; and the School of Educational Studies, University of Surrey, England.

This presented the framework through which to reflect upon and to evaluate the programme's development to date with the key participants. A partnership was formed with the Adult and Community Education Centre of the National University of Ireland, Maynooth and two researchers worked over a six month period exploring the older people's experience of the programme. The outcome was a major piece of research that articulated the role of the programme in the lives of the specific older people and informed the curriculum and the Museum's approach to adult education. In 1999, as part of the research, the group were involved in creating two exhibitions entitled: '... and start to wear purple' and 'Come to the edge'.

The first exhibition was a survey of artworks and processes that the group had engaged in since 1991 and the latter was a show curated from the Museum's Collection. For three months they worked with two artists in a series of practical workshops exploring artworks from the Collection. They made work in response to selected artworks, focusing on materials and techniques, the content and themes or the responses that the work evoked for them. Then they worked with the Senior Curator for the Collection, Catherine Marshall and Curator Ann Davoren to develop an understanding of the curatorial process. Both curators worked closely to facilitate learning in this period. Through a series of weekly meetings, discussions, tours of the exhibitions on view, slide shows of works in storage, the members of the group explored ideas relating to collections and collecting policies, acquisitions and donations, exhibitions and exhibition making. They then researched, selected and took part in the installation of the exhibition as well as researching and writing wall texts and catalogue. They were already very familiar with many of the works in the Collection, as they had encountered the works or the artists over the previous eight years of their programme. The older people facilitated tours of the exhibition, mediating the work to 22 groups over a three-month period. The exhibition title was taken from the following poem.

> Appolinaire said,
> Come to the edge,
> it is too high,

Come to the edge,
We might fall
come to the edge
and they came and they flew

EVALUATION AS A KEY COMPONENT OF ALL OF THE PROJECTS AND PROGRAMMES

The involvement of external evaluators brings another perspective linking local experiences to the global. Participants become involved in analysing their experience and in both cases outlined took more control of the programme content and direction. The evaluation process created a three-way dialogue between the museum staff, the evaluators and the participants and thus enabled the participants to have a significant and informed input into the ongoing planning process.

In their study and analysis of the responses of the older people to the programme, the researchers (Fleming and Gallagher 2000) explored the concept of 'keyworker' which was the common research being carried out in the transnational project. They found that

>this group has performed the function of keyworker in an imaginative and exciting way. Their strengths are that they have been through an extensive programme; that they have been expertly supported by the staff at IMMA; that they relate well and meaning fully with visitors to IMMA and art groups around the country. They have learned a phenomenal amount about art, themselves and the process of making art.

The term 'hosts' rather than keyworker was felt to be a more appropriate term to describe the work that the group does in the context of IMMA.

Both projects have been evaluated and now provide frameworks that are specific to each of the processes while sharing common principles of practice. Although both projects started as initiatives to address access for marginalised groups in the museum's locality, the process of evaluating how adults engaged in the programme has uncovered and documented methodologies which should relate to any programme created for adults in the context of a museum. The evaluation work has provided material for a deep study of the Museum's role in developing an art education model that has impacted on the community development sector in Ireland and encompasses principles of adult education and life long learning. In 2000, Fleming and Gallagher had noted that,

> Issues which are at the core of adult education are seen here in practice in IMMA. Adult education is about forging connections and seeing more than two polarities; it is about moving away from dualistic thinking to more connected and holistic modes of learning and action. The programme is a powerful introduction to new ways of thinking, perceiving, acting and interacting. It has important implications for arts in the community (Fleming and Gallagher 2000)

The models that are explored in this context challenge the boundaries between curator and educator and between artist and participant and between museums and the broader society. They challenge the context of museum education and call for an integrated approach within museums in the creation and delivery of access programmes. Integration of internal operations such as education, collections,

exhibitions and acquisitions is essential to ensure that we are not 'merely opening doors' as Anastatia Crickley stated.

Enabling access to long term programmes which are participant centred and commit to engaging with participants as significant actors in the development of the museum's policy and practice has been essential in developing the museum's access beyond 'merely opening doors'. Extending the museum's policy on exhibitions to incorporate artwork and work practices developed through these programmes has also been crucial to this process. The timescale given to these projects have facilitated real learning, respecting the time it may take 'for unlearning and re learning' (Drury 1993) especially in the case of many older adults whose prior learning has not prepared them for the new concepts or practices of contemporary art. The acquisitions policy at IMMA, which was reviewed in 1994 and now states that work created through the education and community programmes in the museum will be considered for acquisition, also facilitated the acquisition of an art work in 1998 from one of the artist-community collaborations.

IMMA'S WORK IN THE CONTEXT OF MUSEUM EDUCATION IN IRELAND

Since 1991, adults, teachers, museum educators, children and artists have come together at the Irish Museum of Modern art to explore artworks, artistic and aesthetic expression, creative thinking and making. The resulting dialogue and exchanges are central to the museum's programmes. These programmes seek to create an atmosphere of genuine exploration, encouraging freedom to respond, interpret, experience, react, perceive and express, therefore coming to a greater knowledge of oneself and the world. Questions are key to opening up any important dialogue and the questions that inform the programme are: why make art? and what is art?

The Museum programme operates on the understanding that the participant is at the centre of the dialogue. The programmes are designed to be open and explorative, to create space for each child or adult's vision and to use the visual arts as a conduit to explore a view of the world. The process used is one that respects each of the individuals involved, the child, the adult learner, the teacher, the artist, and the museum professional.

Social inclusion in museums must address shared agendas and exploit their potential to influence wider society, (Sandell, 2000) but in involving people in these agendas the process has to be empowering for the individuals. At IMMA, working in partnership with community development organisations and sharing responsibility for the promotion of social inclusion has been effective in drawing the attention of government, in generating social analysis of, and political support for, the issues explored; and for identifying the role of the museum as a social partner. Over the past decade ministers of Government have openly supported the programme at IMMA and on occasion have used the museum as a venue for launching government policies, an example of this was in 1998 when IMMA staged an exhibition created by a community group to raise the issue of violence against women (*Once is Too Much*). The first minister for Arts, Culture and the Gaeltacht in Ireland, Michael

D.Higgins launched the *Unspoken Truths* conference that arose from the project. During his ministry he developed the agenda of social inclusion. He also stimulated access to the arts for communities throughout Ireland developing and financing access programmes to involve the long term unemployed and granting seed funding to local authorities to build arts centres in small towns throughout Ireland. At the launch of the Unspoken Truths conference he said,

> I think this question of having one's story told, the right to tell one's story, is the single greatest cultural question in the world. All repressive regimes, all excluding regimes, all people who are intolerant hang together by this attitude of trying to have an official version of things and suppressing the right for other stories and other lives to surface. And it is one of the marks of humanity and the only way to peace and the only way to co-existence in a fragile planet ecologically and in human terms, if we can develop the capacity to be able to allow other cultures find their space and within cultures, people's experience and stories. (Higgins 1993)

The projects explored in this, the first decade of this Museum's life take into account a number of pedagogical approaches and reveal that people are open-minded to the often challenging manifestations of contemporary visual art practice. In the intersection between the experiences of adults described in this chapter and an emerging museum education programme, adults and artists have come together to actively engage in exploring and researching ways of creating effective and inclusive models of practice.

The Education and Community programme has developed a number of strategies that aim to address the context of both museum culture and broader issues relating to arts provision in Ireland. Cultural policy developed in the 1980's was led by thinkers and policy makers such as Ciaran Benson and Martin Drury who wrote seminal documents for the Irish Arts Council advocating wider access to culture for all Irish citizens. Over the past ten years IMMA has grown, developed and existed during two changes of government. The current government which came into power in 1995, though acclaimed by some for developing a stronger economy has not developed the social and cultural policies of the previous one. One initiative though, that the current minister for Arts, Gaeltacht and the Islands is responsible for is the development of a Council of National Cultural Institutions bringing together the ten National Cultural Institutions. One important outcome of this is a research project which aims to audit the existing access provision in all of these institutions. This will form the basis of a developed policy paper to be prepared by the Education, Outreach and Community personnel of these institutions. This group wishes to address the lack of clear policy and co - ordination of resources in relation to Museum education. Currently no guidelines exist from the Department of Education and Science, although in their recently revised curriculum for the primary sector, teachers are recommended to integrate museum and gallery visits into the curriculum. The Arts Council is drawing up a five-year arts plan but they have no dedicated post for arts education on their core staff and little or no co-ordination of provision between government departments exists.

> The Education and Community programme at IMMA aims to create access to the visual arts by developing new audiences, which are both engaged and informed, through a broad range of programmes and projects and to develop good practice in

the field of arts education through action research projects. (Education Statement, Irish Museum of Modern Art)

At IMMA new models of practice have been devised which aim to be socially inclusive, creating opportunities for artists and groups to meet and engage in the context of the Museum's exhibition and studio programmes. Art and contemporary art in particular, can cross the boundaries of social class and education, to build an audience that appreciates and is empowered by its vision and significance. Models of work such as those outlined here, demonstrate the need to build a framework of provision that builds on exemplary practice and encourages the type of experimentation of IMMA's first decade.

Helen O'Donoghue is Senior Curator and Head of Education and Community Programmes at the Irish Museum of Modern Art (IMMA), Dublin, Eire.

REFERENCES

Pollak, Andy., *A Space to Grow,* 10. 1999

Benson, C. *Art and the Ordinary, the report of the Arts Community Education Committee*, Dublin: The Arts Council of Ireland. 1989,

Benson, C. *The Place of the Arts in Irish Education*. Dublin: The Arts Council of Ireland 1979.

Cameron, D. 'The Museum: A Temple of the Forum' *Journal of World History* 14, No 1. 1972.

Davoren, A. and O'Donoghue, H. *A Space to Grow: New approaches to working with children, primary school teachers and contemporary art in the context of a museum*. Dublin: IMMA 1999.

Drury, Martin. Extract from presentation to the Unspoken Truths Conference, *Unspoken Truths: A Cultural Analysis*, IMMA, Dublin: 1993.

Fleming T, and Gallagher, A., *even her nudes were lovely: toward connected self-reliance at the Irish Museum of Modern Art*, Dublin: IMMA. 2000.

Friere, Paulo, *Cultural Action for Freedom*, Hammondsworth: Penguin. 1977.

Higgins, Michael D. (Minister for Arts, Culture and the Gaeltacht, 1992-1997), Extract from presentation to the Unspoken Truths conference, IMMA January 1993

Hutchinson, J., *Inheritance and Transformation*. Dublin: IMMA 1991.

Murphy, A., Fagan, R. O'Donoghue, H. and Downey, M. *Unspoken Truths* Dublin: IMMA 1996

Mc Gonagle, D., O'Donoghue, H. Davern, A. and Lewis R. *Intersections* (the first review of the Education and Community Programme at IMMA) Dublin: IMMA 1996.

O'Donoghue, H. *'Ö and start to wear purple'* Dublin: IMMA 1999.

Once Is Too Much,. A project and exhibition exploring the issue of violence against women, made by women from the Family Resource Centre, St Michael's Estate, Inchicore, in collaboration with artists Rhona Henderson, Joe Lee, Ailbhe Murphy and Rochelle Rubenstein. 1997.

Stannett, A., and Stoger. G. *Museums, Keyworkers and Lifelong Learningî: shared practice in five countries* Vienna: Buro Fur Kulturvermittlung. 2001

Sandell, R. Means to and end: museums, galleries and social inclusion. *Artsbusiness* Issue 44 14 February. 2000

Section B

MUSEUMS AND FORMAL EDUCATION

SILVIA MASCHERONI

DISCOVERING BRERA

Using Experimental Evaluation for the Study of the Relationship Between
Museum Learning and School Teaching

Abstract: This chapter reports on a long-term educational initiative organised by the Brera Art Gallery
and the Superintendency of Historical and Artistic Heritage of Milan. The project addressed primary
school teachers and their pupils aiming to offer them opportunities for building long-term relationships
with the gallery and its collections as well as connections between museum learning and classroom
teaching. During the implementation of the project, an experimental evaluation study was carried out in
order to monitor and evaluate project parameters such as the set objectives and their realisation, the
relationship between teachers and the gallery, pupils' learning, and the organisation of the project. The
chapter discusses the evaluation process and its results and presents recommendations for the
improvement of practice.

INTRODUCTION

The *Discovering Brera* project, a long-term educational initiative, organised by the
Brera Art Gallery and the Soprintendenza ai Beni Artistici e Storici of Milan, began
in 1994 and continues to the present day (*Alla Scoperta*, 1998). The project has been
devised for pupils of the primary school aiming to encourage learning, and long-
term relationships with the Gallery and its collections as well as connections
between museum learning and classroom teaching. During the implementation of the
project, an experimental evaluation study was carried out as an integral part of the
project in order to monitor and evaluate educational processes and outcomes of the
project.

The chapter concentrates on the one hand, on the innovative aspects of the
project, and on the other, on the evaluation study. Emphasis on processes and results
of the evaluation contributes to the understanding of decisive parameters relating to
teaching and learning processes, and of the conditions for the development of such
demanding initiatives. Furthermore, the data of the study are used as a basis for the
development of a series of recommendations, applicable to schools and institutions
more generally, and intended to contribute to the improvement of practice within
collaborative museum-school educational projects.

BRERA AND MUSEUM EDUCATION IN ITALY

Brera is a State museum which hosts a rich collection of art works originally placed
in convents and religious sites that were de-consecrated during the Napoleonic era.
Those art works are mainly paintings with religious themes. Brera hosts not only

93

M. Xanthoudaki, L. Tickle, V. Sekules (eds)
Researching Visual Arts Education in Museums and Galleries, 93-104.
©*2003 Kluwer Academic Publishers. Printed in the Netherlands.*

works of artists of the region of Lombardia, but also of other Italian art schools, documenting the history of Italian art from the fourteenth to the twentieth centuries. The Gallery itself is part of an architectural complex that includes the National Braidesian Library, the Academy of Fine Arts, the Botanical Garden and the Astronomical Observatory.

The educational services of Brera are guided visits for the numerous school groups, adult visitors and tourists. The *Discovering Brera* project has been an innovative initiative devised and carried out by a Gallery that wanted to develop a well-studied and structured educational programme in order to cultivate a long-term relationship with schools.

The starting point for the development of this project has been the collaboration between the Ministry of Cultural Heritage and Activities and the Ministry of Public Education on the issue of the educational role of museums and galleries. The products of this collaboration were, at first, the Commission for Museum Education in 1996, and, secondly, in 1998, an agreement for the development of educational policy in the Italian State museums[2]. The agreement set the scene for museum education requiring provision of educational programmes with specific teaching and learning objectives, production of supporting resources and evaluation of outcomes.

MUSEUMS AND THE ITALIAN PRIMARY SCHOOL CURRICULUM

The primary school curriculum currently in effect has been established in 1985 (Presidential Decree 104, 12 February 1985). The curriculum guidelines encourage the development of opportunities for using cultural and environmental resources, beginning from observing those surrounding the pupil and moving on to the understanding of their historical and social significance and to the awareness of the importance of their conservation and preservation.

Museums are part of the cultural resources to be experienced by pupils, but their use aims also to develop expressive and communicating skills and to the understanding of symbolic languages, such as those conveyed in art works. The use of museums and cultural heritage sites in general is recommended in the context of a range of disciplines, such as visual art education, history and geography.

CONTENT AND CHARACTERISTICS OF THE PROJECT

Project Development

The design and implementation of the project was carried out by members of the Gallery staff, that is, two people from the Soprintendenza and four art historians, all of them experienced in museum education[3]. One very important aspect during both the design and the implementation of the project has been working in partnership (Buffet 1995). On the one hand, partnership among the members of the project group meant that each and every participant contributed their own background, culture and professionalism in a reciprocal relationship of exchange and comparison.

On the other, working in partnership with schools implied continuity in work at school and the Gallery, in the knowledge to be transmitted and in pupils' learning.

The role of the museum and the importance of using its resources played a decisive part in the development of the project. This means that the project was the ground for considering the museum not only as an educational tool investing in human and material resources for realising *Discovering Brera*, but also for reflecting upon its own culture when attempting to translate knowledge into teaching. Questions arose about learning processes and necessary qualifications, appropriate strategies, and effective activities, stimulating reflection on the implications of adopted approaches and decisions. As Quartapelle points out in her study of school-oriented projects:

> The project must be viewed as a complete system in which all the members participating in the … training process relate together and in which interchange also occurs: inside, among the roles and functions of the various actors, and outside, with non-scholastic structures and experiences. In this system, estimated feasibility studies and executive processes are consistently combined in order to reach shared goals and to create an agreed-upon product. The need to effectively wed these two project characteristics - complexity and precisely planned, specifically-intended results and products - requires the exercise of constant attentive control and the use of various procedures and numerous, different monitoring and evaluation tools (Quartapelle, 1999).

During the planning phase of the project, the work group studied the primary school curriculum in order to identify and consider cross-curricular elements linking school teaching and gallery visiting as well as relevant educational objectives and strategies to be promoted throughout the project activities and resources. The project intended to promote not only cognitive learning – development of pupils' skills and competencies – but also encourage the development of their cultural awareness regarding the protection of cultural heritage and the development of notions of citizenship and social responsibility.

Content of the Project

Discovering Brera began in 1994 as a pilot experiment addressing primary school pupils and since then has evolved to a full project continuing to the present day. During the school year 2000-01, eighty-two classes of pupils from the second to the fifth grade have participated in the activities.

The project consists of a series of gallery and classroom activities of progressive character supported by specifically designed resource packs. Those activities take place during four subsequent years, beginning from the second and through to the fifth grade of primary school. Such an approach aims to offer opportunities to build long-term relationships; to work with continuity on the basis of several gallery experiences; use a wide range of methods and tools; and consolidate acquired knowledge and skills. Furthermore, a progressive agenda of activities encourages the development of a sense of belonging and the notion of citizenship in pupils.

The content of the project activities and resources was designed according to the needs of different learning levels of the pupils. Activities and resource materials

have also been developed in line with the aims and objectives of the primary school curriculum, on the basis of an inter-disciplinary approach but with particular emphasis on teaching about cultural heritage.

Teachers have been playing an active role in every phase of the project: from the preparatory phase preceding the visit to the gallery to follow-up work at school, to the evaluation of the project outcomes. The project includes also an initial in-service training phase for teachers participating in it. This consists of ten sessions aiming to develop understanding of the content and objectives of the project as well as of its teaching and learning methodologies. The project activities and use of resources for each grade are explained in detail, while the teachers have also the opportunity to discuss with the gallery art historians issues relating to the collection, to art techniques and restoration of works. Training of teachers takes into account not only the circumstances of school teaching (taxing daily teaching, accommodation of course outside the school hours) but also the requirements of individual teaching plans, and explores possibilities for integrating the gallery experience with classroom processes.

The project is built on the inter-relation between preliminary work before the visit, work in the gallery and follow-up in the classroom. For the preparatory phase, aiming to prepare students for their first encounter with the Gallery, the teacher devises a teaching programme that focuses on the development of the necessary skills and knowledge using different strategies and tools in a multi-disciplinary context. Development of skills and learning tools is considered very important in helping pupils orientate themselves at Brera and elaborate on the work carried out. Pupils learn to identify contrasts and analogies and transfer what they have learned at school to new and different situations.

For the gallery visits, the project consists of five programmes, five thematic gallery 'itineraries', each devised with progressive complexity for acquiring knowledge and competencies and taking into account the teaching aims of the primary school curriculum. The thematic itineraries are:

1. *Discovering Brera: Spaces and Objects* which is addressed to all primary school grades and structured in such a way as to facilitate the first encounter with the museum. It aims to familiarise pupils with the collection and the range of functions in a museum, such as conservation and restoration of art works. This itinerary lays the ground for following visits, encouraging learning through hypothesis, discovery and emotional experiences. Among the activities carried out in the gallery are: orientation in the space using a pupil-devised gallery plan (on which pupils have worked at school before visiting); awareness of the rules applying in a museum; and learning to recognise the components of an art work. Since they are not allowed to touch the originals, the pupils get to know about such details through looking at and touching reproductions (such as a frame, a piece of canvas, etc.) made on purpose by the gallery conservators for the project.

2. *Art Describes: Natural elements in the paintings of the Brera Art Gallery* is designed for the second grade aiming to help pupils to learn 'to read' works of art. It explores representations of well-known scenes of nature in specific paintings and relates them to the pupils' own experience. In preparation for the visit, the pupils look at and discuss examples of naturalistic environments around them (such as the

school garden) and collect, observe and design from objects in such sites. In the gallery, they identify similar elements in the paintings (such as flowers and fruit) and talk about them. They also visit the Botanical Garden where they engage in sowing activities. After the visit, they work on the theme of the garden using different techniques and materials.

3. *Art Represents: Feelings and behaviours in the works of the Brera Art Gallery*. This programme for the third grade concentrates on the use of spontaneity and body language as observational and interpretive tools. During preparatory work, pupils work on face and body expressions and in the Gallery they explore emotions as those are represented in the works.

4. *Art Recounts: Episodes of biblical stories in paintings of the Brera Art Gallery* is a programme for the fourth grade focusing on the narrative component of the pictorial representation and on the relationship between the literary source and painting. At school before the visit, the pupils work on the elements of narrative using only images or both image and text. During the visit, they identify narratives in the paintings which they then illustrate in a 'three-dimensional book'. As follow-up work, the pupils make their own book on the basis of their experience in the gallery.

5. *The work of art recounted or Three investigations into art works of the Brera Art Gallery* is the itinerary for the fifth grade. The most meaningful episodes of the story of a painting become the object of investigation. In preparation for the visit, the pupils work on objects they bring from home, discussing their origins, function and history. In the gallery they learn about the story of some art works, from the moment of their conception to the moment they were placed at Brera. On this basis, at school after the visit, they work towards the organisation of their own exhibition.

For the realisation of the activities the teacher receives the appropriate support pack for each grade. This includes: a) suggestions for preparatory activities and attainment targets for skills and preliminary knowledge to be acquired before the visit; b) working sheets for the activities to be carried out in the gallery; and c) suggestions for follow-up work.

At the end of the gallery visit, pupils and teachers jointly carry out a series of monitoring activities which help both understanding the progress of pupils' learning and the enrichment and elaboration of their gallery experience.

Methodology and Innovative Aspects

The activities of the itineraries are built on observation of selected paintings, cognitive learning via play and active participation, and on activity sheets and workshop activities which are carried out with the help of the gallery educators.

Play is among the most important learning strategies functioning as mediator of cognitive experience and stimulating active involvement. For example, play is used in the itinerary for the third grade, in which the pupils are asked to mime different states of mind getting to understand the difference between the spontaneous nature of feeling and the use of communication conventions.

Alongside *knowing* is also *doing*. The gallery experience is the basis for discovery and creative work in the classroom. Follow-up work elaborates on certain elements discovered during the visit and contributes to the understanding of art and the development of a methodology for 'reading' works of art as objects, images, documents and historical evidence. Special note should be taken of the programme for the fifth grade pupils, who follow-up the gallery experience working on notions of identity, memory and social responsibility through the development of an exhibition of objects taken from family life. Pupils learn the diverse aspects of an exhibition (from creating the exhibition space to publishing the catalogue and advertising the initiative) and their work engages the whole school, families and the neighbourhood community.

Working sheets are another important teaching/learning method in the project. Two types are used: activity sheets during the visit to the gallery which contribute to the development of observation and memory skills; and evaluation sheets during follow-up work in the classroom as a learning monitoring method.

THE IMPORTANCE OF MONITORING AND EVALUATION

A crucial part of the project has been documenting, monitoring and evaluation. The products created along the span of activities at school and in the gallery provided precious documentation for reflecting upon the project's educational outcomes, learning processes and teaching strategies. The complexity of the collaborative work demanded the development of documentation and evaluation strategies from a very early stage, to be used for the scrutiny of processes and results.

Evaluation is integral part of both planning and realisation processes rather than only the final step of a project or the controlling of results. It is the detailed reflection on the unique methods of educational action (the choice of methods, the activities proposed and the tools and materials used) and can serve as guideline for continuous dialogue among members of the project team and as a method for improving the quality of service. On this issue, Margiotta argues:

> The evaluation must be thoroughly prepared in advance at the moment of detailing the goals of an educational intervention. The evaluation coincides with the very first phases of planning the intervention. The problem of evaluation is not only a problem of producing data or information, but also of their fruition and circulation. Evaluation is not the collecting of data, or many pieces of data, nor an analytical treatment of the variables in play, but is the producing of meaningful information which helps those within the system to correct the project in a timely manner, to retroact on choices, to adopt competent strategies and to turn mistakes into resources (Margiotta 1989).

However, no special evaluation tools have been developed for educational projects in the field of cultural heritage. Learning in the museum is of a different nature from learning at school, therefore procedures and tools for monitoring and evaluating should take this difference into account. Heritage-oriented projects tend to adopt evaluation methods from within the domain of schooling as Jacobi and Coppey (1995) recognise:

It is known that when evaluation of the impact of museums on different kinds of visitors has been attempted, that has been based on models of pedagogic evaluation which have been called to the rescue and applied to informal instruction (Jacobi and Coppey 1995).

In addition, the majority of research carried out in the field of cultural heritage has been mainly focusing on evaluating exhibitions providing indications for analysing types of audiences, waiting times and visitor satisfaction (Shetel and Bitgood 1994; Maresca Compagna 1999), whereas relatively few studies have been devoted to the evaluation of educational projects carried out in collaboration between schools and museums. Therefore, a careful translation of such tools is needed for evaluating heritage and museum education, beginning from defining heritage education as such:

> *Heritage education* means a teaching approach based on cultural heritage, incorporating active educational methods, cross-curricular approaches, a partnership between the fields of education and culture and employing the widest variety of modes of communication and expression (Council of Europe 1998).

One of the first and very important steps towards establishing an agenda for research and debate on issues of evaluation was taken in 1997, during the meeting of the International Council of Museums, Committee for Education and Cultural Action (CECA). The Committee studied issues of evaluation in the field and argued for further research and action (Dufresne-Tassé 1998). Later on, Hooper-Greenhill would stress such issues as well:

> Museum visitors, formerly thought of as an undifferentiated mass, as the *general public*, is now analysed using market research methods. *User* or *audience* replaces the concept of *visitor*. What does current visitor research tell us about what people want from a visit to a museum or gallery? There is now a body of research that can be relied upon as valid (Hooper Greenhill 2000).

EXPERIMENTING WITH AN EVALUATION MODEL

The Ministerial Commission for Museum Education was actively involved in the identification of the phases of the Brera project as well as the aspects to be monitored and evaluated. Its involvement implied also the necessity for providing meaningful indicators that could be used for evaluating other projects in the field of cultural heritage. As a result, it was decided that an external evaluator would work for one year alongside the project group aiming to identify procedures and create useful tools for designing an evaluation system. This long-term systematic evaluation strategy was to complement the monitoring methods already used as part of the itineraries (meetings with teachers and team meetings). Such a choice offered a valuable opportunity for all members of the project to reflect on and develop their professional skills and was a useful resource for further project planning.

Among the first steps of the evaluation process was the identification of the potential areas to be studied:

- organisation of the project: composition of the work team, feasibility conditions (resources, funding, professional competencies, space and timing), criteria for the choice of strategies, tools, resources, etc.;
- management of the project: structural limitations, problems and solutions adopted, roles of the participants;
- collaboration: between the gallery and the schools, between the gallery and the Soprintendenza, the school administration and the teachers;
- training of teachers for the project: methodology for teacher training, content and structure of the course, relationships between the gallery staff and the teachers, innovative aspects;
- pupil learning: coherence between project objectives and pupils' needs, suitability of methods and materials, timing of activities, knowledge acquired;
- documentation: methods, languages and tools, areas to be documented, documentation of pupils' work, problems arising;
- overall project context: whether the project was integrated within the school teaching programmes; whether and how it changed the relationship between the school and the gallery; whether the project was integrated within the museum culture.

After the identification of the potential research areas, the project group decided that the external evaluator should concentrate on the study of aspects regarding the teachers, especially their training/preparation for the project and the implementation of the activities, using the sample of teachers participating in the project during the school year 1997-98. Regular meetings with teachers were carried out in order to discuss the conditions of evaluation, but were also used as monitoring strategies. The minutes of those meetings were recorded and became the basis for the preparation of an evaluation questionnaire which focused on the following issues regarding both general aspects of the project and the specific itineraries for each class:

- general information about the project (timing, materials, methods used for the itinerary activities, and organisational issues);
- organisation: management of issues such as permission for visits, timing, transport;
- teachers' training: content, methods and materials of the course for teachers, effectiveness and problems;
- integrating the project into the school teaching programme (possibilities for cross-curricular teaching through the suggested activities, pedagogical methods, pupils' motivation and participation);
- relationships between the teachers and their heads, other colleagues and the parents during the implementation of the project;
- carrying out preparatory activities in the classroom for individual itineraries (learning processes, level of pupils' skills and knowledge before the first visit, limitations, emerging needs);
- teachers' views about the itineraries and activities in the gallery (coherence between project content and goals, pupils' learning needs and motivation, effectiveness of methodologies, language and resources, pupils' participation in the activities, organisation of teaching in the Gallery);

- pupils' learning (development of skills and knowledge, suitability and effectiveness of materials);
- long-term usefulness of the project (use of acquired knowledge and skills in the long run, possibility for using learned methodologies in other museum-oriented activities, possibilities for improving relationship with the school and the families).

Once the questionnaires were filled in by the participating teachers, the project group then gave them a constructively critical reading. The monitoring conducted with the teachers throughout the process and at the end of each school year gave significant information for the improvement of the content and implementation of activities and for developing materials and improving teachers' training.

OUTCOMES OF EVALUATION

Some of the outcomes of the evaluation are presented here to provide indicators of what was experienced, in such a way as to give a concise picture of both positive and problematic aspects which emerged during working in the project.

Firstly, the project structure and educational approach allowed work in depth on a range of concepts and development of further possibilities for teaching and learning. Learning was built on gradual acquisition and consolidation of skills and information, starting from the basic knowledge of the museum and extending to more complex notions of citizenship and cultural awareness. The pupils discovered and familiarised themselves with the gallery space not only through looking but also by doing, and were offered opportunities for creating personal experiences. They developed awareness and confidence by getting to know the gallery, its space and history and by learning to look and understand a painting – knowledge and methodology which could be well utilised in other museum visits. The project was the ground on which pupils established a long-term relationship with Brera, which resulted in regular visits and expanded to the engagement of their families.

The teachers recognized the coherence between methodologies and contents of their own training for the project, the educational methodologies adopted in the school context and pupils' learning needs. They appreciated the advice provided to them on a constant basis and were able to create new teaching activities and plans within the school curriculum, using inter-disciplinary environments as well as a range of techniques and methods for teaching the arts. With regard to their training for the project, in particular, evidence from evaluation indicated the need for devising sessions devoted to active engagement with art through personal experimenting with techniques and materials.

Regarding the issue of relationships, the project stirred diverse responses by the gallery staff. Scepticism was encountered in some cases, whereas the general reaction of gallery staff and especially the attendants was positive. In particular, most were able to verify the validity of the proposed approach as well as its positive results, and to confirm that no complications in terms of museum management were implied or damage to the paintings was caused.

IMPROVING PRACTICE

Working within a museum-school educational partnership is still not widespread practice in Italy, but attempts for the development of long-term projects between schools and cultural heritage institutions are increasing. The recommendations that follow indicate the conditions which should exist in order to reduce potential uncertainties and problems that could risk success or even attempts to start educational initiatives. Some recommendations apply to the particular circumstances of the Italian reality, while others are applicable to more general situations of schools and institutions.

To start with, planning of projects should be careful, with clear objectives and methodology. Pilot study of the devised processes and materials proves a useful method for controlling the effectiveness and suitability of the product. At the same time, monitoring and evaluation strategies should be defined at an early stage and allow the involvement of an external evaluator.

An important aspect in the design of museum-school projects is human resources. Defining roles and tasks for each team member is fundamental for realising and assuming responsibility for each action. Availability of professionals for full-time management of administrative and practical issues means that museum educators (or other content-related specialists) are able to devote their time and attention to more 'content-related tasks'. Administrative management means keeping contacts with the schools, giving out information, handling documentation, etc. In addition, projects of this kind require an on-going relationship with teachers which, in turn, requires investment in time and personnel – especially in cases that the need for advice, reassurance, explanations, clarification and motivation is taxing. It may be necessary therefore, to consider the involvement of a teacher co-ordinator, who can be a teacher herself and who, after having completed the training course is able to assist colleagues.

It is also important to engage a variety of specialists in the work group (for example, from the fields of education/schooling, communication, computer technology, etc.), who would be able to contribute their experience and competencies to the development of a coherent and complete project.

Working in partnership is an essential element of a joint project, which means not only collaboration between the members of the project team (gallery educators, teachers, other professionals) at all stages, but also opportunities for exchange of experience and expertise with other realities working similarly in the field. Exchange is a mode for professional development – learning from other projects, creating networks and encouraging further research.

When it comes to the relationships between the museum and other agents, the Italian reality in the field of museum organisation and management proves particularly problematic for the realization of museum projects in co-operation with schools (Cisotto 2000, Prete 1998). Such projects as well as the very existence of an educational service within museums are not yet considered a primary task within the managing agent of State museums, the Soprintendenza. It is important therefore, that a new understanding of the value of education in museums is reached for all

members of museum staff, in order to avoid cases where educational activities are considered optional and therefore eliminable.

With regard to documenting the project, detailed recording of each phase is crucial. The taxing process of documentation might require the involvement of a professional and, possibly, also of especially designed software. Such documentation includes students' products, accounts of competencies and tools used throughout the project and results achieved, all of which constitute precious material for assessment and reflections as well an effective way for reviewing actions and behaviours. In addition, teachers can be asked to prepare a report of their work with the pupils, which would help outline the ways in which the project was incorporated into the school curriculum.

Inevitably, issues of funding and resources also arise. Financial and structural resources should be stable and adequate in order to ensure the smooth realisation of the enterprise without disturbing a planned schedule for museum or classroom activities. The museum should ensure the availability of adequate space for welcoming classes, activities, workshops, and for meeting teachers as well as for consultation of teaching materials and other documentation useful for both museum education experts and teachers.

Finally, when it comes to publicising the project, it is necessary to ensure wide distribution of information about process and products, not only to museum professionals or teachers (that is, potential users) but also to the general public. Publicising through the press, information pamphlets (that include the project among other museum activities) are among the most effective means for ensuring access to the project but consequently also to the museum services in general.

To conclude, devising and offering projects such as *Discovering Brera* has fundamental value for the development of the pupils' (and future citizens') awareness of cultural heritage and their responsibility towards it. It is, however, also fundamental that together with social responsibility, pupils develop an understanding of museums and their collections as agents of knowledge and history, overcome the prejudice that museums address only the scholars, and use them as resources for lifelong learning and enjoyment.

Silvia Mascheroni is an art historian specialising in museum and gallery education.

NOTES

[1] Soprintendenza is the national agency that has the responsibility for the protection and conservation of cultural heritage in Italy and well as the management of the State museums and galleries. Such agencies are established at local level by the ministry of Cultural Heritage and Activities.

[2] The Commission was instituted to rethink the educational function of the Superintendency and of museums, also in the light of the difficulties and deficiencies in the field across the country (Ministerial Decree, 16 March 1996). On 20 March 1998, the agreement between the Ministry of Cultural Heritage and Activities and the Ministry of Education was signed. It provides for the joint creation of annual or long-term educational projects by those responsible for Cultural and Scholastic Institutions. The first priority of the Commission was to establish a Center for Educational Services in Museums and to carry out the coordination and documentation of activities promoted by the

educational services of Museums in Italy (Ministerial Decree, 28 March 1998). For more information, see *Verso un Sistema*, 1999 or consult the website of the Ministry of Cultural Heritage and Activities www.beniculturali.it

[3] The educators responsible at Brera were Emanuela Daffra and Sandra Sicoli, who can be contacted for more information and documentation about the project at: Pinacoteca di Brera, Via Brera 28, 20121 Milano, IT.

[4] The project requested a commitment of minimum two subsequent years by the participating schools (at any point between the second and fourth grade) in order for the continuity to be possible and for educational objectives to be reached.

[5] For monitoring indicators and evaluation methodologies see Castelli 1996 and Quartapelle 1999.

REFERENCES

Alla Scoperta di Brera (in Italian). Milan: Ministero per i Beni e le Attività Culturali - Aisthesis & Magazine, 1998.

Buffet, F. "Between School and Museum: the Time for Cultural Education Partnership" (in French). *Publics et Musées* 7 (January-June 1995). Lyon: 47-64.

Cisotto, Nalon, M. (ed). *The Museum as Laboratory for Schools. For Art Education* (in Italian). Padova: Il Poligrafo, 2000.

Dufresne-Tassé, C. (ed). *Museum Evaluation and Education: New Trends* (in French). Paris: ICOM-CECA, 1998.

Hooper Greenhill, E. "Understanding and Improving Visitor Experiences in Art Museums." In Bodo, S. (ed). *The Relational Museum: European Reflections and Experiences* (in Italian). Turin: Giovanni Agnelli Foundation, 2000.

Jacobi, D. and O. Coppey. "Museums and Education: Beyond Consensus, in Search of Partnership" (in French). *Publics et Musées* 7 (January-June 1995): 10-22.

Maresca Compagna, A. (ed). *Young People and Museums* (in Italian). Rome: Ministry of Cultural Heritage and Activities, 1999.

Margiotta, U. *From Planning to Evaluating Training Interventions* (in Italian). Venice: Cà Foscari University, 1989.

Prete, C. *Open to the Public. Communication and Educational Services in Museums* (in Italian). Florence: Edifir, 1998.

Quartapelle, F. (ed). *Planning Europe Together. Evaluation Kit for European Education Projects* (in Italian). Milan: Franco Angeli, 1999: 31.

Shettel, H. H. and S. Bitgood. "Evaluation Practices for Expositions: Some Case Studies" (in French). *Publics et Musées* 4 (May 1994): 9-23.

Verso un sistema italiano dei servizi educativi per il museo e il territorio. Materiali di lavoro della Commissione Ministeriale (in Italian). Rome: Ministero per i Beni e le Attività Culturali, 1999.

MARIA XANTHOUDAKI

MUSEUMS, GALLERIES AND ART EDUCATION IN PRIMARY SCHOOLS

Researching Experiences in England and Greece

Abstract: The chapter analyses the contribution of museums and galleries to art education in primary schools. In particular, it focuses on the ways teachers use stimuli and ideas offered during a museum visit into their classroom art practice. The evidence is drawn from comparative research in two museums, three galleries and sixteen primary schools in England and Greece. The research revealed two basic methodological 'models' of educational programmes in terms of their contribution to art education: 1) 'the gallery as a classroom resource' and 2) 'the gallery as teacher about its own collection', models which differ in terms of teaching and learning approaches, flexibility of educational tasks and relation to classroom teaching. The models are discussed in the context of the existing curricula and school practice in the two countries, and also of educational provision in the museums and galleries. The comparative approach aims to draw attention to more 'universal' realities rather than institutional, classroom or country characteristics, and develop suggestions for the improvement of the relationship between museum educational services and art practice in schools.

INTRODUCTION

Education services of museums and galleries have been developing in ways that increasingly address the needs and interests of different types of public (such as families, young people, adults, people with special needs, etc.), but schools remain still the audience best served by the majority of such institutions making up one third of their public (Xanthoudaki 1998). Whether in the form of traditional one-off guided visits or long-term collaborative projects, museum programmes aim to encourage pupils' active engagement with art works and artefacts, the development of skills, knowledge and understanding, as well as the development of a lifelong habit of museum visiting. However, research has shown that the school visit is (or should be) only one component of a 'three-part unit' of museum-related activities. In order for the visit-oriented skills and knowledge to be consolidated, enriched and used in the long term, pupils' museum experience should be extended to the classroom both before and after the visit (Hooper-Greenhill 1991 Hargreaves 1983); while the museum experience should be seen in the context of an educational project, jointly devised by the teacher and the museum educator (Mascheroni 2002). The importance of museum-related activities in the classroom as well as the increasing development of collaborations between schools and museums, brings forth the issue of the educational responsibility that museums and galleries have towards schools, especially for supporting teachers in enriching their pupils' knowledge and understanding. In this context, this chapter aims to study the

105

M. Xanthoudaki, L. Tickle, V. Sekules (eds)
Researching Visual Arts Education in Museums and Galleries, 105-116.
©2003 Kluwer Academic Publishers. Printed in the Netherlands.

contribution of museums and galleries to education in the arts, in particular, by examining the ways in which different pedagogical approaches to museum visiting and educational activities help teachers extend their pupils' museum experience and develop their learning in the arts.

The data and arguments on which the chapter is based derive from research in two museums, three galleries and sixteen primary schools in London and Athens. The methodological and theoretical framework of the research is presented at first, followed by presentation of the schooling reality in the two countries. On this basis, the evidence of the fieldwork is then analyzed and discussed.

RESEARCH DESIGN

The research was built on the notion of the 'three-part unit' of: preliminary work before the visit, the visit to the museum or gallery and follow-up art activities in the classroom, focusing on the relationship between the museum experience and classroom art work. In this context, the research examined educational methodologies in the museum and classroom, museum/gallery policies reflected in their school programmes and the overall curriculum/teaching framework within which the museum-related work unfolded. This examination allowed the identification and understanding of influential variables within the 'interactive relationship' between institutions and schools as well as potential limitations in using museums for art education.

A multi-site case-study approach was used. Diversity of content and structure of educational programmes for schools was the main criterion for choosing the sample of museums and galleries, exactly in order to be able to study the contribution of different educational approaches to the work in the classroom. The identities of the museums, galleries and schools are kept confidential, which helps avoid criticism of individuals and focus on cases. The selected institutions are named, for the purposes of this chapter, *English Museum (EM), English Gallery 1 (EG1)* and *English Gallery 2 (EG2)*; and *Greek Museum (GM)* and *Greek Gallery (GG)*. The sixteen primary schools were chosen from the list of schools booked to visit the five institutions at the time of the research.

The research methods included observations of classroom sessions and of visits to the institutions; interviews with the participants (teachers, museum and gallery educators and members of education departments of the institutions) before and after museum visits; and analysis of primary curriculum documents, reports and museum and gallery educational publications.

All museum/gallery visits and visit-related classroom sessions observed offered evidence mainly about the existence (or lack thereof) and the nature of links between the classroom topic and the visit; teachers' methods and objectives in setting up the 'three-part unit'; the topic, characteristics and educational methods of the visit itself; and the role of the school art curriculum in the whole process. All evidence deriving from observations was triangulated with data from interviews and document analysis.

MUSEUM EXPERIENCE, SCHOOLS AND LEARNING: THEORETICAL FRAMEWORK

In her book *Museum and Gallery Education* (1991), by now a classic, Hooper-Greenhill argues that the best way to fully exploit the learning potential of a museum experience appears to be considering museum and gallery visits as one component of the 'three-part unit' (preliminary preparation, visit and follow-up work). She explains that:

> preliminary work may be carried out in school or out of school and is used to prepare the students so that the maximum value can be gained from the visit itself. (...) It is essential that the experiences of the visit are recalled, discussed, evaluated and responded to back in the classroom, otherwise much of the value will be lost (Hooper-Greenhill 1991, 120).

In this approach the most important component remains the museum visit itself, it being the stimulus for learning, for the development of an interest to know more, and for consolidating already-acquired knowledge. The learning potential of the visit lies in the complexity and unique nature of the museum experience itself, which goes beyond the mere transmission of a specific body of information from the 'museum expert' to the 'novice visitor'. It extends to the interaction between many and diverse factors relating to the museum, to the visitor and to the art object.

Falk and Dierking (2000) point out that the museum experience is influenced by the visitor's 'personal context' that is, the individual properties with which they come to the museum. The 'social context', that is, experiences of group behaviour, and the 'physical context', which means the physical environment of the institution – also contribute to make a unique experience for each individual that visits a museum (Falk & Dierking 2000). Consequently, museum learning is built on the interaction between the visitor's prior knowledge and experience, motivation, attitudes, cultural background, and immediate social and physical environments (Dierking 1996a; 1996b). Museum learning does not occur through a common way with a single expected outcome; but, rather, the visitors' interpretation and understanding are always relative to the individual and the unique circumstances in which they occur (Falk and Dierking 1995 Walsh-Piper 1994; Hein 1998). To this is added the communication process with the museum object, the latter acting as a 'document' holding and recording meaning and information and transmitting it on the basis of different kinds of knowledge, interests and levels of sophistication of the beholder (Pearce 1990).

These arguments pinpoint the significance of viewing a museum experience as an interactive and circular process of communication, taking into account the visitors' personal context as learners in the process of knowledge transmission.

In the case of school visits, the 'personal context' is also the basis for building an educational experience. According to Hooper-Greenhill (1991, 120) that should be developed throughout the components of the 'three-part unit'. This means not only allowing children to express individual interpretations about objects without fearing to get things wrong, but also building on their own interests, experiences and knowledge. The development of associations and comparisons between the knowledge and information conveyed in an object and the childrens' personal and

everyday encounters is regarded as an essential means for encouraging understanding and learning – mainly for two reasons. On the one hand, associations and comparisons between the two worlds (the childrens' and the object's) encourage the enrichment of the childrens' ideas about different cultures, peoples, times and places. On the other hand, the development of links between 'worlds' assists comparative learning, since children appear to remember and be interested in object details or characteristics that somehow connect (without being necessarily similar) to their own experiences, habits, interests and lives (Husbands 1994).

Moreover, the experience of the 'real thing' appears to encourage acquisition of new knowledge and consolidation of already-acquired information. Research reveals that ideas which were formulated with the help of original objects are "absorbed more easily and with greater enthusiasm, and remembered longer and generated interest in knowing more" (Hooper-Greenhill 1987, 46; see also Kyriakidou 1994; Falk and Dierking 1992; Xanthoudaki, 1997).

With regard to education in the arts, opportunities for direct encounters with original art works and artefacts encourage the development of aesthetic experience as a motive for learning and creative/educative interactions between the childrens' own knowledge and experience and the new knowledge and information conveyed in the works (Budd 1995; Hargreaves 1983; Tickle 1996). Tickle studied pupils' experiences of original art works and the links with classroom practice. He offers an account of the influence of such processes on the children's emotions, cognition and skills, pointing out the necessity of developing children's knowledge and experience through encounters with original works, emphasizing the importance of linking gallery visits with art making in the classroom (Tickle 1996). Opportunities for encountering original works not only enable children to become aware of the cultural continuum and the work of artists in different times and places, but they also encourage experience of different symbolic systems, development of aesthetic preferences and incorporation of stimuli and ideas into their own art work.

All the above arguments stress not only the significance of linking museum visits with classroom work, but also the educational responsibility of the institution implied in each individual museum experience and its potential for stimulating learning. Decisions regarding the methodology of teaching and learning and choices of pedagogical approaches to educational services of museums and galleries influence the nature of the museum experience but also, as it will be shown, have implications for the way the visit is used by the teacher in the classroom.

ART EDUCATION, MUSEUMS AND THE CURRICULUM[1]

The 'three-part unit' implies, however, not only museum processes, but classroom processes as well, which are also determined by curriculum and/or teaching-oriented parameters. The curriculum framework within which teachers devise the visit-related activities is presented below.

In England, the National Curriculum Art requirements include the main guidelines for art practice in schools on the basis of which pupils would be equipped to cope knowledgeably and competently with the modern world[2] (DES/WO, 1991). Its main aim lies in the balance between the development of visual perception, and

the use of investigating and making skills on the one hand; and, on the other, the development of an understanding and a capacity to respond to, and make aesthetic judgements about, other people's art works and artistic traditions. As in all the rest of the subjects of the National Curriculum, the Orders for art prescribe neither a specific amount of time for the teaching of the subject, nor particular teaching methods, tools or approaches. In addition, the Programmes of Study for art remain broad and flexible enough to allow wide discretion for schools with regard to topics and teaching methods.

On similar lines, the Greek art curriculum named "Aesthetic Education" – established in the light of the 1981 education reform[3] to include the teaching of drawing, crafts, painting and music – aims at pupils' emotional and sensory development as well as at the acquisition of artistic skills. It emphasises the importance of investing in pupils' individual abilities, needs and interests; and encourages the development of their cultural awareness (Official Journal 1982, 948). However, in contrast with the flexible, open-ended English approach, the Greek curriculum provides detailed guidelines for topics, aims and duration of art teaching, the same for all schools in the country (Official Journal 1982).

A further reform in the Greek art curriculum took place in 1990, which is still in effect.[4] The main change has been the generation of one art textbook for the teachers of all classes in primary schools covering three subjects: Visual Arts, Music and Drama. It contains guidelines and suggestions for activities to be carried out in the classroom. The 1990 version of the art curriculum recognises the importance of pupils' aesthetic development through free and creative self-expression and engagement with works of past and contemporary artists. Aesthetic development is encouraged through visits to museums, ateliers, factories, ports, etc. (Official Journal 1990, 546-548). The number of sessions for teaching visual arts and music have remained the same (as set by the 1981 curriculum version), that is, four hours per week for the first four classes of primary school and two for the other two classes.

The implementation of the art curriculum guidelines in the two countries has been found to have several common characteristics regarding not only the teaching of the subject but also the use of museums and galleries as educational tools. Research has shown that even though there has been an increasing attempt to improve the educational standards of art education, art is not being adequately taught in a number of schools, nor do many teachers feel sufficiently confident or competent about teaching the curriculum for art, especially regarding art appreciation activities (OFSTED 1993; Clement 1994; Tickle 1996; Sekules et al. 1999). In general, while art making activities are rather frequent in schools, opportunities for looking at art appear to be rare, and these are usually from slides or reproductions.

Research has also brought forward the issue of inadequate teaching time available for the subject. Education in art very often maintains a fragile existence, especially at primary level, as the teaching of the subject is seen to be an optional extra, readily viewed as recreational and of no definable worth. In particular, art is often only used to support other curriculum areas, therefore insufficient account is

taken of the specific skills and knowledge associated with the subject (Sekules and Xanthoudaki 2000).

However, museum and gallery visits appear to many teachers as an effective means for supporting teaching and learning in the arts, especially in those cases where teachers show lack of confidence and/or claim lack of specialised knowledge necessary for teaching the subject (Sekules *et al*. 1999; Sekules and Xanthoudaki, 2000). Where teachers had opportunities for collaboration with the museum and/or for overcoming their 'fear' of art by learning about strategies for using it with their pupils, they felt adequately equipped to devise museum and classroom activities with clear objectives and effective outcomes (Sekules et al. 1999).

Visiting museums and galleries is a suggestion of both English and Greek curricula, reflecting the official recognition of their ability to offer opportunities for expanding the syllabus requirements. However, in the English art curriculum, visits are recommended rather than required, to be used at the discretion of the teachers. In the Greek curriculum, museums and galleries are seen as generally contributing to the enrichment of pupils' life experiences rather than as essential primary resources for education in the arts, and no links are encouraged between museum visits and classroom work.

In this teaching and curriculum contexts, teachers who decide to work with objects find a wide-range 'market' of museum and gallery educational programmes to choose from. Their choices are determined by factors such as the location of the museum, the timing of the programme offer, the timing of the teaching of a particular topic, the availability of visit slots, the technicalities of the visit organization etc. But more than that, their choices are determined by the content and structure of the museum programme itself. The content and structure of the museum programme, however, are the parameters that have an effect also (and more importantly) on how the visit is used in the classroom – and this is what the research has been focusing on.

EDUCATIONAL PROGRAMMES FOR SCHOOLS IN MUSEUMS AND GALLERIES

The main structure and content of the museum and gallery programmes used for the research are the following:

English Gallery 1 offers educational programmes tailor-made to individual teachers' requirements and needs, and to the classroom topic taught around the time of the visit. The programmes relate to art education both directly and indirectly through cross-curricular approaches to a non-art theme. They consist of discussion between a gallery educator and the group of children in front of original art works. Art workshops are rare due to the lack of space in the gallery. The published teachers' packs offer general ideas for using EG1 and for related classroom work. The main aim of the gallery policy is to support the National Curriculum by 'helping teachers help themselves'.

English Gallery 2 houses only temporary exhibitions, offering short-term educational programmes focused on themes deriving from the works of the exhibition. These programmes all have the same content and structure and are

common for all visiting schools. Teachers' packs are available for each exhibition offering ideas for work in the classroom. The programmes consist of discussion between a gallery educator and the group of pupils and an art workshop in a specially organised space.

English Museum is mainly regarded by the teachers as a historical museum. Thus, the majority of school visits have a strong historical focus and the art-related activities are seen through a cross-curricular approach. No museum educators are available at the museum for 'guided' visits. The topic, content, structure and learning methods are at the discretion of the teachers. Published teachers' packs offer basic guidelines for the use of the most popular galleries in the light of the National Curriculum. No workshops take place in the museum because of the lack of space.

Greek Museum houses art objects from different periods in Greek ancient history. It is therefore considered as a historical rather than an art institution and such orientation determines the focus of its programmes. The latter are for those school classes whose history curriculum includes topics directly related to the museum collection, that is, only for the third and fourth grades of primary school (pupil age eight to eleven years). Two types of programmes are offered by the museum, one for the third and one for the fourth grade, aiming at the development of an interactive and creative relationship between children and the ancient Greek civilization. The structure of these programmes is common for all pupils of the same class and consists of a) presentation of slides by the educator introducing the main objects of the collection (in the schools area); b) visit to the (relevant) galleries and individual use of activity sheets; and c) (for third grade only) clay workshop.

Greek Gallery houses representative art works of one artist. His life and work are the main focus of the programmes, which have a unique structure for all visiting schools (while the level of difficulty changes according to pupils' age). The aim of the programmes is to bring children into contact with art and aesthetics, to offer them information about the particular artist, and the opportunity to familiarize themselves with the gallery environment. The programmes include:

i) *at school* before the visit: preparation on the basis of the gallery teachers' pack, that is, presentation of thirty-four slides of major art works covering the history of western art, and discussion;

ii) *in the gallery*: presentation of slides of some of the artist's works included in the collection; discussion in front of several selected original art works; and use of activity sheets.

THE EVIDENCE OF PRACTICE

The data analysis of museum and gallery visits and related classroom activities has identified two basic models of educational approaches:

Model 1: *The gallery as classroom resource*
EG1, *EM* and *GM* have been *used mainly as teaching resources by the teachers*. The school curriculum requirements and classroom topics as well as the teachers' needs and set tasks determine the content, aims and methods of the visit to the museum and gallery.

Model 2: *The gallery as teacher about its own collection*
EG2 and GG have been organising and used for specific educational programmes with no direct relationship between gallery visit and classroom practice.

In detail, the educational programmes of EG1, EM and GM were used by the teachers as complementary resources in order to reinforce and expand children's knowledge of a (curriculum) topic through the experience of the 'real thing'. On the other hand, school visits to EG2 and GG aimed to 'teach' children about particular themes and notions related to the institutions' collections or exhibitions and encourage their engagement with original art works.

The research showed that the possibility of using a museum or gallery visit as a method for school art education is higher when the institution takes curriculum, classroom work and teachers' needs into account when designing school services, than in the case of programmes that encourage no links with classroom work. In other words, the 'three-part unit' is reinforced in the case of curriculum-oriented museum programmes.

However, the use of visits for education in the arts is not only determined by the museum educational policy, but is also subject to the existing conditions of art teaching in primary schools. Teaching time, lack of resources, the taxing requirements of the teaching of all subjects, and the secondary role of art are additional reasons determining the use of a visit for supporting classroom work (Evans, 1996). The research also shows that this situation is reinforced by the lack of teachers' specialised knowledge and training in art, as well as their lack of confidence in the teaching of the subject (Sekules *et al.* 1999; Sekules and Xanthoudaki 2000).

In this context, the museum and galleries of the first model were used more for art education in the classroom, given, as it appears, the proximity between educational programmes and teaching plan. The three institutions were found not only to encourage the use of ideas from the visit into the classroom art practice and vice versa, but also to offer substantial support to teachers, especially in cases where they felt unconfident with art teaching or where opportunities for art appreciation activities in the classroom were very limited. The research evidence indicates that the schools visiting EG1, EM and GM1 used the visit as a basis in order to a) develop pupils' art work, and/or b) reinforce teaching and learning of a curriculum topic.

On the other hand, the educational model followed by EG2 and GG offers a different approach to the interactive relationship between museum and gallery programmes and art teaching in the classroom. EG2 and GG organise school programmes with independent themes aiming to teach about the exhibition rather than to be used as explicit recourse for school-oriented processes. Thus, they appeared to encourage less than the first model the use of the visit for classroom art

work because visit-related activities were usually treated as extra-curricular work. The main reasons were that none of the programmes took account of the school curriculum or teachers' requirements in developing school services. Rather, the content and structure of the programmes were determined by the theme of the collections and/or exhibitions. In addition, the gallery programmes adopted an informative rather than exploratory approach to teaching the pupils about art, which allowed for limited connections between new information and pupils' already-acquired knowledge and school or life experience.

The research indicated that the EG2 and GG visits were utilised as method for art teaching only where the teacher herself decided to create space for preliminary and/or follow-up activities. In general, the visit to those institutions was organised in order to "provide a first-hand exposure to great works of art" (Walsh-Piper 1994, 106) but with little attempt to see such objective as part of a project – of a 'three-part unit'. In other words, the visit did not take place in order to support classroom work or curriculum topics, therefore it was considered an autonomous event. Even in cases where the gallery experience was exploited and expanded in the classroom, the work carried out was considered an extra-curricular activity rather than an integrated (art) curriculum-oriented process.

However, given the very few art appreciation sessions taking place in the schools and the acknowledged lack of confidence in teaching art, the teachers regarded the programmes of *all* museums and galleries as a valuable opportunity for children to experience original art works and artefacts (Mitchell 1996; James 1996). Moreover, where the institution offered opportunities of practical art work during workshops those were strongly appreciated by the teachers, especially in cases where the school did not have adequate space and resources for such activities.

MUSEUM-SCHOOL COLLABORATION WITHIN THE 'THREE-PART UNIT'

The existence of connections between museum/gallery programmes and classroom teaching appears to contribute more positively to the use of museums and galleries for art education than programmes with no apparent links. The main reason appears to be that the visit is used for support of the classroom/curriculum topic and is, therefore, integrated in the teacher's plan and in the already-allocated time for art teaching.

However, this cannot be considered as linear 'cause and effect' given that the 'three-part unit' of preliminary preparation, visit and follow-up work, depends also on teachers' priorities, curriculum requirements and teaching context. In practice, it was found that the 'three-part unit' did not always constitute a unity within either of the educational models. Preliminary sessions were usually not regarded as specific and purposeful preparation of the children for the visit, but, rather, implemented the requirements of the particular topic and teaching plan. Ideas from the visit were exploited during follow-up work and regarded as reinforcing children's knowledge in the first model. When the museum and gallery visits took into account classroom teaching and offered support and stimuli for further work to the teacher, the components of the 'three-part unit' were reinforced and expanded even within the limited provision for art. However, follow-up work remained limited owing, again,

to lack of time, taxing curriculum demands for all subjects and teachers' lack of confidence towards art teaching.

Such evidence brings forth the issue of collaboration as the first one to be addressed by museums and galleries as well as schools for the improvement of education in the arts. Collaboration means the following:

a) consideration of the curriculum context for the development of (at least some) museum and gallery school services;
b) extended use of museums and galleries by the teachers for the development of art education and support of their needs and curriculum requirements;
c) development of long-term relationship between museum and school staff (in the form of teachers' packs, in-service training for teachers, direct contacts on the occasion of a school visit, etc.) which opens the museum to the teachers and makes them aware of the opportunities for support of their work; and also opens the school to the museum professionals to help them understand the world of schooling.

The issue of teachers using and learning to use museums and galleries, and that of the necessity for resources for art in schools emerge as topics for further development and research since they strongly affect not only the implementation of the curriculum but also the collaboration between schools and museums (Tickle 1983, 1996). It is only through adequate knowledge and support of teaching that the objectives of the curriculum can be successfully met and the pupils' knowledge can be enriched encouraging also a lifelong relationship with museums and galleries.

Maria Xanthoudaki is a research associate in the Faculty of Architecture Politecnico di Milano, Italy.

NOTES

[1] Since the period of fieldwork, which started in 1995/1996, and the period this chapter was writtten, curriculum reforms have taken place in both countries (see following notes). Although the data refer to specific curriculum versions in effect during the fieldwork, the outcomes of this research find a strong relevance in the light of the continuing changes in curriculum provision for art education. The research argues about museums and galleries as primary contributors in pupils' education in the arts and emphasises the importance of recognising and encouraging long-term relationships between museums, galleries and schools, especially within official curriculum requirements.
[2] The research took place in the light of the 1992 version of the National Curriculum Art. Since then, a revised version of the curriculum was introduced in January 1995 (but was not immediately implemented in schools); whereas in January 1998, the government presented decisions for further changes in an attempt to offer more support to literacy and numeracy. The two revisions did not present major changes in the content of the National Curriculum Art, but in the context of the official general policy to "slim down the curriculum" it became less prescriptive in its detail (Sweetman 1996). In 1999 the Secretary of State announced further revisions (statutory from August 2000), aiming to promote stability in schools and enable them to focus on raising standards of pupil attainment. The main changes focus on the development of a more explicit rationale for the curriculum, a stronger emphasis on inclusion and on clearer and more flexible curriculum subjects (for more details see www.nc.uk/net). As far as art education in concerned, we are now talking about National Curriculum for Art and Design, but the content of teaching has not faced major changes, remaining under the frameworks of Investigating and

Making, and Knowledge and Understanding, aimed at exploring and developing ideas and evaluating and developing work.
[3] The teaching of drawing and crafts has been part of the Greek primary curriculum since the beginning of the century (Vergitsakis 1988). Up until the major educational reform of 1981, art education reflected governmental policies towards employment and economic reform of the country and was regarded as a means for enhancing pupils' self-expression and skill development (Official Journal 1977, 3206).
[4] Since then minor reforms have taken place with no substantial changes in content and approach. An attempt to develop a more interactive relationship between cultural heritage and schools began in 1995 with the introduction of a new curriculum for all levels of education - the 'Melina Project' - which was jointly devised by the Ministry of Education and the Ministry of Culture. This project can be considered as a breakthrough initiative, for it aims to bring together the domains of education and culture and to directly involve museums and galleries in pupils' artistic and aesthetic development (Ministry 1994). The 'Melina Project' started to be implemented in about fifty pilot schools throughout the country in September 1996 and is still undergoing the pilot stage which is planned to last ten years. The experimental phase of the Programme will cover all levels of Greek education, that is, pre-primary, primary, secondary and tertiary (Ministry, 1994, 3-37) During the experimental phase the rest of primary schools continue to use the 1990 version of the art curriculum, which has also been the one examined by this research.

REFERENCES

Budd, M. Values of Art: Pictures, Poetry and Music London: Penguin, 1995.
Clement, R. "The Readiness of Primary Schools to Teach the National Curriculum in Art and Design." Journal of Art & Design Education 13. 1 (1994): 9-20.
Department of Education and Science (DES) & Welsh Office (WO). National Curriculum, Art Working Group: Interim Report. London: HMSO, 1991.
Dierking, L.D. "Historical Survey of Theories of Learning". In Durbin, G. Developing Museum Exhibitions for Lifelong Learning. London: The Stationery Office, 1996a.
Dierking, L.D. "Contemporary Theories of Learning". In Durbin, G. Developing Museum Exhibitions for Lifelong Learning. London: The Stationery Office, 1996b.
Evans, A., "Young at Art." Times Educational Supplement (15 November 1996).
Falk, J.H. and L.D. Dierking. The Museum Experience. Washington D.C.: Whalesback Books, 1992.
Falk, J.H. and L.D. Dierking (eds). Public Institutions for Personal Learning: Establishing a Research Agenda. Washington D.C.: American Association of Museums, 1995.
Falk, J.H. and L.D. Dierking. Learning from Museums. Walnut Creek: Altamira Press, 2000.
Hargreaves, D.H. "The Teaching of Art and the Art of Teaching: Towards an Alternative View of Aesthetic Learning", in Hammersley, M. and A. Hargreaves (eds). Curriculum Practice: Some Sociological Case Studies. London: Falmer Press 1983.
Hein, G. Learning in the Museum, London: Routledge, 1998.
Hooper-Greenhill, E. "Museums in Education: Towards the End of the Century." in Ambrose, T. (ed). Education in Museums, Museums in Education. Edinburgh: HMSO, 1987.
Hooper-Greenhill, E. Museum and Gallery Education. Leicester: Leicester University Press, 1991.
Husbands, C. "Learning Theories and Museums: Using and Addressing Pupils' Minitheories." Journal of Education in Museums. 15 (1994): 5-7.
James, S. "Young Masters." Times Educational Supplement (13 September 1996): IV (Extra: Music and the Arts).
Kyriakidou, A. The Impact of Museum Objects on Children's Expression through Art, Eikastiki Paideia, 10 (1994): 72-78.
Mascheroni, S. L'Educazone e il Patrimonio Culturale, in S. Mascheroni (ed.) Il Partenariaro Scuola – Museo – Territorio: Riflessioni, Aggiornamenti, Progetti, Scuola e Didattica 15 (2002): 50-64.
Ministry of National Education and Religious Affairs. Education and Culture: Melina Project, unpublished paper. Athens: Ministry of Culture, 1994.
Mitchell, S. (ed). Object Lessons: The Role of Museums in Education, Edinburgh: HMSO, 1996.
Office for Standards in Education (OFSTED). Art Key Stages 1,2 and 3: First Year, 1992-93; the Implementation of the curricular requirements of the Education Reform Act. London: HMSO, 1993.

Official Journal of the Greek Democratic State. On the Taught subjects, Curriculum and Timing Plan of the Primary School, Presidential Decree 1034/77, 1. 347 (12 November 1977):3191-3220.

Official Journal of the Greek Democratic State. Curriculum and Timing Plan of A and B Class of Primary School, Presidential Decree no 583/82, 1. 107, article no 2 (31 August 1982): 917-962.

Official Journal of the Greek Democratic State. Aesthetic Education Curriculum for Classes C, D and F of the Primary School, Presidential Decree no 132/90, vol. 1. 53 (10 April 1990): 545-559.

Pearce, S. Objects of Meaning; or Narrating the Past, in S. Pearce, S. (ed.) Objects of Knowledge, London: the Athlone Press, 1990.

Sekules, V. and M. Xanthoudaki. Visual Arts, Schools and Museums. The European Commission, 2000.

Sekules, V., L. Tickle, L. and M. Xanthoudaki. "Finding Art Expertise: Experiences of Primary School Teachers." Journal of In-Service Education, 25.3 (1999): 571-581.

Sweetman, J. Curriculum Confidential 6: The Complete Guide to the National Curriculum. Suffolk: Courseware Publications, 1996.

Tickle, L. "One Spell of Ten Minutes or Five Spells of Two....? Teacher-Pupil Encounters in Art and Design Education." In Hammesley, M. and A. Hargreaves, (eds). Curriculum Practice: Some Sociological Case Studies. London: The Falmer Press, 1983.

Tickle, L. (ed). Understanding Art in Primary Schools: Cases from Teachers' Research. London: Routledge, 1996.

Vergitsakis, G. "Aesthetic Education and School: Judgements based on a Brief Historical Survey." Eikastiki Paideia 5 (1988): 24-27.

Walsh-Piper, K. "Museum Education and Aesthetic Experience." Journal of Aesthetic Education 28. 3 (1994): 105-115.

Xanthoudaki, M. Museum and Gallery Educational Programmes in England and Greece: Their Content and Structure and Their Contribution to Art Education in Primary Schools, PhD thesis, University of Sussex, 1997.

Xanthoudaki, M. "Educational Provision for Young People as Independent Visitors to Art Museums and Galleries: Issues of Learning and Training." Museum Management and Curatorship 17. 2 (June 1998): 159-172

MEG BLACK & GEORGE E. HEIN

YOU'RE TAKING US WHERE?

Reaction And Response To A Guided Art Museum Fieldtrip

Abstract: Fifteen undergraduate students enrolled in an Introduction to Art Education class at an urban women's liberal arts college participated in a guided field trip to the Museum of Fine Arts (MFA), Boston. The goals of the trip were threefold: (1) to take in the gestalt of the museum to familiarise the students with its architectural space; (2) to examine in detail as a group, fourteen works of art highlighted on a museum supplied map, and (3) for the instructor, Meg Black, to study the students' museum experiences. This study, guided by George Hein, was designed to elucidate how this group of students from different social and ethnic backgrounds and with varying previous art experiences felt about the trip to the museum as expressed through a series of follow up assignments. The post-museum assignments — student writing, drawing, interviews and survey — yielded rich data and proved to be an insightful learning experience for both instructor and students. Analysis of the data supports the concept that personal meaning making is a significant factor in visitors' responses to museums, even when the visit is highly structured. No simple, unidimensional categorisation of visitors adequately describes the breadth of responses to a single visit. Because individuals have different life experiences, different levels of perceptual skills and different expectations about any impending event, in this case an art museum field trip, instructors cannot expect to find a single "right" way to bring a group of diverse individuals to a museum.

INTRODUCTION

A college level art instructor for more than ten years, Meg Black, includes a field trip to the Boston Museum of Fine Arts (MFA) in each of her courses. She prefers the museum environment to slide presentations for typical reasons:

1. Viewing an original work of art whenever possible reveals, through the surface quality, the marks left by the creator. This allows for deeper communication with the object.

2. She agrees with Mihaly Csikszentmihalyi and Rick Robinson that "the large, simple environment of the art museum, free of outside disturbances, limits competing information and embodies the initial condition of freedom from distraction" (Csikszentmihalyi and Robinson, 1990, 142).

3. Also, "Looking at one object in context with others can be a great learning experience, as juxtapositions and relationships to other works of that period, culture, other artists, or art made during different times in the same artists' career often happen" (Csikszentmihalyi and Robinson, 1990, 146).

As an artist and avid museum visitor, museum visits are a common activity for her; as an art teacher, she faces the common challenge of structuring a museum visit to meet the needs of individual students. That is, she recognises the distinction between *visiting* an art museum on ones own, versus *hosting* an art museum field

117

M. Xanthoudaki, L. Tickle, V. Sekules (eds)
Researching Visual Arts Education in Museums and Galleries, 117-133.
©*2003 Kluwer Academic Publishers. Printed in the Netherlands.*

trip for a diverse group of students. The museum itself, built in 1909 in the Classical Revival style, is approximately 550,000 square feet and houses a collection of approximately 330,000 objects. With more than 1,300,000 visitors to the museum in FY 2001, the MFA ranks fifth in art museum visitor attendance in the United States (Melton 2002). The MFA is located within walking distance of the college where Black taught, thus, she assumed that her students not only must have passed by fairly frequently, but also, perhaps, visited the museum either with a group from the college or on their own. To her surprise, some members of the class responded with apprehension when she proposed a guided museum visit as part of the syllabus for her course, claiming ignorance about how to visit a museum, and expressing fear that other museum patrons would easily identify them as first time visitors. Literature reviews of how gender, race and social class affect art museum visitor populations explain this response in part, since her students come from diverse cultural backgrounds (Getty 1991). The proposed visit provided an opportunity to test these assumptions by asking the question, "How did students enrolled in an introductory art education course experience their structured museum visit"? To answer this question, the visit was evaluated through a series of tasks that both required and encouraged students to reflect on their experiences and provided the instructor with rich data that illuminated the meanings students attributed to the field trip. Findings from this study provide a model design for taking a diverse group of novice, occasional, and experienced visitors on a guided art museum field trip.

VISITOR EXPERIENCES

Recent authors such as Falk and Dierking (2000), Hein (1998), and Rounds (1999) have stressed the personal nature of visitors' meaning making during museum visits. Regardless of the intention of museum exhibition designers, visitors make personally significant meanings out of the material displayed; they construct meaning. The empirical evidence for this conclusion, drawn from hundreds of research and evaluation studies focused on unstructured family experiences in a wide range of museums is overwhelming. In contrast to studies of unstructured, family experiences, our study looks at a highly structured museum experience intended to accomplish specific goals and to provide, as much as possible, a common experience for all participants.

Studies of visitors in art museums (Getty 1991; McDermott-Lewis 1990; Schloder 1990) support the concept that, depending on background knowledge, experience, and expectations, visitors respond differently to their museum experiences. In addition, analysis of visitor characteristics suggests that visitors to art museums differ from those to other types of museums and that art museum visitation is correlated with specific leisure time interests (Hood 1981).

Melora McDermott-Lewis sought to understand and interpret the museum experience of the non-expert, as in Csikszentmihalyi and Robinson's study (1990), but of the novice (visitors with limited art background) and the advanced amateur (people knowledgeable about art, but who pursued it as an avocation versus a vocation) (McDermott-Lewis 1990, 6). According to her research, aesthetic criteria

valued by novices include prettiness, recognisable content, pleasant subject matter, lots of detail (identifiable talent), and an easily accessible message. French Impressionist art was often mentioned as pleasing by her research subjects. McDermott-Lewis found that, for the most part, novices rarely if ever comprehend art terms and "give no indication they even think about the artist as making deliberate choices in colour, composition, etc. to create a work" (McDermott-Lewis 1990, 20). Novices do *not* understand that the artist can control the feeling he or she is trying to convey; rather, they believe that emotions depicted in or conveyed by a painting are purely accidental. In addition, novices appreciate art that can be used as "touchstones for personal associations [or] memories" (McDermott-Lewis 1990, 17).

By contrast, she found that the museum experiences of advanced amateurs are diverse and therefore difficult to summarise. As a whole, McDermott-Lewis discovered that advanced amateurs tend to (1) understand the artist's ability to control the feeling he or she is trying to convey; (2) challenge themselves to view works of art that will "stretch their minds"; (3) appreciate modern art; and (4) be unafraid to add an element of intellect to their otherwise emotional aesthetic encounter with a work of art. To assist in the aesthetic appreciation of novice and advanced amateur visitors, she recommends, as do Csikszentmihalyi and Robinson, that museums provide information about the perceptual and historical dimensions of each work of art.

Another significant aspect of museum experiences concerns visitors' reaction to the architectural space of the museum, one of three components of Falk and Dierking's (2000) "contextual model of learning" the personal, socio-cultural and physical setting inherent in any museum visit. Further, the authors maintain that mood and expectations, as well as previous knowledge and degree of experience, influence visitor response to the physical space of the museum. These spaces are often large, imposing and monumental, intended to invoke awe and reverence, but frequently inspire fear and confusion instead. A primary concern of novice visitors is orientation; until visitors feel comfortable in the setting, little attention to the exhibition content can be expected (Hein 1998, p. 160).

In addition, it is well known that the design of museum exhibitions has an impact on visitors' responses. As Retsila (1996) notes,

> [In a museum] the organization of space, in the sense of the establishment of cross-references, rhythms and relationships between the objects and the elements of which the space is composed on the one hand, and between the environment and the visitors, on the other, is an expression of the messages and aims, the rules and values of those responsible for its design.

When visitors to art museums have the opportunity to express their feelings and to articulate their responses to their experiences, they often richly illustrate their personal meaning making. For example, Douglas Worts of the Art Gallery of Toronto installed cards for visitors to fill out in the museum's introductory exhibit to record their responses. Worts notes that in their responses people often drew pictures of themselves looking at a work of art and explained the significance of the pictures in accompanying text. According to Worts:

People seem to want to see themselves reflected either literally or symbolically in their imagery-- and in their writing. This has been an important psychological phenomenon for gallery staff to become aware of - people want to see themselves reflected in their visits to museums (Worts 1993, 48).

Worts, like the museum educators previously mentioned, encourages visitor interaction with the exhibit and demonstrates that providing an arena for personal reflection engages visitors in an insightful response to their museum experience.

Not surprisingly, art museum educators are interested in the type of people who are most likely to visit art museums. In her study of psychographic dimensions that influenced adults' leisure preference choices, Marilyn Hood found that six attributes are basic in their decisions to visit or not visit a variety of places ranging from zoos and arboretums to historical sites and art museums. These are, in alphabetical order: (1) being with people, or social interaction; (2) doing something worthwhile; (3) feeling comfortable and at ease in one's surroundings; (4) having a challenge of new experiences; (5) having an opportunity to learn; and (6) participating actively. Based on a study at the Toledo Museum of Art, she claimed that art museum visitors favoured having an opportunity to learn, having a challenge of new experiences and doing something worthwhile in leisure time. Conversely, non-visitors and infrequent visitors favoured the other three (Hood 1983).

THE VISIT TO THE MFA

The design of the field trip and its evaluation considered the theories and suggestions described in the works discussed above. All of the fifteen students were non-art majors with little or no previous art experience. As was revealed during class discussions about the impending trip, approximately half of them had little or no familiarity with the MFA. This lack of experience with the MFA was indicative of their overall museum experience; seven students reported that they had never visited an art museum, and three students reported that they had visited an art museum only once. Of the fifteen students, only two stated that they had visited an art museum other than the MFA on more than four previous occasions. Thus, it seemed prudent to familiarise the group with the gestalt of the architectural space of the MFA and to select a limited number of objects to study in depth. In addition, the instructor devised ways to observe and study the students' reaction to the museum experience, thus enabling her to consider more efficient museum field trip designs in the future.

At the conclusion of the class meeting prior to the museum field trip, the students were instructed to meet in the main lobby of the museum at the start of the next class session. Upon arriving at the museum, the instructor distributed to each student a copy of an official MFA map entitled *Highlights of the MFA: Discover Some of Our Great Works of Art.* The map contained photo reproductions and a corresponding paragraph of information about fourteen objects in the museum and a floor map directing the visitor to each object. The information contained on the map included perceptual, historical and personal information, similar to that suggested by Csikszentmihalyi and Robinson. Using the map was intended to allow those in the group with no experience of the MFA to take in the gestalt of the architectural space

while examining a select number of objects. It also provided a means to focus and direct the visit for all the students.

After distributing the maps, the instructor explained that members of the group would attempt to locate and spend approximately five minutes studying and discussing each object according to the information provided on the map. Once review of an object was exhausted, a student would be asked to lead the group to the next object by following the map until all students had taken a turn as leader (two students shared the task at one point so that all students ended up acting in this role). Having students assume a leadership role in locating and discussing each object provided the instructor with the opportunity to assume the role of participant-observer. The instructor recorded observation notes of the visit.

At the conclusion of the visit, each student was given a two-part assignment to be completed before the beginning of the next class meeting consisting of a one-page paper and a drawing. The following sentence was to be completed verbally and visually; "For me, the museum visit was . . ." During the next class meeting, while students worked on individual projects in the classroom, the instructor interviewed each student individually for approximately seven minutes in a small room adjacent to the classroom asking each student how her drawing illustrated the assigned sentence completion.

At the end of this class, a second data collection task was assigned for the beginning of the following class meeting consisting of a two-page paper in which students were to chose any favourite object they had noted in the museum (whether on the tour or not) and describe the route they would take to find the object again. Finally, each student was asked to complete a third task, the leisure time criteria survey created by Marilyn Hood (1983).

The fifteen female students enrolled in the Introduction to Art Education course varied in age between 19 and 26 years. They came from a range of socio-economic and cultural backgrounds including three students who received tuition assistance, one foreign-born student, two students of foreign-born parents, and two students who were the first of their extended families to attend college. They came from a wide range of disciplines. Only one, an English major, could be classified as majoring in any subject associated with arts or humanities. Prior to this class, students had taken anywhere from zero to three high school or college level art courses. The number of previous visits to the MFA ranged from zero to 50 among the group. Three of the students reported that they had been to the museum frequently (8, 50, and many times) while another three reported a moderate number of previous visits (4-5 times). The rest visited three times or less in total. Their visits to other art museums were also limited. Table 1 provides a breakdown of the students' backgrounds. Student names are pseudonyms.

Table 1. Students' background Information

Student number and name	Age	Major field of undergraduate study	Prior number of high school or college art classes	Prior number of visits to the MFA	Prior number of visits to other art museums
1. Diana	21	Nursing	1	3 or 4	0
2. Jane	20	Physical Therapy	0	1	0
3. Carrie	21	Pre-medicine	0	0	0
4. Beth	21	Special Ed. /Psyc.	0	1	2
5. Lilly	20	Psychology	3	50	5
6. Alexia	21	English	3	2 or 3	1
7. Sarah	26	Education	1	8	1
8. Christine	21	Management	3	3	0
9. Brook	20	Physical Therapy	3	2	0
10. Erica	20	Special Education	3	Many time	5
11. Ellen	20	Physical Therapy	0	4	3
12. Amy	20	Nursing	1	1	0
13. Melissa	20	Psychology	2	2	1
14. Margi	19	Psychology	2	2	0
15. Sara	20	Physical Therapy	2	5	2

The majority of students would be classified as museum novices by criteria used in the relevant research literature. Only Lilly and Erica, and perhaps Sarah could be considered as experienced visitors to the MFA or to art museums in general.

This action research study (May 1993) used a combination of qualitative methods and analysis (Patton 1990). Sources included (1) instructor's observations during the museum visit as a participant-observer (Lofland and Lofland 1971) recorded immediately after the visit; (2) the one page paper and drawing assignment that completed the sentence "For me, the museum experience was . . ."; (3) interview transcripts; (4) the two page paper that described a favourite object; and (5) results from the leisure time criteria study. Reading and re-reading the different sources provided emergent themes, and, for any one student, the five data sources together were examined for consistency and commonality (Denzin 1970).

FINDINGS

Assignment (1) The One Page Paper

Evidence from the one page paper in which students were set the task of completing the sentence, "For me, the museum experience was . . ." reveal four general

categories of response to the trip. These are listed below in order of increasing satisfaction.

1) One student (Diana) felt disappointed with the trip as her "expectations were not met."

2) Three students, Amy, Melissa and Sara, who, despite appreciating the structure of the trip became frustrated and overwhelmed because there was "so much to see and not enough time."

3) Jane, Carrie, and Beth started out feeling anxious, embarrassed, and uneasy due to having little experience visiting art museums, but overcame these emotions to "have fun learning" about the objects and expressed the view that they "can't wait to go back."

4) Eight students, Lilly, Alexia, Sarah, Christine, Brook, Erica, Ellen, and Margi enjoyed all aspects of the trip, referring to the museum as "an old friend," the trip "a familiar and pleasant one," and describe it as a "journey," and an "adventure."

By and large, the findings from the one page paper assignment support Falk and Dierking's (2000) contention that some combination of previous knowledge, degree of experience, mood, and expectations influence visitor response to any museum visit. But the categories of response cut across the simple classification of students by previous experience. For example, although some students who could be considered novices reported frustration, other novices report enjoying their museum adventure.

Assignment (2) The Drawings

The drawings were created on 8 1/2 x 14 in. sketchbook paper. Students used a variety of media to create the drawings including coloured pencils, pastels, watercolours and charcoal. Examination of the drawings, combined with transcripts of the students' descriptions from the interviews, reveal subject matter which can be summarised into the following general categories:

1) Drawings that illustrate a personal statement or memory (Melissa, Diana, Jane, Alexia, Brook, Ellen, and Sarah).

2) Drawings that illustrate a pleasing object (Jane, Christine, Ellen, Melissa, and Sara).

3) A student who didn't like the object she chose to draw, but was somehow impacted by it (Erica)

4) Students who drew self-portraits (Lilly, Amy, Margi, Carrie).

The results from the drawing assignment support Worts' contention that both novice and more experienced visitors like to see themselves reflected in their museum visit as is evidenced by the students who choose to draw self-portraits. Evidence from the drawing assignment also supports McDermott-Lewis's research that novices prefer pretty, recognisable subject matter as evidenced in the drawings of pleasing objects, that novices appreciate art that can be used as touchstones for personal associations [or] memories, as evidenced in the drawings that illustrate a

personal statement or memory, and that more advanced visitors, such as Erica, tend to challenge themselves to engage in more difficult subject matter.

Assignment (3) The Favourite Object

Table 2 lists the favourite objects chosen and whether they were on the tour or not. The responses ranged from single object to the contents of entire rooms and some selections of multiple objects. Although the group only stopped in front of the 14 objects illustrated on the map, a number of students chose favourite objects that were not on the map. In fact, of the fifteen responses to this assignment, seven students mentioned objects that were not on the map compared to five students who mentioned objects that were. Three of those students who chose to describe more than one object included objects or areas not on the tour as well as something included on the tour. From the instructors' perspective of this carefully structured field trip, reinforced by her observations that the only official stopping points of the tour were at the fourteen selected objects, is seemed self evident that the students would chose among the designated objects in selecting their favourite. But, the students' experience was based on their interests, previous knowledge and attention focus which did not match that of the instructor. At some of the stops, they wandered around the room, observing different objects while the group discussed the chosen one. For example, even though the exhibit of glass sculpture was not on

Table 2. Favourite Objects

Student	Object Chosen	On tour	Not on tour	Objects on and not on the tour
Diana	Model rooms from Oak Hill mansion	X		
Jane	*Daughters of Edward D. Boit* by John Singer Sargent	X		
Carrie	*The Madonna in Clouds* by Donatello	X		
Beth	*Fancy Slingbacks* by Carol Cohe		X	
Lilly	Black canvas with yellow square		X	
Alexia	A door from the museum		X	
Sarah	*The Madonna in Clouds* by Donatello	X		
Christine	Gold bracelet of a Nubian queen	X		
Brook	*Deer Skull with Pedernal* by Georgia O'Keefe		X	
Erica	Black and vibrant blue painting		X	
Ellen	Anything in the music room			X
Amy	*Fancy Slingbacks* by Carol Cohe		X	
Melissa	Nubian or Glass exhibit			X

| Margi | *Hot Still-scape for Six Colours–Seventh Avenue Style* b Stuart Davis, Glass Exhibit | | | X |
| Sara | Museums' glorious entrance, Egyptian exhibit, European paintings, Impressionist exhibit | | X | |

the tour, a number of students were apparently affected by it: two students mention the exhibit in their one page paper, four students include an object from the glass exhibit in their drawing, and three students mention objects from the glass exhibit as among their favourite objects. In short, what made an impression on them was apparently dictated to a large extent by their personal agendas. This finding supports constructivist theories as outlined by Hein (1998) and by Silverman (1995) that even tightly controlled pedagogic situations are conducive to personal meaning making on the part of the student.

Assignment (4) The Leisure Time Criteria Survey

This data was intended to help to determine the extent that students' characteristics matched those identified by Hood (1983) as typical of those who frequent museums versus those who prefer other leisure-time activities. In this survey, categories 2 (Doing something worthwhile), 4 (Having a challenge of new experiences), and 5 (Having an opportunity to learn), corresponded to Hood's findings of who would be a likely museum visitor. Category 1 (Being with people, or social interaction), (3) (Feeling comfortable and at ease in one's surroundings), and (6) (Participating actively), corresponded to Hood's findings of who would not be a likely visitor. Table 3 illustrates findings from the Leisure-Time Survey results.

Table 3. Leisure-Time Survey Results

Student	Leisuretime criteria chosen	Numbers associated with art museum goers*	Numbers associated with non-art museum goers*
Diana	3	None	3
Jane	1, 2, 3, 6	2	1, 3, 6
Carrie	1, 2, 3, 4,	2, 4	1, 3
Beth	2, 3	2	3
Lilly	2	2	
Alexia	1, 3	none	1, 3
Sarah	1, 2, 3, 5	2, 5	1, 3
Christine	2, 3, 4, 5	2, 4, 5	3
Brook	1, 2, 3, 4, 6	2, 4	1, 3, 6

Erica	1, 3, 4, 5	4, 5	1, 3
Ellen	3, 5, 6	5	3, 6
Amy	No response		
Melissa	1, 2, 3, 4, 6	2, 4	1, 3, 6
Margi	1, 2, 5	2, 5	1
Sara	3, 4, 5, 6	4, 5	3, 6

* from Hood's (1983) findings

The students in this study are clearly not readily identified as individuals who typically prefer the art museum experience as a leisure time activity. Both those with significant previous art museum experiences and those with little voluntary exposure include members who prefer leisure time activities associated with each classification. Hood's criteria, identified a generation ago among adult art museum visitors, may not apply to current college students. Or they may not be adequate to apply to single, forced visits as part of a higher education course requirement.

INTERPRETING STUDENTS' RESPONSES

Orientation

One purpose of the field trip was to familiarise the students with the museum space, to overcome the problems associated with the need for human beings to orient themselves in unfamiliar surroundings and achieve a sense of comfort in physical settings (Hiss 1990, Falk and Dierking 2000). The carefully structured and controlled trip, with the use of the building map and the requirement that students take responsibility for much of the guidance throughout the building, appears to have contributed to an increased sense of comfort with the architectural space, no matter how they felt about the trip as a whole. For example, even though Diana found the trip "disappointing" she acknowledges that "if the goal of the trip was to find one's way around the museum, then it served its purpose." Sarah, who entered the museum feeling "nervous and a bit anxious", found the design of the trip "extremely helpful." She writes:

> The assignment itself was extremely helpful for me. Usually my visits are brief because I am overwhelmed with the amount of art to view and also because the set up of the museum is confusing to me even if I follow a map. One thing that was great about this visit is that I discovered rooms that I never knew existed. Having to use the map to find specific objects helped me to see the depth of each piece of art, whereas I usually have the tendency to cluster all of the art from one section together and never take time out to study one piece in depth. (Student paper)

Amy, also one of the group of students who described herself as frustrated, reports that due to the structure of the trip:

> I now have a better overview of the types of works in the museum and [the museum's] layout. (Student paper)

Erica, in her paper, states that:

> Unlike a normal trip to the MFA which bores me to death and turns me off from
> visiting a museum independently . . . In contrast, our visit was just that, *ours*. We
> were given the opportunity to lead ourselves and go at our own pace through the
> museum. It gave me a chance to look at other things besides the piece at each
> numbered destination. (Student paper)

Although the reasoning behind individual responses to the orientation were varied, it was clear that taking in the gestalt of the architectural space, much like a long distance runner will stake out the course route before a race, provided a degree of familiarity with the environment and had a comforting affect on all students.

Novice And Advanced Responses

As might be expected from the literature cited previously, and from the evidence in Table 1, a number of students' responses reflected their novice status in this museum, although this classification does not account for all responses. Novices were distinguished particularly in reference to superficially pretty or recognisable pleasing images, evident in Christine, Ellen, Melissa and Beth's drawings, and the desire to illicit personal memories evident in Melissa, Diana, Jane, Alexia, Brook, Ellen, and Sarah's drawings. For example, Christine has this to say about her drawing of the door from the exhibit of the rooms from Oak Hill:

> This one is taken from Oak Hill mansion, it's the door that we found. And, I just
> thought it was very beautiful because of the way it was decorated, although, I don't
> quite like the green color. But it was just so ornately designed. And, the details that
> went into it, it really just caught my attention. And, as we discussed in class, you
> had said that it had probably been an inside entrance. Which I was surprised about.
> Um, just because I would want to display it outside so that everyone would be able
> to see it. I just thought it was very interesting, and the designs, when usually you
> don't see hearts in any sort of art expression too much. But I thought it was very
> beautiful. (Student interview)

While Christine's drawing focuses on what the subject *looks* like, Sara's drawing focuses on what the subject *feels* like, in this case her memories of New York City:

> I drew the Stuart Davis 'cause when I think of New York City I think of chaos and
> bright lights. Instructor: *Does this painting remind you of New York City and chaos
> and bright lights?* Sarah: Yeah, from being there. I haven't been there for a long
> time, since I was younger. But, even when it's perceived on television . . . on the
> news, all of the things that are happening. Especially, I think it reminds me a lot of
> new years . . . or the fourth of July. 'Cause of all the bright things that always
> happen. (Student interview)

In contrast, some students with more experience demonstrate their advanced amateur status by focusing on challenging objects rather than on ones that were easy for them to like. Erica, who reports having made many previous trips to the MFA, draws her interpretation of a painting she did not like. She discusses her choice of subject matter in her interview:

> This wasn't my favorite piece that we saw at the M.F.A. but this was the one that
> really stuck out in my mind. And I haven't gone back to see this yet, and I do want
> to try and do that because I don't remember exactly what it looked like. This is all I
> remember, the black and the yellow box. And, it just stuck out in my mind, I don't
> know why. I was trying to think of other things that I liked, and I just kept coming

back to this. But I didn't even really like it that much . . . I just like the dramatic
colours I guess, the black and yellow. (Student interview)

Range of Responses

The first assignment, the one page paper describing students' responses to the trip,
illustrates the dramatic range of their feelings about the experience, regardless of
their degree of familiarity with the MFA. While some students, all with limited or no
previous exposure to the museum, eventually became comfortable with the trip
(three students in group 3 as described in the first paragraph in the findings section)
eight students in group 4 (of the same classification) including all those with more
previous exposure, but also some novice visitors, enjoyed the trip from the
beginning. Another student (Diana), who reported having visited the museum 3 or 4
times, felt disappointed, and still others, whose previous numbers of visits ranged
from 1 to 5, reported feeling frustrated and overwhelmed (three students in group 2).

The range of responses is as dramatic as they are varied. Jane, a member of
group 3, finds that her comfort level with the field trip is directly related to her
comfort level with the group, "I found this group effort less intimidating and [the
information and conversation] opened my mind up to ideas about art from different
perspectives."

Ellen illustrated her response when she wrote:

> I enjoyed following the map, finding the object on the map, and learning more
> about it . . . I have always gone to the same places in my previous visits and I was
> getting tired of going to see the same things. (Student paper)

Diana, who was disappointed in the trip, "would have liked to have had a bit
more freedom to look around the museum at my own leisure and focus on the things
that I found most enjoyable." The three students in group 2 mention their frustration
in trying to absorb so many stimuli in such a short period of time as the primary
source of their frustration. For example, Margie notes that, "The [museum]
experience was overwhelming for me because there was so much to see and not
even close to enough time." It is worth noting that those who enjoyed the field trip,
the students in groups 3 and 4, all mention the external stimuli of the experience —
the other members in the group and the official map — as providing them with their
level of comfort, while those who did not enjoy the trip all mention internal sources
such as frustration and exhaustion as being responsible for their level of discomfort.

Personal Meaning Making

Taken as a whole, analysis of the data illustrates the importance of personal meaning
making during this structured museum visit. First, although the instructor planned a
tour focusing on specific objects, the participants chose their own stopping points
and focused on objects that interested them, to the extent that they were able. More
than half of the students describe an object or setting that was not on the tour as their
favourite. Of these students, four chose the glass exhibit and two specified Carol
Cohen's glass sculpture *Fancy Slingbacks*.

Second, their comments often revealed highly personal responses to works either in the tour or not. A particularly striking example is Sarah's response to the paintings hung in the reconstructed Oak Hill Dining Room (19th century).

> After leaving the gallery where we stayed about five minutes, a student started telling me how much she hated the paintings that were hung near the Oak Hill exhibit, "when I was a child, I had to stay in a house in Maine with my parents during the summer. Their friends lived there. The bedroom where my sister and I slept had paintings like those all over the walls. We were terrified of them. I still can't look at them without getting scared, I guess, because I just now couldn't wait to leave that room." (Observation notes)

Other students provided evidence that deep personal interests dominated their thoughts regardless of the content of the tour. Despite the level of control that Diana finds so distressing, she is able to engage with a religious object that speaks to her interests and to remember it. She explains her drawing as follows:

> I [drew] this . . . statue of Jesus . . . because it was very striking when we walked by it, and I couldn't help but be taken aback by it It probably struck me more than anything else that we did see. I mentioned in a previous class that I've been getting more religious lately, and so anything with a religious connotation seems to strike my fancy. (Student explanation of drawing)

Likewise, Ellen recalls a vivid memory from her childhood upon seeing the sideboard that was included in the exhibit of the rooms from Oak Hill:

> My mother . . . used to say 'side the table' and I used to ask her what she meant? And she told me that when she was young she had to side the table. And what you do is you take the dishes and you put them on a sideboard. And I have always wondered well, what is a sideboard? And seeing this in the museum, a sideboard, completes the whole thing so I visually know what a sideboard is when my mom says, "side the table." (Student explanation of a drawing)

Another way in which the primacy of personal meaning making is expressed is through student drawings that focus on the experience — either personal or in conjunction with the group — rather than on a particular object or scene from the museum. Lilly, Amy, Margi and Carrie all include a self-portrait in their drawings as illustrations of this type of response. Margi attempts to portray cohesion in her group portrait of students viewing Stuart Davis' painting *Hot Still-Scape for Six Colors-7th Avenue Style:*

> What struck me was . . . how many different types of people that were there, all looking at the same objects. I tried to keep this in mind [when I drew my drawing]. The empty frame symbolizes the fact that the picture is all the same to everyone. Not the actual interpretation wise, but the actual visual picture itself is the same. And all the colors around it symbolize all the different types of people, the different cultures, ages, everything, that come to see paintings. (Student explanation of drawing)

By contrast, Amy attempts to portray a lack of cohesion in front of the same painting:

> By the time we got to the Stuart Davis one, we weren't really this cohesive. We were kind of doing our own thing. And I felt that it wasn't as much of a group activity, because we were all looking at different things, and stopping at different things. So I guess that's why I drew this, because this is how I really thought of

everyone at first, and I was really excited to be there, and ready to go.
(Student explanation of drawing)

Lilly, despite her fifty previous visits, acknowledges being very tired the day of the field trip. She includes a drawing of this emotion along with a drawing of feeling happy about being in the museum:

> At the top of the picture I did a heart encircling a coin, a coin figure from the piano that we saw last. Um, the piano had all these circles on it with Greek mythology portrayals on it, and I love Greek mythology, so that's why I put the circles in the heart. Going clockwise, looks to be scribbles, but is actually the confusion that's going on in my head of what I was supposed to be thinking. I was like in a daze, I think I was so tired that day. So, I was just like very numb. Um, next is a happy face, 'cause, um, I really love being in the museum, and I really enjoy myself in a museum. And it's smeared because I felt like I was going through it really fast. So, that's the motion. (Student explanation of drawing)

By contrast, Carrie, with no previous museum visits and despite her contention in her one page paper that she enjoyed the field trip, draws a self-portrait illustrating the confusion she felt during the trip:

> I attempted to draw myself . . . with an unhappy frown. And this is supposed to be my brain, and, with all the gray arrows are coming out. Because, to me, the color gray is like shady, and you really don't understand. And then, I just put blurbs of color everywhere because that's all I really got out of the museum. Just blurbs of different colors. And, just arrows going every which way from my brain because there was just so much, and my brain was just going in so many different directions, and every arrow is a different color, and they are going every which way, because all these colors, that's all I got out of it. (Student explanation of drawing)

The above statements made about the drawing assignments support research findings outlined previously, specifically Worts' findings that visitors want to see themselves reflected in their visit. Comparisons between data collected from the one page paper and the drawing assignment reveal similar findings: like most visitors, these students were affected by the mood in which they entered the museum and the level of comfort they felt with the idea of visiting an art museum. Their comfort was based, to a significant degree, on the number of previous visits.

Variable Responses

Further comparison between the data from the one page paper and the drawing assignment reveal two new findings not mentioned in the literature. First, some students provided contradictory responses in the two data collection modalities: writing and drawing revealed different aspects of the experience. For example, while Diana responds in the one page paper that she was disappointed with the visit, she also acknowledges being struck, in a positive sense by the figure of Christ on the cross and she chooses it for her visual response. Conversely, Carrie who responds in the paper that she overcame her nervousness to find the trip extremely exciting and fun visually responds to the frustration she experienced during the visit. For Diana and Carrie as least, the museum experience provoked multiple emotions.

Apparently, the opportunity to respond verbally *and* visually provided these students with two distinctive formats that could accommodate quite different kinds of responses.

A closer examination and comparison between responses to assignments 1 and 2 highlights the second new finding. When responding to assignment 1, students reflect *back* on the experience, and write about how it *was* for them to visit the museum, often reflecting on the gestalt of the experience. Even if they describe their feelings about the visit, the language they use is descriptive and matter of fact. Their responses are illustrative of what Dewey (1933) as well as more recent writers (Schon 1983) describe as critical reflection on experience. When responding to assignment 2 (the drawing), all students with the exception of Alexia and Brook, *relive* the experience, and visually respond to how it *is* to be in the museum, often focusing on a single object and never mentioning more than five different objects or reactions. Reflecting back in writing is primarily an intellectual activity, a rational re-examination of action that does not necessarily include a strong emotional response. Reliving an experience in drawing is more likely to trigger a reoccurrence of the emotions originally experienced. The change in focus from rational response to an expressive one supports Susan Langer's theory that art — unlike discursive language, which is governed by the laws of syntax — has the ability to engage us in an emotional response. According to Langer, "Art is the creation of forms symbolic of human feeling" (Langer 1963, 345). That is, the absence of syntactical rules allows the artist added freedom of expression, which can translate to more immediate emotional engagement for artist and viewer. Thus, re-enacting the gestalt of the trip made more sense in the written format, while mentioning feelings made more sense in the visual format.

SUGGESTIONS FOR DESIGNING A GUIDED MUSEUM FIELD TRIP

This research is consistent with previous findings of less structured museum experiences — the more exposure one has to the works of art and the museum environment that houses them, the more comfortable he/she will be during any museum field trip. Also, previous knowledge, degree of experience, mood, and expectations affect visitor response to the museum and, regardless of previous experience, visitors continuously shape visits to match their personal agendas. But the combination of factors is so complex that generalised predictions about particular visitors' responses are dangerous.

Two new discoveries were made from this study: 1) Requiring students to respond verbally and visually provided them with distinctive formats that could accommodate complex and contradictory responses; and (2) re-enacting the gestalt of the trip made more sense to students in the written format, while mentioning feelings made more sense to students in the drawing format. This research study demonstrates that even in a highly structured field trip, these students, who could be considered novice and advanced amateur visitors, were able to construct personal meanings and gain deeper insight into a variety of works of art due to the design of the trip and the dynamics of the group. Requiring students to complete several post-

field trip assignments allowed them to consider and reflect upon their wide range of cognitive and emotional responses to the trip. Findings from this study provide an important lesson for instructors: expect a diversity of response to your required activities (in this case a museum field trip) and organise accordingly. The following suggestions for designing a guided museum field trip emerged from these findings. These may be appropriate for adoption by other instructors planning similar work:

1. Show slides of what students will see before the field trip. Focus the slide lecture on the perceptual, historical, and communicative (personal) dimensions of each object to be studied. Familiarising students with works of art provides them with feelings of "connectedness" and "familiarity" so often cited as important by regular museum visitors as well as by several students in this study.

2. Design the field trip to maintain maximum control over the type and amount of stimuli to be studied during the trip. Use an official museum map if one is available and suggest that students take turns assuming the role of group leader. This tactic enables them to share in the responsibility of the trip. While in the museum, consider the gestalt of the architectural space. All the students, no matter how they felt about the trip overall, reported that taking in the gestalt, and for some, assuming the role of group leader, had a comforting effect as it familiarised them with the space.

3. View only a few works during any single visit; make several visits during a semester if necessary or possible. Despite the comforting effect that taking in the gestalt had on students, a large number of students reported feeling "tired, overwhelmed, or confused" during the museum visit in their one-page papers or when the instructor interviewed them about their drawings. Viewing half as many works, or even fewer, might have eliminated much of this problem.

4. Provide a change of stimulus if possible in order to avoid museum fatigue. This group was in the museum for an hour and a half, which is a long time to try to focus on any task, especially one that involves so many stimuli. Fatigue, whether felt before the visit or as the visit proceeds, is an indication that a change of some kind is needed. A break at the museum cafeteria can prevent these feelings.

5. Post-museum assignments should provide students with the opportunity to respond authentically to the trip. Using a variety of media such as writing and drawing enables students to reflect on their range of cognitive and emotional responses. From these assignments, expect and welcome a diversity of responses from your students, as no two people experience the museum in quite the same way.

Meg Black completed a Ph. D. in the Educational Studies Program at Lesley University in 2000. She is a practising artist and has taught art education at several Boston area colleges.

George E. Hein is Professor Emeritus in the Graduate School of Arts and Social Sciences at Lesley University.

REFERENCES

Csikszentmihalyi, Mihaly, and Rick Robinson. *The Art of Seeing.* Malibu, CA: J. Paul Getty Museum and Getty Center for Education in the Arts, 1990.

Denzin, Norman K. *The Research Act: A Theoretical Introduction to Sociological Methods.* New York: McGraw-Hill, 1970.

Dewey, John. *How We Think*, Boston: D. C. Heath, 1933.

Falk, John, and Lynn Dierking. *Learning from Museums.* New York: Rowman and Littlefield, 2000.

Getty Center for Education in the Arts. *Insights: Museums, Visitors, Attitudes, Expectations.* Malibu, CA: Getty Center for Education in the Arts and the J. Paul Getty Museum, 1991.

Hein, George E. *Learning in the Museum.* London: Routledge, 1998.

Hiss, Tony. *The Experience of Place.* New York: A. A. Knopf, Inc. 1990.

Hood, Marilyn. "Staying Away: Why People Choose Not To Visit Museums." *Museum* News, 61.4 (April 1983) 50—57.

Lofland, John, and Lyn Lofland. *Analyzing Social Settings.* Belmont, CA: Wadsworth, 1971.

Langer, Suzanne. "The Symbol of Feeling." *Aesthetics and the Philosophy of Criticism.* Marvin Levich. (ed.). New York: Random House, 1963. 334—351.

May, Wanda. "Teachers-as-researchers or Action Research: What is it, and What Good Is It for Art Education?" *Studies in Art Education*, 34.2 (1993): 114-126.

McDermott-Lewis, Melora. *The Denver Art Museum Interpretive Project*, Denver, CO: Denver Art Museum, 1990.

Melton, Maureen. *Museum of Fine Arts, Boston (Art Spaces).* Boston: MFA Publications, 2002.

Patton, Michael Quinn. *Qualitative Evaluation and Research Methods*. 2nd, ed. Newbury Park, CA: Sage Publications, 1990.

Retsila-Anzoulatou, E. (1996) "The Museum as Artificial Environment and the Experience of Place and Time in It," in E. Karpodini-Dimitriadi (ed.) *Ethnography of European Traditional Cultures: Society, Cultural Tradition, Built Environment.* Athens: Singular Publications.

Rounds, Jay. (ed.). *Meaning Making in Exhibits. The Exhibitionist* 18.2 (Fall) 1999.

Schloder, John E. *The Visitor's Voice: The Cleveland Museum of Art.* Malibu, CA: Getty Center for Education in the Arts, 1990.

Schon, Donald. *The Reflective Practitioner.* New York: Basic Books, 1983.

Silverman, Lois. H. "Visitor Meaning-Making in Museums for a New Age." *Curator,* 38.3 (1995) 161—70.

Worts, Douglas. "Making Meaning in Museums: There's a Lot to Learn," *Pathways to Partnerships: Linking Collections with Educators, Curators, Guides, and the Community*: Museum Education of Association of Australia and Museum Education Association of New Zealand Conference Proceedings. Melbourne, Australia: Museum Education Association of Australia (Victoria Branch), 1993.

VERONICA SEKULES

THE CELEBRITY PERFORMER AND THE CREATIVE FACILITATOR: THE ARTIST, THE SCHOOL AND THE ART MUSEUM

Abstract. This chapter explores the development of the role of the artist as teacher and workshop facilitator in the context of the art museum. Drawn from research projects over ten years, it suggests that the character of such work needs to develop within a climate of understanding of the different cultures of museum and school, respecting the integrity and distinctiveness of each contribution. Artists' workshop methodology has derived mainly from current artistic movements and practices, balancing between the roles of artisan-craft-worker, celebrity performer, issue-based activist, and conceptual thinker. As creative facilitator, the artist can develop a role which is both valuable for professional development and of enduring value in museum education. If it is developed in partnership alongside school teacher and museum educator, it can also be strategically powerful in developing towards an education which is sensitive to individual strengths, interests and ambitions.

INTRODUCTION

During a round-table conference in Grenoble, held towards the end of the year 2000 for a European Union Socrates teacher training project, an international group of advisory teachers, artists, museum educators and curators, were discussing the role of the work of art in education work between museums and schools.[1] The subject arose of the role of artist-run practical workshops in museums, for teaching about contemporary issues in art. Alice Vergiara-Bastiand, curator of public programmes at the Magasin, Centre for Contemporary Art, argued strongly against the practice. She declared that it was not the job of artists to teach in this way:

> "I don't believe in this custom of artists' residencies and workshops in museums', she declared. 'The artist is properly in residence in the studio, the teacher should teach in school, the museum is for viewing."

Education at the Magasin is organised around the principle that the artist has complete authority to communicate through the work being exhibited and should not be expected otherwise to speak about it (except in order to brief the guides), or to teach any theoretical or practical work.

> "The museum is culturally defined as a place for viewing and responding, not making and doing. We should not compromise the integrity either of the artist as studio practitioner or the teacher in the classroom by confusing boundaries between institutions, roles and expectations."

M. Xanthoudaki, L. Tickle, V. Sekules (eds)
Researching Visual Arts Education in Museums and Galleries, 135-149.
©2003 Kluwer Academic Publishers. Printed in the Netherlands.

A few months later, a manifesto for the arts in education was announced in France by the then Minister for Education, Jack Lang, according to which a hundred artists' residencies were envisaged as taking place in association with schools across the country. At another round table conference, this time in Paris, the place of cultural education and the relationship between teacher and artist in school was raised once more.[2]

> In my view, declared artist Gerard Garouste, 'cultural education is a didactic issue. It must be tackled by teachers who are specially trained, who can teach their pupils how a picture, a piece of music, a film, or a photograph 'function'. I don't believe for a second that the artist would achieve the same goal (Beaux Arts 2000, 61).

Some critics were concerned that quality would slip, that the best artists would keep away (Beaux Arts, 2000, 60-6). On the other hand, at the same occasion, there were strong arguments in favour of the legitimacy of the role of the artist as an educational practitioner, acting as a stimulus to deeper creativity. According to Jean-Jacques Paysant:

> We conceive of artistic creation as an instrument which can express personal autonomy, a critical vision which refers to matters essential to human existence. In art we have a medium of encompassing the political, of introducing, philosophy, even in the primary school. In this the role of the artist is essential. We know that artistic practice is elitist. Our objective is to create a climate whereby everyone can participate in aesthetic enjoyment without any social or cultural barriers (Beaux Arts 2000, 61).

What emerges from the debates in France, is a strong sense of respect for the clear definition of professional expertise. The artist has a particular contribution to make, and many would argue that this should be exclusively reserved for a specialist role as producer of art, exhibitor, a visual thinker able to express profound philosophical ideas. Understanding artistic creation is also a professional matter, but mainly for the teacher, who needs to be trained to respond creatively. But where should the boundaries lie? Should artists venture out of the studio to engage in formal education or not? Do school teachers need to acquire additional skills in order to respond to the work of the artist and should they reserve the exclusive right to their own profession to teach art? And where is the museum situated in this debate? In employing artists to teach practical workshops, are museums confusing their roles and shifting the cultural boundaries?

Precisely as Vergiara Bastiand points out, the museum, the artist, the school, the school teacher, have definable roles which have developed within distinct cultures, and many of the problems of bad communication or poor work which have emerged in past practice have arisen as a result of lack of understanding of the extent to which differences in culture have affected the nature of the work undertaken. Conversely, where cultural issues are confronted head on; where the role of each person involved is closely defined, there is more likelihood that each professional contribution will be able to thrive. Perhaps most important of all, there is a need for careful definition of educational aims and for sensitive differentiation between the range of outcomes which are most pertinent to each of the participants, for surely

they will have different priorities, different goals to reach and different measures of success.

Taking up some of these challenges, I would like to examine the role of the artist as a participant in formal education particularly from the perspective of the museum and art gallery. What contribution can be made by the involvement of the museum as a site of cultural exchange between artist and viewer? Can it offer an enrichment of the educational experience for schools in this field, or additional complications? To what extent can the involvement of the museum as a site for learning enable us to begin to look at the process of teaching about art, objects, artistic processes and all related and contingent disciplines, within a collaborative community of expertise? I will discuss some of these issues in the context of a number of applied research projects at the Sainsbury Centre for Visual Arts, in whose projects I have been initiator, project manager, sometimes co-tutor and always participant observer; and also from comparable data from other sites, where artists' workshop practices in the museum have led to different kinds of outcomes. Each project has implications for the debate about the kinds of values and skills which artists can offer in these situations, how they integrate with teaching in formal education contexts, and how results may be assessed across the different individuals and institutions involved.

HIGHLIGHTING DIFFERENT CULTURES:
THE ARTIST'S WORKSHOP IN MUSEUM AND SCHOOL

Artist residencies in schools in England were first initiated in the early 1970s. Reviewing the achievements of the practice almost twenty years later, the Office for Standards in Education in England (OFSTED), was generally supportive of many of the positive claims which were being made for their effectiveness. These included opportunities for pupils to develop good critical skills, to engage with their own cultural traditions and to widen their cultural experience, giving them a memorable 'peak' experience (Oddie and Allen 1998, 34-7). On the debit side, they quote research which has also revealed such work to be inconsistent in terms of reliable quality and of type and range of provision. Initially there was a tendency for teachers, especially non-specialist ones for 'getting an artist in' when the teachers needed to fill gaps in their own capability and knowledge (Sharp and Dust 1990, 17-18; Oddie and Allen 1998, 27-8). At worst, artists felt bewildered and ill-equipped to intervene, teachers were critical of their relative lack of teaching experience, time-scales for planning between schools and arts organisations were out of synchronisation and pupils were bored. The syndrome was characterised in Oddie and Allens' report as 'artist angst; teacher tensions; planning dissonance; pupil disinterest' (Oddie and Allen 1998, 46-7; Sharp and Dust 1990; Rose, et al. 1998).

While there clearly have been occasional disruptive clashes, artists have been able to make a very distinctive contribution to school education, sometimes in contrast to the prevailing educational ethos, sometimes in enhancement of it. It is apparent that in situations where the artist is well integrated into the school culture, he or she can make use of a training in innovative creative practice, to enrich the

curriculum and bring fresh inspiration at a number of levels. As well as emphasising improvement in artistic skill, as one might expect, artist-led education projects with schools, stress among their advantages, the importance of group work, confidence building, social learning and esteem development (Sekules 1984; Sharp and Dust 1990, 10-13; Oddie and Allen 1998, 49-78). Work with artists extends the boundaries of the kinds of knowledge, for example, practical and aesthetic, which contribute towards the widening of experience. Pupils are given a degree of responsibility and freedom to express opinions and ideas (Sharp and Dust 1990, 10; Robinson 1982, 24; Oddie and Allen 1998, 34-48). However, in order to operate successfully in school, with the notable exceptions of those few artists who have long-term residencies with studios, artists are often required to adapt to school culture rather than the other way round. While they might act as role models, showing the children what an artist does, it is normally in terms of productive labour rather than philosophising or challenging authority. Artists who have been most appreciated for teaching in school need to be able to get good results out of the lesson within a short time scale (Sharp and Dust 1990, 18-19). The ability to communicate clearly and demonstrate craft skill is more important than personal talent. 'Within education work you are employed for your skills and experience, there is little time or thought for the development of the artist' (Bicknell 2001).

In an attempt to aim at a meeting of minds, Michael Parks' contention, almost the opposite of that expressed in Grenoble by Alice Vergiara Bastiand, is that teachers in conventional education can adapt their skills from the methods employed by artists, becoming themselves more attuned to the natural artistry of teaching (Parks 1992). He categorises six attributes of artistic pedagogy which demonstrate both an efficient means of negotiation of professional standards and maintenance of personal integrity which the teacher could fruitfully adopt in the interests of developing the individual, and 'de-emphasising programmed formulae for instruction':

1) The role of communicator, able to introduce and argue especially for a personal point of view
2) The self-aware possessor of self-knowledge in tune with experience
3) The inquirer seeking after knowledge and truth, inventive and unconstrained by convention
4) The qualitative thinker
5) The belief in the value of technical knowledge and ability
6) Exhibition of the product as a means of seeking recognition, dialogue and feedback.
(Parks 1992, 55)

While this list of attributes might lead constructively to greater empathy, it would not necessarily help the teacher to engage in any change of culture, as what it neglects to consider are the fundamental differences in role and aspiration which condition attitudes to professional practice. The development of the exhibiting artist depends on expectations and customs which run counter to many aspects of school culture, and indeed of school-art practice. In absolute contrast to the clarity of objectives necessary in school, artists work with enigma and uncertainty, and are not

bound to explain anything about what they do. Artists are expected to push forward new boundaries, they are pre-disposed to innovate, try the untested and challenge authority. They can range freely into controversial subjects without moral judgements or clear right and wrong answers. In the context of an art gallery, the emphasis on questioning authority may be taken to further extremes. A gallery may, for example, establish value by consensus (the 'ready made' for example), or, it may be the agency through which a single artist's work may acquire the power to challenge and even shift existing values. An example of this was Martin Creed's Turner Prize-winning light/dark environment at Tate Britain in 2001 which questioned aesthetic values and had no commercial value. On the contrary, taken to an equally extreme level, the exam-oriented institution of schools values the orthodox, follows tradition, relies on the steady acquisition and accumulation of knowledge. There is a constant need, and a legal requirement on teachers to set clear aims, to follow clear and lucid paths to learning, to quantify results and aim for close targeting of achievements. It is not so much the emulating of artistic thinking which is needed, but the understanding by one system of the other. It is not a question of assimilation, but of collaborative development.

If the venue for communication and collaboration between artist and school is shifted to the art museum or gallery, the situation may become initially much more complex as the museum does of course impose its own authority and can in itself become an intimidating hurdle to be overcome. However, as a locus for education which has both formal and informal elements, the museum has the capacity to bridge the cultures of artist and school in a way which takes the spotlight away from the dominance of their differences, providing an environment and range of expertise which may complement the professional teaching of artist and school teacher. It can become a territory for educational exchange and experiment where questioning and personal development is the norm.

While museum education has its formal elements and orthodoxies, for the purposes of the present argument, I would like to emphasise aspects of its multi-sensory, polyglot culture which can lead to an ethos of open-endedness and discovery. This is most apparent within the art gallery, which can offer a repertoire of practice which can broadly be characterised as experiential, experimental, encouraging discovery; questioning authority; building upon a sequence of straightforward answers to lead out towards a broad range of ideas; keeping open a range of options for responses; looking at broad aspects of cultural context. (Moffat and Woolard 1999; Durbin et al. 1990; Hooper-Greenhill 2000; Hein 1998; Wilkinson and Clive 2001; Sekules (ed) 1998; Tickle and Sekules (ed) 1995).

For here I would argue in contrast to Alice Vergiara Bastiand, that the art museum especially can be a place not only for viewing and absorbing authorised information about the artistic work, but one where active exchange of experience between maker and viewer may be encouraged. Moreover, as an institution dedicated to the preservation of cultural values, the museum enshrines a sense of the continuity of disciplines (Bennett 1996). For the art gallery in particular, this makes it an especially pertinent site for experimental practical artists' workshops within a context defined by new exhibits and the shifting range of ideas and the dialogues which may be generated by them. The art museum, providing it is practically

equipped with discrete spaces for different activities, is also ideally suited for crossover between theory and practice of art in an environment of professional understanding of both. It can provide an environment for understanding and responding to art which includes discussion and making; which includes the active participation of the artist, and which also includes the collaborative involvement of pupils, school teacher and museum educator.

A GENEALOGY OF PRACTICE

Education in the museum can also provide an appropriate context for examination of artistic practice as a subject in its own right, for which the role of the artist as teacher is not only fundamental, but irreplaceable. Looking back to 1990, a climate in England when the Crafts Council was at its height and the notion of the 'crafts' had a strong identity, an exhibition at the Sainsbury Centre about the potters 'Hans Coper and Lucie Rie and their Pupils', gave an ideal context for exploring influence from teacher to pupil, as an educational exercise. It was two years after the Education Reform Act had first instituted the National Curriculum, among other things requiring teachers of all age groups to develop understanding and practice in the visual arts. Teachers, especially non-specialists in the primary years were anxious to improve their knowledge, so a research project was devised, which would also provide them with an opportunity for some timely professional development. Several of the artists who were represented in the exhibition were employed to offer 'master-classes', to a mixed group of teachers in primary and secondary education (some of whom were also artists), and also to professional full time artists with studio-craft businesses in the region.

While notions of influence and inspiration are common-place in specialist artistic education, their workings are little explored or understood. Artists often like to maintain a sense of mystery about the origins and development of their ideas, they can be reticent to talk about them. Crafts-people are often mute. ((Dormer 1997, 228-230; Sekules and Tickle 1997, 3-7) In the context of school, where there is an expectation that pupils will show their workings, the reverse is often true, giving teachers the responsibility of leading their pupils through uncharted territory in the course of making art. Perhaps it was because the context for the workshops was overtly about influences, perhaps it was also because they were speaking to a professional community in the context of the museum, but the artist-tutors were very ready to talk about their sources of inspiration. Each of them began their day by showing slides of their work and went on to show, in effect, how to reproduce it. Not surprisingly perhaps, all the pots made by participants each day showed a clear pattern of influence, in each case echoing very closely the style of the work of the artist-tutor. Results were thus completely different from one workshop to another. Sarah Radstone taught hand building and the work by participants mirrored the experimental cragginess of her assymetrical pots. Products from Julian Stair's workshop followed his method and taste for precision wheel-throwing. Pastiche art production is normally to be discouraged, but in the crafts, especially at this juncture in their history, mimicry and demonstration as passed down from skilled person to

novice was on the one hand, normal pedagogical practice, but on the other, an increasingly rare occurrence (Dormer 1994, 40-57). It operated here also as a means of self-discovery.

Much as in Howard Gardner's analysis of the practical problem-solving process of artistic creation, whereby an artist uses the crafting process to work through ideas, the participants were being taught how to 'achieve mastery' by creating something from apparently nowhere. (Gardner 1973, 274-6) In one instance the copying ethos seemed to work especially well. Mo Jupp made pots and figures by rolling out thin sheets of clay with a rolling pin and then forming and assembling shapes from the resultant flat or tubular modules. His works were ascerbic and political, yet, having talked about that, he was perfectly prepared to teach the technique alone, which he did engagingly, like a recipe class. His methods echoed the familiar context of the kitchen rather than the studio and his students had become active participants in a kind of genealogy of practice - skills, know-how, tacit knowledge, ideas and inner secrets being passed, as it were - down through the generations. Mo Jupp's session, as the one which was apparently the most focussed on technique, showed most clearly how the participants could build on their own familiar experience in the course of assimilating a new one (Dormer 1994, 10-24, Dormer 1997, 219). The chat during the session, which was taped and transcribed was, like the work, an entertaining hybrid between the worlds of domesticity and art.

The pattern of these workshops embodied Peter Dormer's notion of the dissemination of 'craft knowledge' and 'tacit knowledge' as a skill passed face to face from one practitioner to another (Dormer 1994, 10-24) and some of the research findings echoed his analyses, suggesting that a special discourse of practice exists in the crafts. The professional potters in the group, normally given to solitary practice in their own studios, claimed especially that they relished this rare insight into the ways in which other practitioners made their works, to be able to absorb methods and techniques and to listen, make, and learn from experience. Furthermore, the participants did not only learn technique, the way was open for them to learn about the way an artist thinks and to share in ideas (Sharp and Dust 1990, 13-14; Oddie and Allen 1998, 28, 34-35). Beyond art school there are few professional development opportunities for artists in mid-career to receive an injection of new skills and ideas, and carefully structured museum education has the potential to offer this as a valuable service.[3] In addition, the art museum provided a safe and professional context for the continuity of the discipline from makers working within a wider genealogy of practice. Participants had a frame of reference for the overall arguments, a cultural context for the debates about practical skill and influence, and a wider repertoire of examples of practice, which reached beyond those directly involved in the teaching and learning. The consequent professionalisation of the whole context undoubtedly set the pace for an accelerated level of learning.

FROM THE CELEBRITY PERFORMER TO THE CREATIVE FACILITATOR

The artist as craft-technician operates well as a teacher-demonstrator, passing on methods for making, sharing expertise, helping to raise the level of practice for an

adult peer-group. It is a role similar to the familiar pedagogic 'try-apply' method. 'I will show you what to do, now you do it'. Experienced adults know how to derive more than routine skills from the encounter. The try-apply method is common in artistic workshop teaching. However in the context of art gallery and museum education there are additional elements to do with levels of understanding and interpretation: the transformation of response into creative product, which can require a wider repertoire of pedagogic skill. Experimental projects which aim at thematic exploration of responses are ideal for cross-disciplinary teaching, shared between artist, museum educator and school, but for artists they can also provide exceptional opportunities to develop creatively as educators.

The 'Encompass Project' funded by the visual arts education professional development and advocacy organisation, **engage**, in 1999-2000, was organised in order to address and solicit 'good practice' in projects involving schools, art galleries, artists and families which tested artistic boundaries as well as organisational ones. Fourteen projects around England specifically emphasised innovation and experiment, prioritising the creative role of the artist as a catalyst for new work in school. Also, the art museum's role as experimental centre through which the hierarchy between teachers and artists, and between teachers and pupils, could be collapsed, was crucial. Each project required a complex network of collaborators and fundamental to their success were the values of co-operative planning, something which had been criticised as most often lacking in earlier reports (Nicol and Plant 2000; Sharp and Dust 1990; Oddie and Allen 1998; Gagola 2000). Even so, 'Encompass' could not satisfy every need and timetabling problems again highlighted the need for awareness of the different cultures of museum and school.[4] There was also an issue in a number of the projects about teaching skills and training. For while the artists might have been trained to practice within an open-ended cultural ethos, with one or two notable exceptions, they were not trained as such as teachers. Some found it difficult to push forward the boundaries of creativity for their pupils, without engaging them basically in copycat behaviour, producing work prescribed to a predetermined formula. Another problem of such projects involving artists as the primary educators, is also one of their strengths, in that their success depends on the artist's charisma, personal chemistry and communication skills. In each case the pupils had the artists as role models providing them with a kind of ritualised artistic licence, and freedom to experiment within prescribed limits.

For a growing number of artists, experimental practice beyond the studio can include education as a medium for providing an extension to exhibiting, or a real alternative which allows for equivalent professional development (Bicknell 2000, Harding 2001). There is a concomitant recognition by institutions commissioning education work from artists, that their work may be used to address creative or political issues in order to stimulate change or develop new thinking. Related to the celebrity phenomenon is the virtuoso artist-teacher who works experimentally in the context of museum and art gallery education. One internationally famous exponent of the virtuoso artist-educator trend is the American photographer and teacher, Wendy Ewald, whose portraits of, and ostensibly, by, children are in effect professional products produced in the educational orbit and intended to stand

comparison with any mainstream photographic exhibit.[5] To some extent mirroring the art-world phenomenon of the artist as celebrity, some artists working in education have cultivated, or more likely, had thrust upon them, a cult personality status. Operating around serious issues of political engagement, Polish artist-educator Janusz Byszewski has achieved considerable renown through projects and publications since 1990, as an educational artistic animateur, creating conceptual artworks with his participants inspired by responses to exhibitions in Poland, France, Germany, Sweden, Finland and the Netherlands. In an issue of *Engage Review* for summer 2001, Adela Zeleznik described some of Byszewski's methods which are based around the use of line as an organising force for ideas (Zeleznik 2001). Byszewski is clearly charismatic and generous in sharing ideas. But workshop practice of this kind, while having much in common with quite traditional classroom teaching method, operates on a different time-scale and within different educational parameters. It relies on carefully structured, quick-fire teaching methods based around plenty of creative ideas. Because of its rootedness in recent artistic practice which favours innovation and experiment, it is also differently nuanced from teaching within formal education and owes more to the open-ended ways of thinking developed within the art museum. Results are never judged in either a restrictive or developmental way. Both artistic and educational outcomes are left enigmatically open to interpretation.[6]

Les Bicknell is another one of a growing number of artists who realise that art gallery education work can be of service in their own professional development. Bicknell, a book artist and gifted teacher, uses the museum-education workshop as a creative tool, adopting his participants as agents and conspirators in the creative process which moves organically from response to product (Sekules 2001; Bicknell 2001; Nicol 2001):

> The idea that there could be many answers for the same question was an interesting one to explore......It was important for the teachers that I worked with to understand that there would be times when I did not have a lesson plan – when I stood in the middle of a lesson deciding what to do next, this was about using a different way of working, not a 'failure'. The idea of not having a right or wrong outcome is a difficult one to tackle within the confines of a school day, but this was continually explored by the participants and led to many intense and animated conversations (Bicknell 2001, 41).

In the above passage, Bicknell describes his use of the pause, the momentary indecision, almost as a deliberate device as a means of raising expectations, the class excitedly anticipating their next activity and then launching readily into it once the ideas began to flow again. He wanted the children to understand that the route between idea and product was unpredictable and that elements of surprise could often creep in along the way. He was in a sense exploiting the artist's right to preserve mystery, demonstrating the lack of need to 'show his workings' in proceeding to make work.

The disadvantage of celebrity and virtuoso working methods is the kind of legacy they leave in a formal educational climate otherwise geared, not towards enigma, but towards transparency of communication. It is all too possible for a school having worked with an artist at such an intense level to be left bereft and

unsupported, their normal routine disrupted, carefully constructed curricula upset (Sharp and Dust 1990, 25-28). Again, as Sharp and Dust and later on, Burgess, had already recommended in relation to artists in schools, one answer is to structure the organisation of such short-term projects in advance in such a way as to allow the teacher close involvement and to enable everybody to express a clear idea of their aims and contributions, so that the regular teacher can develop further ideas afterwards into the more routine school curriculum (Sharp and Dust 1990, 47-64; Burgess 1997, 115). It is perhaps also incumbent upon the teacher to reflect metacognitively with the pupils upon the different teaching and learning methods they had experienced. How did the artist's methods differ from those of the normal lesson? How did the artist establish values and measures of success? What did the pupils themselves learn most?

Examples of issue-based practice have been extremely numerous in the UK since at least the mid 1990s, during which time the Arts Council funded such projects under their 'Artists in Sites for Learning' scheme. For the artist, this is another kind of virtuosity, marked by more experimentation with ideas, and with innovative teaching practices which derive specifically from an artist's interests and visual concepts. Yinka Shonibare, prior to exhibiting at the Ikon Gallery, Birmingham in 1998, ran workshops in the local community which stimulated creativity about objects as reflections of personal and cultural identity. These both had a powerful and 'life-changing' impact on participants and extended the artist's own political and social messages, revealing more insights into his work (Gagola 2000, 15).

Less dramatically, artists may be employed in education as creative facilitators provoking both sensitive responses to art and interesting new practical work. During a collaborative project on 'body decoration' between the Sainsbury Centre, artist Sarah Florence and a local secondary school, the teacher commented that even the simplest 'show and tell' device used by the artist could be effective:

> "The very fact that Sarah brought examples of her work into school to illustrate some possibilities for the way things could be made, inspired the students. It extended their experience from the gallery as they could touch things and begin to think how the ideas we discussed could take concrete physical form."

An artist's engagement with an exhibition can start a group off with a clear creative purpose, allowing for very rich, multi-layered results. Working in partnership with a museum educator and teacher, this can open opportunities for multi-disciplinary work too. Sarah Florence often selects a theme which underpins an exhibition or group of work and she stimulates making which can then be followed through with teachers to develop broad ideas in art and other subjects. 'Transformation and evolution' was a modest practical exercise for teachers stimulated by responses to an exhibition of contemporary ceramics on display in September 2002, near a group of tiny antiquities. Talking all the time, supportively, but without a trace of authoritarianism, she guided them through the process of making, each person forming tiny figures in bright plastics, then adding new materials to change their forms. While she talked one could see how the teachers' own imaginations were rapidly leading them in widely different directions as they created miniature visual worlds engaging with many ideas from metamorphosis,

mythology, Pokemon, animals, order and chaos, disguises and fantasy tropical islands.

Practical projects between artists and schools can often lead to a wide range of ideas within a broader culture precisely because they take place within the ambit of the museum exhibition which sets a rich and concentrated context. For the photographer Fay Godwin's 'Landmarks' exhibition at the Barbican art gallery in summer 2001, two artists selected one aspect of her work, the juxtaposition of urban and rural, for further investigation in their education programme. They worked with local schoolchildren to explore 'Lyrical Landscapes' in the urban environment, searching for 'colours, shapes, signs, words, forbidden gardens and nature breaking into the urban', to which the children responded with their own photography. Their book was exhibited on a plinth in the exhibition and the fact of their work relating to a current exhibit, gave it immediacy and relevance, as well as a certain celebratory nature. Guided by the work of artists within a cultural framework, they were engaging in cultural politics as well as in an artistic experience.

The open-ended educational methods cultivated within a museum and art gallery context are designed to facilitate access by emphasising the personal response and the valuing of individual opinion. But some artists are deeply critical of the prioritising of access in art galleries believing that it dilutes their main purpose which is to exhibit art. In the context of a Sunday newspaper investigation of creativity, artist Mark Wallinger exploded testily in print:

> I think the enemy of creativity is society's obsession with accessibility and education in museums and galleries. There's a kind of desperate notion that somehow you've got to meet people halfway. Art can be very difficult and why shouldn't it be? (Wallinger 2002).

Yet, this kind of statement betrays a wilful misinterpretation of the purpose of museum education and of what such programmes are capable of achieving. As accounts of the very few research projects discussed here have shown, artists can and do frequently make a strong creative contribution to education projects in a way which need not compromise their practice and does indeed fully engage with difficult aspects of art, precisely because of the accessibility of museums and galleries and the debates that rage within them. Indeed, artists' training enables them to allow participants to gain access to current thoughts and practices in creativity which can help them to push forward the boundaries of their own capabilities and means of understanding. However, there is a fine line between exploratory practice which is sensitively handled in order to facilitate that, and demonstration which merely give some recipes for copying. Artists and teachers need to be fully aware of the extent to which education can challenge rather than reinforce orthodoxies.

Patterns have begun to emerge from published case studies about types of artist-school-museum collaboration which tend to be successful. (Sharp and Dust 1990; Taylor 1992; Parks 1992; Binch and Clive 1994; Burgess 1995; Reeve 1995; Oddie and Allen 1998; Nicol and Plant 2000; Clive 2001). Guidelines for good practice focus on programmes which facilitate rather than preach. Underlying values are

democratic, focussing on good communication, planning and project management, and above all, on collaborative practices which respect the specialisms of each of the main teaching practitioners involved, and allow individual expression to flourish. (Rose et al. 1998, 29-43; Clive 2001, 8-9). If artists are to thrive as innovative educators, it must be in a partnership with an educational community which really understands the character and potential of their involvement and most importantly of all, knows how to develop their own strengths in parallel. Artist Karl Bretherton, a creative educator who uses his work as a means to develop his own practice needs the school to operate at his level if he is to use his projects to be truly experimental, so that they can be real dialogue and sharing of both aims and expertise:

> "they lacked confidence and the teachers didn't really get involved, I think it should be a condition in future that teachers take part fully. I would really have liked it if the teachers and the pupils had given me things to run with. I would have liked a little more empowerment – "I want to do this", "Can we do that?" I felt I was feeding their dependence, not their independence."

As an artist, he is also more interested in the process than the end result. Out of the process comes the visual thinking which leads to product and it is there that he is seeking his own professional and artistic development, alongside that of his group. This, from his own analysis requires self-restraint for his own creativity, and more freedom from constraints by the teachers working alongside him, a kind of mutual reinforcement of educational process. Lack of creative input by the teachers forced him to fall back on a directive role:

> "....they seemed to want to take a peripheral role....In retrospect I think this creates a kind of creative vacuum.in the instance where I became too directive in my work with X school, I think I filled this space in a way that I might not if a) you had been there in your 'regulatory' capacity b) the teachers had opened themselves to the experience....In retrospect I seem to remember feeling ungrounded, the only way I can describe it is like I was in a kind of Sainsbury Centre bubble in the middle of the school. I felt I was trying to touch reality there but was scraping my fingers against the limits of the bubble. Because of this I probably clung to the aims and objectives you had given me rather than facilitating creativity in the here and now of the classroom. I think I dived into the 'celebrity performer' role because of the vacuum; my sense of omnipotence rose. I think that if I had not been late for the meeting prior to this, the 'meeting of minds' might have been facilitated and therefore a partnership established. I think this is the difference between the artist and the creative facilitator...I think that we are all, as artists in the educational role, capable of fluctuating between these polarities."

COLLABORATION AND CHANGE

Reading now about 1980s or even early 1990s artist-led education projects where success is simply assumed if everybody had a good time (Brunell 1991), brings home just how different the education world is in the new millennium. In the current assessment-driven climate, art can be an unruly and unpredictable tool relegated to end-of- the-week recreation. But it can also be a powerful focus for all kinds of applied skills and learning, providing that teaching programmes exploit its

multivalence and capacity for experiment and systems of evaluation can take account of striking developments which may be unplanned.

Education projects involving artists working within supportive collaborations of fellow teachers sensitive to a wide range of responses, can work strategically to change individuals and cultures. There is a growing realisation, certainly among museum and gallery professionals, but also in a wider political context, that they have a very powerful educational tool at their disposal, which can explore the unpredictable in the most innovative way. On the other hand, led on by the more unruly and subversive elements in contemporary art practice, art museum education can be challenging and destabilising for conventional attitudes and modes of learning and both teachers and artists need to know how to use this constructively. Recent words by Gavin Jantjes, artist and director of the Hennie Onstadt Kunstcenter in Oslo touched upon the incoherence of art, that it may be created and shown in a climate which rejects conventional authority and invites contemplation of personal rather than institutional identities. Jantjes is one of those who recognises the parallel importance of the creativity of making and response:

>in the field of visual art both maker and viewer have to be creative. Both have to embrace creative thinking if art is to be meaningful and have a currency in shaping our world view. What is made manifest is therefore not only relevant to its creator, but to everyone who engages with what is offered up as an image...The educator has to keep an open mind; has to be aware that the world as known could be and will be reformed, rethought and re-described in the visual field (Jantjes 2001, 22).

Rather than the Michael Parks suggestion, quoted earlier, that teachers should adopt copycat pedagogical methods from artists (Parks 1992), another route towards change, which also pays respect to characteristics of the artistry of teaching, is suggested by the kinds of collaborative models which exploit the centrality of the art gallery and museum. Through the projects described in this article, in all of which there has been cross-fertilisation across institutions and between artists, teachers and museum and art gallery educators (some of whom are artists), there has begun to be a wider acknowledgement of the integration of distinct educational roles, the balancing of cultural expectations, and of the kind of positive assessment models that are sensitive to individual and variable strengths. In future, if more fruitful integration between museum and school-based learning is to be encouraged, we will need to know better how to develop towards a surer understanding of the roles, interdependence and distinctiveness of different learning and teaching methods and styles across school and museum so that each party can maintain their integrity and confidently track a route to successful outcomes. (Hein 1998). It is a question of each institution recognising the cultural specificity and difference of the other. This is a critical issue and one which ought to inform decisions about future educational development, especially in a climate of government-sponsored 'creative partnerships' between arts organisations and schools (NACCE 2000; DCMS 2001). Then, perhaps, affective and reflective experience through work with artists across the school and art museum, can contribute towards a raising of educational and creative ambitions.

NOTES

[1] For a project entitled 'In Service Training of Teachers in Primary Visual Arts Education' involving as partners: University of East Anglia, Norwich; Inspection Académique de l'Isère, Grenoble; Galleria d'Arte Moderna e Contemporanea, Torino and Istituto Regionale di Ricerca Educativa, Piemonte; funded under the EU Socrates Comenius 3.1 programme, 1999-2002.

[2] In 2000, Minister for Education Jack Lang and Minister for Culture, Catherine Tasca instituted a joint initiative to elevate the status of the arts in schools with a five year plan to operate across the whole of France. Fundamental to the plan is the idea of the democratisation of access to culture as a basic right, integral to mainstream education. I am grateful to France Wild for drawing my attention to these developments. Barbara Soyer, 'L'art à l'école, un projet politique', interviews with Jack Lang and Catherine Tasca in *L'art à l'école*, (Beaux Art Magazine special issue, 2000).

[3] My translation.

[4] At the time of writing, there is an 'Artist Teacher programme' involving art galleries, and art schools being piloted by the NSEAD and the Arts Council.

[5] 'Galleries need to be aware of the priorities and pressures that schools face, and ideally consult with both teachers and students from the outset to ascertain what kinds of pressures are involved, such as curriculum timetables, exams and holidays.', stressed Ryszard Gagola in the Encompass report. He went on to criticise the timing, set too much in accordance with art gallery schedules: '…it might have been more appropriate to begin the project earlier in the school year so that any influences from the project could later feed into exam work.' (Gagola 2000, 15).

[6] Presented at 'The Active Eye, Art Education and Visual Literacy', a symposium at the Museum Boijmans Van Beuningen and accompanying exhibition at the Nederlands foto institut, Rotterdam, September 19-20, 1997

[7] These comments are also based on personal experience of a workshop run by Janusz Byszewski at the engage conference for 2002.

[8] From interview with artist, July 2002.

REFERENCES

Beaux Arts. *L'art à l'école*. Beaux Art Magazine special issue, 2000.

Bennett, Tony, *The Birth of the Museum*. London: Routledge 1996.

Bicknell, Les. 'What shape is blue?' engage 09, Summer 2001, 40-42.

Brunell, Geoffrey. 'The Artist in Residency Scheme', *Issues in Architecture Art and Design; Art Education Beyond Studio Practice*. Special conference edition, University of East London 1991, 96-107,.

Burgess, Lesley. 'Human Resources: Artists, Craftspersons, Designers' in Roy Prentice (ed) *Teaching Art and Design,* London, New York: Cassel, 1995.

Clive, Sue. *Creative Partnerships between art galleries and teachers of Art and Design at KS3*. London: engage, 2001.

DCMS. *Culture and Creativity. The Next Ten Years*, London: Department of Culture, Media and Sport, 2001.

Dormer, Peter. *The Art of the Maker Skill and Meaning in Art, Craft and Design*, London: Thames and Hudson, 1994.

Dormer, Peter. *The Culture of Craft*, Manchester: Manchester University Press, 1997.

Gagola, Ryszard. 'Outreach and touch', in Gill Nicol and Adrian Plant (eds) *Collaboration: communicaton: contemporary art, 14 projects working with galleries and audiences* London: engage, 2000.

Gardner, Howard. *The Arts and Human Development,* New York: John Wiley, 1973.

Harding, Anna. 'Jumping through hoops'. engage 09, summer, 7-13, 2001.

Hein, George. *Learning in the Museum*. London: Routledge, 1998.

Hooper-Greenhill, Eilean. *Museums and the Interpretation of Visual Culture*. London and New York: Routledge, 2000.

Jantjes, Gavin. ' "Good Practice" and Creativity'. engage 09, summer, 20-23, 2001.

Moloney K.M. 'Aesthetic Assessment and the Reliability Factor' in Malcolm Ross (ed) *The Development of Aesthetic Experience*. Oxford: Pergamon Press, 1982, 195-206.

NACCE. *All Our Futures: Creativity, Culture and Education*. London: National Advisory Committee on Creativity and Cultural Education and Department for Education and Employment, 2000.

Nicol, Gill and Adrian Plant. *Collaboration: Communication: Contemporary Art, 14 projects working with galleries and audiences*. London: engage, 2000.

Nicol, Gill. 'Postscript, Reflections on Encompass' engage, 09, summer 2001, 54-56.

Oddie, David and Allen, Garth. *Artists in Schools, a review*. London: Office for Standards in Education, Stationery Office 1998.

Parks, Michael E. 'The Art of Pedagogy. Artistic Behaviour as a Model for Teaching'. *Art Education*, 45 Sept 1992 51-57.

Reeve, John. 'Museums and Galleries' in Roy Prentice (ed) *Teaching Art and Design*, London, New York: Cassel, 1995, 80-95.

Robinson, Kenneth (ed) *The Arts in Schools: Principles, Practice and Provision*. London: Gulbenkian Foundation. 1982.

Rose, Catherine, Sarah Bedell, and Anne Roberts. *Building Better Relationships with Schools, A Guide for Arts Organisations*. Cambridge: Eastern Touring Agency, 1998.

Sekules, Veronica. 'A small child could do it? The University of East Anglia Collection of Abstract Art and Design, an experiment in gallery education' *Museums Journal* 1984, 125-127.

Sekules, Veronica and Les Tickle (eds). *Collections and Reflections* London: Arts Council of England, 1997.

Sekules, Veronica. 'The lady at lunchtime: critical incidents in gallery education work with artists' engage 09 summer 2001, 33-39.

Sharp, Caroline and Karen Dust. (Revised edn), *Artists in Schools, A Handbook for Teachers and Artists*. London: Bedford Square Press 1997.

Taylor, Rod. *The Visual Arts in Education, Completing the Circle*. Brighton: Falmer Press, 1992.

Wallinger, Mark. *Observer Magazine* 22 September 2002, 18.

Wilkinson, Sue and Sue Clive. *Developing Cross-curricular learning in Museums and Galleries*. London: Trentham Books 2001.

Zeleznik, Adela. 'What can we see from the line?' engage 10 autumn 2001, 53-57.

Section C

MUSEUMS AND PERSONAL DISCOVERY

IRENE STYLIANIDES

SIGNIFICANT MOMENTS, AUTOBIOGRAPHY, AND PERSONAL ENCOUNTERS WITH ART

Abstract: The depth, complexity, and very personal nature of interactions with art objects are explored in this chapter. Derived from autobiographical inquiry, it reports on encounters with two particular works of art that had a troubling effect on my general love of art, and on my work as a primary school teacher. The gallery experiences and the uncovering of memories are described and analysed in relation to research methodology and Hargreaves' (1983) theory of conversive and aversive trauma in art education.

COMING TO TERMS WITH ART

As a person who loves both creating and seeing art, and as a teacher of pre-primary children, I used to enjoy every moment of my work each time I had chance to interact with art. Those times were not 'free' or 'leisure' time for me or for children, as a lot of teachers I've met believe they are, because I consider art to be a substantial subject and necessary for the children's artistic and aesthetic development, within the frame of their general development. Like David J. Hargreaves (1983: 130), I am convinced that the artistic, aesthetic and affective domains have a special place in the personal development of the educated person. So my ambition is to provide understanding and other mental equipment for expressing and aesthetically approaching both nature and art, but particularly to help children adopt a positive attitude towards the phenomenon of Art.

Those beliefs, and that ambition, seemed to be strangely challenged while I was looking at some objects, alone, in the Sainsbury Centre gallery at the University of East Anglia, in Norwich. I realised that the objects were making me feel sad whenever I looked at them. At the beginning I couldn't accept that art could provoke the negative feelings that I had. Then, while studying about the teaching of art and considering the emotions that art can stimulate, I realised that while the feeling of sadness itself was a negative feeling, the discomfort about art having such an effect on me was misplaced.

It took some time to recognise that I did not need to characterise the art as negative, even though it caused me to face sadness during my contact with it. I realised this because even though sadness is a very strong feeling, one purpose of the arts is, as Dimondstein (1974: 311) suggests, the education of feelings and the development of sensibility. How could I believe that sadness was something that neither I nor children should feel through encounters with art? Causing a feeling of sadness can be an artist's intention sometimes. For example, Picasso's aim in creating *Guernica* was not just to express his personal sadness and protest against the Spanish civil war, but also to provoke sadness in the viewers, by portraying the

153

M. Xanthoudaki, L. Tickle, V. Sekules (eds)
Researching Visual Arts Education in Museums and Galleries, 153-165.
©2003 Kluwer Academic Publishers. Printed in the Netherlands.

destructive consequences of war. In Greek Tragedy, one of the best kinds of expressive arts, the aim of writers such as Euripides, Aeschylus and Sophocles was to bring about *katharsis* for the viewers. Katharsis, the purgation/cleaning of the soul, would be achieved through spectators of the drama viewing, feeling and living those dramatic moments – imitations - representations. The actual or possible world represented in the tragedy and actually the misfortunes and calamities of the person/hero, would help spectators to identify and elicit the emotions of the katharsis, thus assisting in their own emotional development (Pateman: 1991).

I recognised that it would be Utopian to believe, or to try to convince myself, that children shouldn't feel sad by being in contact with art, when art is a reflection of life, and when it is difficult to distinguish life from sadness. Dimondstein (1974) points out that the arts are a way of knowing about the self as well as about the external world. So I concluded that my aim as a visual arts educator shouldn't be to prevent myself, or children, from encountering the emotions through art, but to find ways for both me and them to understand that art provides representations of life, including the experience and the expression of feelings.

So I became interested in other feelings that an art object may evoke in a person, such as happiness, frustration, anger, calm, and so on. However, in trying to find objects in the gallery that made me feel happy, frustrated, angry or calm, I realised that many of them were actually making me feel sad. This created a problem, for I knew that I loved both creating and seeing art, so couldn't understand what it was that made me feel sad every time I encountered these particular objects. There seemed to be a conflict between my desires and intentions to enjoy all art, and my actual experiences with *this* art. To understand this conflict I decided to investigate the reasons for the overwhelming experience of sadness which I experienced in front of particular objects. I chose two works of art that were making me feel deep sadness: a painting, *The Bathroom at 29* by Anthony Green, and the sculpture *Bucket Man* by John Davies. I had realised that I was trying to avoid seeing them both, that I had developed an aversion toward them. In trying to find what it was that made me feel that way, I came to realise that I was superimposing painful moments of my life on them. Put another way, they seemed to be evoking some recollections of moments and events which I was trying to suppress.

The concern was deep because as one who loved art the experience seemed to be turning me away from that enjoyment, that desire to be in contact with it. If they could do that to me, maybe they could put other people off, to cause an aversion, so that they would not come to enjoy art. I was not sure at the time how to interpret the experience; only that I was confronted by it; intuitively challenged by its unfamiliarity; and concerned to understand it better in the hope of holding on to my love of art.

Having thought that the strength of my reaction was caused not just by the objects themselves but by my own experiences at other times, I chose to use autobiography as a research method. That kind of naturalistic research seemed to offer the most suitable method for investigating feelings, thoughts and ideas that determine the character and the behaviour of a person. I believed this kind of method would help me understand my self in front of those objects, and also understand

what lay behind my reactions, and what might be done about them in the future. As Van Manen pointed out,

> Lived experience is the starting point and the end point of phenomenological research. The aim of phenomenology is to transform lived experience into a textual expression of its essence-in such a way that the effect of the text is at once a reflective appropriation of something meaningful: a notion by which a reader is powerfully animated on his or her own lived experience (Van Manen 1990: 36).

In the words of Finley & Knowles

> How we view the world and who we are as adults, parents, teachers, teacher educators, scholars, researchers and community members is the sum total of our prior experiences, and the meanings we have derived from them, coupled with the visions we have for our futures (Finley & Knowles 1995: 126).

I considered the research as significant and substantial for both my own personal understanding, and for my development as a teacher of young children because, as Taylor (1986:35) pointed out in relation to the art education of children, an alert educator needs to play a part in trying to prevent aversive experiences.

Thus, trying to become an alert educator, I presume to give to every child the opportunities to develop the aesthetic side of her/his self and consequently a positive, or conversive attitude towards art in general. Yet my experiences seemed to contradict this goal. How could I prevent children feeling some aversion to art objects when I was feeling it myself? Or how could I explore with them the possibility that it was not the objects that caused the feeling, but something in themselves which was evoked by the art?

A lot of people who love art, who glorify its significance and especially the significance of teaching it, consider it to be a medium that feeds the soul, and helps people express their selves, either when they create or when they just see art objects. It is claimed that it develops children's experiences, feelings and imagination, and helps them understand themselves (Abbs 1989; Pateman 1991; Warren 1993). Thus, they argue that art education needs to engender in children a love for the arts that will last for their whole life (Abbs 1989; Taylor 1986).

These are fine ideas, but what do they mean in practice, given those negative feelings which now confronted me? By correlating the viewing of the art with significant moments of my life, I tried to understand why the objects caused me to feel such pain. If I could succeed in my personal understanding and find ways to accept those sad feelings, I hoped to formulate a more informed approach to teaching art. I hoped to become able to better understand similar experiences among children and also help them appreciate the complex nature of their own interactions with art objects.

AUTOBIOGRAPHICAL RESEARCH AND ART EXPERIENCE

I asked the question: are Finley and Knowles correct to focus only on prior experiences? I wanted to appreciate more fully the relationship between my prior experiences, which I would seek out in my memory; the new experiences in the gallery which I could record in the present; the correlation between these; and my

anticipation of future experiences. By understanding these in myself I believed I would be able to plan and deal with the experiences of children in a better way. However, there was a theoretical and methodological background to autobiography, and to the significance of aesthetic and artistic development, which I needed to explore. Autobiography is a Greek word consisting of three parts: from the word *eaftos* which means self, *vios* which means life, and *grafo* which means 'I write'. Thus, autobiography can be defined as the written story of the self. Usher (1998) defines it as

> ... a special kind of representational practice; a representation of the self through inscription telling the story of the self through a written text and writing a text through a culturally encoded meta-story. (Usher 1998: 19)

So I considered the process and the benefits of autobiography in relation to David.H.Hargreaves (1983) theory of *conversive* and *aversive* trauma in art. This is concerned with the kind of aesthetic encounter developed in a person during her/his initiation into art experience, and which influence her/his mood towards art in general and consequently her/his aesthetic and artistic development. I will return to that in a while.

At the beginning of the research, I doubted the value of writing about significant moments of my life and relating them to my attitude towards the two objects. I couldn't understand if my own experience could count as evidence for the research, or if writing about significant moments of my life could be useful for my professional career as a visual arts educator. However, at that time I read Feder & Feder (1981: 70) who argue that 'what is unconscious... cannot be modified or educated until is made conscious...' So I decided to try to make conscious those reasons that make me feel sad, I would try to find them through focusing on significant moments of my life reflected in the two objects, or evoked by them. It would be a kind of interpretive interactionism, as Denzin (1992) called it, in which the individual with her/his experiences gives new meanings to the object interacting with the self. With interpretative approaches, autobiography can be used to uncover the background to such relationships.

Although Campbell (1988: 63) points out that autobiography's disadvantage is that it gives a one-sided view, other researchers see it as central in the process of re-telling our lives to our selves and others, describing, evoking and generally recreating the development of our experience, as we come to understand ourselves. Understanding ourselves gives us the opportunity to understand others who possibly have the same experiences as us (Abbs 1974; Griffiths 1995; Roberts 1998; Van Manen 1990). And when this happens, reliving our experiences, examining and understanding one's self, we develop our ego, and that is a valuable pedagogic resource (Usher: 1998). Usher also asserts that autobiography is 'a progressively unfolding journey to discover the unity of the 'real me', the essential self... a microcosmic reflection of this big universal story' (Usher 1998: 19). Abbs (1989) in his essays on creative and aesthetic education gives a different dimension to autobiography. He wonders: '(could) the making of autobiography be adapted for use in personal therapy or is the therapy already a mode of autobiography?' (Abbs 1989: 163).

CONVERSIVE AND AVERSIVE TRAUMA

At first I perceived my personal aversion to some art objects as a reaction that needed therapy, if I might give this name to the procedure that would lead me to accept the objects that made me feel sad. But therapy has a connotation of illness or damage, and as I said already, my research problem is more complex than that. It is more about self-construction, looking for a kind of understanding that can build on what I know and have experienced. I already loved art. Yet I was suddenly challenged by it in a new way. It was not therapy I wanted, it was the development of my own understanding. I found David H. Hargreaves (1983) traumatic theory of aesthetic learning, which refers to how people have developed or not developed their interest towards art, very helpful in my search. Confusingly, his work is summarised by David J. Hargreaves, (1989) who notes his namesake's observation that

> ... some informants describe their response to certain art works as disturbing, or even shattering; their normal mental state is somehow unbalanced in those moments, and this has a powerful impact on their learning and long-term memory (Hargreaves D.J. 1989: 147).

David H. Hargreaves, (1983) asserts that interest is based on particular experiences or events that happen to a person, remembered because they were disturbing. However, trauma has both a positive and negative meaning, in the way that 'shattering' can be applied to a distressing experience, or to a dramatic but very pleasant surprise. In other words, he claims that initiation into art experiences in our lives may lead a person to become interested in or turned away from art. If a person has pleasant initiating experiences, he argues, s/he will develop a positive view of art. On the other hand, if a person has unpleasant initiating experiences, s/he may well develop a negative disposition towards it. So trauma can be *conversive* when the person develops positive association and has the desire to continue or repeat the experience. But when the person has unpleasant experience trauma can be *aversive* and s/he can come to detest or avoid whatever is related to art. On this basis, I feared the possibility that my distress might have long term negative consequences for my involvement with art.

UNCOVERING EXPERIENCE

> 'Autobiography is then an interplay, a collusion between past and present. Its significance is indeed more the revelation of the present situation than the uncovering of the past' (Pascal 1960: 11)

By placing myself in a learning situation to investigate and to record memories of significant moments of my life, I hoped to find the reasons that made me feel sad whenever I looked at *The Bathroom at 29* and at *Bucket Man*. Observing the two objects evoked significant past moments of my life, but also created important new ones, in the change they brought about in my relationship with art. To record these, I kept field notes in a form of a diary in which I described how I felt in front of the objects. A personal story of encounters with the objects was used as a medium for communicating with myself. The research plan was as follows. By examining my

thoughts, feelings and ideas, I hoped to find the probable reasons why an art object can influence a person's mood so strongly, and discover how moments of life experience could be connected with the feelings generated while looking at them. The aim was to gather evidence from those memories and immediate experiences to help me in my attempt to understand the reasons why the two particular objects made me feel sad. There was a desire to find ways through which to become more easily able to accept looking at those objects, with a view to applying those ways of encountering art and developing personal responses in my teaching. To achieve this would require careful interpretation and analysis of my responses, my thoughts, feelings and ideas about the specific interactions which I built around the two works of art.

I made four visits to the gallery, two for each work. I had tried looking deep in myself through significant moments of my life to clarify and write up my feelings and the thoughts evoked by looking at those objects. I was guided by the idea that 'although autobiography is always writing in a narrow sense, it actually works like a speech in guaranteeing the authenticity of a human presence' (Usher 1998: 21)

I came to call these moments Past-Present-Future. While I might realise that my memories of past experiences influenced my present considerations about the works of art, I wanted also to consider how they affect the present, and might determine my future response to art. That might allow me to formulate a personal understanding of the relationship between past experience, present responses to objects, and strategies for approaching art in the future. The personal understanding of this relationship would, I believed, allow me to develop a professional approach to teaching art. The extracts which follow introduce notes from the diary in which I recorded my thoughts during encounters with the two objects. The diary entries, like the art itself, were the way of 'giving shape' to the experiences. As Van Manen (1990) put it:

> Objects of art are visual, tactile, auditory, kinetic texts - texts consisting of not a verbal language but a language nevertheless, and a language with its own grammar. Because artists are involved in giving shape to their lived experience, the products of art are in a sense, lived experiences transformed into transcended configurations. (Van Manen 1990: 74)

The diary was regarded that way. I developed each account by using a metaphor that in just a few words reflected my thoughts about each new experience and its relation with the past. For my memories about *The Bathroom at 29*, I chose to represent the beginning of that recollection as resembling a volcano that suddenly - while it was silent - erupted. My thoughts and feelings about that painting flowed like lava from my mind, making me remember things that were hidden. My memories overflowed, an old and loud voice from the heart of my past experiences flowing in various directions. This flow functioned as an indicator that showed me my situation where I was now standing – what my thoughts and feelings were about my self and my view of the painting. I could also imagine a range of new directions which could provide me with alternative paths to follow, perhaps to choose the one that might extend the way to my future appreciation and understanding.

The Bathroom At 29 *by Anthony Green*

Anthony Green's paintings are about his life, his family, his home. They are full of detail and each detail has a story pertinent to the subject matter. In this instance, the artist himself is depicted in his bath, being bathed by his wife, under a single light that hangs from the ceiling. The vantage point of the painter / viewer is somewhere high on a wall, with a fish-eye view of the room and its contents, in all their detail.

February 16ᵗʰ 1999

I am standing in front of The Bathroom at 29. There are some people in front of the object also. I listen to them saying that they like this picture very much... They find it humorous... They say that they want to fall in the water... Why can't I have the same feelings? Why is it that the more I look at it, the more it makes me feel bad? My head is hurting... I am wondering if the man in the painting is the artist of that painting...

The man seems to be ill or something like this... Ill, helpless... Even his body has something strange. The proportions of his body are not regular. His head is too big in relation to the rest of his body. He seems to have a weak body that needs help from everyone.

The room makes me feel sick.

The first time I saw this painting, it was the only object from that gallery that made me feel well. I liked its vivid colours, its shape... It was a strange painting, I had never seen a painting like that...I was impressed! A happy painting with a couple in a very close relation... And now my impression is completely changed...

I can't stand being in front of this painting any longer, at least for the moment. Enough for today...

One memory invariably opens a door to another taking the autobiographer further down the passage of time (Abbs 1974: 8)

February 27ᵗʰ 1999

Here I am again, standing in front of The Bathroom at 29. I wanted to rest today because I had a very hard week studying from the early morning till late at night. I was having my coffee when the telephone rang. It was Nefeli... She called me because she wasn't feeling well. I was feeling quite well. I was relaxed, ready to enjoy every minute of this day. But something happened again... She was crying in the phone, telling me that she was feeling bad again and that she wanted to speak to me. I caught myself not wanting to listen to anything that makes me feel depressed... I had enough. I want to be free... I want to be happy (at least to try)... I know that life can't be full of happiness all the time but it's been a long time since I could say that I am happy. I don't want to become depressed again.

I hung up - not at the moment I wanted to – at the moment she was feeling better if I can use this word. Even though I want to go back to my country to meet my parents, I don't want to see her again… I am confused… I want to breathe…

The colour that prevails in that painting is yellow. Yellow walls, a yellow door, a yellow bath sponge, a yellow vessel for the toothbrushes, a yellow soap… Those two people seem to be in the same situation as me… They seem to feel the same as me… They seem to depend on each other from the way they touch each other, from the close relation they have (you don't give a bath to everybody…). Something suffocates me. I want to leave the gallery but on the other hand I really need to think, talk to myself, find a solution…

The door is closed and I have the feeling that outside of the door there are Nefeli's parents. They are always there at the end…

… We were carrying some chairs in the school where we work together when she confessed me her secret. I am still wondering if it is natural to confess such a significant subject at a time like that and also to a person you have met a few days ago…

Today I feel familiar with the object. I have the impression that although it reminds me of a very bad part of my life, it will help me better understanding myself in that situation. Although the bathroom seems to be very clean I have the impression that it is very dirty, even disgusting…

I remember the time she asked me to help her dying her hair in that bathroom. In that yellow, narrow bathroom. I couldn't do it. At the end I did it… The bathroom was so dirty… Not actually dirty but I perceived it like that. I wanted to vomit… I knew that this was the place where she was destroying herself...

At this moment I feel I want to cry… I wish I could change the things… Such bad moments… Why?

I remember the time she told me that when she was in a crisis she was engraving her arms in that bathroom with a razor… I remember the time she came to my house because she wasn't feeling well. It was the first time I saw her in such a bad mood… She couldn't communicate… She was telling me all the time that she wanted to tell me something… "I want to tell you something…", "I want to tell you something…". And when I was telling her "Alright, tell me" she was keeping saying the same sentence: " I want to tell you something…". I had really felt afraid. I didn't know what to do… After a long time, she decided to say more. " Irene, I did it again…"

The only thing I can remember is that I couldn't feel my legs… But I should do something… I asked her to show me what she had done. I will never forget that view… I will never forget that smell…

I can't continue any more… Perhaps, tomorrow.

I am trying to look at the other objects of the gallery, the objects near "The Bathroom at 29". They may help me feel better…They don't. I look at those men, the "Two figures" of John Davies… Their arms are naked, hopefully without bleeding scratches…

I can't continue… I have to become accustomed with that thought.

Bucket Man by John Davies

John Davies intended his work to be like real people rather than like sculpture; so Bucket Man is to be met as 'him' rather than 'it'. His head, chest, hands, and feet are sculpted from resin cast into moulds taken from a person, standing full height, eyes staring forwards into space. He is dressed in old workmen's clothes, with an empty workman's bucket in each hand.

For my memories about *Bucket Man*, I chose to represent my recalling as resembling a dance with my shadow. I imagined *Bucket Man* as the shadow, a presence that is very close to me and has common experiences with me. At this stage, coming close to him, it is like a dance with myself and my shadow, which is an extension of my self.

March 13ᵗʰ 1999

Bucket Man was the first object that had impressed me the very first time I visited the gallery. Although I didn't know anything about it except that it was an imposing object for me because of its size, it had succeeded in provoking sad feelings in me whenever I looked at it. I couldn't understand why this was happening, until I decided to find the source of my sadness. I am now sitting in front of Bucket Man and I feel that he is going to talk to me. I feel that he desperately wants to speak, to talk about his sadness, but he can't. Objects can't speak, at least in the mind of most of the people. Nevertheless, I feel that I can hear him, I can feel him. He seems so sad. I couldn't avoid that. I couldn't be happy. His eyes are inexpressible as if there is nothing in his life that could give him happiness. How could I be happy when nothing that could heal the intrinsic wounds and bring the balance in my life, could be found? How could I be happy when I couldn't live the life I wanted? I wish I could help my self and Bucket Man as well.

March 16ᵗʰ 1999

Here I am again, in front of Bucket Man. The only thing I know is that I need Bucket Man's buckets to become able to balance my life. That is the point that makes me feel that something common joined our lives and that something in his view was making me feel sad...His figure is like a pair of scales trying to balance the weight he lifts.

How could I balance my life? Why does the balance of my soul have to be based on such fragile threads as those Bucket Man holds by his mouth?

His eyes are without expression. A glassy stare. He knows that it's not easy - even impossible -for him to find the lost happiness (at least the way I consider happiness).

Why did my life go so wrongly? I admit that I had made a lot of mistakes. But do I have to be condemned for the rest of my life to be dipped in Bucket Man's plaster? I remember moments and facts of my past. Moments that remind a whole life. A whole life is placed on us, Bucket Man. The whole earth is placed

on our head, Bucket Man. Everything depends on you because a basic order has to predominate.

I feel oppressed. I wonder if I could finally live as I and not others want it. Will I someday become able to make things that make ME and not OTHERS, happy? Will my glance be changed as a more lively person to be seen through my eyes? Will I become able to replace my dirty clothes with clean? Will I find my real laughter- laughter that springs from a clear soul? I wonder if Bucket Man will still feel so badly in his whole life. I wonder if he could change his life. I wish I could ask him sometime about his feelings in some years maybe. But objects can't speak, at least in the mind of most of the people. I can't forget that.

RETHINKING CONVERSIVE AND AVERSIVE TRAUMA

I began this study by agreeing with David H. Hargreaves' theory of aesthetic learning (Hargreaves: 1983). As I mentioned in the theoretical overview, Hargreaves argues that if a person had pleasant initiating experiences of art, she/he will develop a positive association with it, having the desire to continue or repeat the experience she/he had. On the other side, he argues that if a person had unpleasant initiating experiences, she/he will develop a 'negative' response with long-term effects, detesting or avoiding whatever is related to art. What happened in my case was that I was already 'converted', when my positive association with art was seriously challenged. Then, at the beginning of the study, I found myself trying to avoid those works of art. In the end, I transformed my negative feeling to a positive disposition. Yet that did not mean a pleasant or pleasurable experience was substituted for the disquietude. On the contrary, in my way I found a route to recognise what I will call 'the positive in the negative' by recalling my life experiences, and distinguishing between my reaction to these, and my understanding of the art objects' role.

It was really painful for me to recall those memories. It was very difficult for me to express them on paper. It was an emotional, intellectual and psychic revolt; but it was worth the trouble. I couldn't explain why I would like to minimise that reaction, if not wipe it out, when at the same time I felt compelled to confront it, except to say that I couldn't accept that art that I usually love could provoke those sad feelings. I wanted to feel well in front of those objects, yet I could not. Each time I was standing in front of them trying to write down in my diary what they were saying to me, or what I was saying to them, I knew that they had a lot to tell me, and me them. But on the other hand, I knew that I had a great difficulty in looking at them.

During the process of keeping a diary I experienced a mixture of thoughts, feelings, and ideas that came directly from looking at the objects and recalled from my life experience. Then, when studying about Interpretative Interactionism (Charon 1895; Denzin 1992) I came in touch with the consideration that

> Objects may exist in physical form, but for the human being, they are pointed out,
> isolated, catalogued, interpreted, and given meaning through social interaction.
> (Charon 1985: 37).

Thus, I began to appreciate the route I had to follow, which was to understand the responses to signals, impressions or effects on my mood. Did I interpret and give

specific meaning to those objects because they were interacting with my personal life? If I did, I needed to 're-live' the significant moments through my diary-construction. Then the question was: how could I conduct this research based on the interpretations of those objects and those entries when it was painful to construct the diary entries themselves? I couldn't do anything to avoid this. I had to face it. I had to stand in front of the objects, looking, investigating and analysing them, although it was extremely difficult for me. And I had to find the words to portray those events from my past, to re-read them and re-author them as I tried to fashion a picture from my memory, and a plan for gaining future satisfaction from art. This meant that the analysis was a continuous but painful process and quite unpredictable, because I didn't know what would emerge.

My autobiographical accounts related to the interaction with those objects were developed in two parts for each object. It was obvious to me that on the first day I visited each object I couldn't write a lot. I couldn't or rather didn't want to look at them. Deep in my mind, I knew that the problem I had was that I couldn't or rather didn't want to recall memories related to the process of looking at them. As time in front of them passed, however, I realised that I was becoming more familiar with them. The more I looked, the more familiar I felt. They were gradually coming closer to me in a very gentle way as if they were trying to become friends of mine. I was conscious of watching and feeling what was happening inside my self. It was as if the objects were changing their subject trying not to scare me any longer. It was really a strange change, a strange feeling.

Feeling better, I was persuaded to bring out my thoughts, feelings and ideas more completely. During the second day as I visited each object, I realised that my thoughts and feelings were more developed, in a clarified way. I became able to accept the experience of looking at those works of art, more able to recall my past experiences in detail. That in turn seemed to give me opportunities for handling other experiences in the future.

I don't want to say that in writing about those significant moments of my life that my sadness disappeared. Nothing changed my sad feeling. The thing that changed was that I became familiar with those encounters, becoming able to accept the sadness they evoked, and able to accept that feeling sad is not something bad or forbidden. I now believe that writing about those events helped me a lot to make conscious the idea that understanding and accepting one's feelings can lead to understanding and developing attitudes to art. It is now well understood why looking at those objects I was feeling so sad. It would be very strange, abnormal and 'sick' to feel happy in front of an object that somehow represented sad experiences in your life. How could a normal person feel happy in such circumstances? How could I have a positive response -as I had named my conversive attitude -towards those objects, when their reflections in my memories were so negative and aversive?

REALISING FUTURE DIRECTIONS

Coming to the end of these encounters and considering my diaries, I have revised my belief that art should not provoke negative feelings in a person; that it is

supposed to make her/him feel well. And consequently, I know that I will not be surprised if during my future career as a visual arts teacher I meet a child experiencing an aversive response. I now know that I will not try to change this attitude simply by attempting to always give a positive meaning to the emotion which is evoked, and thus to the art object, or vice versa. Rather I will need to develop strategies to enable others to understand the feelings (sad, happy, angry, frustrated etc) generated in front of an art object, and use that understanding as a suitable way to accept the meanings of the surrounding world, of life experiences, and of the purpose and beauty of art as well. To distinguish between the aversive (or conversive, as the case may be) response to life experience, and the response to the art object itself, will need to be a central principle in that strategy. That distinction is one that David H. Hargreaves' (1983) theory does not make clear. It is a distinction which my struggles with autobiographical research methods helped me to realise. And the implications of those methods for pedagogical practices of those working as educators in galleries are considerable.

I believe that it is difficult for children to develop a positive attitude without the right guidance, through proper and sensitive handling by the teacher or other agent responsible for a child's education. Our job as visual arts educators is to help children coming closer to art, knowing that it

> is not a medicine that must be taken three times a day after meals. However, it can feed the soul, motivate an individual to want to recover and in certain circumstances, cause physiological changes in the body (Warren 1993: 94).

As an educator I hope to become able to better understand art experiences among children by understanding how art connects with their life experiences, and thus, help them to accept their own feelings and attitudes towards particular art objects. This suggests that I will need a more complex, more subtle strategy for trying to 'increase the percentage conversely affected, minimising aversive reactions' (Taylor 1986: 34) than simply believing in the love of art, as I did before being challenged by the encounters with *The Bathroom at 29* and *Bucket Man*. I have learned that for myself, at least, autobiography promises a strong framework for this kind of approach to art. It is now clear to me that we can change our relationship with objects not because the object changes but because we change their definition (Charon: 1985). However, as Griffiths (1994: 81) argues, autobiographical writing is demanding and can be painful. It demands the detailed recall of events and acceptance of memories that may be very difficult to come to terms with. On the other hand, the benefits of autobiography are that by describing, evoking and generally recreating the development of one's experience, you understand yourself better. Also, that understanding of your self provides the opportunity to understand others who possibly have similar experiences (Abbs 1974; Griffiths 1995; Roberts 1998; Van Manen 1990). Reliving those experiences of mine, examining and understanding my self has become a valuable pedagogic resource (Usher: 1998). I feel that I have become more able to help children standing in front of an art object, by helping them to accept that what is happening is connected to their experiences elsewhere, beyond the moment in the gallery. Viewing an art object that reflects

personal memories is a medium for this acceptance, and in this way, children can develop a fine relationship with art, appreciating its complexity and significance.

Irene Stylianides is a primary school teacher in Paphos, Cyprus.

REFERENCES

Abbs, P. *Autobiography in Education,* London: Heinemann Educational Books Ltd.,1974.

Abbs, P. *A is for Aesthetic: Essays on Creative and Aesthetic Education*, Lewes: The Falmer Press, 1989.

Campbell,J. "Inside Lives: The Quality of Biography" in Sherman & Webb (Eds), *Qualitative Research in Education: Focus and Methods*, Lewes: The Falmer Press, 1988.

Charon, J. *Symbolic Interactionism*, New Jersey: Prentice-Hall, 1985.

Denzin, N. *Symbolic interactionism and cultural studies,* Oxford: Blackwell, 1992.

Dimondstein, G. *Exploring the Arts with Children*, New York: Macmillan, 1974.

Feder, E. & Feder, B. *The Expressive Arts Therapies,* New Jersey: Prentice-Hall, 1981.

Finley, S. & Knowles, J.G. "Researcher as Artist/ Artist as Researcher", in *Qualitative inquiry*, vol. 1, no. 1, pages 110-142. 1995.

Griffiths, M. (Auto)Biography and Epistemology, in *Educational Review*, vol. 47, no. 1, pages 75-88, 1995.

Hargreaves, D.H. 'The teaching of art and the art of teaching.' in Hammerslay, M. and Hargreaves, A. (Eds), *Curriculum Practice: Some Sociological case studies,* London: Falmer Press, 1983.

Hargreaves, D.J. *Children and the Arts,* Milton Keynes: Open University Press, 1989.

Pascal, R. *Design and Truth in Autobiography*, London: Routledge and Kegan Paul, 1960.

Pateman, T. *Key Concepts: A Guide to Aesthetics, Criticism and the Arts in Education,* Lewes: The Falmer Press, 1991.

Roberts, B. 'An Auto/Biographical Account of Educational Experience.' in Erben, M. (Ed), *Biography and Education*: *A reader*, London: Falmer Press, 1998

Taylor, R. *Educating for Art,* London: Longman, 1986.

Usher, R. 'The story of the self: education, experience and autobiography.' in Erben, M. *Biography & Education*: *A reader*, London: Falmer Press, 1998

Van Manen, M. *Researching lived experience,* Canada: The Althouse Press, 1990

Warren, B. *Using the Creative Arts in Therapy*, London: Routledge, 1993.

LES TICKLE

THE GALLERY AS A SITE OF RESEARCH

Abstract: The chapter explores the problematic nature of 'the artist as researcher', a concept which has gained currency in recent times. It reports research carried out in co-operation with professional artists, in a project which investigated the ways they used art held in a major gallery as a stimulus to the creation of their own work. The project considered the complex relationships between past and new experiences in artists' professional learning and the development and use of research in the gallery and the art studio.

ART, ARTISTS AND RESEARCH

Central to the discussion which follows is an examination of the nature of artists' work as research, and the place of the gallery in that research. The discussion is focused on the social and conceptual constructs in the idea of the artist as researcher, and the testing of this idea in a study carried out in co-operation with four professional artists. The project investigated the ways in which the artists used a major collection of art, and explored how they took their responses to the collection into account when making their own new works of art. The research team, including the artists, was interested in the ways a gallery could, or would, be used as a resource in the creative process. It aimed to open up the complex relationships between response, research, and creativity, and between past and new experiences, in the artists' making of new art.

There were a number of reasons for instigating the project. First, in England during the 1990s curriculum policy for art in schools came to require teachers to have all pupils make art in ways which took account of their responses to the work of other artists. That is, pupils were required to research the life and work of artists, to respond to art from diverse cultures, and to make art which was in some (unspecified) sense both personal and creative but also derivative from those encounters and that research. Galleries and museums were, inevitably, deemed to be a major resource for these young artists. What the nature of such research might have been, how it might have reflected what artists themselves did, and the best ways in which it might have been helped by gallery staff, teachers, and pupils themselves, were left to be explored.

At the same time, the problematic nature of 'the artist as researcher' raised its profile because of the inclusion of art exhibited by academic staff as products of research in the Research Assessment Exercise in England, on which University funding is partly based. Peer judgements about the nature, extent, quality, and worth of the research activities of those artists who work within art institutes, and their place in the research training of other artists registered in doctoral programmes (for example), thus raised questions about artistic practice as research. Whether and in

167

M. Xanthoudaki, L. Tickle, V. Sekules (eds)
Researching Visual Arts Education in Museums and Galleries, 167-182.
©*2003 Kluwer Academic Publishers. Printed in the Netherlands.*

what ways art collections and galleries might play a part in such research was unknown.

The concept of the artist as researcher raised by these events was also brought into focus for me because of its equivalence to the increasingly popular idea of the teacher-as-researcher (Stenhouse 1975; TTA 1998). That has been a fundamental basis of my own work and my teacher educator colleagues at the University of East Anglia, Norwich. The international adoption of Educational Action Research (Elliott 1991, Hollingsworth 1997) and pursuit of *reflective practice* in other professions (Schon 1983) have been widespread, yet problematic because of different interpretations of these ideas. Although I had worked extensively with teachers as researchers in a variety of situations (Tickle 1987; 1999; 2000) including the art gallery (Tickle 1996) the opportunity to explore the potentials and problems of practitioner research with professional artists seemed like a worthwhile thing to do.

The question about whether artistic production constitutes research also derives from the wider social context of the arts. There is an apparently increasing demand for accountable productivity from professional artists who receive public funding, and popular patronage (for example, from Funding Councils and National Lottery grants in the first case, and through print- and broadcast media in the second). The controversy and contestation which is a part of the arts, the demand for intellectual freedom and pursuit of the *avant garde* on the one hand, and outputs which are deemed to be relevant to social purposes on the other, remain buoyant. So, in intellectual discourse beyond the academies, there is evidence of continuing debate about the role of artists as public intellectuals (Becker 1996), their relationships with society, and their claims for recognition as contributors to certain paradigms of knowledge production.

Finally, and more politically and pragmatically, gallery staff and funding bodies have increased their self-questioning and curiosity about the purpose and role of their institutions in society. This has included consideration of the nature and value of what they offer to artists themselves, and to their professional development and practice, such as through artists residencies and other uses of accumulated cultural wealth.

PUBLIC INTELLECTUAL WORK

Increasing activity in seeking to understand different forms of 'evidence-based practice' derives partly from growing distrust of, and accountability in, the professions and public institutions. But there is also an abiding intellectual interest in ways of knowing and thinking, which complement the rationalist and positivist assumptions of Western thought associated with the Age of Science. That interest has often centred on the question of the practice – theory relationship, the place of social action in relation to knowledge, and the extent to which action is linked with or itself constitutes research. The theoretical background to, and professional interest in, notions like reflective practice and practitioner research derives partly from enduring philosophical questions about the nature, acquisition, and application of

practical knowledge, and the relationship between knowing (epistemology) and being (ontology).

Those intellectual encounters have led to the pursuit of substantive evidence, methodological precision, and theoretical awareness in relation to the individual identities and collective work of many professional groups. Artists seem to provide a good case for exploring the processes of inquiry which contribute to the public good through the production of cultural knowledge. In particular they offer an exemplary case for meta-researchers interested in examining what constitutes research and where, in the case of artists, public institutions such as galleries figure in it. Given the essence of artistic endeavour, they offer a chance to put phenomenology clearly in the frame, with the methodological view that research is a 'first-person exercise. Each of us must explore our own experience, not the experience of others, for no one can take that step back to the things themselves on our behalf.' (Crotty 1998: 85). From an educator's point of view this position was well represented by Maslow's (1973) 'humanistic, existential, phenomenological' image of mankind which strips research (or art) of its institutionalised and elitist trappings, to become a domain of inquiry for everyone. But is that view legitimate?

For the purpose of the Research Assessment Exercise research is 'to be understood as original investigation undertaken in order to gain knowledge and understanding' and as 'systematic investigation to establish facts or principles' (RAE 1997). However, that goes much further than the literal 'recherche' (to seek, to search again) and the idea of carrying out an investigation into, or collecting information on, a subject or problem, which is much closer to commonly held views of what constitutes research. What is more the RAE itself allows for work which is directly relevant to the needs of commerce, industry, and the public service sectors of society – that is, *applied research*. Perhaps more importantly in the case of artists, it also includes the invention and generation of ideas, images, performances and artefacts, where these lead to 'new or substantially improved insights'. While it excludes routine testing and analysis of materials, components and processes, it includes the use of existing knowledge in experimental development to produce new or substantially improved materials, devices, and products. So while 'outputs' accepted in the Assessment are predominantly the conventional academic ones of books, chapters in books, articles in journals, and conference contributions, *exhibitions* of products are counted. Clearly this opened up new territory, albeit in an institutionalised context, which raises interesting questions about the role of artists, the nature of their work as public intellectuals, and their use of the cultural knowledge base of their discipline, much of which is housed in galleries and museums.

ARTISTIC PRACTICE AS RESEARCH

The developments in the school curriculum, the inclusion of art in the RAE, interests in research-based professional practice, and debate about the role of artists as public intellectuals seemed to conspire in raising significant questions about the nature of art practice and the place of research within it. Or, *vice versa*, about the nature of

research and whether art practice qualifies for inclusion. For example, when children (or artists) learn about the technical properties of materials and how to manipulate them in order to make art, gleaning technical know-how from the master producers whose original works of art are encased in museums and galleries, it implies they engage in a kind of research. Perhaps this is somehow equivalent to the conventions of literature searches, the use of academic reference points or of models in medical or engineering research, and of original sources (texts) in theology, law, and government. Interacting with art works for the purpose of interpreting their meanings, researching the backgrounds to and contexts of their production, and using them to support and complement personal ideas and imagination in their classroom (or studio) art practice, suggest another possible branch of (applied) research.

In schools, teachers sometimes call these kinds of research 'historical references', sometimes 'personal studies', or 'critical studies'. The research process thus carries the hallmarks of biography (albeit using mainly secondary sources); or art history; or connoisseurship (Eisner 1979) and so on. Or else it may be data gathering in the search for imaginative ideas or in seeking understanding of the use of visual elements such as colour, form, shape, use of expression, and the like. And herein lies a problem. These few examples suggest that when we talk about research we include many kinds of investigation with different purposes, and with different relationships between understanding and action (knowledge and practice). Those examples convey a sense of research as a mode of personal inquiry. In the case of school practice, the curriculum does not explicate whether or how students' research can lead to original insights, nor imply that it should. What is more, it doesn't indicate any ways in which the processes of making art constitute a research endeavour, rather than being merely an apprenticeship in the conventions, practices, and skills of the trade. Indeed, nor does the Research Assessment Exercise indicate the sense in which the activities of artists preceding an exhibition constitute research practice. So the questions about the nature of art practice and the place of research within it (and *vice versa*, about the nature of research and whether art practice qualifies for inclusion), and particularly the way the cultural base is used, remain open.

Let me, in passing, be clear that even as an apprenticeship, via a school's curriculum or in the education of next-generation artists in the art institutes, I subscribe to Bruner's (1977) view that any subject should be presented to and experienced by students in an 'intellectual honest form'. Its essence should be experienced, albeit in ways which are pedagogically appropriate to students' prior knowledge and learning capabilities. That is to say that the discipline as known and engaged in by experts in the profession should be clearly represented in and reflected by educational institutions. With that in mind, the question underlying our research project arose: *what do art practice and the working processes of artists look like at a professional level?* In this particular instance we were keen to know about the use of galleries and museums as sites of research within the practice of professional artists.

On the face of it the inclusion of art products as the possible outcome of research for the purposes of the RAE appears already to have answered the question: *is art*

research? Or, *are the process and products of art activity commensurate with the practices and benefits of what we usually call research?* But it is a *prima face* answer, which Finley and Knowles (1995: 140) sought to open up when they said it was time for them to 'expand our definitions of research activity to encompass the aesthetic – to observe, to interpret, and to illustrate, with an artist's eye – to pursue boldly a broadly conceived notion that extends to answer the question "what is research?"'

This is indeed a crucial underlying question. Newbury (1997) deemed the art/research relationship to hold three possibilities: research prior to practice; research following (as a reflection upon) practice; and practice itself as a research process. For the latter he argued that artistic work has a method which equates to (but is not necessarily the same as) other kinds of research. But the underlying question is even more fundamental than one of differences in method. It is about community of purpose. In a profound essay, Professor Arthur I Miller asked rhetorically: "What did Albert Einstein, George Braque and Pablo Picasso have in common?" His answer is that each searched for "new means to express the inner beauties of nature While Einstein expressed himself in mathematics, Braque and Picasso applied paint to canvas" (Miller 1997). Miller placed the work of all three in the intellectual, scientific and artistic contexts of modern Europe in the first quarter of the twentieth century. This was a time in which ways of seeing and ways of thinking were challenged and changed by creativity and invention in many fields, at a rapid pace. But Miller's essay was part of a debate at the end of the century, about whether art and science have the same goals, as well as procedures, or are very different disciplines.

Even within the sciences, the humanities, and the arts, the paradigm debate about their goals, the merit of different theoretical perspectives, and the trustworthiness of methodological procedures, which stem from the world views of researchers, has resulted in considerable complexity which even experienced students of the topic find perplexing (see for example Denzin and Lincoln 1998; Crotty 1998; Hein 1998). There may well even be 'paradigm differences' among artists, but that is too big a question for this chapter. For the moment what matters is that artists' work has been seen as offering new means to explore and express 'the inner beauties of nature' as Professor Miller put it. Its role in conveying new perceptions of or ways to represent the world is clearly acknowledged alongside the sciences. Sometimes in its public role it presents new aesthetic insights. Perhaps it will comment on the social and emotional (dis)order of the day. Or maybe it will simply play with new means to entertain the senses. The reasons why artists make art and the processes by which they do so are manifold (for example, see Knobler 1970). The question under present consideration is about the ways their work contributes to knowledge and to our communal sense of being. Or is the work simply personal for each artist, providing individual well-being through kinaesthetic satisfactions for its producer? Is it just a means of externalising inner feelings and communicating lived experiences? Does it merely convey fantasies? Or is it about providing a mechanism for campaigning against various oppressions? To this selection of artistic purposes others could be added, but the general point is that even if it were any of those, or others, we wanted to ask: *in what ways does the work constitute research?* The

subsidiary question was, *can galleries and museums invest in that research, or contribute to it?*

INTRODUCING THE PROJECT

The artists research project was thus devised in order to treat the idea of the artist as researcher in a problematic way, and to expose those questions to scrutiny through a focus on the occupational practices of professional artists interacting with a particular collection. Through a procedure of advertising, discussion and interviewing, four visual artists joined the project team as research fellows. They were: Heather Allen, a sculptor concentrating on large installations; Shirley Chubb, a painter and sculptor who uses a variety of media; Roger Dickinson, who uses mixed media, found objects and ready-mades; and James Rielly, a figurative painter. Their task was to prepare new work, informed by responses to the Sainsbury Centre for Visual Arts, which contains The Robert and Lisa Sainsbury Collection of art from many locations, from 4,000 BCE to the present day. Marianne Majerus, a professional photographer, documented the project using experimental photographic methods to record evidence. It was co-ordinated by Veronica Sekules, Head of Education at the Sainsbury Centre for Visual Arts, and Les Tickle, Professor of Education in the University of East Anglia. In particular, the initial questions addressed by the project were: What are the processes and products of artists' work? How do artists research the work of other artists and take these into account in the production of their own work? In what way can these processes and products be thought of as research, and an artist be thought of as a researcher? For working purposes, we began with the question: are artists interested in the work of other artists, and if so, why?

We were conscious that this was an intervention in the artists' normal way of working, though it was not a major departure from their past experience. Each had used other collections for a variety of purposes. However, they knew they would be required to open up access to their thinking, planning and working processes to each other, Marianne, and the project directors.

The research questions were a little puzzling for the artists at first, but they were prepared to be open minded, in their response to the Collection as well as in reflecting on, documenting and discussing the exploratory and preparatory processes which lay behind the work they produced. Their thinking, responding, interpreting, selecting, using, portraying, and so on, in co-operation with a researcher / photographer and project directors, encouraged us to use naturalistic research methods to foreground the philosophical and educational questions which we were interested in, and to gather the data co-operatively.

As well as encounters with the Collection, the artists worked in their own studios. They visited the gallery whenever they wished, each artist deciding how and when to proceed within the project time scale of six months. Arrangements were made to record the progress of work in their studios, with each also keeping their own independent journals and notebooks. We met occasionally, to discuss the project and the work produced; to view and respond to the photographic record; and

to view, listen to, and record their own impressions of their work within the project. Towards the end each artist wrote a statement describing what he or she had done, and a public exhibition and report presented evidence from the research.

Capturing the complex visual, intellectual, and creative processes of the work of the artists as they responded to the Collection, and as they took account of their responses in the making of their own art, involved many moments of conversation. There were multiple lines of communication, documentation in journals and notebooks, and audiotape and video film recordings of our meetings. Many photographs were taken of the exhibitions and of the artists themselves. The dual role of photographer / researcher, the collaborative nature of the meetings, and personal record keeping by the artists, captured their playfulness, inquisitiveness, thoughtfulness, experimenting, questioning, enquiring, discussing, reading, purchasing, travelling, and exhibiting. The association of thoughts, conversations, and images was both intense and constant, resulting in an extensive portfolio of documentary materials, as well as much unrecorded evidence of passing occurrences, ideas, telephone calls, and the like. There was sharing of pictorial evidence of each others' activities - in their moments of looking, gleaning, sifting, thinking, and crafting. For each of them, prior experience and abiding interests were important factors in determining the direction each person took with their work. Their work in its various stages from conception to display was put on record. As well as their individual inquiries the overarching project research process was one of looking, selecting, discussing, capturing, sifting, judging, and eventually choosing images for display and for publication. Our joint task was guided by the essence of creating something authentic to the artists themselves, and to the aims of the project.

THE ARTISTS' RESPONSES

The artists' responses were mostly not with particular art objects, as anticipated in the project's aims, but very much more complex and wider ranging. Each person started in the same way, by looking at the displays and discussing the Collection as a whole. Ways of generating ideas and methods for producing work were not discussed initially, but remained in the personal and private domain. The artists came with different interests in terms of subject matter and media, and maintained their individuality in terms of how they would proceed and what work they would produce. There was a considerable amount of common ground in their interests in collecting, collections, and the interpretation of information in the gallery. The physical and emotional experience of being among those particular displays, which have a very distinctive character due to the architecture, layout, lighting, and juxtaposition of the objects, also prompted much discussion. The differences and common themes among the artists are illustrated in observations of, and personal commentaries from, each of them.

James Rielly

James Rielly saw the pursuit of his own interests, ideas, and mode of working, as paramount, having come to the project with a preconception of what he wanted to gain from it. He knew that the Collection contained objects which he had been interested in since being a young figurative artist working in a predominantly non-figurative artistic climate. His plan was to revisit earlier influences on his paintings such as the work of painter Francis Bacon and sculptors Alberto Giacometti and John Davies. They were artists who had 'helped him out' with his work in the past, especially during a time when figurative painters were fewer:

> "when I was bombarded by abstract art, and there was I trying to paint in a figurative kind of way...looking for mentors I suppose".

James was reluctant to diverge from this interest in a particular part of the Collection or from his normal pattern of working or style of painting. New thoughts and ideas in response to the Collection were elusive. Change and development in his work resulting from the project was difficult to detect.

> "You are left to make up your own mind on how the pieces interrelate or don't, or how relevant or meaningful they are to you. Having said that I suppose I haven't really responded to it (the Collection) at all".

By revisiting those older influences in this particular setting, though, he did show a notable change in that the pieces he produced became smaller than his more usual large canvases, and were displayed in multiples, in random association, reflecting the gatherings of small objects displayed in the gallery. Retrospectively he said he had wanted to reflect the seemingly random nature of the Collection, though that was not a conscious connection with his own work at the time. On reflection, James felt there was no 'hierarchy' between the various pieces displayed. He produced a group of forty small paintings which he said might or might not relate to each other or to pieces in the Collection. The result was a loose, free-floating body of ideas and themes, "similar to browsing through somebody else's family album, not knowing the individuals but maybe recognising the situation."

Roger Dickinson

Roger Dickinson is an inveterate collector and accumulator of objects himself, and the project stimulated that interest in the activity of collecting. He spent time looking at the whole Collection and concurrently reading about collectors. He roamed around various ideas related to reliquaries, but as impressions settled his work became a series of comments on collectors and collections. He worked on a series of ideas, testing and rejecting them as he went along until his own artwork emerged out of a combination of research, immediate experience and experiment. His first piece of work, a baby's dummy 'enhanced' by a hundred or more outwardly pointing sharp needles, was – perhaps, he said - triggered by a single piece of contemporary

sculpture which he had seen during his second visit to the gallery. Roger described *Skuttle* by Daniel Harvey as:

> "a powerful and curious combination of half a cow's skull bristling with rusted cast iron tendrils, with a strange symbolic resonance, a sinister charm, the two elements in some ways strangely harmonious whilst in others painfully jarring. The cow, symbol of all that is maternal and nurturing, giver of milk, is reduced to a sun bleached skull. Spiked tendrils are at once physically corroded and harsh yet fleshy, plant-like and organic in appearance".

The child's dummy and rusted pins came (fully formed) to mind:

> "one of those rare situations where all that had to be done was to buy the dummy and pins, and make the damn thing. Analysis of its symbolic structure is like tackling an equation in reverse, breaking down the solution in order to reveal the symbols. There was a good deal of mischief."

Roger interpreted the diversity of objects in the Collection and the number of cultures represented as so many languages so arranged as to excite and beguile the senses. "It was like being in the Tower of Babel." Thinking about the gathering together which this inferred led him to make an object from a bucket, a spade and a brush, a light hearted way of using tools which are a crude means of collecting and holding material. These were assembled to resemble – and yet to mock - a satellite, a sophisticated means of collecting, storing and distributing information. Collecting was for Roger associated with consumption, indicated by the frequency with which collectors draw parallels between eating and their pursuit of items.

> "They hunger for objects; are starved for the want of a particular piece; and are nourished by their collections. Like eating disorders, collecting often follows a never-ending binge/purge cycle of lustful pursuit and guilt ridden self-loathing."

The second object he made borrowed an idea from the story *The Golden Apple of Eternal Desire* (Kundera 1991) about the activities of a particular collector whose energies are devoted to the pursuit and acquisition of objects. Having gained possession of a thing, its appeal rapidly diminishes to be replaced by some other object yet to be obtained. In the work produced by Roger, apples - symbol of knowledge and fecundity – coated in gold leaf were used. In a relatively short time they decayed, shrank, and the gold surface shrivelled. This process of shrivelling was photographed at intervals, the images accrued becoming the basis of a separate work.

Involvement in the project served to highlight Roger's habits as a collector. He noted that he made art and collected objects for the same reasons, in his attempt to understand the world and the particular circumstance he lives in, and as a means of constructing his own microcosm which he controls and understands according to his own terms. They were the terms of the private and public playful intellectual, engaged in searching, sifting, gathering, and re-presenting data – the collecting process, artistic process, and research process rolled into one.

Shirley Chubb

Shirley Chubb had long standing interests in producing art that engaged in a dialogue with the intellect, with ideas derived from broad cultural references. Her project was closely related to earlier work done in museums and academic institutions, using a combination of visual and academic research. The whole University as well as the gallery became a resource, guided by a particular interest in the interpretation and meaning which people place on objects from other cultures and times. Her own understanding, as a white, middle class, female artist, was central. She sought out objects that were common to non-western cultures - a series of masks. The intention was to draw out connotations of the objects from students originating from the same countries as the masks. She also used academic texts found in the anthropology section of the library, especially commentaries used to appraise these kinds of artefacts, the communities from which they came, and the customs of the people who made them. These were distilled into short statements, which referred to the fabrication of objects, and to the broader observations that described aspects of the societies from which they derive.

These texts were superimposed onto a graphic image of the original mask laid on to canvas. In the resulting work, textual information such as catalogue details of each object, classification, provenance, and date ripples out from the centre of the images. This is flanked by comments on the making of the masks. Text at the extremes of each canvas comments on social characteristics of the people among whom the mask makers lived. Image and text create layers of information inviting the eye to shift between different ways of understanding the original object. The textual language of academic interpretation became enmeshed with the images themselves, and the language is used to demonstrate not the 'otherness' of cultures, but the similarities between them.

The body of work uses the archetypal western art format of painting as a medium, yet the imagery employed within it, mimicking the original masks, questions our understanding and empathy for what we recognise as art. This point was further emphasised by exhibiting the paintings directly alongside the original objects themselves.

Heather Allen

Heather Allen's work began by exploring the environments in which objects are displayed. It grew out of what was described as "meandering experience" as a viewer, and her responses to the many sensations of light, sound, and sight in the gallery. She spent time observing the lighting, shadows, reflections, vibrations, voices, encasements, fixings, the inaccessibility of objects, and their detachment from each other and from visitors. She noted down her reactions, took slides, brought friends to judge their reactions, watched visitors, read around the subject of collecting, and reflected on her own collecting habits. She experienced the feel of the Collection and what was happening in it, the inference of spaces, reflection,

illusion and sounds. She read two transcripts of interviews with Sir Robert Sainsbury, its patron, and researched various texts on the impulse to collect.

> "Art was being kept in cages, waiting to be rescued, or attempting its own escape. My photographs showed me layers of 'real' and illusory space, boxes of art that existed alongside their reflected 'doppelgängers'."

Heather structured her ideas before working on material to produce an installation that came very clearly and logically out of them. She worked on several ideas at the same time, experimented with layering sound tracks that used titles from the Collection over softly vocalised entreaties. She photographed other people's collections, and took slides of eyes looking at objects. She sifted through old family snapshots that took on new meanings when catalogued academically. She tried out mesh boxes with images of objects projected onto and through them. She inverted and subverted the experiences, and re-presented them, overlaid with concerns derived from the idea of collecting. Those concerns were about accumulation, classification, ordering of material, and the style and process of display. A period of reflection enabled her to combine prior interests in the development of installations, direct experience of the Collection, and continuing research on collecting and collections. The resultant work of art re-classified and re-contextualised an entire set of experiences, images, text and ideas, so that viewing her work is quite unlike the experience of looking at art by wandering in the gallery. The box became an important element because so much of the Collection is closed off within transparent cubes, the objects untouchable and contained. She made a maquette and tried different items inside, put a blanket over the base, covered the floor with rows of plasticine people, and then removed them.

> "The box and its space ended up as a white cube - the site for so much contemplation on art, a closed but almost visible and empty physical space where images of the manifestation of the urge to collect would take shape."

The installation *Object of Desire* became a large empty space in which light is projected, carrying text from the titles of objects, conveying notions about self-constructed and projected desire: "I left the objects out and used just the titles." Projections alternated with images from her own 'collection', catalogued according to her own system (whim?), for which she constructed her own method of provenance.

> "An intriguing relationship emerged between cataloguing and its subsequent intellectual 'authorisation', and what may have started as a personal emotional need of the collector."

Collector's Piece embodied experimenting with other types of image which explored the nature of the relationship between the impulse to collect and the collected object.

THE ARTISTS' WORK AS RESEARCH?

Inclusive Criteria

The evaluation of outcomes from this project is very complex and must be alert to many different facets of activity, both in the individual, 'first order' action research of each of the artists, and in the 'second order' collaborative research of the project as a whole. The question is, can the activities be regarded as research, judged by the criteria discussed earlier, or by some others applied hereafter? There was a danger of constraining the project by trying to fit it into pre-existing research paradigms, rather than pushing the parameters of research in ways consistent with the work of the artists themselves, or with Finley and Knowles' (1995) expansion of research to encompass the aesthetic. For example, the choice of a photographer as principal researcher, the use of experimental photographic methods, and the production of the original largely visual report (Allen et al 1997) which is itself a work of art, provoke the need to read this research project differently and on its own terms. Yet its starting point and peer references are also in part those external contexts from which the project arose. So it is still necessary to search for evidence of the processes, in visual and other forms, that inherently constitute the activity we call research. As far as both the individual, personal research of the artists, and the combined team-project are concerned, I want to claim that the research process involved:
- a hunt for perceptible stimuli, ideas, influences and starting points;
- justifying purpose and intention in personal *and* social terms;
- discovering reference points in the research / artistic culture;
- identifying ways in which the senses respond to environments / data;
- recording and interpreting data in rigorous ways;
- generating meaning and creating metaphors for representing them;
- reflecting on preconceptions and new meanings;
- publicly presenting perceptions, interpretations and representations of experience.

Ideas were filtered through intellectual processes and translated into different visual languages at both levels of the research. Images crystallised as a result of background reading, self-reflection, and even a sense of mischief, but also as a result of seeking novel and stimulating means of representing ideas. Sometimes ideas acquired greater significance through public discourse. The art, and the project report, were created from an accumulation of experiences, and a search for the language and means of 're-presentation' which might excite viewers. The work created by the artists became meaningful to themselves when each absorbed it into the context of their own pre-existing ideas, reflected on it in the light of their current research, and brought to it the character of their own artistic personalities and styles of production. In this sense the insights were due to be, and became, idiosyncratic and personal, but also shared and discursive.

What Kind of Research?

The features of this process seem to correspond with the characteristics of research as it is commonly understood, and also more specifically with Schon's (1971, 1983) analysis of the relationship between practice and research. He certainly offers a perspective from which to consider the artists' work as research. Though his ideas are complex, they are based on a simple notion: that when a professional person reflects in action he/she becomes a researcher in a specific and particular practical situation. Because situations are complex and uncertain, and always unique because of the combination of variables which come together, practice problems are usually difficult to identify. They are also difficult to act upon, since judgement and action need to be taken to fit the particular characteristics of each case - 'selectively managing complex and extensive information'. This central notion seemed to represent the situation of the artists working in the project and the nature of artistic work more generally.

Crucially Schon argues that the purpose of professional activity (teaching, counseling, *artistry*, engineering, and architecture), unlike 'pure' research, is to change the situation from what it was to a desired state. Once action has been taken, further management of information is required, to judge the effects of action and assess the newly created situation. According to this thesis, the constant activity of appreciation, action, re-appreciation and further action leads to the development of a repertoire of experiences of unique cases in practice, which are then available to draw upon in other, unfamiliar, practice situations. That repertoire, those points of reference, are inevitably personal, derived from exploring one's own experiences. Yet when entered into the public domain they become communal, feeding back into accumulated cultural knowledge.

This too seemed to fit the evidence of activities among the artists, who were seen to work for change in several respects – for example, in their own outlook and perceptions, in the manipulation of materials, in the reformulation of imagery and representations, and the reformation of their audiences' perceptions and understandings. These changes – this extension to the repertoire of knowledge - was used, as Schon described it, through the recombination of *elements* of past and current experiences, rather than as what he calls 'recipe knowledge' which replicates previous solutions. In this process each new situation is dealt with through reflection-in-action, further enriching the repertoire of practice. The process of reflection-in-action, in this view, involves the construction of each aspect of professional practice, through experiment and inquiry.

The model again seems to fit the artists' predisposition towards their artistic activity, in which the idea of sequences, series, schematic explorations, and variants were commonplace. The evidence of the work of these artists, examined in these terms, presents a case of *this kind* of research.

Perhaps the most important characteristic of Schon's view of practitioner research is that the experimenting (in our case the artists' work) is different to methods of controlled experiment, because professionals attempt to realise their own 'imagined solution' to problems. It is also different from some other activities which

we normally think of as research because all the factors involved in the experiment are not under control, making situations unstable and outcomes relatively unpredictable. This has particular poignancy to an artist's case, where there is no claim to manage or control the realm of imagined possibilities, even though there might be (but by no means always is) a desire to control the physical materials by means of which those possibilities can be realised. Indeed, an intrinsic part of the imagined situation is often the desire to be ambushed - visually, intellectually, sensually, emotionally. There are engagements with paradox in art and intentions to be disrupted and to disrupt.

Schon argues that the cycle of engagement with experience, though, is a feature of the construction of the theories and understandings of practitioners. It is a form of practical experimenting. He defined three kinds of such experimentation. *Exploratory experiments* involve a kind of probing, playful, trial and error activity. In *move-testing experiments* action is taken with the intention of producing change. *Hypothesis testing* involves discriminating between competing hypotheses and seeking confirmation or dis-confirmation that they are correct. In these respects research based practice does not and cannot provide an emulation of controlled experiment. Indeed, he argues, such experiments in practice necessarily violate the canons of positivistic research, residing more justifiably in the realms of 'artful inquiry' (Schon, 1983, p.268). This too seems to equate nicely with some of the activities of the project artists.

The objection might be raised that these characteristics of research / art practice provide little confidence in the trustworthiness of the knowledge gained; or that there is nothing systematic here, when we might expect rigour in experimental research. Depth of attention and seriousness of intention would seem to be desirable and necessary in artistic practice in order to develop new perceptions, ideas and understandings. That is both necessary and achievable, Schon argues, by means of generating and testing knowledge in the 'here and now'. This is existential knowledge, in which modes of research such as case history and narrative, and the study of processes internal to a project, are important. There are certain preconditions which are essential to the formation of knowledge by these means. The maintenance of continuity over the learning process is one condition. Recognition of the open-ended nature of all situations is another. Subjecting 'models' derived from experience to testing, allowing for their modification, explosion, or abandonment is essential. So is the willingness of learners to make leaps in problem solving, through an ability to synthesize theory and formulate new models while in the situation (Schon, 1971, p.235). These kinds of characteristics, I would contend, can be found in the evidence of the working processes of the artists in this project.

ARTISTS AS PUBLIC INTELLECTUALS

So much for the process, but what of the public contribution to knowledge? Here I believe Carol Becker (1996) has an interesting contribution to make. She argued the case for artists as public intellectuals, creating interpretations of the complexity of

the world, in the hope of generating both personal response and public debate on matters within that complexity. Becker (*ibid*:: 18) cites Gramsci's claim that all of us are intellectuals, but that a distinction can be made between two types. *Professional intellectuals* such as teachers and priests, are seen as those handling stable, transmittable, and 'at times even stagnant' knowledge. *Organic intellectuals*, on the other hand, are seen as constantly interacting with society, 'struggling to change minds', engaged in the evolution of knowledge, raising issues in the public domain, and defending decent standards of social well-being, freedoms, and justice.

The distinction she uses is crucial, dividing 'those who simply represent the information that they were trained to pass along and those who are innovative, daring, and public in their re-presentation of their own personal interaction with the world.' (*ibid*: 19) The latter can certainly be claimed to fit the evidence in the case of the project artists. The gallery was another commodity, among the many they had available for use, a bit of the world which was put to good use in a search for issues, ideas and the incitement of the senses, emotions, and intellect. It temporarily housed their interest, generating a hunt for perceptible stimuli, influences and starting points. They examined the purpose and intention of their work in personal and social terms. Reference points in the research culture were discovered. Ways in which the senses respond to environments / data were identified. Data were recorded and interpreted in rigorous ways, creating meanings and metaphors for representing them. Preconceptions and new meanings were reflected on, and interpretations and perceptions were publicly presented. This, I believe, provides a challenging model for the ways in which practices in the gallery can serve artists. It can also be translated into school curriculum practices, so that the concept of the organic intellectual and its associated research processes can be developed at an early stage with students. We might then ensure that the nature of professional art practice and art in schools represents that expanded definition of research activity which Finley and Knowles were seeking. By such means the gallery might be transformed into a multi-dimensional research resource, extending its contribution to public discourse through the arts.

Les Tickle is Professor of Education in the School of Education and Professional Development, University of East Anglia, Norwich, UK

ACKNOWLEDGEMENTS

I would like to extend my thanks to the Arts Council of England for funding the project *The Assimilative and Transformative Uses of Art Objects*; to my colleague Veronica Sekules, Head of Education at the Sainsbury Centre for Visual Arts, UEA, Norwich, and to the artists Heather Allen, Shirley Chubb, Roger Dickinson, Marianne Majerus, and James Rielly. A full visual report of the project, Collections and Reflections (Allen, et al 1997) was published by the Arts Council of England. Some aspects of that report are included in the present paper.

REFERENCES

Allen, Heather, Shirley Chubb, Roger Dickinson, Marianne Majerus, James Rielly, Veronica Sekules and Les Tickle. *Collections and Reflections*, London: The Arts Council of England, 1997.

Becker, Carol. The Artist as Public Intellectual. In Henry Giroux, and Patrick Shannon (eds). *Education and Cultural Studies*. London: Routledge, 1996.

Bruner, Jerome. *The Process of Education*. Cambridge MA: Harvard University Press, 1977.

Crotty, Michael. *The Foundations of Social Research*. London: Sage, 1998.

Denzin, Norman and Vonne.Lincoln. *The Landscape of Qualitative Research*. London: Sage, 1998

Eisner, Elliott. *The Educational Imagination*. London: Macmillan, 1979.

Elliott, John. *Action Research for Educational Change*. Buckingham: Open University Press, 1991.

Finley, Susan, and Gary Knowles. Researcher as Artist/Artist as Researcher. *Qualitative Inquiry*, 1(1) (1995): 110-142.

Hein, George. *Learning in the Museum*. London: Routledge, 1998.

Hollingsworth, Sandra (ed). *International Action Research*. London: Falmer Press, 1997.

Knobler, Nathan. *The Visual Dialogue*. New York: Holt Rinehart and Winston, 1970.

Kundera, Milan, The Golden Apple of Eternal Desire, in *Laughable Loves*. London: Faber and Faber. 1991.

Maslow, Abraham. What is a Taoistic Teacher, in Louis. J. Rubin (ed) *Facts and Feelings in the Classroom*. London: Ward Lock 1973.

Miller, Arthur I. Three Wise Men, Two Worlds, One Idea, in The Independent on Sunday, (23rd February, 1997): 40.

Newbury, Darren. Research Training Initiative: Interim Report, University of Central England in Birmingham, 1997.

R.A.E. (Research Assessment Exercvise) Circular to Higher Education Institutions. London: Higher Education Funding Council of England, 1997.

Schon, Donald. *Beyond The Stable State*. San Francisco: Jossey Bass, 1971.

Schon, Donald. *The Reflective Practitioner*. New York: Basic Books, 1983.

Stenhouse, Lawrence. An Introduction to Curriculum research and Development. London: Heinemann, 1975.

TTA (Teacher Training Agency) *Teaching As A Research Based Profession,* London: TTA,1998.

Tickle, Les (ed). *The Arts in Education: some research studies*. London: Croom Helm, 1987.

Tickle, Les. *Understanding Visual Art in Primary Schools*, London: Routledge, 1996.

Tickle, Les. Teacher self appraisal and appraisal of self, in Richard P. Lipka and Thomas M. Brinthaupt (eds*) The Role of Self in Teacher Development*. Albany, NY: State University of New York Press, 1999.

Tickle, Les. *Teacher Induction: The Way Ahead*, Buckingham: Open University Press, 2000.

MARJO RÄSÄNEN

INTERPRETING ART THROUGH VISUAL NARRATIVES

Abstract: According to my model of experiential art understanding, art experience comes into being when personal and social identities of the artist and the recipient meet in terms of the context where the work of art is explored, guided by the artwork's material and expressive cues. I approach the artwork's contextualization with the help of art disciplines based on verbal conceptualisation and premises of artworlds, and develop these inquiry methods on the terms of the learner's lifeworld and artistic production. In this chapter I give an example of how teachers and museum educators can bridge students' lifeworlds and artworlds. I tell a tale of a high school class interpreting Akseli Gallen-Kallela's painting the Aino Myth (1891) through verbal and visual narratives.

A WORK OF ART AS A MEANS OF CONSTRUCTING SELF

Experiential Art Understanding

Educational practices and research are in transition. One of the basic claims in the change of research paradigm in the humanities is that art should be considered as valuable a form of knowing as science (Eisner 1991), and the new methodology includes discussion of arts-based inquiries (see Diamond and Mullen 1999). According to this view, artistic research involves making use of different fields of the arts as an object of research, as a means of research, and as a form of reporting. Artistic inquiry crosses boundaries between different ways of knowing. Expressing personal encounters with experience is the basis of artistic research. The notion of art as research has led to a new conception of art learning where we speak about art as a special kind of cognitive process and a means of inquiry.

Take a strip of paper and join both its ends so that you wind one end upside down before fixing it together with the other. The double-faced Möbius strip you get symbolises interaction between art and science. It also shows the dualistic and endless movement of artistic knowing. (Mullen et al. 1999) Similar to this, David Kolb (1984) speaks about the double knowledge theory where conscious and unconscious grasping are combined through the transformation processes of apprehension and comprehension.

In the model of experiential art learning which I developed from Kolb's learning conception (Räsänen 1997), I connect experiential-constructivist learning theories with some cognitive art learning models (Parsons 1987, Koroscik 1997, Perkins 1994). In my model the knowledge base of art learning is represented in the form of a triangle consisting of 1) expression and skills; 2) facts and ideas; and 3)

183

M. Xanthoudaki, L. Tickle, V. Sekules (eds)
Researching Visual Arts Education in Museums and Galleries, 183-195.
©*2003 Kluwer Academic Publishers. Printed in the Netherlands.*

perceptions and emotions. Above this triangle, an experience is transformed through reflection, conceptualisation, and production. The experience may arise from a learner's inner world as well as happenings and symbolic objects like works of art in the outer environment, but the prerequisite of learning is that one gives conscious meaning to the experience and puts his or her new understanding into action, i.e. makes a work of art.

My model of art understanding is based on the idea of visual conceptualization. It means interpreting a work of art through creating new artworks. Using pictorial appropriation and 'recycling' according to the postmodern meaning does not exclude the use of traditional methods of art research based in verbal conceptualization. However, instead of delivering facts, I emphasise the importance of the inquiry processes used in art research and the students' ability to transfer learning to new contexts. For example, art historical methods such as iconography and biography are still valid while connected to visual production that deals with issues and problems relevant for the learners.

Besides visual conceptualisation, the second core concept of experiential art understanding is contextualization. If the viewers shape the interaction between the artist, the artwork, and the viewer, they have also understood that the process of learning is a spiral where interpretations keep changing according to the rethinking caused by a new context. However, this does not lead to complete relativism but to the emphasis of the role of the viewer's self-reflection. Even when all interpretations have their justification, the best interpretation is the one that connects the realities of the artwork, the artist, and the viewer.

Bridging Lifeworlds And Artworlds

My proposal for art understanding derived from the triangle and spiral of experiential art learning is based on a metaphor of building a bridge or better still an aqueduct. The process of experiential art interpretation always takes place preconditioned by the learner's lifeworld. The first, base level in the 'aqueduct' of art understanding is founded on the personal and social knowledge of the viewer. This means connecting the learner's life history knowledge with his or her first experiences of an artwork, with the cultural knowledge mediated by the artwork. The prerequisite and goal of art understanding is an ability to transfer personal knowledge in the context of social knowledge and vice versa.

An indispensable element for that transfer to occur is the 'key stone' of the vault carried by the two main pillars of the aqueduct, that is the learner's self. Self is a concept in a state of constant change; it is a whole consisting of different roles and relations, cultural identity being a crucial part of it. Self-construction is an unlinear collage of collected life experiences possessed by each individual. The feeling of continuity separates an individual from another even when it is socially determined and connected with other people's lifeworlds. (Gergen 1991, Giddens 1991)

The artworld is approached by inquiry based on experiences and inquiry based on concepts, and a work of art is both the starting point and the outcome of the inquiry. At the level of conceptual inquiry, the work is approached in the

comparative context of the artworld, from the perspectives of art history, criticism, and aesthetics (see Addis and Erickson 1993, Barrett 1994, Lankford 1992). The students learn to understand the meaning of the work in its historical and cultural context. They learn to make reasoned judgements about art and to understand the grounds upon which those judgements rest. Finally, they learn to participate in the discussions of the artworld through their own artworks.

The experiential-constructivist model of art learning is based on the movement from lifeworld to artworld and back again. In art interpretation, transfer between art understanding and self-understanding can occur in the way that the phenomena with which a work of art deals, relate to a student's experiences. From this point of view transformation means learning to learn. This metacognitive level means developing the ability to describe one's artistic learning process and the possible effects of new learning on other school subjects and in other experiences of everyday life.

Transfer may be promoted by integrating the three disciplines of art research: history, criticism and aesthetics. In my opinion, the inquiry processes of these disciplines should all be used in the context of art making. Making notes and mindmaps through sketching, comparing pictures and organising them into collages, or letting students discuss with each other through polarisation of pictures, are some of the means that can be used to strengthen the power of images in the field of art research dominated by words. I find 'pictorial art interpretation' to be an appropriate and effective way to connect the experiential learning goals to visual and verbal conceptualization: reflection, conceptualization, and production are all needed while studying images. My research provides evidence that pictures and words are not rivals in art interpretation but verbalization also contributes to the artistic quality of student works. Along with applying the verbally based methods of art research (used in academic traditions of art history, aesthetics, and criticism), enriched with the visual inquiry methods associated with art making, the students are constantly reflecting through sharing and writing in their pictorial diaries.

From Associations To Appropriations

In the model of experiential art interpretation, there are three stages. Art understanding begins with RESPONSE. It means starting with each student's personal experience, emphasising a sensuous encountering of the work of art. This is followed by reflection both individually through pictorial and verbal notes and through sharing in group conversations. At this stage, the learner verbalises his or her preunderstanding. The process continues with CONTEXTUALIZATION when the first experience is enriched through acquiring both verbal and pictorial background information. Reflection is central also at this stage: sharing the experience is now extended from the small group to representatives of different periods and cultures who are indirectly taking part in the discussion. At the third level, PRODUCTIVE ACTIVITIES, the learners are making art from art. The appropriations created are again reflected through writing and shared in the group.

I have applied my model with different age groups both in classrooms and museums. The process usually starts with the group gathering around the artwork,

either a reproduction or an original. I ask the students to see the image as open-mindedly as they can. They look at the picture for a couple of minutes quietly and then begin to jot down words, sentences, and small sketches about details in the painting or whatever comes to their mind. After sharing the verbal and visual notes I ask the class to make a picture about something in their lives that the artwork brings to mind. The students present their images to the group. The lesson ends up in students reflecting on their experiences through the questions given in their journals, which deal with the inquiry process and connections to their lifeworlds.

The key idea of the first phase of interpretation is to make the students understand that different people may respond to the same painting differently. Always when it is possible, I take the group to visit the original artwork in the museum in order for them to understand how the art experience is also dependent on its physical context. At the stage of contextualization the painting is approached using art historical, critical, and aesthetic inquiry methods which are connected to art making. Building a bridge between the artist's biography and the viewer's life leads to the main visual assignment of the class where the artwork under study gives birth to new pictures. In the final assignment, I ask the students to give a pictorial answer to the question What does the painting mean to me?

Experience based interpretation aims at recontextualizing the artwork studied. The goal of the process is to recycle the image in an intertextual web of works of art and other texts, and transform it to an appropriation that carries the traces of the process of interpretation and represents the student's lifeworld and personal meanings given to the work. I call the simplest form of appropriation a pastiche. It refers to a copy of an earlier artwork where the maker's own 'hand-writing' can be seen. Another form, paraphrase has always to do with change: it means a work of art which reflects an earlier work in a way that reveals similarities and differences between the two. A paraphrase is a form of interpretation which makes clear the viewer's interpretation of the original. Finally, palimpsest involves productive activity that has its roots in the original artwork, but shows that the student has been able to make a thorough interpretation of the work and connected it to his or her lifeworld. The student has transformed this personal meaning to a new artwork with a thoughtful form and content. When analysing a sophisticated palimpsest, it is possible to trace the layers of different visual and verbal interpretations shared during the experiential learning process. What is crucial in this kind of appropriation is that the 'student artist' is able to explicate these references.

Understanding Self And Art

The relationship between self-understanding and art understanding can be revealed from students' journals and appropriations. I see the development of self through the way students see the relationship between their past, present, and future selves. I pay special attention to the relationship between self and others. In the beginning of self-development, considering self as unchanging and isolated from others is often connected to the importance of rules and roles in social relationships. Interpersonal

relationships become an important parallel with differentiation. A coherent self-concept system is needed for co-operation with others. (See Damon and Hart 1988.)

I use the concept of discourse to describe the process of understanding the dependence of self on different social practices. In experiential art interpretation, students examine the discourses embedded in works of art. A tendency to explain both human behaviour and art in universalist terms is usual to novice art interpreters. The increased ability of self-reflection leads to acceptance of self as social being and openness to different multicultural issues and the potentials of a related self. Finally, self is understood as a product of culture and time. Realising the interdependence between self and others often leads to recognising or adopting habits and discourse positions which were previously disapproved of. (See Gooding-Brown 2000, Walker 1996.)

Students' art conception can be studied through their understanding of the relationships in the triangle of artist, viewer, and artwork (see Parsons 1987). My study (Räsänen 1997) gives support to Parsons' view that at the beginning of aesthetic development, the artist is seen as an imitator of perceptible reality, and judging the artwork is not distinguished from judging its maker. Gradually, students' view of the artist changes from a skilled craftsman to an intentional subject trying to express itself. Students understand that creating an artwork is dependent on the artist's lifeworld, and that the subject matter and content also have to do with issues related to the viewers' cultures and lifeworlds.

The viewer first identifies his or herself with the artwork as if it was a part of the real world. Development moves from reciprocal relation between the artist and the viewer to participating in what Parsons calls a "great conversation" with artists and philosophers across the centuries. Seeing the artwork from the perspectives of critics, art historians, teachers, and peers places it within a community of viewers. The artwork becomes a part of a cultural tradition.

In the beginning of their aesthetic understanding students conceive the significance of an artwork as a subjective insight that is not related to the medium or style. The ability of contextualization is first distinguished by seeing style as a characteristic of an artist and gradually it is related to cultures. Technique is no longer seen as a leading principle of art making but as something that the artist chooses for his or her purposes. Little by little, works of art are understood in a social-historical context. Understanding the subject of an artwork develops from demands of mimetic representation to personal meaning giving. It means connecting the work of art to both the artworld and the viewer's lifeworld. The student is able to approach the work by means of disciplinary knowledge and understands the reasons for his or her own response.

Aesthetic development has to do with our criteria for judging the artwork and with the awareness of self in our judgements. If the student is able to understand art as a conversation between individuals and traditions, a central prerequisite for transfer is achieved. Autonomy in art understanding means being aware of our changing self and the need for constant reinterpretation of our experience of the artwork and ourselves. As we clarify our response to an artwork, we also clarify ourselves. By judging a work, we judge the elements of our experience and hold their character and value in question. If we adjust them in light of their sense of their

value, we adjust our self. It is here that the transfer between self-understanding and art understanding happens.

CONTEXTUALIZING THE AINO MYTH THROUGH NARRATIVES

Narrative As Inquiry

Art transforms emotion and knowledge into interpretation which can be repeatedly replaced with new interpretations. Artistic representations have a special ability to express the quality of experience. On the other hand, art similar to other representations filters, organises, and transforms experience. The arts transform experiences into a form that can be handled and shared with others. Artistic forms of sharing are, for example, pictures, stories, dance, and drama. We share our narratives of the world in myths, histories, glass paintings, comic strips, newspaper articles, etc. (Diamond and Mullen 1999.)

We construct our identities through the stories we tell about ourselves. Our personal narratives are made out of what we have read and seen or heard and felt. The construction of self is a study of transactional relationships within which one's story is in constant change. This kind of narrative approach abandons the concept of a modernist unitary self and presents selfhood as a site of identity production, in relationship to the world around us. Selfhood turns from noun to verb, to a process of autobiographical study. Self-referential and intertextual narratives help us to reflect on and change our plans and dreams. (Diamond 1999.)

Artistic narratives offer new challenges to educational research and help us to see the practices of art education from a new point of view. Narrative research can be defined as a form of conceptual storytelling. Many contemporary methods of literary and visual art research can be used in creating narratives. Most often, writing still seems to provide the easiest method of inquiry in this kind of storytelling and visual conceptualization is neglected (Räsänen 2002). In visual narratives, creating the 'text' follows the advancing process of meaning giving. Image based 'research reports' often consist of intertextual excerpts, where 'texts' are characterized by unlinear movement and connections between visual metaphors. It is in symbols, analogies, and metaphors where the power of visual conceptualization lies. (Feinstein 1982, Jeffers 1996, Lakoff and Johnson 1980.)

Visual narratives in films and comics are perhaps the closest forms to verbal narratives, and demonstrate the possibilities of equalising the forms of conceptualization of non-verbal fields of art with those of verbal ones. Storytelling also offers one challenge for approaching art in museums and classrooms: building bridges between verbal and visual narratives focuses on art making as a form of interpretation and strengthens the power of visual conceptualization. In the second part of my article, I tell how I have used this kind of intertextual art interpretation based on visual narratives as a way of supporting the students to see an artwork as well as their lives in a new way. My descriptive story about a museum visit also serves as an example of the model of experiential art understanding. The story originates from an action research project I conducted in a Finnish high school class

(Räsänen 1997). Each lesson of the 35 hours long course consisting of interpreting and making art was connected to Akseli Gallen-Kallela's painting the Aino Myth (1891).

The museum visit we made in the course is an example of how all phases of experiential art interpretation may be included in one lesson. The response stage began with a personal experience while meeting the original painting. After a short reflective observation, the class moved to the stage of contextualization and explored the artworks in the exhibition with the help of verbal information. Then the small group works were shared and some reflective writing was made. The verbal transformation process had to do with art history and criticism. Art critical inquiry mainly took place through reflective writings, based on a feminist model (see Hicks 1992). Aesthetics was implicitly present while I posed art philosophical questions and asked the students to ground their judgements. In the case of the Aino Myth, intertextual analysis started by recalling the Kalevala saga which Gallen-Kallela has transformed into a visual narrative. Productive activity of this lesson took the form of written narratives and storytelling through comics that students used to interpret the triptych. Sharing the student works completed the learning circle some lessons later.

Gallen-Kallela's Triptych

Akseli Gallen-Kallela: The Aino Myth, 1891. Oil on canvas. Centre panel 153 x 153 cm, wings 153 x 77 cm. Ateneum Art Museum, Helsinki. Photo The Central Art Archives/ Hannu Aaltonen.

Before entering the exhibition hall, I gave the students a postcard reproduction of the Aino Myth, and asked them to enter. The group stood quietly in front of the huge triptych as if they were in a church. I told the group to look at the painting from the other end of the room and then slowly approach the painting again.

All students study the artwork closely, and a quiet discussion starts in the group. I ask the students how the original artwork differs from the reproductions we have seen. Johanna thinks that "The original is much lighter. I prefer the postcard version because I am used to it". Someone states that the figures are much bigger than he could imagine. I say that "Art historians use a word CONTEXT to tell that our response is dependent on the place and situation where we see the artwork. Seeing a naked woman printed on a T-shirt affects you differently than seeing the same nude in a painting in a museum".

"Why do you think the Aino Myth and the artworks around are put in the same room? They are all painted at the same time, about one hundred years ago. Here you get a handout where you can see how art historians write about art. The styles of the Finnish art in the 1890s were National Romanticism, Karelianism, and Symbolism. Please divide into four small groups and search for a representative of one style based on the description marked in your handout entitled HOW IS THE ARTWORLD AT THE END OF THE LAST CENTURY REFLECTED IN THE AINO MYTH?".

After sharing the contextualization phase through brief group presentations, students continued reflecting on their experiences of the Aino Myth through writing. Students were asked to describe the way Akseli Gallen-Kallela depicts women. They were pushed toward idea generation and theorising by asking for reasons as to his representation. Students were also commenting on the way other artists in the exhibition represent women. The third question had to do with the skill to relate art historical objects to contemporary visual culture. I asked the class to identify differences between the ways of depiction in the 1890s and the 1990s. I also wanted to promote student abilities to see things from another's point of view by asking how they would feel if depicted in the same way as Aino. In order to relate the women of the 1890s to contemporary women, I asked if Aino reminds students of someone else. (See Räsänen 1997, pp. 206-207.)

Visual Narratives

After moving to the museum's studio class, we recall how in our national epic Kalevala, Väinämöinen met the young Aino in the forest and went to her mother to ask for her hand. Aino's mother said yes even though her daughter burst into tears. Mother told her she would become the most prosperous woman of the region: Väinämöinen was a big boss, like some famous scientist, actor, politician, or millionaire of today. However, Aino preferred anything else to marrying an old man. In the middle part of Gallen-Kallela's triptych, the innocent girl symbolically runs out of the hands of the man. In the third panel Aino has literally run away from Väinämöinen. In the Kalevala, we can read that Aino went to the lake, took off all the clothes and the jewellery that Väinämöinen had given her that represented those social values her mother would have wished her to respect. Aino heard the water-nymphs invite her to a place with eternal peace. And she went to the water. The middle panel actually illustrates how Aino came to tease Väinämöinen after her suicide.

"Look at the postcard of the Aino Myth. Continue the story of the painting and consider, what might have preceded the events depicted in the triptych. What will happen after the third panel? Place yourself into the happenings - you can be Aino, Väinämöinen, yourself, or someone else! You can turn aside the Western reading

direction and tell the story from right to left or cut the panels of the triptych apart and reorganise them. Even if Gallen-Kallela has written the story to the frames of the triptych, thus telling that his intention was to illustrate the Aino saga, we can study the triptych as separate from it. Notice that not even the artist has depicted the sad end of the story in his painting but a girl feeling the water and contemplating. You can totally forget the Aino saga in the Kalevala!"

Through the complicated intertextual double-coding of Kalevala and Gallen-Kallela's interpretation of it included in the exercise, most of the comics turned at least into paraphrases. All except two of the students placed their story within the framework of the original Kalevala. However, only one of the student works can be interpreted to end according to the myth. The rest of the students used the beginning of the original story with the old man harassing a young girl, often giving detailed information of the girl leaving home. Four of the alternative endings were about revenge: in three stories Väinämöinen's boat capsized and he got drowned. In Laura's story, the girl turned into a gorgon who killed Väinämöinen. Johanna also reversed the relationship between the man and the woman, making Aino into a jealous girl who is so in love with Väinämöinen that she wants to drown herself because of the man's affairs. The love-story ends up with a happy reunion.

Elina's story was moved into our own time and it was the only work where Aino's difficult choice was clearly connected to the viewer's own values. There the girl got support from a boy of her age and made an independent decision of leaving the old man and following the youngster. Three girls used the I form in their comics. When asking about the students' own roles in the pictorial story, the only ones to answer were two girls who said they were the narrators and one who told she was the gorgon. It was apparent that even though the students found it easy to identify themselves with the figures of the painting, they were not willing to build a reciprocal relationship between self and other represented in it. Students' inability to explicate the relationship between the original and its appropriation makes their works remain at the transition stage between a pastiche and a paraphrase.

Three students used the triptych only as a source of inspiration for a narrative pastiche. Isko's comic describes a heroic, violent life in the past. In her romantic comic Heli tells about a robber's bride in the Middle Ages. Sini's paraphrase reflects a longing for the safe childhood, where guardian angels in the form of teddy-bears come and help the girl in trouble. Mika's story forms an interesting contrast to Sini's sentimental world view. It happens in contemporary life and includes a cruel comic solution parallel to the Aino saga. In the first part of Mika's paraphrase Aino and Väinämöinen meet on the street with blocks of flats. They go to the man's summer house where Aino refuses to make love with Väinämöinen. The man cries "If I don't get it from you now, I will change into Jekyll!" The story ends with the escaping Aino and Väinämöinen, who is replaced by a monstrous comic figure with a knife and a fork in his hands.

Verbal Narratives

Most of the students did their reflective writings at home. Students were asked about the object of Aino's gaze. In the follow-up question, I gave a cue of interaction

between the artist and the viewer by asking what Aino might say to them. I then told the students to make an outline of a story from the perspective of Aino based on the visual cues in the artwork, and to write a dialogue between her and the student or some of the women portrayed in the exhibition. I also asked students to explain reasons for the conversation.

Students' drafts reflected the importance of peer relationships and moral contemplation in their self-development. From the perspective of art understanding, the narratives reflected egocentrism so that the only perspective used was that of the viewer, and no contextualization was made. What connected the students' stories is empathy with Aino who is asking for help. Similar to the comics, the plots of written narratives usually imitated the Kalevala saga. Different from it, in students' narratives Aino was not alone with her anguish, but got support from a friend. The only exception was Mika's dialogue where he turned the conversation into a joke where Aino and Mika meet, greet each other and say good bye. It seems to me that Mika's narrative was directed to his peers, thus strengthening my view of the stories as reflections of the importance of others in students' construction of self.

Heini is the only one who explicates any visual connections between the triptych and her story. According to her, Aino's position in the painting indicates fear and her face expresses sorrow. In Heini's dialogue, the naked Aino who has just escaped her harasser is asking someone ashore to bring her clothes. When Aino thanks her helper, the person says that she/he would never leave a good friend in trouble. In her similar narrative Henriette openly identifies herself with the helper, telling that of course she helped Aino. In Anna's dialogue Aino tells a girl in the painting next to the triptych in the museum about the terrible old man who is following her, and the other girl advises her to hide herself behind the stones. Anna explains that in her story, Aino wants to hear the opinion of another young girl. Isko as well as Anna emphasises that Väinämöinen is Aino's enemy. Isko explains that in his story Aino is also angry because she is in trouble and he as a passer by just watches her. Finally the girl gets help from him.

Aija, Sini, and Heli also place themselves in their story. The role of Aino's mother is dealt with in the dialogue they write together. In Heli's journal, Aino expresses her desperation because her mother is forcing her to marry the old man, telling that she would rather drown herself. Heli lets herself say: "Think about the sorrow you will cause your mother! And what about your own life? Do you really think you will give it up just for an old man? Nobody can force you to marry Väinämöinen. Choose rather escape than death. You have heard my opinion. The final solution is of course yours!" Elina also takes a moral stand to Aino's dilemma. She places herself in the role of Aino, who tells how she loathes and fears the old man, and how the water nymphs seem to be her only friends. "I feel it would be lovely just to go swimming and never return". Elina's real-life personality says: "Why, life is such a great thing! Nobody can force you to Väinämöinen's wife, make your own decision!"

Johanna outlines a story where Väinämöinen falls in love with her. "I am having a lovely morning swimming, when Väinämöinen rushes out from the bushes, shoves off his boat and soon catches up with me. His dirty fists are enormously big, when he maliciously reaches them toward me. I flee for my life and finally succeed in

escaping. But my life is spoilt and I decide to drown myself. The water nymphs persuade me and I go down to the water". The way Johanna writes gives me the impression that she considers Aino's situation at the same time exciting and frightening. In the dialogue that Johanna writes, her 'feminist self' is heard. Someone tells the crying Aino to run: "You are more agile than the old man, don't panic, you'll make it!"

Leena is looking at things as an outsider. When the water nymphs are warning Aino of the danger, she does not listen to them, and "too late does she notice that her harasser is reaching out for his lost youth". In the dialogue, Aino is asking Leena to help her. Leena's answer to the girl shows that at the same time when she can identify with the reality of the artwork, she has the role of a viewer. Leena bridges the two realities by answering "I cannot help you because we are living in different eras. My destiny is to be only an innocent outsider in the story". Leena explains that she cannot imagine any real dialogue between Aino and herself. Leena's narrative makes an exception among the writings, reflecting the ability to contextualize both the artwork and the viewer.

ARTISTIC INQUIRY AND ACTION RESEARCH

The description of the students' narratives in this chapter is only one example of the ways I was trying to combine verbal and visual conceptualization during the project. It illustrates how I offered students material for integrating their own views of the themes included in the artwork into the visual interpretation of their final assignment. Storytelling was followed by studying the biography of the painter and comparing it to the lifeworlds and values of the students. The 'bridging' culminated in discussion about change in the concept of art in our postmodern culture, where the viewer is considered to have an active role in interpreting a work of art. The students took a role similar to many contemporary artists who no longer praise the ownership of an artist to his or her work, but make their own appropriations based on others' works in order to participate visually in discussions between individuals, cultures, and times. This is what my students also did through their final, palimpsestic visual interpretations.

The kind of intertextual play between verbal and visual texts which I and my students were playing during the class illustrates my view of both art and learning. It represents a pragmatic and constructivist conception of art learning, where art is seen as a vehicle for constructing oneself. Also, it makes clear my view of a teacher as a learner searching for new knowledge together with the students. It also illustrates my aim to develop action research in the direction of artistic research by searching for parallels between the working methods of a reflective teacher and an artist (McCutcheon and Jung 1990, May 1993, Collins 1992).

In my research report (Räsänen 1997) about the Aino project, along with my theoretical, pedagogical, and personal voices, the reader can hear the voices of the sixteen adolescents participating in it. The description I have written is not trying to tell the 'truth' or to generalise our learning experience, but it tells one of the tales that takes place in art learning in different contexts. My story aims at helping art

educators as well as those outside the field to understand how diversified art learning may be. My project can also be approached as a proposal for an art class that concentrates on one theme instead of the 'surfing' characteristic of art lessons at schools and museums. The qualitative analysis model I have developed affords one way to give shape to the learning and teaching process in art. Being a strong advocate for action research utilising arts based inquiry methods, I invite teachers and museum educators to become researchers of their own work and to share their personal stories with colleagues.

Marjo Räsänen is Senior Researcher at the Department of Art Education, University of Art and Design, Helsinki, Finland.

REFERENCES

Addiss, S. and Erickson, M. Art History and Education. Champaign-Urbana: University of Illinois Press, 1993.

Barrett, T. Criticizing Art. Understanding the Contemporary. Mountain View: Mayfield Publishing Company, 1994.

Collins, E. Qualitative Research as Art: Toward a Holistic Process. Theory into Practice, 31(Spring 1992), 181-186.

Damon, W. and Hart, D. Self-understanding in Childhood and Adolescence. Cambridge: Cambridge University Press, 1988.

Diamond, C.T.P. Signs of Ourselves: Of Self-narratives, Maps, and Essays. In Diamond, C.T.P. and Mullen, C.A. (Eds). The Postmodern Educator. Arts-based Inquiries and Teacher Development. New York: Peter Lang, 1999.

Diamond, C.T.P. and Mullen, C.A. (Eds). The Postmodern Educator. Arts-based Inquiries and Teacher Development. New York: Peter Lang, 1999.

Eisner, E. The Enlightened Eye. Qualitative Inquiry and the Enhancement of Educational Practice. New York: Macmillan, 1991.

Feinstein, H. Meaning and Visual Metaphor. Studies in Art Education, 23(2, 1982), 45-55.

Gergen, K. The Saturated Self. Dilemmas of Identity in Contemporary Life. New York. BasicBooks, 1991.

Giddens, A. Modernity and Self-identity. Self and Society in the Late Modern Age. Stanford: Stanford University Press, 1991.

Gooding-Brown, J. Conversations about Art: A Disruptive Model of Interpretation. Studies in Art Education, 42(1, 2000), 36-50.

Hicks L. The Construction of Meaning: Feminist Criticism. Art Education, 45(1992), 23-32.

Jeffers, C. Experiencing Art through Metaphor. Art Education, 49(3, 1996), 6-11.

Kolb, D. Experiential learning. Experience as the Source of Learning and Development. Englewood Cliffs: Prentice Hall, 1984.

Koroscik, J. What Potential Do Young People Have for Understanding Works of Art? In Kindler, A. (ed.). Child Development in Art. Reston: National Art Education Association, 1997.

Lakoff, G. and Johnson, M. Metaphors We Live by. Chicago: The Chicago University Press, 1980.

Lankford, L. Aesthetics: Issues and Inquiry. Reston: National Art Education Association, 1992.

May, W. "Teachers as Researchers" or Action Research: What Is It, and What Good Is It for Art Education? Studies in Art Education, 34(2, 1993), 114-126.

McCutcheon, G. and Jung, B. Alternative Perspectives on Action Research. Theory into Practice, 29 (3, 1990), 144-151.

Mullen, C.A., Diamond, C.T.P., Beattie, M., and Kealy, W.A. Musical Chords: An Arts-based Inquiry in Four Parts. In Diamond, C.T.P. and Mullen, C.A. (Eds). The Postmodern Educator. Arts-based Inquiries and Teacher Development. New York: Peter Lang, 1999.

Parsons, M. How We Understand Art. A Cognitive Developmental Account of Aesthetic Experience. Cambridge: University Press, 1987.

Perkins, D. The Intelligent Eye: Learning to Think by Looking at Art. Santa Monica: The Getty Center for Education in the Arts Occasional Paper Series, 1994.

Räsänen, M. Building Bridges. Experiential Art Understanding: A Work of Art as a Means of Understanding and Constructing Self. Helsinki: Publication Series of the University of Art and Design Helsinki UIAH A 18, 1997.

Räsänen, M. book review of Diamond, P.C.T. & Mullen, C.A. (eds.) 1999. The Postmodern Educator. Arts-based Inquiries and Teacher Development. In Studies in Art Education, 43(2, 2002), 175-181.

Walker, S. Designing Studio Instruction: Why Have Students Make Artwork? Art Education, 49(5, 1996), 11-17.

JULIET MOORE TAPIA WITH SUSAN HAZELROTH BARRETT

POSTMODERNISM AND ART MUSEUM EDUCATION

The Case for a New Paradigm

Abstract. The governing concept of this chapter is the contention that shifting trends in contemporary, postmodern society are leading to concurrent changes in the theory and practice of current art museum education. This chapter begins with a description of general theories of postmodernism and postmodernist pedagogy and an analysis of how museum education can employ these characteristics of postmodern education. The argument that facets of postmodernism are manifesting themselves in contemporary museum education is reinforced by a case study that describes the educational mission and selected programmes of one particular museum between the years 1991-1994. This case study is placed in the context of postmodern education and is used to generate a definition of postmodern art museum education.

POSTMODERN MUSEUM EDUCATION

In 1923, Benjamin Ives Gilman, Secretary of the Boston Museum of Fine Arts, spoke unequivocally about the ancillary role of education in the museum. His opinion that "a museum of art is primarily an institution of culture and only secondarily a seat of learning" has been echoed throughout the twentieth century by generations of museum directors and curators who perceive the role of education as secondary to the mandates of collection and preservation. In our postmodern era, however, this perception of the art museum as a temple of ideal contemplation has become increasingly untenable, as cultural institutions are challenged to address issues of cultural identity, representation, and interpretation. Indeed, if museums become further entrenched as monolithic manifestations of modernism in a period of postmodernist diversity, then, as the cultural historian John Kuo Wei Tchen argues, "U.S. cultural institutions will be either torn asunder from real and/or perceived insensitivity or passed by to shrivel up out of sheer irrelevance and public apathy" (1992, 114).

One measure of the divide between the museum and the public was made in 1991, when the J. Paul Getty Museum and the Getty Center for Education in the Arts conducted a large-scale, qualitative research project that involved eleven art museums in the United States. Using focus group research methods, the project investigated the attitudes of first-time art museum visitors and museum staff. The results showed major gaps between staff expectations and visitor experiences in terms of such logistical aspects of a museum visit as orientation, information, and direction. Many visitors reported feelings of intimidation and confusion upon

197

M. Xanthoudaki, L. Tickle, V. Sekules (eds)
Researching Visual Arts Education in Museums and Galleries, 197-212.
©2003 Kluwer Academic Publishers. Printed in the Netherlands.

entering the buildings. They wanted support in deciding what objects to view and how they could be interpreted, and they wanted more information about events, activities, and services (Getty Center for Education in the Arts, 1991, 46). These findings support studies by Bourdieu (1991) and Bourdieu, Darbel and Schnapper (1991), showing that the majority of visitors require direction and support - in other words, effective education - when they enter the museum. A minority of highly educated connoisseurs may not need such support, but one of the presuppositions of this chapter is that museums should no longer cater only to the few but must concentrate on reaching a larger community of visitors.

As an enterprise devoted to communication with those outside the walls of the museum, an education department is able, in theory, to reflect the postmodern engagement with pluralism and to meet demands for pedagogical modes that address the needs of diverse visitor populations. Thus, museum education is well situated to take a proactive role in the construction of an institution that strengthens the connections between the museum and its larger sociocultural contexts. Such an approach would entail the identification of the role of the arts and humanities in everyday life and consider a problematization of how the museum can participate in society at large. Paradoxically, however, museum education has traditionally been placed lower in the organizational hierarchy than other curatorial departments, so institutional change will require that museum educators define and articulate an increasingly vital role in the museum.

What is the level of conscious and involved awareness with which museum educators participate in the development of programmes, exhibitions, and institutions that either perpetuate or challenge the structures of power embedded in the museum? How does the museum and museum education fit into the context of contemporary, shifting cultural and socio-political structures? How does museum education address these new configurations? These are the central questions of this chapter, which argues for a theory and practice of postmodern art museum education that recognizes itself as a function of an ideologically based cultural institution and yet responds to the shifting cultural and socio-political structures of contemporary society.

Although, by its very nature, the term "postmodernism" is notoriously difficult to define, most descriptions follow Lyotard's conception of postmodernism as a cultural condition that results from the erosion and rejection of modernist ideals, including: the progressive liberation of humanity through science, the universality of knowledge, the existence of an artistic avant-garde, and the inherent logic and rationality of realms of knowledge (Lyotard 1984). For Lyotard and other postmodern critics, the postmodern condition is one in which the master narratives, such as universalist interpretations of culture, have lost their power, relevance, and credibility. Instead, the world is given meaning by local events and personal narratives. For Hebdige (1989), who holds that postmodernism "enhances our collective and democratic sense of possibility" (p. 226), postmodernism entails "the erosion of triangular formations of power and knowledge with the expert at the apex and the 'masses' at the base" (p. 226). In the world of art, postmodernist critical analysis is characterized by the effacement of the boundaries between art and everyday life; the collapse of hierarchical distinctions between high and popular

culture; use of parody and pastiche; and the decline of the concept of the original work of art (Featherstone 1991).

By casting art museum education within the framework of postmodern challenge and inquiry, interpretations of art can take place within the wider context of the everyday life of the visitor. Thus, educational approaches to the objects in the museum can be framed in terms of postmodernists' challenges to universalism and grand narratives, and can lead to such programmatic features as: community and school participation; shared processes of decision-making; the equal provision of respectful forums for all voices and perspectives; and collaborations between school, community, and museum.

In terms of museum education programmes, these characteristics of postmodernism can translate into activities that incorporate personal narratives, collaboration, interplay between high and low culture, multiple interpretations, and desanctification of the museum space. Operating as strategies of postmodernist pedagogy, such activities question issues of representation, power, and authority, and thereby subvert the embedded sociocultural assumptions and behaviors that have been associated with the modernist museum.

Within the realm of the museum, these postmodern practices foster questions such as: "Who does the work address? For whom is it made? For whom is it exhibited? Who benefits from it? Who is excluded—both from actually viewing it and from understanding the cultural, intellectual worlds it represents?" (Becker 1992, 65). Other questions could include: Whose art history identifies this as a work of art? On what basis is this a work of art? How can this work of art be recontextualized so that it is seen as a product of its culture?

In terms of museum education, this strategy of deconstructive inquiry challenges modernist modes of interpretation and traditional ways of seeing the museum itself. Enabled by this type of questioning strategy, the postmodernist museum educator can help to bring into the museum "the basis for a cultural politics and the struggle for power that has been opened up to include the issues of language and identity" (Giroux 1993, 30).

The following alternative practices form the basis of a pedagogy of museum education that accept challenges identified by postmodernism. Museum educators who accept challenges identified by postmodernism should participate in the rethinking of the missions of their institutions and in the identification of the modernist mythmaking constructions that permeate the museum's exhibitions, publications, and programmes. As a preliminary stage towards effecting change, educators need to define which culture or cultures they are representing, and acknowledge the cultural messages communicated by their institutions. With such processes of deconstruction, educators can support the creation of programmes and spaces, both intellectual and physical, where diverse and alternative practices and knowledges can be nurtured. They can foster the development of non-hierarchical, dialogic programmes (assuming the participation of the public) that encourage the public in interpretation and reflection and allow multi-faceted histories to be constructed.

POSTMODERN CURRICULUM

According to Efland, Freedman and Stuhr (1996), there are four major characteristics of a postmodern curriculum, each of which corresponds to ideas developed by postmodern theorists such as Jean-Francois Lyotard (1984), Michel Foucault (1980), Jacques Derrida (1976), and Charles Jencks (1989). The first characteristic is that of the local narrative, which shifts the curriculum from the "universalizing tendencies of the modern to the pluralizing tendencies of the postmodern" (1996, 112). Implications of this characteristic include a use of local knowledge and local content and a move away from conceptions of art that privilege the expert interpretation.

The second characteristic of a postmodern curriculum is the power/knowledge link. Informed by the writings of Foucault, this characteristic involves examining the social construction of the privileging of certain types of knowledge. Deconstruction, the third characteristic, involves finding conflicting meanings in texts and cultural artifacts that are read as texts in order to undermine fixed interpretations and to show that no points of view are privileged. This strategy emphasizes the role of the reader or viewer, and the use of collage, montage, and pastiche. The fourth characteristic of a postmodernist curriculum, Efland, et al. (1996) identify as the detection and study of multiple meanings or messages embedded in a work of art, so that contradictory and alternative meanings are simultaneously presented and interpreted. This process is referred to as double-coding.

Despite the wealth of postmodernist cultural critiques, and despite the description of postmodern curricula outlined above, there are few descriptions of how the characteristics of postmodernism are actually experienced by different groups of learners. Aronowitz and Giroux (1993) point out that, "there is little if any sense of pedagogy in this discourse, which is overly focused on the reading of cultural texts, without a concomitant understanding of how people invest in signs, signifiers, images, and discourses that actively construct their identities and social relations" (p. 72). In an attempt to develop just such a sense of how a postmodern museum education can be articulated and implemented, the following section of this chapter describes the education programmes of one particular museum that manifests many of the characteristics of postmodernism.

THE JOHN AND MABLE RINGLING MUSEUM OF ART

The John and Mable Ringling Museum of Art in Sarasota, Florida is the site that we have selected to demonstrate and exemplify, in specific terms, the argument that principles of postmodernism can beneficially influence the field of contemporary art museum education. Through our qualitative, descriptive case study of education at the Ringling Museum, we hope to reinforce our theoretical argument that facets of postmodernism are manifesting themselves in contemporary museum education. The selection of this site is based on familiarity with its philosophy and educational programmes and the recognition that these programmes manifest many of the principles of postmodernist pedagogy.

The John and Mable Ringling Museum was established in 1927 by John Ringling, a real estate developer and one of the founding partners of the Ringling Brothers' Circus. Ringling concentrated on acquiring Italian and Flemish baroque art of the seventeenth century, and amassed the largest privately owned collection of paintings by Peter Paul Rubens in the world (Buck 1988). Like many other self-made businessmen such as Henry Frick, Andrew Carnegie and John Pierpont Morgan, Ringling fit into the mold that Calvin Tomkins (1989) has termed the "men of fortune and estate" whose art collections were, in part, overt manifestations of their power, prestige, and social position, and whose bequests form the core of many art museums throughout the United States.

The mission statement of a museum usually provides a good indication of its professional values and institutional biases. The mission statement of the John and Mable Ringling Museum, written in 1993, is no exception to this generalization:

> The mission of the John and Mable Ringling Museum is to enable a large and diverse audience to see, understand and take delight in the best of the world's visual arts, the traditions of the circus, and the historic buildings, gardens and grounds of the Museum. To carry out this mission, we develop and preserve the collections and historic facilities of the Museum, support research and increased awareness of the Museum and its collections locally, nationally and internationally, and exhibit and interpret these treasures for the people of Florida and all visitors to the Museum.

This mission statement positions the Ringling Museum, as an institutional whole, squarely within the modernist tradition. Its emphasis on concepts such as "delight," "the best of the world's visual arts," and "treasures," echoes similar statements made by formalist museum directors and educators, such as Benjamin Ives Gilman, for whom the museum is a place of "thoughtful pleasure...a paradise of fancy...a temple" (1923, 80). The lack of reference to responsibility to the community and to the educational programmes of the Museum betrays the institutional bias, or what Michael Apple (1996) would term "the hidden curriculum" (p.12) towards modernism and formalism. The mission statement contains no overt reference to the Museum's education department or to the contribution towards the fulfillment of the Museum's mission that is made by its educational programmes.

In contrast, the Education Department's description of its philosophy shows a notable difference in tone and content:

> Education programs are developed and based on a process-oriented model that supports collaboration and community building. Teachers, students, parents, administrators, community members and others work with Museum education staff to design and produce all programs and materials. These premises inform the process:

> (1) The work of art/exhibition is central. Original works are inherent storehouses of profound and life-changing experiences. The ideas and issues raised are born from them.

> (2) The learning process is equal in importance to the intended end product. Philosophical discussions, decision-making, and issue examination stimulate creativity and collective quality.

(3) Others' voices are heard in the process. Education staff aim to empower others, not by acting as though they have a franchise on knowledge about art and its purpose, but by actively listening to the ideas that come forth.

(4) Education beliefs create the foundation for the process. The beliefs are: (a) Education is about the practice of freedom; learning at its most powerful liberates. (b) Education is not about providing information only, it is about raising questions and fostering thinking about how one lives and behaves. (c) Education is active rather than passive. (d) Education is not about promoting individual values, interests or beliefs; educators encourage discussion about multiple perspectives to increase understanding, knowledge and appreciation of art works.

From this statement it can be seen that the Education Department articulates many of the precepts advocated by a postmodern curriculum. The exception is the first premise, that "original works of art are inherent storehouses." This statement subscribes to the modernist belief that meaning is ineluctably fixed by the artist in the work of art and that it is the responsibility of the viewer to detect that meaning. This premise, of course, denies the postmodern characteristic that gives increased weight to the role of the viewer's experience in creating an interpretation of a work of art (Featherstone 1991).

Its first premise excepted, the remaining clauses of the Education Department's philosophy fit easily into the context of postmodernism. The philosophy recognises process, the voice of the Other, and the belief in the liberatory, inquisitive, and active nature of education, all characteristics of postmodernist pedagogy. In addition, this statement of philosophy and purpose is publicly displayed in the education gallery, indicating a reflexive openness to self-critique and self-awareness that is characteristic of postmodernist enterprises. These statements also accord with the central challenge of postmodern art education as conceived by Efland, et al. (1996): "The postmodern questioning of representation gets to the heart of the matter for education: Why and how do people create meaning and come to understand knowledge, art, et cetera?" (p. 46).

Another indication of the postmodernist tendencies of the education philosophy of the Ringling Museum is its opposition to modernist characteristics of education. The recognition, for instance, that there is not one authoritative interpretation and that visitors can find personal meanings in the work of art is one that contradicts the tenets of the modernist tradition that emphasizes that there is, indeed, a correct way of approaching a work of art and that correct way is articulated by curators and historians at the museum. The process-oriented and collective nature of the Education Department's method—for instance, all of the education packages result from collaboration between the museum staff and teachers, and provide suggestions for teachers within schools to work with each other—is also in opposition to the emphasis upon the hierarchical nature of modernism.

PROGRAMMES AT THE RINGLING MUSEUM OF ART

This section looks at three examples of programmes developed and implemented beginning in 1991. The following narrative descriptions of the programmes culminate in a discussion of how they fit into the context of postmodernism.

1. Lewis Baltz: "Rule Without Exception"

In 1991, the Museum hosted a travelling exhibition of works by the contemporary photographer, Lewis Baltz. Part of the impact of the show, entitled "Rule Without Exception: A Retrospective Exhibition of the Photographs of Lewis Baltz," comes from its sheer size—a collection of over 800 black and white photographs. It was the responsibility of Ileen Shepard-Gallagher, Curator of Contemporary Art, and the artist to organize the configuration of the images in the gallery.

Indicative of the high modernist tone of the collection of photographs is the value accorded to objectivity, formalism, and non-referentiality by the artist:

> To function as documents at all they (photographs) must first persuade us that they describe their subject accurately and objectively; in fact, their initial task is to convince their audience that they are truly documents, that the photographer has fully exercised his powers of observation and description and has set aside his imaginings and prejudices. The ideal photographic document would appear to be without an author or art (Baltz, in Bowman 1990, 188)

According to the traditional, modernist mode of interaction between museum departments, the development of educational programmes would take place in reaction to the installation of the exhibition, and no educational activities would take place until after its opening. In this case, however, staff educator Hazelroth Barrett approached the Curator Shepard Gallagher with the suggestion that a group of high school students be allowed to install and to interpret the exhibition of Baltz photographs. This project would require the collaboration of the curator, the artist, the museum educator, high school teachers and students, and they would all be expected to work in ways that would take them outside the normal pattern of their respective roles.

Over a period of three months, high school students and a team of four teachers (anthropology, world history, English, and video) analyzed the issues addressed by Lewis Baltz in his photographs. Six students worked with the Curator of Contemporary Art, Lewis Baltz, and the Museum's installation crew to hang the exhibition in, according to their stated goals, an intelligent and challenging way. In order to share the experience with other students in the region, the entire installation process was video documented, edited, and transformed into an entertaining and creative visual and musical narrative. The video, running on a continuous loop, was installed at the entrance to the exhibition along with an explanation of the entire project.

A group of approximately one hundred of the high school students produced critical writing about Baltz's work. About a photograph titled *The Tract Houses*, student Emily Rees wrote:

> This photograph exemplifies the lack of individuality that is emerging from American society. The bleak and shabby buildings express oppressiveness and dullness. They show how creativity is no longer valued in our society. These houses depict the devolution of the American people toward a society that cannot create without the approval of others. The houses are crude and artificial. They do not express beauty or creativity and cause the viewer to question his own individuality.

Students Amy Widman and Cara Lindsley collaborated and wrote:

> The series of photographs entitled *The Tract Houses* makes a bold statement on the creative rut into which modern society has fallen. Baltz has portrayed the bland, painfully similar house that began to be mass-produced in the twentieth century. He illuminates the rampant conformity of the times through his photographs. Baltz is making one last cry for individuality while everything around him is corrupt. By choosing to photograph run-down, dirty houses, Baltz points out that society often settles for less than is possible.

When Baltz was shown the students' critical writing, he said that he wanted every student's writing to be part of the exhibition. All were transformed into wall labels. Unlike most wall labels that merely provide the name of the artist, title, and date of the piece, these labels included that information along with interpretations identified by the writer's name. The labels were well-written and thoughtfully considered descriptions and interpretations that gained the endorsement of the artist and were meant to contribute to the public's understanding of the art from the perspectives of the students.

As part of the exhibition programmes at the Ringling Museum, Baltz and six students talked about the installation and interpretation process with thirty Florida museum directors and educators, local teachers, and business owners who were attending a conference organized by the Education staff to share ideas about communicating and partnering with schools.

2. Eric Fischl: Four Friends

In 1994, a traveling exhibition entitled *"Four Friends"* was held at the Ringling Museum. It showed the work of four contemporary artists who are linked not by artistic similarities, but by ties of personal friendship. As with the exhibitions of Baltz's work, this show was originally conceived and curated with the sophisticated adult viewer in mind; however, the collaboration between the museum education department, the curator, the artists, and students and teachers from regional and district schools resulted in interdisciplinary materials and activities that enabled elementary school children to develop meaningful interpretations of the art and to analyze their own values and roles in the world.

Twenty-two teachers collaborated with Hazelroth Barrett on the development of an educational package that Ringling Museum staff disseminated to teachers and students throughout Florida. Infused with material relating to art history, aesthetics, criticism and production, as well as other interdisciplinary materials, the teacher package contained information and activities that encouraged students to consider such concepts as the values of friendship, experiencing rites of passage, and methods of storytelling. Instead of learning about school subjects as unconnected topics, teachers and students could relate the themes of the exhibition to their own experiences and personal narratives, and to see how English literature, geography, history and art can illuminate philosophical questions of their lives.

An example of this interdisciplinary and personal approach can be seen in the exploration of the theme of friendship, which included a component in which students experienced the Iroquois "Council Process" and discussed issues related to the topic of friendship. The teaching packet described the Native American Council

as "a practice that supports group interaction—philosophical discussions, storytelling, decision-making, and co-visioning. It offers opportunity for community building. The talking stick is used to empower each person in the group to speak in turn." Suggested topics for the Council were short stories about a family member, dreams, or the associations of an old photograph or beloved object. The relation of personal narratives and perspectives was encouraged in the Council by the talking stick, which the teachers' packet described as "a symbol of the group's integrity and capacity for open communication. The stick is meant to empower the expressiveness of the individual who holds it and invite listeners to hear from their hearts. Equal to talking is listening."

At one point during the exhibition, students participated in a teleconference with the artist, Eric Fischl, who was in his studio in New York, and the guest curator, Bruce Ferguson, who was in the Museum galleries. The questions that the students asked of the artist and the curator display the depth and sophisticated understanding that resulted from the students' intensive work with the art. Typical of the questions addressed to Bruce Ferguson were the following:

> You obviously consider the work of all of these artists important. What merits do you see in the work of all four artists and why do you think their exhibits, either individually or as a group, are so effective?

> Why do you feel that the exhibit of "Four Friends" featuring Mr. Fischl's work was representative of him as an artist, assuming it was your aim to represent him; and which paintings of the exhibit do you feel are the strongest in conveying him, and why?

Students asked the following questions of Eric Fischl:

> Do you find that your paintings could have sound? For example, in your painting, *By the River*, the camel in the foreground looks like it's baying, mouth agape. Thus the viewer, if he or she is imaginative, hears the sound in his or her mind. Can we find that in other works, and is it intentional?

> How would you respond to Holland Cotter's article in <u>Art in America</u> describing *Manhattoes* as artificial, strained, and which said that it never entirely worked? What did you intend to say in this work and what inspired it?

> In your paintings, three certain items seem to occur frequently: patio furniture, dogs, and nude figures. Is there a thematic significance to their placement in your work?

> One of the reviewers of your work said that you were influenced by the work of the American painter, Robert Henri. The Ringling has a work by this artist. Would you mind looking at *Salome* with us to see if you agree with the reviewer and if so point out any connection you see between this painting and your own work?

After students had explored the concepts connected to the exhibition in their classrooms around Florida, those who could, visited the museum to experience the original works of art and to participate in a "friendship wall" activity, wherein visitors wrote messages of friendship to each other. Brandon Oldenburg and Ryan Sias, two students from the Ringling School of Art and Design, arranged a display of the over two thousand messages sent by Florida students and teachers using the

"Four Friends" lesson unit. These messages were shown in a room adjoining the galleries. Oldenburg and Sias's installation inspired and motivated Museum staff to establish a designated area called *The Inner Space* within the contemporary galleries for future interpretive projects produced collaboratively with students, teachers, and others.

3. Cardinal Albrecht Moves Into the Twentieth Century

This program developed out of art teacher Barbara Kenney's desire to write a lesson for her students to help them become more aware of their personal values. This resulted in a unit of instruction written by Kenney and her students in partnership with Museum staff based on a painting in the Museum's permanent collection, *Cardinal Albrecht of Brandenburg as St. Jerome,* by Lucas Cranach the Elder (1472-1553). The education package included a large poster-size reproduction of the painting and was sent to all sixty seven school districts in Florida. The unit required students to become knowledgeable about the historical and aesthetic characteristics of the painting through a review of the values embodied in both the cardinal and the saint. Students went on to examine other historical figures from the Renaissance, identifying the achievements and clarifying personal and social values of that era. The analysis of social values led to a discussion of contemporary ethical issues and the personal views and values of the students. Students in classrooms across Florida were asked:

> If you had the opportunity Cardinal Albrecht had in the 1400s to memorialize himself, who would you choose to represent yourself? Use the following categories to help you think about someone who represents your values or what is important to you: someone from your culture—writers, composers, artists, leaders; teachers or mentors; someone from your church, temple or religious institution; someone from your family; friends or peers; celebrities.

The students created a picture of their chosen person and attached a statement explaining the reasons for their choice. Their works were sent to the Museum and displayed in a statewide student and teacher exhibition held at the Museum.

The choice of role models ranged from relatives to celebrities to politicians. A fifth grade student, for example, selected his mother because, "My mom is special to me because she brought me into this world. She also helps me a lot with my homework. She puts clothes on my back, and food on the table. She also does a lot more." Explaining his choice, twelve year-old Evan Beach wrote:

> I chose Albert Einstein to represent someone who shares the same values as me because he did not care much about style, clothing and hair. I also do not care too much about these because they are not necessary to living. Einstein was very peace-loving, scientific and religious. Also he was one of the more intelligent people of the century and wisely used this quality to help humankind. I did some research and found out what kind of values were important to him and included the owl for wisdom, the Star of David for his religion and a violin and music stand because he also was a musician. Therefore, Einstein makes a good role model for me because of our similar values.

Another component of this multi-layered and wide-ranging project was the creation of a collaborative work of art in which students from Barbara Kenney's class portrayed contemporary figures in a manner similar to Cardinal Albrecht's symbol-laden depiction. The question posed to them was: "If Cardinal Albrecht were living today, whom would he choose to represent what he values?" Twenty high school students analyzed the values conveyed in the Renaissance portrait and explored historical and social issues of that period. The students researched the metaphorical meanings of the symbols in the sixteenth century painting, and they identified contemporary iconic representations of the values and messages conveyed by those symbols. They worked together to select Arnold Schwarzenegger as the cultural icon with whom Cardinal Albrecht might have identified.

The students created an overall design for the contemporary version of Cardinal Albrecht, and they then worked individually to create components of a large painting that was pieced together to become *Cardinal Albrecht of Brandenburg as Arnold Schwarzenegger*. Schwarzenegger is depicted surrounded by contemporary symbols of qualities that Albrecht might have valued, as well as those prized by Schwarzenegger himself—thus, qualities such as generosity, leadership, loyalty and determination are symbolized by such motifs as family photographs, children, healthy food, and body-building equipment. Upon its completion, the contemporary collaborative painting was exhibited for the next five years next to its sixteenth century inspiration in the permanent galleries of the Museum.

POSTMODERN PEDAGOGICAL PRACTICES AND THE RINGLING MUSEUM OF ART

According to most definitions of postmodernism (Foster 1983; Hebdige 1992; Lyotard 1984; Risatti 1990), one of its primary characteristics is the denial of the validity of the universalizing master narratives, or defining myths, of modernity. Instead, the world is thought to be characterized by local events, individual stories and personal narratives. This is the first of the four major characteristics of postmodernism identified by Efland, et al (1996). Curricular implications of this characteristic include a use of local knowledge and local content and a move away from elitist conceptions of art that privilege the expert interpretation (1996).

The Ringling Museum's educational programmes exhibit this characteristic. In "Rule Without Exception", for instance, the involvement of the students in the conception, installation, and interpretation of the exhibition represents a shift away from the privileging of the expert interpretations of the curator and critic and towards the creation of a forum in which students can learn to hear and value their own voices. The demystification of authority occurred, for instance, in the inclusion of the students in the process of writing the interpretive wall labels that, in most museums, are anonymous and brief and written by museum educators. Aronowitz and Giroux (1993) point out that, "the concept of voice, in the most radical sense, points to the ways in which one's voice as an elaboration of location, experience, and history constitutes forms of subjectivity that are multilayered, mobile, complex, and shifting" (p. 100). It is these elaborations of experience that are elicited through the

creation of a processual process-oriented environment in which the validity of each contribution is recognized.

This "coming to voice," as Giroux (1993) terms it, should not be interpreted to suggest that the informed professional is denied or denigrated. Rather, the ability to listen with respect is a skill fostered through the programmes of the Ringling. An example is the concept of the talking stick utilized in the "Four Friends" program, which specifically emphasizes the importance of listening to each voice. Bell Hooks (1994) writes: "In our classroom, students do not usually feel the need to compete because the concept of a privileged voice of authority is deconstructed by our collective critical practice" (p. 84). Similarly, the collaborative nature of the Ringling's programmes means that the modernist, hierarchical, and competitive model is subsumed into one in which multiple viewpoints can be simultaneously presented and equally respected.

A common characteristic of all the Ringling's programmes is the personal story, or the "little narrative," defined by postmodernists as a primary feature of postmodernism. In each of the programmes described in this chapter, the students' ability to tell their own stories and to place them in the larger context of the exhibition is fostered. In the "Four Friends" project, for instance, students used narratives and collages to construct stories and visual representations of their understanding of the concept of friendship. These personal explorations were then linked to the works of art in the exhibition in a way that allowed the students to develop interpretations of the exhibited art works that were further enriched by their encounter with the artist and curator of the exhibition.

Similarly, the "Cardinal Albrecht Moves Into the Twentieth Century" programme took the students from an analysis of a Renaissance portrait to the narration of personal stories through the exploration, in both written and visual forms, of their own values. That the project culminated in a collaborative project that related the students' personal experiences and the contemporary world back to the portrait is an illustration of the way in which postmodern practices can lead to multifaceted and complex interpretations of works of art.

The second characteristic of a postmodern curriculum, the power/knowledge link, entails the examination of the social construction of the privileging of certain types of knowledge. At the Ringling Museum, this characteristic is evident in alternative models of interpretation and exploration developed through inclusion of local voices and the shared process of decision-making. So, for instance, the traditional boundaries between the audience, the artist, and the curator were eroded through the process of communication and collaboration that characterized the "Four Friends" exhibit and the "Rule Without Exception" exhibit. The institutional myth of the anonymous voice of curatorial authority was similarly debunked as the students learnt about the intellectual processes of interpretation, the practical aspects of installation, and the components of human interaction, all of which are usually invisible to the museum visitor and to students involved in museum education programmes.

Also linked to the examination of power/knowledge structures in art and museums is the erasure, according to the postmodernist paradigm, of the dichotomy between high and low art. In terms of the Ringling's programmes, the most striking

example of this characteristic comes from the "Cardinal Albrecht Moves Into the Twentieth Century" programme, in which the students' interpretation of the Renaissance painting was based partly on their own creation of a work of art which was placed next to the original painting by Lucas Cranach in the galleries of the Museum. This strategy fits into the challenge to the authority of the temple of art represented by the anti-aesthetic. Speaking of this, Giroux says:

> As an anti-aesthetic, postmodernism rejects the modernist notion of privileged culture or art, it renounces 'official' centers for 'housing' and displaying art and culture along with their interest in origins, periodization, and authenticity. It is well known that postmodernism breaks with dominant forms of representation by rejecting the distinction between elite and popular culture and by arguing for alternative sites of artistic engagement and forms of experimentation (1993, 27).

By applying a collaborative process to a product that would not be termed a work of high art, in the modernist sense, and by then placing the students' contemporary painting in the privileged space of the Museum, this project created an interplay at the boundaries where high art and low art meet, while simultaneously challenging the modernist myths of the inviolability of the space of the museum and of the individual artist working in a solitary and isolated fashion.

By blurring the boundaries between high and low art; between the sacred space of the museum and the secular space of the classroom; between the expert and the novice; between the artist and the viewer; and between an original work of art and a pastiche, "Four Friends;" "Cardinal Albrecht Moves Into the Twentieth Century;" and "Rule Without Exception" represent examples of how elements of postmodernism can be incorporated into a museum education programme that is ostensibly operating within a traditional modernist discourse, and which could easily have remained within the confines of traditional museum education.

A strategy of deconstructive teaching (the third characteristic identified by Efland et al) changes the idea of what knowledge is by helping students realize that knowledge is a "text" that has been created and is therefore never absolute but partial and open to critique. According to such a strategy, students read texts by creating a text within a text; they interpret by creating "metatexts" or texts upon texts; and they critique by creating texts against the text. These processes are grounded in social experiences which form the base and context of the reading (Szkudlarek 1993).

If the work of art in the museum, and the museum itself, is regarded as the text, then it can be seen that the programmes of the Ringling accord, to differing degrees of complexity, with this strategy of postmodern education. A reading and critique of the text, for instance, occurred when the students worked with the curator of the museum and the artist, Lewis Baltz, in learning the usually invisible processes of the installation of an exhibition and in creating interpretive wall labels that subvert the myth that such an act is the sole domain of the privileged expert. The creation of metatext occurred when students interpreted the portrait by Lucas Cranach through the process of creating their own work of art that built upon the sixteenth century original, yet was also a direct result of the social experiences of the students.

Personal narratives; collaboration; interplay between high and low culture; multiple interpretations; desanctification of the museum space; popular culture;

metatexts and intertextuality: all of these characterize the education programmes of the Ringling Museum as a postmodernist enterprise operating within the predominantly modernist institution of the Museum itself. Operating as strategies of postmodernist pedagogy, they act to question issues of representation, power and authority, and to thereby subvert the embedded sociocultural assumptions and behaviors that have been associated with the modernist museum.

SUMMARY

In this chapter we discussed postmodernist education and provided examples of the educational programmes of one particular museum between 1991-1994. By placing the description of those programmes within the context of postmodernism, this chapter has outlined a specific instance of what may be termed a postmodernist art museum education. Any statement that contains the word "generalization" runs the risk of tending towards the modernist characteristics of universalism, and it is the postmodernist critique and problematizing of such totalizing and prescriptive efforts that has led to many of the theories and practices of postmodernism (Giroux 1993). Giroux points out, "The search for a postmodern practice grounded in difference is going to be a search for a practice that has no mandate at all to be universally applicable, but must somehow also remain locally effective" (p. 442). Likewise, a postmodernist art museum education cannot be a simple replacement of modernist traditions with a prescriptive and universal doctrine of contemporary museum education, but should, rather, be an arena in which individuals are able to think about and act within the contexts of art, the museum, and society.

As many scholars have noted (e.g., Crimp 1993; Danto 1992; Meyer 1979), objects must be defined as "art" in order for them to be recognized and interpreted as art. The museum is one of the primary agencies of validation and canonization of works, and its inclusion or exclusion of objects shapes the way visitors perceive and define art. A postmodern museum education that works within the parameters of the museum and its canonized objects is effecting a double-coded act that apparently accepts the aesthetic authority that takes into its galleries certain works as art, yet simultaneously identifies, subverts, and questions that authority through programmes that encourage the critique of that authority and the objects that it has sanctified as art.

Based on observations made in this case study and on identification of theories of postmodernism, the following general definition is offered: a postmodernist museum education is one that acknowledges how the museum and museum education fit into contexts of shifting cultural and socio-political structures and addresses issues associated with these new configurations. Postmodernist museum educators are concerned with developing pedagogical approaches that both serve as cultural critiques and that encourage students to develop senses of connectedness between themselves, the objects in the museum and the world at large. As art educator Terry Barrett (2000) wrote, "A multiplicity of interpretations can unify rather than divide a group of individuals, helping them form a community that values diverse beliefs about art and life."

Like any instrument of society, art museum education is a function of its culture and is therefore amenable to discursive analysis that can place it within the context of current debate within postmodernism. If practitioners and theorists in the field of art museum education can hone their sense of self-awareness and purpose through the development of theory and practice, and through the implementation of the strategies described above, then it is less likely that museum education will be a mere reflexive reaction to the ideology and agenda of the museum as a whole. Just as postmodern critics are looking at institutions such as the museum, the art world, and education, so it is necessary for museum educators to concern themselves with the observation, analysis, and implementation of new forms of theory and practice that constitute a paradigm of postmodernist museum education.

Juliet Moore Tapia is an independent scholar and art educator. Susan Hazelroth Barrett was a museum educator at the John and Mable Ringling Museum of Art from 1988 to 1998. Barrett is the developer of the programmes Tapia examines.

REFERENCES

American Association of Museums. *Excellence and Equity: Education and the Public Dimension of Museums*. Washington, DC: American Association of Museums, 1992.

Apple, Michael. *Cultural Politics and Education*. New York, NY: Teachers College Press, Columbia University, 1996.

Aronowitz, Stanley, and Henry Giroux. *Education Still Under Siege*. Westport, CT: Bergin and Garvey, 1993.

Barrett, Terry, "*Studies*, Invited Lecture: About Art Interpretation for Art Education." *Studies in Art Education*. Reston, VA: National Art Education Association, 42(1), 5-19, 2000.

Becker, Carol. "When Cultures Come Into Contention." *Different Voices*. New York, NY: Association of Art Museum Directors, 1992.

Bowman, Leslie Green. *American Arts and Crafts: Virtue in Design*. Los Angeles, CA: Los Angeles County Museum of Art, 1990.

Bourdieu, Pierre. *Distinction: A Social Critique of the Judgment of Taste*. Cambridge, MA: Harvard University Press, 1984.

Bourdieu, Pierre, Alain Darbel, and Dominique Schnapper. *The Love of Art: European Art Museums and Their Public*, trans. C. Beattie and N. Merriman. Stanford, CA: Stanford University Press, 1991.

Buck, Patricia Ringling. *The John and Mable Ringling Museum of Art*. Santa Barbara, CA: Albion Publishing Group, 1988.

Crimp, Douglas. *On the Museum's Ruins*. Cambridge, MA: The MIT Press, 1993.

Danto, Arthur. *Beyond the Brillo Box: The Visual Arts in Post-Historical Perspective*. New York, NY: Farrar, Strauss, Giroux, 1992.

Derrida, Jacques. *Of Grammatology*. Baltimore, MD: Johns Hopkins University Press, 1976.

Efland, Arthur, Kerry Freedman, and Patricia Stuhr. *Postmodern Art Education: An Approach to Curriculum*. Reston, VA: The National Art Education Association, 1996.

Featherstone, Mike. *Consumer Culture and Postmodernism*. London: Sage Publications, 1991.

Foster, Hal (Ed.) *The Anti-Aesthetic*. Seattle, WA: Bay Press, 1983.

Foucault, Michel. *Power/Knowledge*. New York, NY: Pantheon Books, 1980.

Getty Center for Education in the Arts and The J. Paul Getty Museum. *Insights: Museums, Visitors, Attitudes, Expectations*. Santa Monica, CA: The J. Paul Getty Trust, 1991.

Gilman, Benjamin Ives. *Museum Ideals of Purpose and Method*. Cambridge: Harvard University Press, 1923.

Giroux, Henry. "Postmodernism as Border Pedagogy: Redefining the Boundaries of Race and Ethnicity." Joseph Natoli and Linda Hutcheon (Eds.), *A Postmodern Reader*. Albany, NY: State University of New York Press, 1993.

Hebdige, Dick. *Hiding in the Light*. New York, NY: Routledge, 1989.

Hebdige, Dick. "A Report on the Western Front." Francis Frascina and
Jonathan Harris (Eds.) *Art in Modern Culture*. New York, NY: Harper Collins, 1992.

hooks, bell. *Teaching to Transgress*. London: Routledge, 1994.

Jencks, Charles. *What Is Postmodernism?* London: St. Martin's Press, 1989.

Lyotard, Jean-Francois. *The Postmodern Condition*. Manchester: Manchester University Press, 1984.

Meyer, Karl. *The Art Museum: Power, Money, Ethics*. New York, NY: William Morrow and Company, Inc., 1979.

Risatti, Howard. (Ed.) *Postmodern Perspectives*. Englewood Cliffs, NJ: Prentice Hall, 1990.

Szkudlarek, Tomas. *The Problem of Freedom in Postmodern Education*. Westport, CT: Bergin and Harvey, 1993.

Tchen, John Kuo Wei. "Ancestor Worship, Sacred Pizzerias, and the Other: A Few Conceits of Anglo-American Modernism," *Different Voices*. New York, NY: Henry Holt and Co., 1992.

Tomkins, Calvin. *Merchants and Masterpieces: The Story of the Metropolitan Museum of Art*. New York, NY: Henry Holt and Co., 1989.

Section D

LANDSCAPING THE FUTURE

DOUGLAS WORTS

ON THE BRINK OF IRRELEVANCE?

Art Museums In Contemporary Society

Abstract. Traditionally, art and visual culture have provided opportunities for individuals to connect to the deeper cultural reality of a group. By living with and reflecting deeply on the symbols of culture, individuals developed more or less of a personal consciousness of the world in which they lived. As our modern world of specialization evolved over recent centuries, art has been increasingly housed in museums - largely because of its objectified value, both economic and intellectual, which had to be protected - thus removing the art from any integrated form of symbolic experience in the lives of individuals. Today, there is a profound public need and desire for symbolic experience that can re-connect individuals at a deep level to nature, to other people and to the past. Museums have the potential to play a part in responding to this public need, yet they have not assessed how to balance their custodial responsibilities for material objects with their cultural facilitation role in the realm of symbolic experience. Museums are hampered by a tradition that honours intellectual knowledge about objects over the more irrational and creative experiencing of cultural symbols. This chapter explores some of the many issues related to this topic, within a framework of understanding the role that culture plays in the sustainability, or unsustainability, of human life on our planet. The Canadian Museums Association and LEAD International and LEAD Canada provided support for this work.[1]

INTRODUCTION

Development divorced from its human or cultural context is growth without a soul.
(UNESCO 1995, 15)

Today, virtually all museums consider that they exist for public educational purposes that contribute to our collective cultural well being. However, it is one thing to declare a commitment to the service of public education and another to demonstrate that such a goal has been met.

Through the past several decades, there has been increasing pressure both from within and outside the museum profession to see these cultural organizations become effective and relevant for the general population. In the United States, for example, a series of developments at the American Association of Museums provide evidence of this trend. First was the release of *Museums for a New Century*, in 1984, providing a new vision for understanding the potential of museums to be vital agents in the cultural well being of communities. *Excellence and Equity: Education and the Public Dimension of Museums*, which was published and widely distributed in 1992, offered a new framework of principles for the operation of cultural organizations that would be engaging and meaningful to the public. Co-incidental with *Excellence and Equity*, the AAM launched a heavily subsidized, nation-wide, self and peer

M. Xanthoudaki, L. Tickle, V. Sekules (eds)
Researching Visual Arts Education in Museums and Galleries, 215-231.
©2003 Kluwer Academic Publishers. Printed in the Netherlands.

assessment programme the MAP 3 (Museum Assessment Program - Public Dimension) that would help museums to review and improve their public dimension activities. Other countries, including Britain and Canada, also have developed interest in and mechanisms for addressing public cultural needs (Anderson 1999; Canadian Museums Association 1992). In all, these constitute examples of how the profession has itself tried to develop its ability to play a meaningful and relevant role within our communities.

Despite all the efforts to become more significant players in the life of society, art museums continue to struggle with the challenge of cultural relevance. Part of the challenge is in understanding how one judges relevancy. What are the performance measures for such assessment? Should these be measured at the individual level, the community level or a larger collective level? Visitor learning is one aspect of the museum experience that has undergone considerable development in recent years. George Hein, John Falk and Lynn Dierking, all authors in this volume, have made significant contributions in this regard. Their focuses on individuals, both at the time of a museum visit, and the longer-term impacts, have become foundation blocks of our emergent field. However, educational work of this type still remains the exception. And there is a deeper concern.

The vast majority of museum visits occur without human mediation. From my research at the Art Gallery of Ontario, and from observations at art museums across North America, a ten percent rate of visitors attending some kind of programme (gallery talk/tour, lecture, workshop, etc.) is considered high. Most people 'graze' through exhibits, spending only seconds looking at any individual works. The more ambitious educational initiatives, such as those experiments in constructivist learning, usually occur with human mediation that helps to establish focus and generate reflection and dialogue. A cynic might question the use of exciting programmes that accommodate a very small and select audience and which are laid on top of exhibitions that, on their own, are poor communicators and facilitators of individual reflection and public dialogue. One can even see that successful educational programs might play a compensatory role that enables a sacred cow of traditional art museums (i.e. the art exhibit) to be preserved in a form for which there is little evidence of significant visitor-based outcomes and might even be considered largely disfunctional.

My contention is that human communities have cultural needs that are not necessarily being addressed by the existing strategies of our cultural institutions - especially art museums. I would go further to suggest that our current preoccupation with building, preserving, exhibiting and marketing collections of objects, has not evolved from an awareness of the cultural needs of the population. In fact, my twenty years of experience in the field suggests that within museums there is little knowledge of, or interest in, the cultural needs of communities. Rather, most art museum collections are assembled through opportunistic exchanges with collectors/donors - since few art museums have large acquisition budgets. The place of new individual objects in institutional collections, and any new directions in collection building, are then rationalized into institutional frameworks using discipline-based approaches to the objects (e.g. art history). Rarely is there research into the cultural needs of community and a proactive use of institutional resources to

address those needs. I know of some cultural organizations that have attempted to follow such a path (e.g. Indianapolis Children's Museum, Chicago Historical Society, and Ecomuseé de Haute Beauce), but the results are mixed and it is rare in art museums.

The relevancy of art museum operations needs to be judged by assessing outcomes in community, and requires pertinent feedback loops. Traditionally, art museum feedback has taken such basic forms as the balancing of the corporate books, meeting projected attendance levels, publishing for academic and public markets, loaning and borrowing significant art objects, meeting membership targets, corporate donations, column inches in the press and minutes of TV and radio coverage. Very little focus is placed on understanding the quality of visitor experiences or on the needs/wants of those who do not tend to visit. By using a traditional approach to feedback and assessment, art museums have tended to maintain the institutional status quo - e.g. attracting audiences that are comprised largely of tourists, the well-educated and the relatively affluent (Department of Canadian Heritage 1992; Ernst and Young 1990; 1991; 1992). If art museums want to move towards being relevant in a changing society, they will need to create mechanisms for relating to the larger population in meaningful ways. Current internal and external pressures for museums to succeed within the spheres of entertainment and tourism seem to be taking art museums more towards would - be 'blockbusters' and further from fulfilling their potential as cultural facilitator within community. Part of this pressure seems to come from an economic imperative to generate revenue and drive numbers of people through the doors. The rhetoric of 'quality' and the reality of passive viewing experiences have become hallmarks of much within the art museum world. The resources already allocated to our cultural institutions could be redirected towards addressing community cultural needs, but would need a new framework. I propose that the lens of sustainable development provides a way to re-frame the role that art museums play in our society.

The following sections of this paper will explore the concepts of sustainability, culture, art and creativity, with a view to envisioning a refreshed way of imagining the goals, methods and assessment of the art museum.

CULTURE AND SUSTAINABLE DEVELOPMENT - AN OVERVIEW

(Sustainability is...) meeting the needs of today's world without compromising the ability of future generations to meet their own needs (World Commission on Environment and Development 1987).

The concept of sustainability has evolved from a realization that the well being of humanity relies upon a dynamic balancing of three major and interdependent systems - humanity, the biosphere and the economy. The classic model, seen below, helps to differentiate these three elements.[2] As a system, the natural environment is made up of ecosystems that function locally, regionally and globally. Biodiversity is an important factor in the health of the environment - with interdependent plant and animal species maintaining their cycles of life. Humanity too is complex in the varied ways that groups have learned to live within the dynamic balances of local

ecosystems, but also in the many ways it has created balances of roles and interactions within the human community. As the human community has evolved, with its unique potential of conscious functioning, it developed economic systems to help manage and mediate the relationships between humans and the natural environment. These systems now are so interwoven in the values and operations of the human enterprise, that they have become a third factor in the model of sustainability.

Fig 1. Classic model of sustainable development

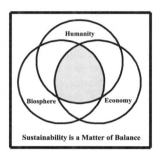

Culture is not often considered in discussions about sustainability. Generally when people think about culture, it is common to hear reference made to history, art, music, food and practices of an ethno-cultural group. When seen in this way, culture is usually considered an important, but essentially non-critical element within the social dynamics of our global interactions -- hardly a make-or-break dimension of securing a livable and sustainable future. Science, economics, law, policy, regulation and enforcement are all considered to be of more immediate consequence than is culture. Recently, some progressive thinkers[3] are understanding culture to play a foundational role in the very value systems of our societies – societies which are embracing globalization, while holding onto a range of cultural traditions and uniqueness. My evolving understanding of culture is the sum total of all values, collective memory, history, beliefs, mythology, rituals, symbolic objects and built heritage which reflect the manner in which a people relate to both those aspects of life which: a) they can know and control; as well as, b) those they cannot fully understand or control, but to which they need to have a conscious relationship. In this context, knowledge of the past is essential for living culture, but is insufficient. The past must be brought into a meaningful relationship with the present and with a mindfulness of the future. And it is the second part of this definition of culture which may be the most important - the way in which we develop a conscious, respectful and humble relationship with the mysterious, unknowable and uncontrollable aspects of life. Seen in this way, culture can be understood as a system by which individuals are connected through a dynamic balance to the values and behaviours of the larger collective and to the economic and natural systems of our world. It is true that these connections exist regardless - humanity is woven into

the fabric of life on Earth. But these connections can be either conscious, or largely unconscious. At this point in time, with over six billion people sharing a planet that has a limited capacity to support the population of this size, consciousness will be necessary if we are to avert a re-balancing of the Earth's systems through means such as war and disease.

Values are exceedingly complex, layered and often conflicted phenomena. How an individual consciously embraces a set of values and beliefs that support sustainability is made all the more complex and layered with the habits, expectations, attitudes and prejudices of their society, all of which have evolved over long periods of time. For example, in Western societies, extraverted, rational pragmatism, largely channeled through one's ability to acquire material wealth and personal power, is a favoured mode of relating to the world. One of its core beliefs is that humanity can dominate and control the natural world. On the other hand, in some Eastern societies, more introverted, spiritual approaches have held sway in the past - based on a belief that people must live in harmony with the nature that surrounds us. All systems of values have their strengths and weakness. Our future may depend on integrating these approaches both at the collective level and at the individual level.

If we examine North America's general approach to culture, we often encounter an institutionalized and discipline-based approach to understanding human life that carves our world into small pieces of academic specialization. Thus specialized organizations have evolved to manage specific 'cultural functions'. Ballet, theatre, opera are three manifestations of the performing arts, while museums have their own special discipline-based focuses, such as history, art and science. Creating such silos of specialized functions is characteristic of the modernist era, and like most aspects of western life, culture has been subjected to this process. Whether culture is considered a set of separate functions that warrant discipline-based isolation, accompanied by institutionalization and commodification, or whether culture demands being understood as woven into the fabric of everyday life is a very important question for art museums to sort out. An interesting aspect of this question pertains to the place of 'popular culture'. It is common for those who value 'high culture' to also spurn 'popular culture'. The latter most often is seen as being controlled largely by corporate interests and usually geared toward influencing (i.e. increasing) consumption patterns that support the economic foundation of our society. The former tends to be ghettoized into institutions of higher knowledge that attract elite publics and have very questionable links to the cultural fabric of peoples' lives. Neither is particularly geared towards facilitating the development of a conscious awareness of humanity's relationship with nature and economy in ways that link to sustainability and survival. In order for that to happen, a much better system for providing meaningful feedback to individuals and collectives is required. Within a framework of sustainability, these feedback loops need to provide individuals with insights about their personal relationship with the evolving realities of society, biosphere and economy.

If culture is linked to human values and is to be considered a foundational element of achieving a sustainable future, then a major reassessment of our infrastructure of cultural activities and agency must take place. Regardless of how

good our environmental science becomes, how effectively our regulatory systems operate, or the impressiveness of our 'blue box' recycling programmes, sustainability will likely not be possible unless there is a shift in the core values of civilization. Individuals need to feel that they are both empowered and responsible participants in achieving a sustainable future. It is not enough that citizens drag a portion of their recyclable materials to the curb once a week, especially if there is no change in consumption patterns. Educational strategies regarding the interconnectedness of environmental, social and economic systems will be important in informing the public about the possible outcomes of staying our current course of development. But people also will have to experience these possibilities through more than intellectual arguments. Our natural and human environments need to be experienced through the senses, the emotions, human spirituality, as well as by the intellect. Only then, will our efforts at 'sustainable development', whether it be in Toronto, Sao Paolo or a rural village in China, have what the World Commission on Culture and Development called 'soul'. It is my firm belief that art museums are capable of contributing in a meaningful way toward this process, but will require a wholesale re-thinking of all aspects of current operations.

WHAT ROLES HAVE ART MUSEUMS PLAYED IN THE PAST?

Apart from royal and religious collections of precious objects, which have been assembled for hundreds of years, the history of museums really began with private collections of curiosities. Largely consisting of exotic materials from around the world, these collections provided a link to how other people lived - often with the purpose of academic study, within the framework of imperialistic ideologies. Later, the idea of museums as public institutions with educational missions emerged, complementing the learning environments of schools. Over the years, museums specializing in art, science and history emerged. Art museums would collect what was considered to be the highest 'quality' objects of visual expression, and then display them for the benefit of viewers. It was through public exposure to these symbolic objects that a viewer was supposed to gain insight into the archetypal and timely human experiences that have inspired human creativity in the past.[4] How this process was supposed to work or how it was to be facilitated was never made terribly clear within the art museum world, but it was clear that artists had a special ability to create images that carried the emerging insights and themes of their times. But instead of exploring the psychology of creativity and symbolic experience, art history developed as the discipline considered the core expertise for assessing, collecting and discussing artworks in the museum context. Art historians then became responsible for building collections, conducting research and preparing interpretations designed to decode the significance of the works. It is important to remember though that collector/donors are perhaps the most significant factor in the building of public art museum collections. Because our public cultural organizations have relatively few funds for acquisitions, there is a reliance on donations. Therefore, it is the relationships that are created between museum curators and collectors that determine in large part how the collections grow. Carol Tator (1998), in her book *Challenging Racism in the Arts*, discusses how power structures in the

society at large can affect the fundamental operation of our cultural organizations - frequently perpetuating problems of systemic racism. To further complicate matters regarding collection building, the art market mushroomed through the 20th century as a significant influence on the designations of quality, value and importance of artworks. Thus, the art market enabled dealers, agents, auction houses, collectors and art specialists to affect what objects are considered valuable and collectable. The question that remains is how much does the collecting practice of art museums truly reflect the cultural realities of the larger society?

Historically, of all the various forms of museums, art museums tended most to believe that a viewer needed to experience the object directly, unencumbered by interpretation. It was believed that by providing little more than the artworks, a source of light and a contemplative space, the viewer would participate in the living mystery of the creative process. Discussions about the meanings of the works were generally reserved for publications. Today, art museum officials continue to believe in the primacy of the art object. And although one encounters considerably more interpretive materials in art museums than was the case some decades ago, art museums are still characterized by rooms full of paintings or sculptures that are supported by little more than 'tombstone labels' and introductory, declarative text panels. Part of the reason for this is the ongoing belief that the real value of an artwork is derived from experiencing it directly, so visitors are left to make their own way with the objects. There may be some validity to this belief; however, the museum-viewing environment can actually undermine such behaviour. An average art museum exhibition contains approximately 60 to 150 artworks. Normally, seating is at a premium and rarely placed where someone needs it in order to spend extended time with any particular work. Moreover, the rationale for an exhibition of a group of artworks is usually based not on the depth experience of individual objects, but rather on an art historical thesis that is argued only in a catalogue. Given the leisure time context of most visits to art exhibitions, individuals will spend an hour or two trying to take in as many individual works as possible and glean some sense of meaning – whether or not it relates to the organizing theme or thesis. But audience research across the field commonly reveals the characteristic behaviour of 'grazing' - or wandering slowly past many artworks, spending only seconds looking at any work in particular. It is relatively rare to watch a visitor spend more than a minute with any individual artwork. Within this reality, it remains unclear just what the expected or desired outcomes of art museum experiences are - from a visitor point of view. Increasingly I believe that one of the core issues for art museums is differentiating its outputs from its outcomes. It is all too clear - even cliched - that what art museums do is what they always have done - produce exhibitions. This is their major output. Minor ones, as gauged by the resources committed to them, include educational programmes, publications, events, etc. Often these try to compensate for the inability of the core to achieve a significant public outcome. Oddly enough, it is quite unclear what art museums believe their public outcomes should be.

Today, collectors constitute a cornerstone of the museum world. Directors and curators actively woo donors for their stuff, largely because they don't have the discretionary funds to purchase what they want to acquire. It is no surprise then that

museums often reflect the values of the collectors, within the setting of a shrine to the acquisitiveness of rich individuals. This is not to disparage either the collector/donor or the curator/director, only to point out that our system of museum building has certain inherent peculiarities.

Within the framework of their educational missions, museums have offered individuals a host of experiences that they otherwise would likely not have had. Through the great range of museum types (history, art, science, etc.), it is possible to examine the material culture from countries around the world, as well as historical materials that are significant to local communities. However, the art museum as a public education or cultural model has proved to be questionable. Visitation to art museums is sporadic at best, when examined from the point of view of individuals. Most people tend to visit museums primarily when they travel, not as a way of establishing or maintaining connection with the cultural collective of which they are a part. Also, art museum experiences are frequently characterized by authoritarian and paternalistic messages and tones, in which experts tell visitors the meanings of cultural objects selected by the museum. In this environment, it is unclear for most visitors what role they should play other than that of passive recipients of expert knowledge. Art museum practices are not oriented toward engaging the public in reflective practice or participatory exchanges, with some exceptions that have emerged more recently.[5] Rather they tend to reflect North American ideals of specialized centres of expert knowledge that is imparted to the non-expert. Increasingly, there are pressures both from museological and non-museological sources that are challenging museums to develop more holistic public engagement models to guide our cultural organizations toward a more relevant and integrated role in society. It goes without saying that the traditions of the museum will resist this type of fundamental challenge - but perhaps no more so than the for-profit, corporate sector that also must reassess and reformulate its value system if it is to survive into the future.[6]

THE CHALLENGE OF CULTURE IN PLURALIST ENVIRONMENTS

Globalization is currently changing the very nature of human life on this planet. Technological advances in communication and transportation, made over the past century, have effectively shrunk the world. Simultaneously, populations of urban centres have been growing at record rates, and will continue to grow in this way over the next thirty years (UN 1999). Our current population of 6.1 billion is projected by the United Nations to become 8.1 billion by the year 2030, with the growth of 2 billion being all in urban centres. In addition to simple growth of numbers in cities, current trends towards pluralization through immigration are expected to intensify.

Changes in demographics do not manifest only at the global level, but also locally. As the accompanying table indicates, the demographics of Toronto have changed dramatically over the past 30 years.

Fig 2. Population Trends in Toronto, Canada (Lastman, 1998)

Toronto in 2000
• **More than half of Toronto's population was born outside Canada** • **Almost half of the population was non-white** • **Over 70,000 immigrants come to Toronto (each year), from over 160 countries, speaking over 100 languages** • **Over 40% of new immigrants speak neither English nor French**

Toronto over 30 Years
• **In 1961, non-whites comprised 3% of Toronto's population** • **In 1991, non-whites made up 30% of the population** • **Before 1961, about 92% of immigrants came from Europe** • **Today, less than 17% of Toronto's immigrants are from Europe**

Toronto proudly lays claim to being one of the most multi-cultural cities in the world. Like many cities in the western world, Toronto's cultural mosaic is perhaps most evident on the downtown streets, in schools and when riding the public transit. People whom once were referred to as 'visible minorities', now constitute the majority. With wide-ranging ethno-cultural and religious backgrounds, Toronto has evolved over the past 50 years to be a city that is rich in its cultural diversity. The question that emerges from this scenario is "what constitutes the culture of pluralism?" Individuals who seem to be associated with a particular ethno-cultural group do not live in isolation from those outside that group. Rather, these people live within the political, social and economic context of a complex civil society. Differing ethno-cultural world-views dynamically mingle within the pluralist community, creating hybrid perspectives and actions within the population. What seems important here is that, despite the survival of aspects of imported cultures, a new framework is created that constitutes the culture of our civil society.

In pluralist cities, individuals abide by laws that apply to all. Citizens share civil rights, including access to education, fair treatment in employment, housing, health care and more. But it is important to note that the infrastructure that is put in place to support the cultural diversity of cities exists to address the needs of a pluralistic 'civil society'. Although there is still room for improvement in ensuring complete social justice and equity, Canada's civil society framework does reasonably well in recognizing and responding to the civic needs of the whole society. Building a civil society framework is critical for the success of pluralism, but it may be insufficient. Geared toward the pragmatics of life in a secular world, our frameworks for civil society provides little focus on how human beings relate to the mysterious, unknowable and uncontrollable dimensions of life. It is exactly this relationship to those things that we can't control that offers the potential of finding our values related to sustainability. Global warming, loss of biodiversity, diseases, famine, pollution, and systemic hatred all speak to the problems of a world in which

humanity has mangled its relationship with the larger natural systems of which we are only a part. But such matters are not high on the list of priorities of politicians and policy-makers - or on the minds of most citizens. And, to be fair, there is no history of such focuses in public life, nor is there an expectation that leaders will have the necessary competencies to grapple with such issues. Cities, at least in recent times, have not evolved for cultural reasons, but rather for pragmatic, civil ones.

Economic efficiency of providing services to people, which accompanies the concentrating of populations in cities, continues to be a strong argument for urbanization. But urbanization has many costs. For example, in large cities, individuals have a difficult time establishing a personal relationship with the forces of nature and forging a set of values that is fully conscious of the intimate way in which each of us is a part of nature. Beyond this problem, alienation and anonymity, which can thrive in cities despite the large numbers of people, can hamper one's ability to live successfully. It is easy to see how one's individual need to survive in the city (e.g. housing, food, social acceptance, etc.) can over-shadow one's consciousness of the relationship we each have with the environment and other people. However, our individual and collective relationships with nature and with other human beings are essential if the goal of sustainability is to be achieved. In order to develop a conscious relationship with the environment, humans need to have meaningful feedback concerning the relationship. People who live in rural settings may have an easier time of maintaining their relationship with nature. Weather, topography, rhythmic changes within ecosystems and such all are more evident within a rural setting than in the paved and built environment of cities. Building a relationship with nature is difficult in the city. Some of us are lucky and rich enough to be able to visit wilderness areas. But for many people, experiences of nature are limited to such activities as the use of local parks during our leisure time (when the weather is nice) and balcony or window box gardening. If we limit our relationship with the larger forces of nature to contact only during leisure-time or entertainment activities, do we not seriously minimize our relationship with nature?

Being aware of our relationship with nature is getting harder, but this is not our only relationship challenge. For example, purchasing goods made in developing countries by slave or child labour makes us active players in social injustice and exploitation. Yet our values in this consumer culture propel us towards 'bargains', regardless of the hidden costs. It can be argued that, despite the cultural values that have existed in our personal or ancestral pasts, the pressures and norms of our contemporary urban culture become dominating overlays that steer our behaviour. And this urban culture is geared towards unconsciousness consumption – at least not consciousness related to sustainability.

And the issues become even more layered. David Goa, a Curator at the Provincial Museum of Alberta sees a strong emphasis in today's society on the creation of a level playing field for all citizens - specifically in terms of social justice, equal access to opportunity and distribution of wealth. It seems obvious that such a leveling of the playing field is absolutely necessary for sustainability. It may, however, not be sufficient. Goa (1994) suggests that a major shortcoming of our civil society agenda is that it doesn't nurture a soulful connection amongst

individuals, between people and the environment, or linking citizens with the mysterious realm of the spiritual. The civil society is governed primarily by rationality and ideals of fair treatment, but doesn't have much capacity to privilege the irrational dimensions of life (e.g. spirituality, creativity, emotion) – which may be the most powerful forces that humans experience. Goa claims that a cultural framework for a sustainable world needs to include spiritual dimensions. Since these dimensions are difficult to control, and since our culture favours those things that it can control, spirituality will have a difficult time finding an honoured space in our contemporary world. Generally, the messiness of a constantly evolving culture is not well tolerated in our society – and especially in our cultural institutions.

We are currently in need of good mechanisms that connect our values, beliefs and lifestyles to our sustainability. With such mechanisms, organizations like museums, can re-assess their functions in relation to current realities and desired futures. From this point, museums could contribute in a more substantial way our living culture. But, in order for museums to go down this road, they will have to re-frame their terms of reference for judging their successes and failures. It is my hope that art museums will increasingly take their lead for public programming from the pulse of the community, not simply continue to invent an ongoing stream of exhibitions that have unclear, or even questionable, outcomes.

ART MUSEUMS AND PERFORMANCE MEASURES

Like governments that need to expand their assessment of public well-being beyond the traditional, one-dimensional method of Gross Domestic Product (GDP), art museums too need to develop effective feedback systems that enable them to understand the cultural needs and experiences of individuals within evolving communities so that museum programmes can be responsive and relevant to the public. Traditionally, art museums have been sensitive to a couple of different types of feedback; the most obvious one is economic. As publicly accountable organizations, art museums have had to balance their books. But keeping income in line with expenses only reveals a very small part of the fiscal picture. The average cost per visit to an art museum is very high - in fact, for Canadian organizations, it is $35.88 (Statistics Canada 2001). In individual institutions across the country there is wide variation in the per visit cost, ranging from about $10.00 to over $100.00 for one visit (Fenger 1994). Some might argue that art museums do much more than offer access to visitors - like research, acquisition and conservation of collections. However, since all museum functions ultimately are geared toward public accountability, the outcomes are largely reflected in visits, which have both quantitative and qualitative dimensions. If our art museums were facilitating truly amazing cultural experiences that had significant impacts on community, that would be one thing. But to the best of my knowledge, few, if any, art museums attempt to measure their cultural impacts and outcomes. If they were to do so, it would be an obvious next step to analyze the relationship of expenditures to outcomes and begin planning towards the optimization of cultural well being within the community. The distinction that is being made here is between outputs (those activities that museums are identified with, such as exhibitions, lectures, catalogue production, etc.), and

outcomes (the net effect on the larger public to whom the organization is ultimately responsible). Stephen Weil, the noted museologist from the Smithsonian, recently discussed this problem, distinguishing between the means and ends of museums (Weil 2000). Museums, Weil suggests, are on a means-oriented treadmill that produces what has always been produced, specifically exhibits, programmes and publications. When it comes to grappling with the 'why' of their operations, most museums are extremely unreflective about why they do what they do and never effectively gear their operations to the cultural needs of human community. In some respects, this unfortunate situation, which creates operational costs in the vicinity of $35 per visit, is a minor part of the problem. The more serious issue relates to the opportunities for truly vital cultural activity for which there has never been sufficient funding - because the large institutions always consume the lion's share of the cultural funding.

Developing new or revised economic feedback loops can help art museums plan and carry out their work more effectively. But it will be in the development of meaningful feedback loops related to the mysterious power of art and creativity that offers art museums the greatest opportunities for development. Over the past few decades, the field of visitor studies and audience research has helped provide greater professional awareness of the need for outcomes-based approaches to museum programming (e.g. Falk and Dierking 1992). By creating a focus on the physical, intellectual, emotional and social interactions between visitors and exhibits, researchers have done much to help exhibit and programme planners to create more effective educational strategies. However, much of what has been done in this regard has been quite narrowly focussed on concrete educational activities that are prescribed by the museum. To date, audience research has not shed much light on how to best understand the cultural needs of communities. In my view, progress on this front will demand that art museum professionals actually grapple with several important considerations: the nature and significance of symbolic experiences with objects; the fundamental place of culture in the lives of individuals and groups; the potential of museums to be truly neutral, safe spaces for the negotiation of issues within the public sphere; and, the building of community.

Culture is by its nature contentious and messy - with every cultural group having numerous factions that are in conflict/negotiation at any given time. It is ironic that art museums - one of our society's chosen mechanisms for facilitating culture - never feel messy. Instead, art museums present very tidy reflections of culture. Characterized by precious objects and text panels that make authoritative, declarative statements about what is believed to be true about the objects, from a discipline-based perspective, art museums have a very low tolerance for living culture. And the pluralization of society poses difficult questions that most art museums would rather avoid. Whose precious objects are to be collected? Whose history, values and perspectives will be included? Is there unlimited room for storing collections which grow to reflect the shifting profile of society? Should art museums place so much emphasis on the traditionally central role of art objects, or should the focus become more balanced with the staff and public creativity that constantly reinvents and rediscovers meaning in objects? What skills, expertise and wisdom is required to operate a cultural facility that balances the history and tradition of people

with the emerging present of cultural dynamics? And, if adequate answers to all of the above questions are forthcoming, there is still the question of what is to be done with the collections. Are exhibitions of art objects that are viewable only behind plexiglass barriers very effective at encouraging personal experiences of symbolic significance? If not, what alternative strategies would be required to rectify this situation and maximize the public resources dedicated to cultural facilitation in a pluralist society? If these questions are addressed, it should become obvious that seeing art museums as instruments of cultural tourism, highbrow entertainment and economic engines is to fundamentally misunderstand the potential of art in living culture.

Joseph Campbell, the noted mythologist, reflected in a 1989 interview that humanity has a colossal challenge on its hands in order to make the leap from traditional life in communities/nations to mindfully and responsibly occupying the planet in a globalized world (Boa 1989). Individuals have enough difficulty becoming conscious of their inner selves and relating successfully to a complex day to day world. But cultivating the ability to stretch one's consciousness to include the rest of Earth is exceedingly difficult. Certainly news, books, internet, and even travel for the privileged few, provides a partial awareness of the invisible relationship we all now have with the global community. However, the complexities of these relationships are daunting. Do we really understand how each of us constitutes a contributing unit within the Western economy? How many are aware that our lifestyle is predicated on the inequitable consumption of resources, which, in turn robs billions of their fair share of the Earth's productivity? Increasingly, we in the West are becoming aware of issues associated with burning fossil fuels, relying on science or politics to solve our problems, as well as the unsustainability of our growth and consumption-based economy. But the gap between rich and poor is widening. The polar ice caps are melting from global warming. Our culture(s) within the Western world are slowly adopting the meta-values of civil society that are shaped primarily by the dominating force of globalization -- economics. But sustainability is only achievable if balance is secured within the spheres of humanity, environment and economy - applied mindfully to the lives of individuals, communities, nations as well as the global population. If we are to find a way to balance a global population of more than six billion people, with equity and social justice for all, as well as develop a respectful relationship with the other species that share planet Earth, then our cultural perspectives must shift. One of the best feedback mechanisms for developing consciousness of this situation is through the Ecological Footprint (Rees and Wackernagel 1995).

The calculation of our 'ecological footprint' suggests that each person living in a city, like Toronto, requires the equivalent of a plot of land over seven hectares large in order to support their consumption and waste-production patterns. Rees and Wackernagel make the point that if we divide the amount of productive land by the population of the earth (i.e. six billion), the sustainable footprint is a mere two hectares per person (allowing a tiny slice of the biosphere for the other species that we share the planet with). In Toronto, on a per capita basis, we demand use of more than three times our 'fair share' of the productive capability of the Earth. How many people are truly conscious of this reality, let alone committed to minimizing their

impact and adjusting their lifestyle to become more sustainable? We turn on a tap and water appears. Food is always available at the local store. Soiled water disappears into the sewer. Our garbage is whisked away by city workers, and we never see where it goes. Life in urban settings has been designed to remove these worries from our daily reality. Wackernagel and Rees provide an analogy to help clarify our situation. If a frog is placed in a pot of boiling water, it will immediately hop out and save itself. However, if the same frog is placed in a pot of cool water that is then placed on a stove, the frog will not realize that the temperature is rising and will eventually perish. Our blindness spot is part of our cultural reality - a fairly worrying part. Many of our contemporary artists attempt to address these issues in their work, however, art museums seem to do little to use these artworks as catalysts and focal points in the stimulating of public discussion and dialogue.

Fig 3. Selected Ecological Footprints of Countries

Ecological Footprint
Country Rankings
(adapted from Wackernagel, 1999)

USA	10.3 hectares/person
Canada	7.7 hectares/person
United Kingdom	5.2 hectares/person
France	4.2 hectares/person
Costa Rica	2.5 hectares/person
China	1.2 hectares/person
India	0.8 hectares/person
Bangladesh	0.5 hectares/person

World Footprint	2.8 hectares/person

Sustainable Footprint	2.1 hectares/person

There is an increasing number of feedback mechanisms being developed to help us make the leap towards a global consciousness. The Genuine Progress Indicator (GPI) is an example of the kind of approach to feedback that offers ways of gauging changes to quality of life, but which also tracks environmental and economic factors. The great value of the Ecological Footprint analysis is that feedback can be obtained on one's personal, community, national and global relationships to sustainability, since it provides a fairly graphic picture of the relationship between an individual and the larger spheres of identity which that person exists within. The effect, which can be both motivating and paralyzing, is essential if humanity is to stretch its consciousness in a way that enables for responsible inhabitation of the planet.

Art provides for a very different type of feedback mechanism. Since it provides people with access to the mythic and the archetypal, art offers a meaningful counterpoint to our exceedingly pragmatic world. On a personal level, art can draw a viewer into a deep reflection about his or her values. These intensely reflective experiences have a power all their own, and sometimes have meanings entirely independent of the artistic intention (Worts 1995). By grounding the personal experience in deep reflection, I would suggest that individuals are able to participate more consciously, and hopefully responsibly, in the shared use of the planet. To

work towards such an approach to art is a profoundly challenging situation for art museums. It demands that our cultural agencies become committed to functioning in a purposeful manner that is not simply oriented toward the rear-view mirror of traditional exhibits and programs, but which enables the public to become more reflective and which provides vehicles for democratic, public engagement in contemporary issues.

FINAL THOUGHTS

We are living in a world that is experiencing many 'firsts'. Population has never been so high and is climbing exponentially. The gap between 'have's' and 'have not's' is wider than ever. Global travel and communication is almost instant because of technology. Natural resources can be extracted from the earth in ways not even dreamed of a short time ago. Urbanization is bringing together people in all sorts of new ways. Species are becoming extinct at an unprecedented rate. The polar ice caps are melting because of global warming. These and other phenomena are part of our age. As individuals and as communities, we try to find a way to relate to these developments – but it is difficult to stretch our consciousness in a meaningful way to embrace the world. Thus far, globalization has been driven by the pervasive reach of economic thinking that believes that growth is always positive and can continue forever – a belief that is hard to defend. Because globalization principles have not been applied to the environmental and human dimensions of the sustainability model, there are no counterbalancing forces to challenge the dominance of economics. We don't have to look very far to find evidence that this imbalance is not only capable of negative repercussions but that they are already here. September 11th 2001 is an example. Somehow, at individual and collective levels, humanity needs to become conscious of and committed to creating balance.

Art museums have the potential to become effective 'places of the muses' in which our place as individual human beings within a complex set of systems can become more conscious. Much more than being simply the repositories of material culture that 'experts' agree are important, these organizations can honour the role of creativity and the symbolic in human experience. Never has there been a time in which humanity has been more in need of the wisdom that comes from a conscious relationship with the mythic and the creative in order to provide a perspective that is humble enough to understand our situation and smart enough to act effectively. An historical view will be essential, but it needs to be placed in the service of the present and with a view to the future. Through the creativity of artists, individuals can engage in the images that connect us with the archetypal patterns that are at play. But, as Picasso said, the artist creates material that enters the public sphere, only to begin a new creative process with the viewer.[7] Each form of creativity provides links with potential awareness. The art museum occupies a unique position between the artist and the public, and is capable of facilitating human consciousness. If the widespread institutional commitment to the expert/novice paradigm as our dominant way of understanding the meaningfulness of art can be released from the core values of art museums, new possibilities for reflection and responsible living can ensue. Much change within art museums will be necessary to promote the

importance of creativity amongst both artists and non-artists, and to find ways to give it a place of honour in everyday life. But by doing so, perhaps art museums may step back from the brink of irrelevance.

Douglas Worts is a museum educator and audience researcher at the Art Gallery of Ontario in Toronto, Canada.

NOTES

[1] LEAD (Leadership for Environment and Development) Canada is part of a cross-disciplinary international network of people committed to furthering the goal of sustainable development on a global level. LEAD International was started by the Rockefeller Foundation in 1992 and is now an independent NGO with associates in over forty countries. LEAD International headquarters in London England.

[2] This model suffers from the illusion that the three elements are somehow separate. In reality, humanity and the economy are not separate from nature; they are part of it. Nonetheless, this model does have value in helping to differentiate aspects of this complex system.

[3] For example, the authors of <u>Our Creative Diversity</u>, the Report of the World Commission on Culture and Development, UNESCO, 1995.

[4] The term 'symbolic' here refers to the power of an object to bring a subject into a deep reflective state in which a new insight can emerge, as opposed to an object that stands for, or is equivalent to, something else. This sense of the word 'symbolic' comes from the work of CG Jung, and is explored in depth by Edward Whitmont (Jung; 1964 Whitmont, 1991)

[5] Examples of some programs which seem truly committed to engaging the public in meaningful ways are: Dubinsky, *Reading the Museum*; the new Te Papa Museum in Wellington, New Zealand; 'Share Your Reaction' card system at the Art Gallery of Ontario, see Worts, 1995.

[6] Corporations too are slowly assessing their core assumptions and values in relationship to long-term profitability. Some are realizing that the use of non-renewable resources cannot go on indefinitely and that the environmental and social impacts of their operations will have a serious impact on their ability to exist into the future. See Hawken, Lovins and Lovins, 1999.

[7] Picasso once said, "A picture is not thought out and settled before hand. While it is being done, it changes as one's thoughts change. And when it is finished, it still goes on changing, according to the state of mind of whoever is looking at it. A picture lives a life like a living creature, undergoing the changes imposed on us by our life from day to day. This is natural enough, as the picture lives only through the man (sic) who is looking at it." From a 1935 interview with Christian Zervos.

REFERENCES

American Association of Museums, *Excellence and Equity: Education and the Public Dimension of Museums*, Washington, D.C.: American Association of Museums, 1992.

Anderson, David, *A Common Wealth: Museums in the Learning Age (2nd edition)*, London: DCMS, The Stationery Office, 1999.

Atkisson, Alan, *Believing Cassandra: An Optimist Looks at a Pessimist's World*, Vermont: Chelsea Green Publishing, 1999.

Boa, Frazer, *This Business of the Gods: Joseph Campbell in Conversation with Frazer Boa*. Ontario: Windrose Films, Ltd., 1989.

Department of Canadian Heritage, *Canadian Arts Consumer Profile*, Ottawa: Government of Canada, 1992.

Canadian Museum Association, *Workforce of the Future: Competencies for the Canadian Museum Community*, Ottawa: Canadian Museum Association, 1997.

Dubinsky, Lon (Ed.), Reading the Museum: Literacy Program of the Canadian Museums Association, newsletter, **http://www.nald.ca/rtm.htm**

Ernst and Young, *Audience Research Consortium of Toronto* (Reports 1 - 3), Toronto: Ernst and Young Management Consultants, 1990, 1991, 1992.

Falk, John H. and Lynn D. Dierking. *The Museum Experience*. Washington D.C. Whalesback Books 1992.

Fenger, Anne-Marie, "Performance Measurement for Canadian Museums", unpublished MBA Research Paper, Simon Fraser University, Vancouver 1994.

Goa, David, "Introduction", in *Cultural Diversity and Museums: Exploring Our Identities*, Ottawa: Canadian Museums Association, 1994.

Hawken, P., Amory Lovins and Hunter L.Lovins. *Natural Capitalism: Creating the Next Industrial Revolution*, Boston: Little Brown and Co, 1999.

Jung, C.G., *Man and his Symbols*, New York: Doubleday, 1964.

Karp, Ivan and Stephen Lavine, eds. *Exhibiting Cultures: The Poetics and Politics of Museum Display*. Washington: Smithsonian Institution Press, 1991.

Lastman, Mel (Mayor of Toronto) "A Paper on the Diverse Nature of Toronto", Presented to the G- 8 "Summit of the Cities", Birmingham, England, May 13 - 15, 1998.

Rees, W. and M. Wackernagel. *Our Ecological Footprint*, New York: New Society Publishers, 1995.

Statistics Canada, "Profiles of heritage institutions", Ottawa: Statistics Canada, <www.statcan.ca/english/Pgdb/People/Culture/arts06.htm> 2001.

Tator, Carol, Frances Henry and Mattis Winston. *Challenging Racism in the Arts: Case Studies of Controversy and Conflict*, Toronto: U of T Press, 1998.

United Nations, "World Urbanization Prospects: the 1999 Revision", United Nations Population Division, <www.un.org/popin/wdtrends>

UNESCO, *Our Creative Diversity: Report of the World Commission on Culture and Development*, France: UNESCO, 1995.

Weil, Stephen, "Beyond Management: Making Museums Matter", paper delivered at Canadian Museums Association Conference, 2000.

World Commission on Environment and Development, *Our Common Future*, United Nations, 1987.

Worts, Douglas, "Extending the Frame: Forging a New Partnership with the Public", in *Art in Museums*, Susan Pearce (ed.), London: Athlone Press, 1995, pp. 165-191.

INDEX

Abbs, P., 155, 156, 159, 164, 165
Abrams, C, 27, 31
Academy of Fine Arts, 94
access, 1, 2, 5, 6, 8, 21, 54, 77, 78, 80, 82,
 83, 86–88, 103, 145, 148, 172,
 223–225, 228
action research, 3, 10, 89, 122, 133, 168,
 178, 182, 188, 193, 194
activity, 2, 6, 9, 30, 38–40, 59, 65, 71, 72,
 83, 97, 98, 111, 113, 117, 126, 129,
 131, 143, 168, 171, 174, 178–181,
 186, 189, 205, 226
Adams, M.M., 6, 17, 21, 22, 26–28, 31,
 32
Addiss, S., 194
Adorno, T., 66, 76
Adult and Community Education Centre,
 85
adult education, 6, 10, 85, 86
aesthetic, 4, 10, 12, 21, 28, 33, 39, 41, 43,
 45, 47–49, 52, 54, 58, 61, 67, 87, 108,
 109, 111, 115, 116, 118, 119, 133,
 136, 138, 139, 148, 153, 155–157,
 162, 165, 171, 178, 185–187, 189,
 194, 204, 206, 209–211
aesthetic education, 109, 116, 156, 165
aesthetic encounters, 4, 12, 67, 119, 156
aesthetic museum, 54
aesthetics, 10, 48, 49, 111, 133, 165, 185,
 189, 194, 204
affective, 4, 6, 20, 24, 33, 35–40, 44–48,
 147, 153
affective experiences, 6, 38
African Art, 21, 25, 26, 31
Aino Myth, 183, 188–190
Alla Scoperta di Brera, 93, 104
Allen, G., 137, 138, 142, 145, 149
Allen, H., 172, 176, 178, 181
America (USA), *see* also United States, 1,
 4, 216, 219, 228
American Association of Museums, 2, 32,
 115, 211, 215, 230
Amsterdam Museum, 36, 40
Anderson, D., 216, 230
Apple, M., 201, 211
applied art, 36

applied research, 4, 137, 169, 170
applied research methodology, 4
appropriations, 185, 186, 193
archaeology, 36
Aronowitz, S., 200, 207, 211
Art Around the Corner Programme, 27,
 28, 31, 32
art criticism, 10, 55
Art Describes, 96
Art Gallery of Toronto, Ontario, 119,
 216, 230
art history, 10, 170, 185, 189, 194, 199,
 204, 216, 220
Art Recounts, 97
Art Represents, 97
Art Sparks Interactive Gallery, 28, 29, 31
art teaching, 8, 9, 109, 112–114
artist as researcher, 10, 165, 167, 168
Artist as Teacher, 135, 140
Artists Work Programme, 77
Arts Council of Ireland, 89
Artworld, 183–185, 187, 190
A Sense of Place, 85
Ashton, D.N., 51, 62
Aspin, D.N., 59, 60, 62
Assen Museum, 36, 40, 47
associations, 83, 85, 107, 108, 115, 119,
 123, 185, 205
Astronomical Observatory, 94
Ateneum Art Museum, Helsinki, 189
Athens, 106, 115
Atkisson, A., 230
audience development, 1
authentic experience, 7, 65–67, 69, 71,
 74–76
autobiographical encounter, 10
autobiographical writings, 7, 65, 72, 164
autobiography, 10, 69, 76, 153, 155–159,
 161, 164, 165
autonomy, 136, 187
aversive trauma, 153, 156, 157, 162

Bacon, F., 174
Baltz, L., 203, 204, 209
Bangladesh, 228
Barenholz, H., 21, 31

233